GERMAN EXPRESSIONISM

Documents from the End of
the Wilhelmine Empire to
the Rise of National Socialism

THE DOCUMENTS OF TWENTIETH CENTURY ART
General editors,
Robert Motherwell
and
Jack Flam

Other titles in the series by G.K. Hall & Co.:

Joan Miró: Selected Writings and Interviews
 Margit Rowell
The New Art—The New Life: The Collected Writings of Piet Mondrian
 Harry Holtzman and Martin S. James

GERMAN EXPRESSIONISM

Documents from the End of
the Wilhelmine Empire to
the Rise of National Socialism

Edited and annotated by Rose-Carol Washton Long

With the assistance of Ida Katherine Rigby
and contributions by
Stephanie Barron, Rosemarie Haag Bletter, and Peter Chametzky
Translations from the German edited by Nancy Roth

G.K. Hall & Co. • New York
Maxwell Macmillan Canada • Toronto
Maxwell Macmillan International • New York Oxford Singapore Sydney

German Expressionism: Documents from the End of the Wilhelmine Empire
to the Rise of National Socialism
Rose-Carol Washton Long

Copyright © 1993 by G.K. Hall & Company

G.K. Hall & Company Maxwell Macmillan Canada, Inc.
Macmillan Publishing Company 1200 Eglinton Avenue East
866 Third Avenue Suite 200
New York, New York 10022 Don Mills, Ontario M3C 3N1

Macmillan Publishing Company is part of the Maxwell Communication Group of Companies.

Library of Congress Cataloging-in-Publication Data
German expressionism : documents from the end of the Wilhelmine Empire
 to the rise of national socialism / edited and annotated by Rose-
 Carol Washton Long with the assistance of Ida Katherine Rigby ;
 with contributions by Stephanie Barron, Rosemarie Haag Bletter, and
 Peter Chametzky ; translations from the German edited by Nancy Roth.
 p. cm.—(The Documents of twentieth century art)
 Includes bibliographical references and index.
 ISBN 0-8057-9954-0 (alk. paper)
 1. Expressionism (Art)—Germany—Sources. 2. Art, German—Sources.
3. Art, Modern—20th century—Germany—Sources. I. Long, Rose-
Carol Washton. II. Rigby, Ida Katherine. III. Barron, Stephanie.
IV. Series.
N6868.E9G37 1993
709'.43'09041—dc20 92-20500
 CIP

The paper used in this publication meets the minimum requirements of American National Standard for Information Sciences—Permanence of Paper for Printed Library Materials. ANSI Z3948-1984.

10 9 8 7 6 5 4 3 2 1 (hc)

Printed in the United States of America

CONTENTS

CONTENTS

ILLUSTRATIONS

PHOTO CREDITS

ACKNOWLEDGMENTS

Many colleagues and friends have contributed to the conception and development of this anthology. For their seminal role in this project, I would like to thank the faculty and students of the Ph.D. Program in Art History at the Graduate Center of the City University of New York. Preparing graduate courses on German Expressionism made me dramatically aware of the need for such a collection of documents since many of the primary sources that I wanted students to read were not available in English and were not even easily accessible in German. As I collected texts, distinguished Professor Jack Flam of Brooklyn College and the Graduate Center and editor of The Documents of Twentieth Century Art series encouraged me to organize them into an anthology. Throughout the long gestation of this project, his support has been invaluable.

Working collaboratively with other art historians in the preparation of the different sections of the anthology has been an especially enriching endeavor. I owe special thanks to the efforts of Professor Ida K. Rigby. Not only did she prepare individual sections but in addition she generously offered her good counsel on the entire manuscript, including problems of translation, interpretation, and style. Specialists Stephanie Barron, Rosemarie Haag Bletter, and Peter Chametzky gave the annotations of each document in their sections the necessary depth and clarity which the material deserved. I am grateful for their scholarship and contribution. As translation editor, Nancy Roth turned clumsy and literal translations of the German into fluid and readable English. Her patience and flexibility as we decided upon one phrase or term over another was remarkable.

Several foundations provided financial support for the extensive research which the preparation of this anthology required. A John Simon Guggenheim Fellowship allowed a sabbatical year to be extended for an additional semester and provided funds for travel in Germany as well as time for research. A travel grant from the Robert Gore Rifkind Foundation made possible several trips to the rich archival resources in Los Angeles. A grant-in-aid from the American Council of Learned Societies provided funds for the initial trips to German archives. Queens College of the City University of New York supported the project in its earliest stages through its Faculty Incentive Award, a Faculty-in-Residence Award, and a Mellon Fellowship. The PSC-CUNY Research Foundation also gave invaluable financial assistance.

A number of colleagues in this country offered special support. I am especially grateful to the collector Robert Gore Rifkind for his encouragement of the project and for his thoughtful introductions to scholars and curators in Europe and America. Professor Peter Selz of the University of California at Berkeley provided invaluable support and guidance. I owe

special thanks to Christine Vigeletti, assistant registrar at the Los Angeles County Museum of Art, for her unflagging efforts to locate material and photographs, and to Susan Trauger, librarian, and Timothy O. Benson, director of the Robert Gore Rifkind Collection at the Los Angeles County Museum, for their willing assistance with bibliographic and other matters. I'd like to thank Professors Brigid S. Barton of Santa Clara University, Barbara Buenger of the University of Wisconsin, Alexandra Commini of Southern Methodist University, Charlotte Douglas of New York University, Marcel Franciscono of the University of Illinois, Charles F. Haxthausen of the University of Minnesota, and Robert F. Herbert of Mount Holyoke College for their careful suggestions. I would also like to acknowledge the support of numerous faculty from the City University of New York, among them Professors Milton Brown, Harold Bruder, Mona Hadler, Gabriel Laderman, and Burton F. Pike.

Directors and curators of German archives and museums contributed major assistance. Dr. Magdelena Dröste of the Bauhaus Archiv provided much help with the Gropius letters and other Bauhaus materials, and patiently arranged for photographs and xeroxes to be sent. Dr. Peter Hahn, now director of the Archiv, generously extended every courtesy. Dr. Armen Zweite, previously director of the Städtische Galerie in Munich and now head of the Kunstsammlung Nordrhein Westfalen in Düsseldorf, made the material in the Kubin and in the Kandinsky-Münter archives accessible and provided all necessary support. Dr. Gerhard Wietek, director of the Schleswig-Holsteinisches Landesmuseum, patiently offered endless advice and graciously guided me through his and other archival sources. Dr. Paul Raabe, director of the Herzog-August Bibliothek in Wolfenbüttel, generously gave me free run of his personal library on Expressionism and arranged for numerous copies of previously unobtainable material to be sent to me. Titus Felixmüller was very helpful with his father's archives and was exceptionally hospitable as were Max K. Pechstein and Leonie Pechstein, who patiently gave me access to the photo archives of H. M. Pechstein. I would also like to thank Dr. Ursula Frenzel of the Archiv für Bildende Kunst of the Germanisches Nationalmuseum in Nürnberg, Hans Bollinger of Bücher and Grafik in Zürich, Professor Klaus Herding of the Universität Hamburg, and Dr. Elisabeth Dückers of the Altonaer Museum in Hamburg for their special assistance. I am also indebted to the late Professor Karlheinz Gabler of Frankfurt, the late Dr. Wilhelm F. Arntz of Haag, Dr. Eberhard Roters, former director of the Berlinische Galerie, Dr. Jörn Merkert, present director of the Berlinische Galerie, Dr. Magdalena M. Moeller of the Brücke Museum, Dr. Wolfgang Henze of Campione d'Italia, Dr. Gunter Krüger of Berlin, Dr.

Ursula Peters of the von der Heydt Museum, Uppertal, Dr. Juta Penndorf of the Staatliche Lindenau Museum, Altenburg-Thuringia, Joachim Heusinger von Waldegg of the Staatliche Akademie der Bildenden Künste Karlsruhe, and Achim Wendschuh of the Akademie der Künste, Berlin.

Over the years, a number of CUNY graduate students and others assisted with the research and with numerous tasks involved in preparing the manuscript. I'd like to thank Peter Chametzky, Carmen Stonge, Andrea Feeser, Kathleen Friello, Lori Schafer, and Thalia Vrachopoulos for their careful research; and Peter Harris, head of Educational Resources at CUNY, for his assistance with the photographs. Thanks also to Maria Brendel, Antje Wedding, and Gabriele von Zon for work on the translations and to Beth Harris, Andrea Feeser, and Kimberly Paice for their meticulous efforts with the word processor. To my editors, Anne M. Jones, formerly of G. K. Hall, Mark Zadrozny, Lesley Poliner, Paul Dippolito, and Edward Ferraro of Twayne, I extend my deep appreciation for their careful work with all aspects of the anthology.

Finally, I would like to thank Johanna Lewinsky and her family for providing a second home in Germany, my parents for continued encouragement, my son Dan for his patience during the "seemingly endless" years of the project, and my husband Carl for his unflagging support and understanding throughout the entire process.

INTRODUCTION

Why produce a volume of essays written by diverse figures associated with German Expressionism? What can statements made by painters, sculptors, architects, critics, art historians, and collectors tell us about this particular direction in the visual arts in Germany from the end of the Wilhelmine Empire to the rise of Hitler's Third Reich? In addition, doesn't any selection of documents implicitly contain the danger of codification and limitation? Weighing these questions against the value of direct contact with a diverse body of opinions from a particular period, I tip the scales in favor of presenting a variety of voices to convey the numerous issues that give German Expressionism its own identity and significance. For a variety of voices culled from a particular period have a special force in presenting not only the dominant tenets but also the paradoxes and contradictions that lie within any movement.

Since the mid-twenties interpretations of Expressionism increasingly failed to convey many of its complex and multilayered implications. Where Expressionism was once equated with avant-garde modernism and experimentalism, with utopianism and internationalism, and with anarchism and socialism, it became characterized instead as apolitical, romantic, subjective, narcissistic, formless, and wildly irrational. Supporters of Expressionism, discouraged when their exalted vision of art did not bring about the radical cultural and social changes they envisioned, attacked the very rubric they had once championed. Succeeding developments in the arts such as Dada and Neue Sachlichkeit defined themselves by their opposition to Expressionism, and politicians of the communist left and the fascist right attacked Expressionist artists for vapidity and degeneracy. The negativism of the 1920s was a mere shadow of the intense animosity directed against Expressionism in the 1930s. It is ironic that while the Fascists viewed Expressionism as leading to communism, the Stalinist communist left viewed Expressionism as leading to fascism.

After the Second World War historians, disillusioned by these ideological battles, tended to emphasize the aesthetic viability of Expressionism. Concentrating on the giants of early Expressionism, they were not inclined to examine the occult and political sources of that generation's messianic visions, and they ignored the more politically radical artists who emerged after the First World War. Not until the past ten years has the number of books, exhibitions, and catalogues devoted to an examination of the historical context of both major and minor figures of the first and second generation of Expressionists proliferated.

These recent studies, such as Donald Gordon's *Expressionism*, posthumously published in 1987; the exhibition *German Expressionism, 1915–1925:*

The Second Generation, sponsored by the Los Angeles County Museum in 1988, and the 1989 catalogues *German Expressionist Prints and Drawings: The Robert Gore Rifkind Center for German Expressionist Studies* (2 vols.) and *The Catalogue of the Library of the Robert Gore Rifkind Center for German Expressionist Studies*, have more clearly defined the parameters of Expressionism and have raised significant questions about the role of Expressionism in Germany's political and cultural history. Interpretative studies, such as Jill Lloyd's *German Expressionism: Primitivism and Modernity* of 1991, have begun to appear and add enriching dimensions to the field. Yet, many of the basic documents of the movement have either not been translated into English or appear in editions no longer in print and thus not accessible to an interested public. Others exist only in archives neither published nor catalogued.

This volume of documents is meant to supplement and enhance the recently broadened scope of interpretations by reinvolving the reader in many of the lively issues that circulated among the Expressionists during their thirty-year presence in the cultural life of Germany. Although the use of completely uncut translations was an initial aim, the size limitations of the volume and the goal of capturing a variety of voices to convey the complex strands within Expressionism necessitated excerpts from the lengthier originals. The original editions and sources are clearly cited so the reader will be able to locate the primary text. The inclusion of unpublished material, references to archival sources, and recommended articles and books in the annotations should provide a stimulus and guide to further exploration.

Among the numerous issues that the documents included in this volume are intended to illuminate are questions about the initial usage of the term *Expressionism*. Although some art historians have asserted that the term was used only by art dealers and critics, and others are unable to agree as to which artists should be included under the term, sufficient evidence in the form of exhibitions, manifestos, artists' letters and essays exists to confirm Expressionism's recognized power and earlier presence in Germany's cultural life from roughly 1909 to 1921 and, albeit in altered form, even into the 1930s. From examples of the first appropriations of the term, we may discover why it gained acceptance in 1911 among artists, intellectuals, and collectors. The documents also reveal the varying emphases made by those who wished to support the new approach in the arts in Germany. While critics such as Paul F. Schmidt and Paul Fechter stressed its Teutonic qualities in order to create greater acceptability for Expressionism in Germany, others such as Wilhelm Worringer and Her-

warth Walden stressed the impact of French art and the international qualities of this new approach.

The identification of Expressionist antinaturalism with French culture began a long series of critiques (as the text by Carl Vinnen especially reveals) that positioned Expressionist modernism as un-German. Germany did not become a nation until 1871, and a longing for a Germanic culture, a patrimony, gave an intensity to discussions about a national style. While artists and critics in other European countries at that time were concerned with nationalistic issues, the diversity of Germany's many mid-size cities and towns could have diluted nationalistic chauvinism at least until 1918. Berlin and Munich were artistic centers, but they did not dominate the way Paris dominated France. Yet, many of the most virulent attacks against Expressionism came from artists living in provincial towns or rural areas who felt excluded from a style they considered cosmopolitan—a code word often used to refer to foreign or international art.

For the open-minded, however, the belief that artistic innovations could bring about moral and ethical change encouraged the experiments of the Expressionist painters with color, line, space, and texture to spread into the other arts. A reading of the documents included here enlarges our comprehension of the appeal of Expressionist painting to architects, sculptors, and printmakers. From the Blaue Reiter to the Bauhaus, the conviction that each art form could utilize innovations from the other was enhanced by the concept of the Gesamtkunstwerk—the combining of all the arts to create a powerfully effective monumental work. Yet, the essays by Kandinsky, Gropius, and Taut reveal different levels of conviction about the interrelationship of the applied arts and the fine arts, for example.

These documents also bear witness to the involvement of the Expressionists with the extraordinary events of the period—industrialization, nationalism, World War I, the November Revolution, the economic shortages—and the impact of these events on their work. From the very beginning, artists associated with Expressionism attacked not only the conventions of art but also the conventions of a society they found materialistic and dehumanizing. The rapid industrialization of Germany at the end of the nineteenth century, set up conditions that paved the way for art movements that questioned authority. Artists searched for a style that would not repeat the Imperial traditions of the Wilhelmine Empire and they championed an international language of form and color as well as international political and social ideologies such as anarchism, socialism, and theosophy. Longing to inspire the masses to work for the greater

good of mankind they favored freedom from censorship, individual choice, sexual openness, and often equality for women. Women, excluded from traditional art schools, were encouraged to exhibit with Expressionist groups, but few were singled out or praised at all.

Compared to the French avant-garde, however, Expressionism was more involved with the relationships between art and society, art and politics, and art and popular culture. Because of this engagement, artists and critics dealt with a wider range of questions about the artists' interaction with the state. The issues of communalism and individualism were highly charged for most Expressionists, as a perusal of these documents will indicate. Social anarchism, with its promise of mutual help and a state that would wither away, set the frame for the Expressionists utopian and optimistic estimate of the possibilities of individual creativity. Because of the dominance of the state in artistic affairs in the Wilhelmine Empire, artists and architects struggled to free themselves from national or state regulations that might determine the direction and content of their works. At the same time, these artists were interested in public art and were eager to reach the multitude. Whether it was Franz Marc writing before the First World War or Karl Schmidt-Rottluff after that war, their desire to affect a large number of people is clear. Questions about their responsibility to the public and about art education were essential to painters, sculptors, and architects alike. At the same time, the concept of creativity was central to Expressionism. Many artists agreed with Taut's point of view that residents for a public housing project needed to participate in the decision-making process but that the artist/architect had to have the final voice. The ability to be individualistic and creative was viewed as one of the factors in effecting social change.

Although most artists associated with Expressionism favored a harsh antinaturalism to communicate their critiques of societal materialism and their utopian visions, consistency of style was not a primary attribute. Texts such as Adolf Behne's review of a Sturm exhibition indicate approval of the Expressionist absorption of international styles such as Italian Futurism and French Cubism. Essays such as Fechter's reveal the admiration for both abstract and figurative expressionism. Whether abstract or figurative, writings by artists such as Kandinsky and Meidner indicate a concern for incorporating spatial elements as a device separating their efforts from decorative and frivolous work. A number of documents offer a variety of justifications of antinaturalism. For example, the sculptor Barlach referred to Assyrian art, the critic and art historian Carl Einstein used African art, and the critic Adolf Behne cited appropriations from medieval Gothic art. Others praised children's art or the visual efforts of the insane to decrease

dependence on the Greco-Roman-Renaissance tradition and to support the antinaturalism of Expressionism. The documents also reveal the frequent equation of uninhibited sensuality with freedom and creativity. Molzahn's blend of ecstatic, erotic imagery with cosmic phrases is but one example of the complex vitalism of the period.

The First World War intensified the desire of artists associated with Expressionism to change society. The documents in this volume also indicate how the war became a catalyst for a more activist stance among many. The need for internationalism, a new brotherhood among men, seemed imperative to world peace. The documents include manifestos and guidelines from three of the most influential postwar groups, the Novembergruppe, the Arbeitsrat für Kunst, and the Dresden Secession Gruppe 1919, which help to explain the artists' commitment to free art education, public museums and exhibits, and mass participation in public projects. The new Weimar Republic wanted to build upon the most innovative style before the war—Expressionism—and use its freshness and aggressiveness to stimulate art forms, which, being freed from the imperial and materialistic past, could unify mankind. Abstraction, by virtue of its nonspecificity as to nationality, race, or religion, became extremely popular among artists and intellectuals. On the other hand, documents such as the Friedeberger essay on Expressionist political posters also point to the resistance of the broad public, particularly the workers, to the stylistic innovations of the Expressionists. Paradoxically, the antinaturalism most Expressionists believed would stimulate change met with resistance from the very classes they wished to inspire. Hence, the call of a few artists and critics to return to the object and to abandon mysticism is found among the documents as well.

Unlike the radical artists in Russia, who for a few years were able to integrate experimental art with the structure of the new Soviet government, most artists in Germany could not identify completely with the new Weimar Republic. Although many supported the Social Democrats and the Independent Socialists, a number became quickly disillusioned with socialism after the strikes and street battles of 1918–19 and turned away from politics; a few joined the Communist party. The letters by Tappert and Kollwitz illustrate the dilemma the public-minded and morally conscious artist of that date faced.

Although much was written about the end of Expressionism (examples here include a Hausenstein essay of 1919 and a Worringer lecture from 1920), references to Expressionism continued to permeate the art criticism of the twenties as the Gustav Hartlaub and the Franz Roh excerpts indicate. Moreover, the debates about Expressionism in the thirties among

the National Socialists (typified by the A. Rosenberg, the Robert Scholz, and the Emil Nolde material) and in the Moscow based German emigre periodical *Das Wort* (represented by the Klaus Mann, the Herwarth Walden, and the Ernst Bloch essays) testify to the enduring power of the concept of Expressionism. That the enemies of Expressionism could include both Fascists and Communists should give some pause to those who wish to ascribe one level of political interpretation to an artistic style.

By presenting some of the conflicting and contradictory attitudes of many of those associated with Expressionist experimentation, the documents in this volume may also contribute to the current debate about the degree of political and cultural activism provoked by Expressionist work. While we recognize that many Expressionists wanted art to effect moral, social, and political change, we are less aware of their uncertainty about how art was to achieve this. Their attempt to walk the tortuous path between apathy and involvement, commercialism and utopianism, commitment to political goals and avoidance of ideological rigidity is closely related to the tension and conflicts so readily apparent in their painting, sculpture, and architecture. Yet, the content and formal solutions of Expressionism have so often been trivialized or even ignored. Exposure to the multivalent views of those associated with Expressionism, with all their ambivalence about participatory democracy, capitalism, the role of women, and the power of abstraction or figuration to communicate social ideas, should create a basis for further discussions not only about the creative products of Expressionism but also about a wide range of international modernist developments in Germany. Indeed as a variety of modernist styles are being reexamined for their complex and paradoxical relationship to the concept of a political avant-garde, a focus on German Expressionism should contribute to the ongoing reorientation of the literature and theory of modernism.

Part One

Early Manifestations

I. FIRST IDENTIFIERS

INTRODUCTION

For many artists and critics in Germany the term *Expressionism* came to be synonymous with modern art and its rejection of traditional Western naturalistic conventions. By the late fall of 1911 groups such as the Brücke and the Blaue Reiter and sculptors such as Ernst Barlach were beginning to be referred to as Expressionists. Critics committed to these new directions wrote of the Expressionist artist's ability to convey the cosmic, the eternal, the heroic, and described the art's revolutionary forcefulness. By the summer of 1912 several began to suggest Expressionism's superiority to other manifestations of modernism such as French Cubism and Italian Futurism.

Yet it was only in April of 1911 that the Berlin Secession, under the guidance of its director Lovis Corinth, had grouped young French painters—André Derain, Maurice Vlaminck, and others from the circle around Henri Matisse—in one room and referred to them as "Expressionisten" in the foreword to its exhibition catalogue.[1] The grouping and catchy term took an immediate hold on the critics and the public. In his review of the Secession exhibition, the critic Max Osborn referred to the "Expressionisten" as ultramodern and commented on their break from Impressionism, the influence of Cézanne and Gauguin in their work, and the new directions they offered Berlin artists.[2] Walter Heymann, among others, considered this room to be "a showplace of the elements of our artistic cultural condition,"[3] but asked why German artists were not included in this grouping!

Heymann's question was eminently reasonable because artists in Germany had been experimenting with intense antinaturalistic colors, forms, and spaces several years before these qualities began to be associated with Expressionism. Moreover, they had exhibited alongside the same French artists in several earlier exhibitions. In Düsseldorf in the summer of 1910, for example, the Sonderbund had invited Matisse, Braque, Derain, Vla-

minck, and Symbolist artists like the Nabis (Maurice Denis and Edouard Vuillard) to exhibit with artists from the Dresden Brücke (such as Max Pechstein and Ernst Ludwig Kirchner), the Berlin New Secession (including César Klein and Georg Tappert), and the Munich Neue Künstler Vereinigung (led by Wassily Kandinsky and Alexi Jawlensky). In Munich the NKV had invited artists from Matisse's circle, as well as Le Fauconnier and Picasso, to their second exhibition in September 1910.

Even more significant, German critics had viewed the works of groups like the New Secession—to which the Brücke artists Kirchner and Pechstein heavily contributed in 1910, and which the NKV joined in 1911—as developing from van Gogh, Gauguin, and Matisse.[4] Moreover, writings by Matisse and Denis were frequently used to justify and explain the antinaturalism of the new style. The critic Max Raphael, who under the pseudonym A. R. Schönlank had written the foreword to the 1911 New Secession exhibition catalogue, quoted from Matisse's "Notes of a Painter" in a more concise essay for *Der Sturm*. He emphasized that the New Secession artists did not want to give a glimpse of the fleeting as the Impressionists had done but to evoke the enduring and the eternal in art.[5] The 1909 German translation of Matisse's essay, with its use of *Eindruck* in reference to Impressionism and *Ausdruck* as expression,[6] reinforced the concept that Impressionism was the antipode of Matisse's work.

At the same time, nationalist and provincial German artists and critics reacted negatively to the bright colors, flattened shapes, and distorted forms of the new style. Their anger and the confusion of much of the public helped to shape the particular nature of Expressionist criticism in Germany. In 1911 *A Protest of German Artists* (*Ein Protest deutscher Künstler*) (fig. 1) edited by the landscape artist Carl Vinnen, chauvinistically attacked modernism as un-German and too French in its orientation. A rebutting anthology, *The Struggle for Art: The Answer to the "Protest of German Artists"* (*Im Kampf um die Kunst: Die Antwort auf den "Protest deutscher Künstler"*), vigorously denied the charges of conspiracy, snobbery, and aestheticism and asserted the importance of artistic criteria beyond national boundaries. The art historian Wilhelm Worringer, writing in *The Struggle for Art*, sought to relate the new artistic directions to a metaphysical and primitive tradition, explaining that Western rationalism was encouraging fragmentation and limiting experimentation.

The 1912 Sonderbund responded to the controversy by including artists from even more countries than before and referring to the works in the exhibition as Expressionist. Following in part the approach of Roger Fry in his 1910 Post-Impressionist exhibition in London (which in 1911 had even been called Expressionist by several critics),[7] the Sonderbund saw its purpose as educational and selected artists who appeared to prefigure Expressionism. Unlike Fry, however, the Sonderbund emphasized North-

ern artists, particularly van Gogh and Edvard Munch, rather than the French artists, notably Cézanne and Gauguin—who, along with van Gogh, Fry had deemed the forerunners of modernism. Just a few months earlier Paul F. Schmidt, a museum curator and Brücke patron, had also pointed to Northern sources—Munch and Ferdinand Hodler—as contributing to the particular intensity of Expressionist art in Germany.

Nonetheless Expressionism continued to shock the public, and many supporters attempted to justify the new developments with two major arguments: the indigenous sources of Expressionism, which were either Northern artists or the Nordic past; and the universal, metaphysical, and transnational power of the new art forms. Although these arguments would eventually be used to dethrone Expressionism,[8] at the time they helped to establish it as the most powerful phenomenon of early twentieth-century German art.

1. Carl Vinnen, "Quousque Tandem," from *A Protest of German Artists*, 1911*

Carl Vinnen's polemic against modernism (soon to be called Expressionism in Germany) represents a long-standing aspect of German criticism in which internationalist influences were seen as the direct cause of the decline of German art and culture. In 1911 the purchase of a van Gogh by the director of the Bremen Museum, Gustav Pauli, was the catalyst for a number of bitter denunciations of the influx of foreign art into Germany. The essays in *A Protest of German Artists*, which Vinnen (1863–1922) organized and for which he wrote the preamble and the introductory essays, reveal the belief of many provincial artists in Germany in 1910 and 1911 that inferior French works were flooding the galleries and museums and were responsible for the commercialization of the German art market.[9]

Vinnen's organization of *A Protest* brought the fame that his paintings could not win him. As a young landscape painter, Vinnen had joined the Worpswede artist's colony near Bremen and had become a member of the Berlin Secession. In 1903, the year he left Worpswede, he won a gold medal in the Berlin salon, but he never achieved the recognition he felt his works deserved. Increasingly he grew to equate his personal failure with a national one.

*Carl Vinnen, "Quousque Tandem," *Ein Protest deutscher Künstler* (Jena: Eugen Diederichs, 1911), 2–16.

In the essay translated here, Vinnen uses both sarcastic praise and invidious critiques to describe modern French painting as inferior. He also points to the French artists' lack of ability and ignorance of fundamentals, and complains that the German imitators of French artists have lost their indigenous "Nordic" qualities and hence their creativity. His essay reflects a thinly veiled antiurban and anti-Semitic bias.[10] His belief that internationalist influences led to the weakening and dissolution of German culture was to be used even more demagogically by the National Socialists against all aspects of international modernism.

<center>****</center>

In light of the great invasion of French art that has been in progress in so-called progressive German art circles over the past few years, it seems to me that necessity bids German painters raise a warning voice, and not be daunted by the reproach that only envy motivates them.

For to be an artist also carries an obligation!

As the entire movement of the last quarter century had its beginning in France, admiration of its great masters—which is certainly justified—has led to certain excesses among us today that threaten to transform a blessing into its opposite.

In the violent battles for new direction, if one can speak of such a thing, the avant garde artist has a faithful ally, namely the modern art-author.

<center>. . . .</center>

Recognizing, not incorrectly, that Rhineland art has fallen from its former position of power into obscurity, the "Sonderbund"—an artists' association there with many influential benefactors in its own province and beyond—is seeking intimate association with the latest Parisian extravagants—Matisse among others—and so is moving from one extreme to another.

<center>. . . .</center>

Far be it from me to devalue the way in which our culture has been stimulated through the high culture of French art, and if I myself recently spent some time in Paris in order to learn, that should be proof enough of my admiration.

But speculation has become a factor in the matter. German and French art dealers have shaken hands, under the pretext of promoting artistic goals, and Germany is being flooded with great quantities of French pictures.

<center>. . . .</center>

This tide of pictures enters the land through the flood-gates of art litera-ture, and the literature becomes reinfatuated with it; the infatuation in the press in turn helps the dealers to unload the pictures on German collectors at exorbitant prices. By way of illustrating how much these values increase, one might consider the Lady in a Green-Black Dress by Monet, which netted the artist 700 francs and cost the Bremen Museum 50,000 marks.

Yet at the time, I myself supported Director Pauli, who has done so much for the development of artistic life in Bremen and for the formation of our gallery, when he suggested its purchase; and I would support him again, considering the high artistic value of the painting. There are exceptional cases, finally, in which money can be no object.

No real artists would want to quibble where real masterpieces—the achievements of a great man, of whatever nationality—are concerned.

But when we see how even the casual studies by van Gogh, even those in which an artist misses all three dimensions—draughtsmanship, color and mood—draw 30 to 40 thousand marks with no questions asked, how not enough old dregs from the studios of Monet, Sisley, Pissaro, etc., can be put on the German market to satisfy the demand, one must say that in general the prices of French pictures have been driven up to such an extent—of course France itself does not pay these prices—that we seem to be faced with an inflated esteem in which the German people should not cooperate indefinitely.

It's doubtful whether these prices, which today are driven to dizzying heights by means of market manipulation, will ever even approach stabili-zation.

One must distinguish between the ephemeral, that is, the art historical value of these pictures as evolutionary factors, and their permanent value, which they will also have for the sensibility of times to come,

More important is the other question:

What constitutes the great danger of introducing foreign art, when speculation takes hold of it?

Well, mostly in the overestimation of foreign nature so that our own, original character doesn't measure up.

Accomplishments since Monet are, to put it briefly, dedicated to the surface of things.

. . . .

The art of a Cézanne, a van Gogh, was too characteristic of its creator, with too little attention to structure to found a school and to make way for successors.

. . . .

A rush, a hunt begins, everybody wants to be modern, everybody searches . . . for his individuality in imitation.

. . . .

Because let it be said again and again, a people is only driven to great heights by artists of its own flesh and blood.

. . . .

There should be no doubt that we have *completely* lost the world market for art, which we formerly dominated. The reasons our modern painting was so inadequately represented in the last great World-exhibitions are certainly sufficiently well known. This lowered us into an art of second rank in the eyes of the world, especially the Americans. Now the great international stream of foreigners that flows through Germany every year sees how the often truly mediocre French pictures are enthusiastically praised, hung in the places of honor in our galleries and the windows of art dealers, how our illustrated art magazines are full of them, our youth zealously and diligently imitate them.

How can we expect the foreigners to hold us in higher esteem than we do ourselves!

And yet now would be the time to win a place in the sun for our art, ideally and materially, as we have been able to do for our crafts with such conspicuous success.

. . . .

Even if every true artist, everything great and beautiful of whatever heritage, should enjoy a right to hospitality at the German hearth, a great cultural people, a people possessed of such powerful aspirations as is our own, can not forever tolerate a foreign presence that claims spiritual authority.

And as this is being foisted upon us by a large, well-financed international organization, an earnest admonition is in order: to proceed no further in this way, and to be clear about what we are in a position to lose, namely nothing less than our own essence and our inherited native capacity.

Our art history tells us that this would not be the first time a great tradition had been lost for a long time, and it also tells us the consequences.—

So we must struggle in the best of faith, not in reactionary ways, not in sentimental ones, but in the spirit of the best that our art has achieved.

—Cuxhaven, early spring 1911

2. Wilhelm Worringer, "The Historical Development of Modern Art," from *The Struggle for Art: The Answer to the "Protest of German Artists,"* 1911*

The art historian Wilhelm Worringer (1881–1965) was one of the first to provide a theoretical defense for Expressionism. His doctoral dissertation, *Abstraction and Empathy (Abstraktion und Einfühlung)*, published in 1908, had become a guide for many artists working in Germany. In the third edition of 1910 he acknowledged that his thesis had a "resonance" for young, practicing artists who were struggling to find "new goals of expression."[11] It is not surprising then, that Worringer would write for the anthology *The Struggle for Art* to defend the new artistic developments that were causing such a negative reaction among numerous German artists and critics in 1911.

As a rebuttal to Carl Vinnen's collection *A Protest of German Artists*, Worringer dealt with the charge that the new art was formless, decadent, and superficial by tying the antinaturalist tendencies of the new artists, whom he referred to as "new Parisian Synthetists and Expressionists," to a metaphysical and primitive tradition. He argued that the European, classical Renaissance heritage, with its focus on illusionism and rationalism, had prevented man from seeking metaphysical values by keeping him too close to the world of appearances. He urged the viewer to learn the secrets of primitive art[12] in order to move away from the individualism and fragmentary nature of past art.

Influenced by Riegl's concept of "Kunstwollen,"[13] Worringer informed the reader that the stylistic characteristics of art outside the European classical tradition were not the result of inferior skills but of different intentions. For Worringer, that art, particularly from the time prior to history, was elementary, mystically effective, and capable of providing a foundation for new directions. Reminding German museum directors that German artists in the past had achieved greatness through a dialogue with other cultures, Worringer called upon them to reflect the struggle of their times

*Wilhelm Worringer, "Entwicklungsgeschichtliches zur modernsten Kunst," *Im Kampf um die Kunst: Die Antwort auf den "Protest deutscher Künstler"* (Munich: R. Piper & Co. Verlag, 1911), 92–99; reprinted in *Der Sturm* 2, no. 75 (August 1911): 597–98. © R. Piper & Co. Verlag, München 1911.

by supporting the new experiments in international and German art.

<center>****</center>

Vinnen's brochure is entirely understandable to me, psychologically, and I don't hesitate to regard it as a symptomatic phenomenon. I even welcome it as a timely call for an honest discussion of principles. The crisis in which we find our conceptions and our expectations of art cannot be kept quiet: it must lead to open and decisive discussions.

With these points in mind I must regret, however, that Vinnen's promotional piece fails to treat the basic questions seriously, only touching on them fleetingly here and there and using space instead for popular turns of phrase and emotional pronouncements that cannot be substantiated. Thus the main argument with which the attacking faction wishes to engage the public is not the sort of refutation of new artistic principles that could be discussed impartially, but an irresponsible denunciation of the personalities on the other side, transposed into every possible key. . . . For it is not right to cultivate, in a general public made gullible through innate inertia and an instinct for self-preservation, the gratifying conviction that the movement under attack consists of a senseless game among impotent, sensation-hungry artists, undiscriminating art writers swayed by every whim of fashion, and cunning art dealers who, suppressing their laughter, reap profits from this comedy.

<center>. . . .</center>

For besides such irresponsible hangers-on there stand artists who search in earnest, who for all their sober self-awareness remain perfectly modest; there stand serious theoreticians who preserve, despite their productive partisanship, a historical consciousness and with it, a critical discretion; there stand finally art dealers who, although they of course have business matters to consider, still foster, with inner conviction and understanding, a movement in which one's profits are at far greater risk than they would be in marketing some simple, recognized commercial product.

<center>. . . .</center>

If I understand Vinnen correctly, he wants German art, in finding a new artistic form, to guard against the influence not of the great classic Impressionists such as Manet, Monet, and Renoir, but of the so-called young Parisians, who follow Cézanne, van Gogh, and Matisse in searching for a new kind of artistic formulation.

. . . Where an unprepared and backward public sees and can only see the products of willful self-indulgence and idiotic sensationalism, we sense historical necessity. We see above all a unity in the movement that has something fundamental about it, before which everything that seems

to be self-indulgent disappears. Yes, I think I make no mistake in seeing the deepest roots of this new artistic drive precisely in the desire to conquer willful self-indulgence and personal limitations. This unmistakable striving for impartiality, for a compelling simplification of form, an elemental openmindedness about artistic representation, is bound up in the basic character of the new art, which some believe can be trivialized as primitive or childish comedy played before the adults of Europe.

But the only ones to be affected in this way will be those who have not yet come to understand primitive art and who see in it only a lack of skill over which one chuckles with the superiority of grown-ups. Today the cultural arrogance of Europeans is eroding, however, yielding to insights into the fundamental grandeur of primitive life and its artistic expression. The same need that makes us want to understand the new Parisian Synthetists and Expressionists has also developed in us a new eye for primitive art. How transparently clear it seems today that the stylistic character of primitive art is not determined by any lack of skill, but by a different conception of artistic purpose, a purpose that rests on a great, elementary foundation of a sort that we, with our well-buffered contemporary approach to life, can hardly conceive. We only vaguely sense that the grotesque distortion and compelling simplification of this primitive art (compelling, however, only for those who can distinguish between a compulsion for form and a compulsion for illusionary effect) emanates from a higher level of tension in the will to artistic expression, and we learn to recognize that the difference between our artistic achievement and the primitive is not one of degree, but of kind. A difference in kind that consists in reckoning art's achievements not in today's terms, namely in the release of a certain fine quality of feeling—sensual or spiritual, but in the release of a fundamental sense of the inevitable. An affirmation of the ambiguity of phenomena: in this lay the meaning, in this lay the essence, the mystique of this art. . . .

Of course today we can't artificially force ourselves back to the level of primitive people, but the subliminal urgency we feel today is finally not only a reaction against Impressionism, but also against the whole previous development in which we have been involved since the European Renaissance, whose starting point and direction is embraced in Burckhardt's concise statement about the discovery of the individual. The vast wealth of factual learning of the past epoch has left us poor, and out of this sense of impoverishment we are today demanding consciously from art approximately that which primitive people naively demanded. We want art to affect us again, to affect us more powerfully than does that higher, cultivated illusionism that has been the destiny of our art since the Renaissance. In order to achieve this, we are trying to free ourselves from that rationalization of sight which seems to educated Europeans to be natural

sight, and against which one may not transgress without being cast as a complete fool. In order to achieve this, we force ourselves to that primitive way of seeing, undisturbed by any knowledge or experience, which is the simple secret of the mystical effect of primitive art. We want to push external symbolism, hailed as a national trait of German art in particular, back into the innermost center of the artwork, in order that it might flow out from there of its own natural energy, free of every dualism of form and content. In short, the primitive art of seeing, to which we force ourselves, is only a means of approaching the elemental possible effects of art. . . .

Such a return to earlier, elemental stages of development, such a generating of creative force from the concentrated reserves of power of the past, is not new to one who thinks in historical terms. To him it is only the repetition of a historical pattern so regular it seems almost to follow some natural law. Only the length of the pendulum's swing changes. And it is only the best sign of the power and passion of our time that the pendulum has swung as far as it has, and that it is now going back to basic and most essential things, things from which we have been separated by the pride of our European-classical inhibition and the myopia of the European adult attitude. One goes back to the elemental stages of development because one hopes to again come closer to nature by doing so. And the unnaturalness that has been so ridiculed and disdained in recent painting is finally nothing other than the result of such a return to nature, although to a nature not yet filtered through the rationalizing optics of a European education, and from whose chaste purity and symbolic affective power the average European can know nothing.

. . . In the final analysis it is in the interests of future generations that we concern ourselves with the present. For this modern primitiveness is not supposed to be the last word. The pendulum does not rest in its extreme position. This primitivism should rather be understood as a long, deep breath, before the new and decisive word to the future will be pronounced. . . . Surrounded with such broad vistas, let us in any case retreat from the narrow sphere in which Herr Vinnen fights over French and German art, and tries to persuade us with financial statistics.

Apropos of which, just two words in regard to the national aspect of the question. He who really knows about being German, who knows above all the history of German art, he knows that it is not given to us, with our innate ambiguity and with our inborn, sensual, instinctive uncertainty, to find the direct route to a form, he knows that we always take our cue first from outside Germany, that we have always had to give up and lose ourselves first, in order to find our real selves. That has been the tragedy and the grandeur of German art from Dürer to Marées, and he who would cut our art from interaction with other art worlds is betraying our real national tradition. Such a statement of de-

pendency degrades our art only from a very childish and psychologically immature point of view; to me the characteristic quality of German art history has always been this theater of engagement and this passionate striving beyond one's own narrow bounds. I would not want to be without this tragedy, this ambiguity, for it has given German art its singular dynamic.

Still one short observation pertaining to the external impetus for the whole discussion: the position our museum directors have taken on the new movement. The problem from their point of view can be formulated briefly as follows: should they just buy good pictures, that is, good in terms of average taste, or should they now and then sacrifice such relative security in the interests of something that is historically significant, but that has not yet been sanctioned by the majority's taste? This question is only now becoming urgent for our museums because they themselves have just reached a historical crisis, and must decide which way to go. They were founded as institutions of courtly luxury: adventurousness and persuasiveness were not part of their nature. Should they retain this mature, culture-saturated, backward-looking character of luxury, or will they try to suit themselves to the rhythm of the times and make a dead herbarium into a living one? Should they only register history or should they make history?

. . . Whether these experiments lead to a positive result or turn out to be a useless expenditure of energy, a valuable piece of the actual inner life of our time has animated them. For this reason they deserve a place in our museums: a place not superior to, but certainly on a par with, the unproblematical art products that, as mentioned above, reflect the average character of our epoch and so force much of the finest and best into silence. Even failed experiments have their essential value and their historical meaning.

3. Paul Ferdinand Schmidt, "The Expressionists," *Der Sturm*, 1912*

First published in the fall of 1911 in *Das Rheinland*, Schmidt's essay defended Expressionism not only by deeming it a logical continuation of the work of Cézanne, Gauguin, Denis, and other artists associated with the French Post-Impressionist tradition, but also by

*Paul Ferdinand Schmidt, "Die Expressionisten," *Der Sturm* 2, no. 92 (January 1912): 734–36.

stressing its absorption of northern-European qualities from the works of van Gogh,[14] Edvard Munch,[15] and Ferdinand Hodler. Schmidt (1878–1955), who had studied medieval architecture at the University of Strasbourg, was curator of prints at the Kaiser Friedrich Museum in Magdeburg and an early supporter of the Brücke.

Although he explained that Expressionism had no formula, he argued that the simplifications of forms, the contrasts of bright color, the emphasis on painterly texture allowed the artist to transmit universal, cosmic feelings instead of the minute details of topical interests. Schmidt predicted that this new trend would reach unheralded heights in Germany.

Perhaps we are standing at another turning point in the development of painting similar to the moment when Manet's first pictures aroused such shock and anger. The circumstances are quite similar: the public laughs or raves, artists are fearful and protest, and the critics side with them, at least in part. We have only advanced inasmuch as the principal better critics exercise restraint or even, like many collectors and the majority of the young people, enthusiastically support the new.

What is it about those artists who choose to be known as "Expressionists"? Why are they dissatisfied with Impressionism and searching for a new way? Do we really need anything new?

The very fact that the new exists demonstrates its necessity: and the rapid spread of its ideas should make clear that there is persuasive power in them. The idea is to get free of Impressionism. . . .

This undertaking is nothing so very new. It evolved logically in France from the Impressionists. Cézanne taught the great simplification of tones, Gauguin the effect of flat planes, and van Gogh added the flaming, radiant power of color. Maurice Denis, Vuillard, and Bonnard tried to make a grand style out of simplification to a plane, but they lacked compelling expression: Teutons of the north and extreme south, Munch and Hodler, found it. . . .

. . . .

It is useless to speak about casual sketchiness. No system can be discerned from which all "Expressionists" work more or less uniformly. Where the entire personal outlook is expressed so directly in all aspects of a picture, there can be no talk of a system. What relationship does Pechstein have with Puy, in what system do Vlaminck and Herbin have something in

common with Nolde? They are united in having pushed aside any obligation to be "correct"; but while one paints in sharply defined planes, another sets down a riot of color, and a third floods one color over into another, or contrasts bright with muted color. Their common name is the product of uncertainty, for it says little.

Instead of an external plausibility, these works possess the powerful configuration of inner truth. Taking the pictorial back to the strongest accents in color and plane and carefully framing the space (this is also what is meant by composition, and it also escapes that term's deadly aftertaste) lead automatically to a strong decorative effect. These pictures do not flow into one distinct mass; nor do their colors give off, at a distance, the sensual glow required for mural decoration. . . . It seems that from this art the long-sought monumental painting is to be generated. The one painter of fresco in the grand style still alive today belongs to it in his innermost being: Ferdinand Hodler.

But the release from the last bonds of personal art has also brought an astonishing increase in the number of expressive possibilities. The associative values of color are released first; the beauty of an unbroken glow of color shows what spiritual value we can gain directly from painting, and how much we have missed it up until now. A real painterly fervor can now replace the simple slice of nature, whose presence terrorized painter and viewer alike. It often required attention to peripheral matters and so distracted rather than focused one's attention. Now the crucial thing is to be able to "see correctly" in another way: not to insist on a comparison with reality, but to convey the perception of reality in such purity and intensity that the means become persuasive. Art is again exercising its ancient right to extract its works from nature according to higher laws.

. . . .

It was a Dutchman, van Gogh, who set off the movement. Frenchmen have recognized this movement as the bearer of the great painterly tradition of modern times. Their paintings are still far superior to German ones in terms of taste. But the "Sturm und Drang"[16] brewing among their German pupils, the broadening of the movement here. . . , seem to predict that Germany will be its land of destiny. The active participation of those of moderate sensibility argues that this is the ideal moment in the history of expressive painting. Further, we have experienced related movements in various aspects of culture in recent decades. In poetry the turning from naturalism, in the crafts and architecture the establishment of the great laws of simplicity and of the organic are considered successful. With their similar aspirations, the paintings of the Expressionists fit the same pattern. . . .

4. Richart Reiche, "Foreword," International Exhibition of the Sonderbund, Cologne, 1912*

The Sonderbund exhibition of 1912 helped to popularize "Expressionism" as the slogan for international modernism in Germany. With the backing of such eminent figures as Carl Ernst Osthaus,[17] owner of the Folkwang Museum in Hagen, and the Düsseldorf art dealer Alfred Flechtheim, Richart Reiche,[18] the director of the 1912 Sonderbund, chose examples of the most recent artistic developments throughout Europe. In the foreword to the exhibition catalogue, Reiche (1876–1943) described the new "Expressionist" works as monumental and as the antipode to naturalism and Impressionism because of their intensification of color, form, and decoration. He urged his audience to examine medieval art, the subject of his dissertation at the University of Strasbourg, in order to understand the connection between the "modern movement" and older art.

The Sonderbund had been founded in Düsseldorf in 1907–8 as a secession movement, and in its second and third exhibitions of 1910 and 1911 had included a number of innovative works by both French and German artists, among them Matisse, Vlaminck, Braque, Kandinsky, and Jawlensky.[19] Although many German artists and dealers protested about the dangerous influence of the French upon German artists and dealers, Reiche continued the Sonderbund tradition of inviting international as well as German artists for the 1912 exhibition.[20]

The exhibition also displayed works of older artists from the Post-Impressionist tradition such as Cézanne, Gauguin, and van Gogh, who Reiche indicated, as had Roger Fry in his 1910 exhibition,[21] were the foundation of the new art. But in the Sonderbund exhibition van Gogh received space for three times as many works as the other two, and the Norwegian Edvard Munch was also given a retrospective (fig. 2). Both factors testified to the Sonderbund's interest in finding northern antecedents for Expressionism. One work by El Greco was also included, reminding us of the contribution of the art historian Julius Meier-Graefe, whose 1910 reassessment of El Greco as well as his studies of van Gogh had contributed to making the new directions in art accessible.[22]

*R. [Richart] Reiche, "Vorwort," *Internationale Kunst-Ausstellung des Sonderbundes westdeutscher Kunst-freunde und Künstler zu Cöln* (Cologne, 1912).

This year the fourth exhibition of the Sonderbund presents a survey of the current state of the most recent movement in painting—the one that replaced atmospheric Naturalism and Impressionism and now strives for a simplification and intensification of forms of expression, a new rhythm and color, a decorative and monumental configuration. The exhibition attempts to give a survey of this movement, which has been called Expressionism.

Younger artists from practically all European cultural centers have joined this movement, and it was the intention of the Sonderbund to unite the results of their efforts, when possible, in an international review. Thanks to the active participation and kind support of our foreign friends, who put together a representative selection of the new art from their countries for Cologne, we can present German art lovers with at least an attempted overview of the new painting in France, Austria-Hungary, Switzerland, Holland, Norway, and Russia (the latter represented in the works of artists of Russian descent residing in Munich).

Participation in the German section has been expanded farther than in previous exhibitions of the Sonderbund. This indicates a general change that has turned the Sonderbund from a small group of Rhineland painters (who meanwhile organized themselves under the name "the peace-lovers" in Düsseldorf) into an association of Rhineland art lovers and museum directors. This Rhineland group stands for progress in the arts wherever it may occur. While this international exhibit of the works of living artists attempts to give a cross section of the Expressionist movement, a retrospective section will expose the historic underpinnings upon which this controversial painting of our days is founded, namely the work of Vincent van Gogh, Paul Cézanne, and Paul Gauguin. Thanks to the extraordinary and obliging cooperation of our German, Swiss, Hungarian, and, particularly, Dutch collectors, over one hundred paintings, the actual core of the exhibition, could be assembled of that great Dutchman, whom we proudly hail as one of our own. The two French masters are represented with smaller collections, mainly from domestic as well as foreign private ownership, which, nevertheless, in their major works, are representative of their art. We would like to complete the chain of relationships linking modern painting to the art of previous classic artists with special exhibits of the Neo-Impressionists Cross and Signac, made possible through the generosity of sympathetic German collectors.

May this retrospective section, which seeks for the first time to fulfill a demand made by recent scholarly criticism, contribute to the solution of the heated artistic debate of our day; may it also become a source of inspiration and reflection for artists and thus create a bridge of understanding between this new art and all friends of the arts.

And whoever experienced the blazing flame of the grand line, the radiant luminosity of van Gogh's colored planes, the dreamlike silence of Cézanne's incomparable color poetry, the calm of Gauguin's fairy-tales, should then go into the Wallraf-Richartz-Museum to examine the old masters of this city. And he would be amazed to discover to what extent the modern movement looks back to the old masters and to learn what manifold ties bind the newest in painting to the golden age of medieval art.

. . . .

5. Max Deri, "Cubists and Expressionism," *Pan*, 1912*

Deri's essay reveals the euphoric attitudes Expressionism aroused in many German critics. For Deri (1878–?), Expressionism was a heroic style, one that could communicate the dynamic ideas of the period by the angular thrusts of its irregular forms, the power of its strong color, and the strength of its texture. Referring to the painters of the Brücke and the Blaue Reiter as well as to the sculptors Barlach and Lehmbruck, Deri celebrated the Expressionist artists' freedom from the limitations of naturalism and their rejection of outworn subject matter such as genre figures or classically rendered nudes.

Deri received his doctorate in art history from the University of Halle. Unlike Schmidt and Reiche, he did not move into the museum world but instead turned to lecturing at the University of Berlin in addition to writing art criticism. More theoretically and psychologically oriented than many of the early critics of Expressionism, Deri attempted to place the movement in an evolutionary context, explaining how it grew out of and beyond the optical approach of Impressionism. He referred to empathy theory as well as to Symbolist and Fauvist ideas and frequently rephrased Maurice Denis's and Matisse's justifications of antinaturalism. For Deri, both Futurism and Cubism were way stations on the road to Expressionism, but they were for the most part too tied to the perceptual world. He found Expressionism, on the other hand, because of its faith in the power of color and forms to evoke specific moods, to be the most universal of styles.

*Max Deri, "Die Kubisten und der Expressionismus," *Pan* 2, no. 31 (June 20, 1912): 872–78.

. . . .

So it needn't be regarded as accidental that there is a group of painters who call themselves Futurists or Cubists, except that Futurism or Cubism is hardly ever discussed. On the other hand, the word Expressionism is used much more often than the word Expressionist. For the first two represent more of a personal possibility, the third more of a general direction, a movement.

. . . How Cubism flowed into Expressionism is a rather complicated matter. Yet perhaps it might be resolved through an approach from the psychological side.

. . . .

And now the problem becomes even more complex. Psychologically based art theory is still in its beginnings. . . . Yet this much is certain, that there are two fundamentally different kinds of art. In one, the path leads from external to internal. It is familiar today, for we are just coming out of such a period. I look into nature, something affects me deeply, transmits a feeling. And I try to capture this feeling, to render it. . . . But isn't a second kind of art possible? Through previous experience I have thousands of feelings available, even without any immediate external stimulus. The psychologist says: universal feeling. I can also capture these feelings, such as desire, or joy, or pride, or power, in some kind of form that has nothing directly to do with the external world. In lines, surfaces, in distortions of "correct" naturalistic form. . . . And we stand today just at the end of such a naturalistic period and at the beginning of a time of distance from nature.

It was for just this reason that the Futurists were so instructive. . . . [The Expressionist] too, has experienced the world before. But he neither paints it in the course of such experience, as "seen through a temperament," nor does he paint the vague remnants of experience just past; rather he paints with full receptivity. On the basis of his experience he has certain feelings inside himself, and now he tries to express them. Although instinctively chosen, the name Expressionism is a brilliant one for this way of painting. . . . Michelangelo or Grünewald didn't "see" their figures the way they painted and drew them either. They transformed them according to the feeling they wished to express. They painted in just such an idealistic period, remote from nature; they were Expressionists.

. . . .

From now on "nature" no longer serves as the standard. I have the right, if it seems appropriate to me, to use every artificial, if you wish even antinatural, form, color, proportion, or arrangement to express a valuable emotion and transmit it to the viewer. Take Pechstein's "Yellow Dancer" in the Secession. The great thing about this painting is the power in it,

19

how it conveys a feeling of strength. The color laid down full strength: this brutal yellow against the green, the red and black inside them. Whether a human body is yellow or not doesn't matter. . . . The same sentence is true for this picture as for Oppenheimer's "Operation" or the sculpture of Barlach or Lehmbruck, or for all the art of the upcoming generation; **any distortion of nature that conveys a worthwhile feeling is justified**.

. . . .

. . . Now, where it is no longer enough to see the world through a single retina, where rather it is necessary to relinquish nature, to recreate, reconstruct it, where great, powerful emotions cry out to be contained, to be given form, now the content of the picture emerges. Just make us something once again that isn't "still life," in which content is more than a "carrier of color." That means to us contemporaries—with regard to the contents—what the Creation of Adam in the Sistine Chapel or the Crucifixion or Mary of Colmar meant to the people of earlier times. But don't lean hypocritically on these ancient legends (unless you do it the way Oppenheimer does). But **find contents from our time**. See old Hodler, with his "Eurythmia" or his "Awakening Day," paint "The Awakening City" or the "Revolution," paint our great, living ideas. Leave the nudes alone, milling or bathing, the sphere holders and riders, the dancers and barmaids. First become capable people, then have dynamic ideas: and you will see how easily you triumph.

Today all this is really still embryonic. . . . For each new art needs the ruins of the old as its nourishment. And in fifteen years we will have our hero, who will be strong, of his own time, rich in form and in idea. We must wait for him, prepare our hearts by helping to destroy the old. . . . Today it is our turn to be in the front lines, however, to be alert, to catch the scent of what is to come. For even here, the rising of the sun will certainly herald a terrible uproar.

II. THE BRÜCKE

INTRODUCTION

The artists of the Brücke group were among the first German nationals to be called Expressionists. Even before they were identified as such, German critics like Karl Scheffler recognized the provocative and revolutionary nature of their painting and prints.[23] The brilliant, clashing colors and the jagged brushstrokes in their oils, the stark contrast of their prints, and the vital eroticism of their subject matter contributed to the Brücke artists' reception in Germany as heirs to the tradition of Cézanne, Gauguin, van Gogh, Matisse, and Munch.[24]

Originally based in Dresden, the Brücke was founded in June 1905[25] by Ernst Ludwig Kirchner, Erich Heckel, Karl Schmidt-Rottluff, and Fritz Bleyl,[26] all of whom had studied architecture at the Technische Hochschule in Dresden. Determined to liberate themselves from the repressive values of the established Wilhelmine culture, they chose the name Brücke to signify their call to other young artists and intellectuals to create through their work a freer and more vital age. Inspired by Nietzsche,[27] especially his portrayal in *Thus Spoke Zarathustra* of the artist as the belligerent leader of a new morality, the group aimed to express their vision of spontaneity and renewal through the use of vibrant symbolic images that were defiantly antinaturalistic.

The Brücke consciously detached themselves from their own middle-class background, settling into a rebuilt butcher shop in a working-class Dresden neighborhood. Initially they produced communal art works in their studio, created joint graphics where one member formulated the design and another printed the work, and shared the models they hired. They experimented with a variety of media—oils, watercolors, lithography, etching, wood engravings, woodcuts, sculpture, furniture, and other crafts.

As one of the Brücke aims was to arrange exhibitions in order to disseminate their work to a wider public, they extended membership to other

artists who wished to participate in their exhibitions and their anticonventional, communal way of life. Max Pechstein joined in 1906, as did the older, more established Emil Nolde (who remained for a year and a half) and the Swiss artist Cuno Amiet. Both Munch and Matisse were considered for membership. Although the Brücke exhibited in several cities in northern and western Germany, their contributions in 1910 to the Berlin New Secession under Pechstein's direction brought them much more publicity. Pechstein, and to a lesser extent Kirchner, Heckel, and Schmidt-Rottluff, were increasingly discussed by the press. By 1911 all the artists of the Brücke had moved to Berlin, where they felt they had found a more supportive audience. By 1912 their individual outlook and styles began to outweigh their communal beliefs. Conflicts over leadership and the demands of exhibiting as a group led to their dissolution in May 1913. But their vision of renewal as reflected in their shared themes—tension-filled depictions of city life,[28] penetrating psychological portraits, sensual interpretations of naked men and women in primeval junglelike settings,[29] their shared styles—angular lines, claustrophobic space, vivid colors and oppositions of blacks and whites—had a long-lasting effect on German twentieth-century art.

6. E.L. Kirchner: program of the artist group, Brücke, 1906; "Chronicle of the Brücke," 1913; letter to Erich Heckel and Max Pechstein, March 31, 1910; letters to Gustav Schiefler, June 27, 1911, and March 16, 1913*

Ernst Ludwig Kirchner (1880–1938) is most frequently described as the leader of the Brücke, not only because of his design for the 1906 Brücke program (fig. 3) and of a chronicle of the group in 1913, but also because of the originality and quantity of his work. Although the 1906 program is often attributed to him, it reflected communal efforts. Kirchner hoped his 1913 history of the association would also be a unifying force, but the rupture with Pechstein in

*[E.L. Kirchner, et al.], program of the artist group, Brücke, 1906, Brücke-Museum, Berlin; E. L. Kirchner, "Chronik der Brücke," 1913; reprinted in J. K. Roethel, *Moderne deutsche Malerei* (Wiesbaden: E. Vollmer, 1957), 73, and published here with the permission of Dr. Wolfgang and Ingeborg Henze, Campione d'Italia, Switzerland; letter to Heckel and Pechstein, March 31, 1910, Altonaer Museum, Hamburg; letters to Gustav Schiefler, June 27, 1911 and March 16, 1913, published here with the permission of Dr. Wolfgang and Ingeborg Henze.

1912 injected a tone to the chronicle that the other Brücke members found self-serving and misdirected.[30] Nonetheless, the chronicle, like the more euphoric manifesto, highlighted the faith in the future that the Brücke search for renewal generated. The chronicle also portrayed Kirchner's conviction that he and the other Brücke members were working together to create a new German art, which stood in opposition to the barren art of the Wilhelmine establishment.

Although Kirchner denied being influenced by international modernism, he readily acknowledged in the chronicle his debt to the tribal arts of Africa and Oceania as well as to the Gothic.[31] Precise conclusions about the date of Kirchner's first experience with tribal arts cannot be deduced from the chronicle, but a letter of March 1910 to Heckel and Pechstein indicates the restorative powers tribal arts continued to have for him. By that date Kirchner had decorated the Brücke communal studio in Dresden (fig. 4) with rough hand-carved furniture and wall coverings whose erotic, non-naturalistic designs were based on Palau artifacts exhibited at the Dresden ethnographic museum. Kirchner refused to separate the applied arts from "high" art. His letters to the Hamburg collector Gustav Schiefler explain that his experiments with applied art,[32] with graphics, and with sculpture were often essential to the innovations in his paintings, which, along with his prints, were the focus of critical attention before the First World War. Nonetheless, Kirchner's denial of influence from French Fauvism and Cubism and from Italian Futurism, contradicted by other Brücke members, contributed to the paradoxical myth developed during the war that Expressionism was primarily Germanic in origin rather than part of international modernism.

[E. L. Kirchner et al.], Brücke Program

With faith in evolution, in a new generation of creators and appreciators, we call together all youth. And as youths, who embody the future, we want to free our lives and limbs from the long-established older powers. Anyone who renders his creative drive directly and genuinely is one of us.

E.L. Kirchner, "Chronicle of the Brücke"

In 1902 the painters Bleyl and Kirchner got to know each other in Dresden. In addition, through a brother, who was a friend of Kirchner's,

Heckel joined them. Heckel brought along Schmidt-Rottluff, whom he had known back in Chemnitz. They all worked together in Kirchner's studio. Here they had the opportunity to study the nude, the basis of all visual art, freely and naturally. Based on such drawing, they gradually began to feel that only life should provide inspiration and that the artist should subordinate himself to direct experience. Each man drew and wrote his ideas one next to the other, in a book "Odi profanum," and in this way they compared their individual qualities. So they developed naturally into a group that came to be called "Brücke." Each inspired the other. From southern Germany Kirchner brought the woodcut, which he revived under the stimulus of the old prints from Nürnberg. Heckel carved wooden figures again; while Kirchner enriched this technique by using polychromy in his figures and sought the rhythm of compact form in stone and pewter. Schmidt-Rottluff made the first lithographs on stone. The first exhibition of the group was held in its own rooms in Dresden; people ignored it. However, Dresden's old culture and the charm of its landscape provided much stimulus. Here the "Brücke" also found its first art historical support—Cranach, Beham, and other German masters of the Middle Ages. Amiet was made a member of the "Brücke" during his exhibition in Dresden. Nolde followed him in 1905. His fantastic individuality gave a new stamp to the "Brücke." He enriched our exhibitions with his interesting etching technique and learned about woodcuts from us. On his invitation Schmidt-Rottluff visited him at Alsen. Later Schmidt-Rottluff and Heckel went to Dangast. The harsh air of the North Sea induced Schmidt-Rottluff especially to develop a kind of monumental impressionism. Meanwhile, in Dresden Kirchner continued his compact compositions; he discovered a parallel to his own work in Negro sculpture and South Sea beam carvings in the ethnographic museum. The intense desire to free himself from academic sterility led Pechstein to the "Brücke." Kirchner and Pechstein went to Gollverode to work together. The exhibition of the Brücke with its new members took place in the Salon Richter, Dresden. This exhibition greatly impressed the young artists of Dresden. Heckel and Kirchner tried to relate the exhibition space to the new painting. Kirchner decorated the rooms with murals and batiks on which Heckel had also worked. In 1907 Nolde left the "Brücke." Heckel and Kirchner went to the Moritzburg lakes in order to study the nude in the open air. In Dangast Schmidt-Rottluff worked to perfect his color rhythm. Heckel went to Italy and brought back the inspiration of Etruscan art. With a commission to paint decorations Pechstein went to Berlin. He tried to bring the new painting into the Secession. In Dresden Kirchner discovered how to print lithographs by hand. Bleyl, who had become a teacher, left the "Brücke" in 1909. Pechstein joined Heckel in Dangast. In the same year both men joined Kirchner at Moritzburg in order to paint

nudes by the lakes. In 1910 the "New Secession" was formed after younger German painters were rejected by the old Secession. In order to support Pechstein's position in the new Secession, Heckel, Kirchner, and Schmidt-Rottluff also became members. In the first exhibition of the N. S. they got to know Mueller. . . . In order to keep "Brücke" efforts pure, the members of the "Brücke" left the New Secession. They promised each other that they would only have joint exhibitions in the "Secession" in Berlin. Following this there was an exhibit of "Brücke" work which filled the whole Gurlitt gallery. Pechstein betrayed the group by becoming a member of the Secession, and he was expelled. The Sonderbund invited the "Brücke" to its Cologne exhibition in 1912 and commissioned Heckel and Kirchner to decorate the chapel there. The majority of the "Brücke" members are now in Berlin. Even here the "Brücke" preserved its intrinsic character. Inwardly unified, the group transmits its new way of working together to all modern art production in Germany. Uninfluenced by contemporary currents, Cubism, Futurism, etc., it fights for a humane culture, which is the basis of true art. The "Brücke" owes its present-day position in art to these efforts.

Letter to Heckel and Pechstein,

Dresden, March 31, 1910

Dear Erich and Max,

It seemed for so long as if Lotte seriously wanted to get away, so one shouldn't be surprised. Perhaps Max will be able to come here then all will look together for a place in Moritzburg. I'll come to the opening, Matisse might be quite interesting after all. As for women, I have nothing new, am too short of money. I had to go to Chemnitz for the sake of money, passed several very bad days and achieved little. After paying the rent I have 5 marks left. The Munich print-lover got scarlet-fever. Emy overheard appeals for money. Did you get the 300 marks? People are really born unlucky. When I saw once more the low character and narrow-mindedness of those people in Chemnitz, I really lost the courage to go on living. I look at things from a different viewpoint (like a) philosopher, even more so.

The ethnographic museum here is open again, only a small part, but still refreshing and gratifying; the famous bronzes from Benin, some things from the Pueblos in Mexico are still exhibited and some Negro sculptures.[33] I wrote before about Hettner in the Florence art association. Am enclosing a funny review by Paul Fechter. Extremely learned, I don't understand anything of it. Well, its just something different than people like us do.

Did you go to Meier-Grafe's once more? Is the Gutbier-[?] exhibition also definite? What about the Juryfreie in Berlin? After the Secession there will be an enormous number of pictures available for it. Isn't E. F. doing better again? Well, there isn't anything else that's new, a circus is here again and Samoans, Negroes, etc., are coming to the zoo this summer!

<div align="right">
Best regards,

Ernst
</div>

Letters to Gustav Schiefler

<div align="right">
June 27, 1911
</div>

Dear Herr Director,

I have just finished the plate you gave me last year. Working on such a smoothly polished surface has its own fascination. I enjoyed handling the needle with very little pressure almost as if drawing. In the printing the background comes out as smooth as velvet. I am sending you the print and am adding a number of other new prints. Maybe you will find something of interest among them. You can send the folder back whenever you get a chance. The maple wood we got from you is very easy to work with, it is so short in the fiber and homogenous throughout. One is tempted to polish it. I made a sitting figure with a bowl on its head and am now working on a standing figure in dancing position. It is so good for painting and drawing to create figures. It gives consistency to drawing and it is a sensual pleasure when the figure grows out of the wood step by step. In every trunk is a figure, it only has to be peeled out.

It was so nice when you were here last year. I hope to see you again soon. It looks as though I will be unable to come to Hamburg this year, unfortunately.

Friendly regards

<div align="right">
Your devoted

E.L. Kirchner
</div>

<div align="right">
Lighthouse Staberhuk,

June 16, 1913
</div>

Dear Herr Director,

Many thanks for the nice letter. Besides the photos the chronicle also contained 17 sheets of original prints. We attach too much importance to prints to be able to do without them.

Hopefully the chronicle will be published in the fall. Almost everything is ready for it.

There has always been a reactionary group in the Secession that opposed Cassirer[34] and the other older people without being progressively minded themselves. I cannot understand how these people can have the power to split the Secession. The unfair attack on Liebermann and all the other squabbling do not establish anything better. Cassirer has his faults just like anyone else, but we do have to appreciate the fact that this year he has created a highly interesting exhibition, such as has not been seen in the Secession for a long time. In my opinion, people who do not themselves create should always be at the head of the artists' associations. These individuals are able to direct all their energies into the success of such things. For the creative person those things should only be dealt with under duress, for sensuous feeling is always the opposite of business sense.

You may keep the print portfolio as long as you wish. Your thoughts about it are very interesting to me. After all, I do not notice when I change and the new element grows out of the interaction of painting and drawing with the three dimensional working of the wood and the material advantages of printmaking.

Currently I am taking up the old stippling technique [*Schrottechnik*] again, inspired by the engraving process. I am experimenting with small zinc plates. I want to illustrate something by Döblin with it.

The price is of course the same as always. I charge 60 marks for the Sakuntala sheets.

It was stormy here for a few days, but now the nice weather seems to be holding.

Best regards

<div align="right">

Your devoted
E.L. Kirchner

</div>

7. Karl Schmidt-Rottluff, postcard to Cuno Amiet, January 8, 1909, and letter to Gustav Schiefler, ca. 1913*

Karl Schmidt-Rottluff (1884–1973), born Karl Schmidt, combined his birthplace, Rottluff, with his name, and remained a Brücke member until the group disbanded in 1913. He became friendly with Heckel in 1903 when both were studying at the same gymna-

*Schmidt-Rottluff, postcard to Cuno Amiet, 1909, Brücke-Museum, Berlin; Schmidt-Rottluff letter to Schiefler, c. 1913, Brücke-Museum, Berlin.

sium and moved to Dresden in 1905. Schmidt-Rottluff frequently corresponded with the Swiss artist Cuno Amiet who was one of the Brücke's direct links with French Symbolist painting and theory. Before exhibiting with the Brücke in 1907, Amiet had worked with the French Symbolist painter Emile Bernard in Pont Aven in 1892 and 1893.

Schmidt-Rottluff had strong ties to northern Germany. Two Hamburg patrons, the art historian and art collector Rosa Schapire[35] and the judge, print collector, and critic Gustav Schiefler, became sustaining Brücke supporters. By 1911, Schmidt-Rottluff moved from Dresden to Berlin, and his works began to reflect the vitality and eroticism of African art. He made wood sculptures and contributed prints to journals such as *Der Sturm* and *Die Aktion*. He served in the military during the war and after the November revolution became active in radical groups such as the Arbeitsrat and the Novembergruppe.

Postcard to Cuno Amiet, January 8, 1909

Dear Amiet,
Do you know van Dongen in Paris? We intend to name him a member.
We're also speculating about H. Matisse and E. Munch. What do you think? Do you have someone in mind as well?
Greetings

>Your,
>Schmidt-Rottluff
>[indecipherable] Rottluff bei Chemnitz Sa.

Letter to Gustav Schiefler, nd., c. 1913

Most Honorable Herr Director!
Of course you can keep the woodcuts a while longer. I would give you some "explanations" about the new things if I were not completely convinced that they would be absurdities, aside from the fact that it would scarcely help you. Besides, during intellectual discussions I easily get lost in uncertainties, which does not happen so easily when I am engaged in creative activity; there I have an almost real world under my fingers.

On several occasions I have achieved an enhancement of forms, which, although it contradicts scientifically established proportions, is balanced and proportioned in its spiritual relations.

I often have exaggerated heads monstrously compared to other body forms as the nexus of the whole psyche, all expression. But all other body shapes tend to move spiritually toward the head, assemble there and thus the shape grows big all by itself. With the breasts it is the same. They are an erotic element. But I want to detach it from the transitory nature of experience, as it were, to create a relationship between the cosmic and the earthly moment. Perhaps one might say it is the erotic raised to the transcendental. This sounds somewhat mystical in our thoroughly cynical age, but whatever has been left to us in the course of time from the art of the past—Egypt, Michelangelo—what gives these their immortality: it is the experience of transcendental things in the earthly.

Of course I believe you when you say it is not so easy to write about my material. But I also believe you will come to the same untroubled sympathy you have shown toward older material.

With the best wishes for a happy holiday and friendly regards to your family.

Your devoted,
S. Rottluff

8. Erich Heckel, letters to Franz Marc, Spring 1912 to Winter 1912/13*

Erich Heckel (1883–1970) frequently functioned as a business manager for the Brücke, locating exhibition space and writing to potential members. The letters included here were written to Franz Marc, the co-founder of the Blaue Reiter primarily during 1912,[36] and reveal Heckel's interest in organizing exhibitions that would include both groups. Both artists recognized their common search for alternatives to the conventional views of art and life. Marc found Heckel, of all the Brücke artists, the most "blessed,"[37] and Heckel admired Marc's skill in defending the new art against the denunciations of more academically oriented artists such as Max Beckmann.[38] Heckel's letters to Marc underscore their shared preoccupation with finding opportunities to make their work visible to the German public. The rivalry between gallery owners such as Herwarth Walden

*E. Heckel, letters to Franz Marc, c. 1912; reprinted in Karlheinz Gabler, *Erich Heckel: Zeichnungen und Aquarelle* (Karlsruhe: Städtische Galerie in Prinz-Max-Palais, 1983), 109, 110, 114, 115. Courtesy Erich Heckel Estate, Hemmenhofen.

and Paul Cassirer to represent the young artists is also quite evident.[39] The letters, especially where Heckel discusses his joint work with Kirchner on the Sonderbund chapel, testify to the seriousness with which the Brücke viewed their goal of communal exhibitions. These letters also document the exposure of the Brücke to the international sources of Futurism and Cubism.

Steglitz Mommsenstr. 60, n.d., c. April/May 1912

Dear Herr Marc,
 I have sent a catalogue of our exhibition to your address. For a long time I have been wanting to write something about your interesting essays in *Pan*, but preparations for the exhibition and for our yearly portfolios have kept me very busy. Unfortunately I did not succeed in arranging exhibitions for the collection of the "bl.R." When I was negotiating with Mannheim about another matter, the Kunsthalle informed me that an exhibit of the most modern drawing was being planned and that invitations would be sent out. As soon as I hear something, I will let you know. Do you have any other exhibits for the painting collection of the "bl.R."? It could have been so interesting to have had a common exhibit for all of us together—but Commeter in Hamburg wasn't at all interested. Cologne will probably be next. As to *Pan*, I liked your second essay very much. I would have loved to use it as a foreword for one of our exhibitions. In Cologne there may be an opportunity to exhibit writings in a reading room or library space. The *Pan* series must be included! When will Goltz come to terms? That is, when will he return things? Our exhibition here looks good compared to the rather lukewarm one of the Secession. Too bad that the villa of Sturm is a little remote—attendance is bad and the special proximity of our two exhibitions is also illusory. Do you still want to speak with Tannhauser sometime? Whether he may want to take the "Brücke" collection for November—after the September exhibition in Hamburg. I would be very grateful for your intervention. With kind regards
 Your,
 Erich Heckel

Steglitz Mommenstr. 60, n.d., April/May 1912

Dear Herr Marc,
 Sunday I went to see the Futurists in the lovely little villa.[40] Their ideas are certainly in part quite correct, but they hardly succeed at all in realizing

them in the picture. There is Boccioni, a true young Italian: sweet in color, even sweeter in form, female heads in tasteless smoothness—in concept as well as the mode of painting. Nr. 8 A modern Ideal: light effects on a female portrait—very bad. Then Carra, a second Brandenburg. The best, Severini. Nr. 28 Pan Pan Dance in Monico, the attempt to paint noise; then the dissolution of form with electric light in the Yellow Dancers. His technique is unfortunately so schematic—almost ruler-straight lines enclose geometric forms, triangles and squares are pedantically filled in neo-impressionistically with little lines. Also his color is very loud. Russolo is similar to a certain Belgian Knopfh [sic] or Odilon Redon. A Kandinsky, perhaps left from another exhibit, seems so wonderfully grand in color and rhythm next to those others. The planned 3d exhibition of Sturm is supposed to bring "Hodler" and French prints. . . . More pleasant news for me: a Mr. Gralston has written to me that he wishes to purchase the lithogr. reproduced in the bl.R. catalogue. I have ordered it from Cologne and sent it to the gentleman in Krailing near Munich. If you still want me to send the picture to Vienna please let me know exactly how I should address it. Best regards to you and your wife from Sidi[41] and myself.

<div style="text-align:right">Your Erich Heckel.</div>

<div style="text-align:right">n.d., ca. April/May 1912</div>

Dear Herr Marc,

Our letters crossed, and my epistle was in many ways an answer to your letter of April 14th. It is certainly sad that we have not reached an agreement, but perhaps sooner or later you will abandon Sturm or the New Secession after all. Or else you are right, and we are in error in the attempt to make the exhibition halls of the Secession more interesting. Perhaps an understanding will then be possible. For the best exhibition is one in which an art dealer and enough interested parties are available to speak on behalf of the exhibited pictures. Then I have only to be concerned about creating while others manage the selling, which is the "basis of continuing work." If a substantial advocate is there, then, in my opinion, pictures in different styles, such as Corinth's or Beckmann's, do no harm, or at least do less harm than recent derivative pictures, such as the New Secession shows.

I am not a member of the Sonderbund. If I am invited there, then I will not exhibit alone but together with other members of the Brücke just as in the Secession. There in particular it will be obvious that the "Brücke" is necessary, since it will attempt, in the context of the larger exhibition, to set up picture compared to picture, example against counterexample, as the only encounter that should be decisive.

Finally, the four of us, who do not have financial backing and who have a hard enough time staying afloat, have to consider the present economic situation. We do not have the slightest chance to sell with Walden, while the Secession does have a certain clientele.

I have written all this because I truly wish that you understand our course of action. I am looking forward to seeing you here in the fall. I am still hoping to get away during the summer. My girlfriend and I send you both best regards.

<div style="text-align: right">Your Erich Heckel</div>

<div style="text-align: right">Steglitz Mommsenstr. 60, n.d. c. April/May 1912</div>

Dear Herr Marc,
Some time ago I had suggested to the Sonderbund (Osthaus) to do a room with stretched fabrics [Spannstoffen], prints, and wood sculpture together with paintings from the "Brücke."

Only no group exhibition came off, so this idea didn't amount to much. Instead Reiche has now suggested that I install these painted, stretched fabrics in a chapel space.[42] Now I want to tell Kirchner about it and in the next few days send sketches. If and when these are accepted then my trip to Cologne with Kirchner is definite. The matter resolved itself miraculously. Kirchner and I will travel to Cologne this week to do the chapel in colors. Unfortunately it is too late for sculptures. Today your "bl.R." book was delivered. It is a big help for all of us and for the movement; I for my part want to thank you and Kandinsky very much. Please be sure to come to Cologne for the opening. It would make me very happy.

In haste, always yours truly, Erich Heckel.
Address remains Steglitz. I will report to you from Cologne.

<div style="text-align: right">n.d. c. Fall 1912/Spring 1913</div>

Dear Herr Marc,
Unfortunately our letters have crossed again. But I did write to you earlier that after long deliberations we had decided to give the Secession a try. It is curious that Pechstein informed you, apparently in a very kind way, that Slevogt admitted us to the exhibition, especially since we negotiated only with the president of the S., never with the jury, and stipulated our conditions to him. "Walden's Way" was not an option for us here. They say the New Secession is exhibiting as such—but why then, only to enlarge the exhibition—. So we'll wait and see. Perhaps we will succeed in shifting the emphasis of the Secession. If not, then

we will remain alone. We do not have the slightest obligation to the Secession for later. If Corinth, Slevogt, Beckmann, and Pechstein take over, of course, nothing can come of it. Today I received the report about those who quit the Sonderbund. This is much sadder than the Berlin situation, since it was supposed to be, after all, a circle of supporters of our art from various localities. It is a great pity that this circle, so capable of creative work, could be dispersed so easily. If I had known it earlier, all of us who exhibited together in Cologne should have put an artists' group at the disposal of the friends of the arts in order to continue their unfinished work. Now I don't know what will happen to the remains of the Sonderbund. Perhaps it can make up for all of its rhetoric with good deeds. Then it will become evident where the mistakes were made.

I am satisfied with the format; at least I will experiment with it. I think we will still succeed with the book since the book is what we want.

Many warm regards, your Erich Heckel.

9. Max Pechstein (transcribed by W. Heymann), "What Is Picasso Up To?", *Pan*, 1912*

Max Pechstein (1881–1955) was the first Brücke member to achieve critical and public recognition. He was born into a working-class family and received training in decorative design that remained an integral part of his vividly coloristic work. He attended the Kunstgewerbeschule (School of Arts and Crafts) in Dresden and then the Art Academy, where he graduated in 1906 with a scholarship that allowed him to study and travel throughout Europe in 1907. In Paris he met the Dutch artist Kees van Dongen, and became acquainted with other Fauve artists and their works. Of all the Brücke artists, his paintings have the strongest affinities with Fauvism, and these similarities may have allowed his style to be more readily accepted in Germany. Some critics, however, especially Paul Fechter, saw Pechstein's work as more exemplary of purely Nordic characteristics. Fechter, who was an early champion of the Brücke, singled out the work of Pechstein in his 1914 book *Der Expressionismus* as one of the major agents of the new movement.[43]

*Max Pechstein, "Was ist mit dem Picasso?" [transcribed by Walther Heymann], *Pan* 2, no. 23 (April 25, 1912): 665–69.

Pechstein was the first member of the Brücke to move from Dresden to Berlin. He was elected president of the New Secession in 1910, designed the catalogue cover and the poster (fig. 5) for that year, and was instrumental in obtaining exhibition space for the Brücke in Berlin. He urged exhibitions with other international modernists and explored joining forces with the Munich Neue Künstler-Vereinigung and with the Prague artists around Bohumil Kubista.[44]

Pechstein's evaluation of color as the central emotive force in a painting led him to denigrate both Impressionism (for its lack of imaginative color) and Cubism (for its superficial color) in an essay transcribed for the April 1912 issue of the journal *Pan*. Although early in 1912 Pechstein had withdrawn from the New Secession, which had become the Brücke's Berlin artistic showcase, and had rejoined the 1912 Berlin Secession, where he exhibited individually, he continued his allegiance to the concept of Expressionism.

<div align="center">****</div>

The friend whom Pechstein asked to transcribe his words here is the young East Prussian poet Walter Heymann, as remarkable for his sensitivity to art as for the searching, vibrant verses of his "Pictures of a Promontory."
Pechstein, born Dec. 31, 1881, grouped with the "Expressionists," initially discusses why he and other painters and groups have met with prejudice and misunderstanding.

I

"But what is Picasso up to? What are some of the great ones up to, who could no longer be understood under the label of Impressionism: van Gogh, Cézanne? And what are the Cubists, Futurists?

<div align="center">. . . .</div>

. . . One cannot make anything absolutely new, but one can make new associations which, when recognized as such and developed consistently, will realize whole new fields." Thus Pechstein picked up something left behind in the history of artistic means, reassessed it, and made it central. Namely, **"To present the mood content of the color, to use color purely as a means of expression."**
If Pechstein sees oranges, he is going to paint them orange if he feels that way or if, as an element in the painting, they could be orange. The

fact that maybe they could not be orange is a consequence of their accord or discord with other colors. To Pechstein, a real orange is, like a box painted blue, only the **carrier of the color**. For him, human production is simply an extension of natural production.

Nature—that he cannot deliver. For one thing it already contains everything. But his temperament can give a strong impression of a natural phenomenon. . . .

. . . .

II

Pechstein is trying to enhance, show, and depict fundamental ideas, fundamental forms, and fundamental expressions in simple phenomena: to learn from an object, a tree, a boat, then from a tree or boat in the morning or in the evening, and from several trees or boats what kind of **special impression** they give him at present and in what case and under which circumstances. . . . (Pechstein does not use professional models). . . . Thus he receives from a new being—as every human being does—only the movements and characteristics particular to this person, expressing an inner life. He receives a new picture composition or other enrichments. And he feels a person comes to the portraitist as he might come to a doctor: full of trust. Pechstein seeks to justify that trust. He grasps an ungraspable personality finally—provisionally, that is, somewhat—absolutely, through a color harmony. The color he decides to give skin is very important to him. To give the same hue to a "spiritualized" scholar and a butcher's helper would seem disgusting to him, even if that would be true in nature.

A lot goes on before Pechstein produces a painting. He does not make "sketches for a painting." He jots down numerous different impressions as drawings, in drawings. His line is expression of a temperament. In the drawing below he tries for "Expression," but he seeks to allow the surface to resonate evenly; a center of interest may be there but should not come to the foreground. Finally he paints one or more pictures, as sketches to a painting.

III

. . . .

Pechstein does not ask if "the model" lies correctly on cloth or ground. . . . Pechstein rejects specificity—"that is ultramarine, that is green"—whether she is lying correctly "on it" does not matter to him. To such a question as: "Isn't this purely decorative?" he answers: Every and all art, even bad art, is decorative, that is, it embellishes. The word

has taken on a flavor of applied arts. To me a Rembrandt painting embellishes just as much as a purely ornamental woodcut . . .[45] The best art has always been the most decorative—Rembrandt's oeuvre should be acclaimed according to its levels of quality. "People easily learn to differentiate between minor key, forte, piano. If we had the same instruction that is given in music—the painter would not be considered so trivial."

(I already started to doubt if I would get an answer to the question "What is Picasso up to?" But now come the following remarks about the cubic-cubistic):

IV

The painter's tones move between black and white, hues between yellow and violet. But Pechstein uses black and white as hues too—just as he puts earth—and metallic colors on his palette if they give him a certain effect, as black and white do. . . .

If the cubic content of a painting consists of a simulated, in-depth perspective effect, Pechstein eliminates it. He uses **linear** perspective that leads out from the sides of the picture. But the cubic lines that form its constructive framework are the further cubic content of a painting.

Now, if one wants to extract from a picture the last cubic content, one has to consider that tonal values are also carriers of colors. Hence the new Cubism consists of extracting the last cubic content up to the surface, without consideration of color, which is seen only as layering. It must have been tempting to a logical Cubist like Picasso to **totally** or almost totally **relinquish color**, to render the model purely in black-white, in rhythmic lines and planes. Picasso did just that as an intellectual spirit, pondering over the language of form. Now the Cubist paints the cubic content (as a sculptor joins planes to one another) with planes rhythmically placed against or into each other. Example: **The Pont Neuf** at the Secession. Picasso took this theme from Cézanne and surpassed him.

About **Cézanne's and van Gogh's** position **toward the cubic**:

While Cézanne **assembles** that which is contained in the **cubic** in rhythmic color **planes**, van Gogh dissolves the planes in rhythmic color **lines** and **fills** the surface with these, **disdaining** the cubic. As an end result, therefore, van Gogh was able to outline larger areas of color with vibrating lines. . . .

III. NEUE KÜNSTLER VEREINIGUNG MÜNCHEN AND THE BLAUE REITER

INTRODUCTION

In Munich, the Blaue Reiter and the less well-known Neue Künstler Vereinigung (NKV) contributed to the impact of modernism in Germany through exhibitions and publications of works that linked the concepts of primitivism, abstraction, and Expressionism in the public's mind. The Blaue Reiter almanac,[46] which was published in the spring of 1912 with twelve theoretical essays, two musical scores, one drama, and over one hundred reproductions, indicated that the challenge to established ideas and conventions was occurring in all the arts. Influenced by Symbolist, anarchist, Theosophical, and other occult and mystical thought systems,[47] the editors Wassily Kandinsky and Franz Marc believed that a new spiritual epoch would replace their decadent and anxious era. Art, by reflecting change and regeneration, was to play an important role in this transformation. Indeed, they maintained that the artist, even more than the politician or political theorist, had a special gift to bring to the people.

The Russian born Kandinsky, who had moved to Munich in 1896, formed the NKV in 1909 to exhibit his circle's unconventional works. Kandinsky had lived in Paris in 1906–7 and his work had changed dramatically under the impact of Matisse and other Fauves. The first two exhibitions of the NKV were international in orientation, combining Munich painters and sculptors with Russian and French artists of Symbolist, Fauvist, and Cubist orientation, all of whom departed from what Kandinsky considered trivial and mundane imitations of nature. Women artists such as Gabriele Münter and Marianne von Werefkin were given equal rights and membership, a policy not common in Wilhelmine Germany.

By the third exhibition of the NKV, tensions within the group led Kandinsky, along with Franz Marc, Gabriele Münter, and Alfred Kubin

to leave the association. Shortly thereafter, Kandinsky and Marc established the Blaue Reiter. The first exhibition opened on December 18, 1911, in Munich in the Galerie Thannhauser. The second exhibition, devoted to prints, watercolors, and drawings, included even more diverse representatives of the new directions in art.[48] The far-reaching international participation in these exhibitions prefigured the Cologne Sonderbund of that spring, where all these contemporary European currents were enthusiastically labeled Expressionist.

Marc's description in the Blaue Reiter almanac of these currents as *Wilden*—"savages"[49]—more accurately reflected their self-image as rejectors of conventional attitudes, and helped to intensify the hysterical response of the public and unfriendly critics, who attacked their protoabstract works as anarchistic and devoid of meaning. For other artists and intellectuals, however, the contrasting colors and dissonant chords of NKV and Blaue Reiter works were viewed as a sign of the tension and conflicts of their age and consequently a possible tool in the struggle to build a better society.

10. Wassily Kandinsky, "Foreword," Neue Künstler Vereinigung exhibition catalogue, 1909–10, and untitled essay, The Struggle for Art: The Answer to the "Protest of German Artists", 1911*

By the spring of 1912, Wassily Kandinsky (1866–1944) was in the limelight in Germany. His manifesto on painting, *On the Spiritual in Art (Uber das Geistige in der Kunst)*,[50] which went into three editions by the middle of 1912, his co-editorship of the Blaue Reiter almanac, and his paintings were attracting much attention. By 1914 a Cologne exhibition group described him in their catalogue as the "leader of German Expressionism" known for uniting "the new efforts in painting, literature and music."[51] His earlier writings, notably the foreword to the catalogue of the first exhibition of the NKV and his answer to the Vinnen attack on modernism were

*[Wassily Kandinsky], "Vorwort," *Neue Künstler Vereinigung München E.V.*, I, December 1–15, 1909 (Moderne Galerie, Munich; 2d ed. 1909–10); Gabriele Münter-Johannes Eichner Stiftung, Städtische Galerie, Munich; Wassily Kandinsky, untitled essay, *Im Kampf am die Kunst: Die Antwort auf den "Protest deutscher Künstler"* (Munich: R. Piper & Co., 1911), 73–75.

among several theoretical works that helped to ensure the term "Expressionism" 's acceptance among the German avant-garde.

Both statements attempt to provide justifications for the departure from naturalism that was causing such controversy. Elaborating on the concepts of *innere* and *aussere*, Kandinsky emphasized that the artist should not be limited to depicting the visible forms of nature—the external world, but should reflect the inner world in his work. Kandinsky, however, did not intend *innere* to mean personal world or subjective feelings. Rather, as he defined it in the forward to the NKV, *innere* had an almost Bergsonian quality evolving from the artist's concentration on finding forms to evoke "the interrelation and permeations of these collective experiences." Appropriating Symbolist literary and aesthetic theory as well as Theosophical concepts of the interrelatedness of matter and spirit, Kandinsky believed that the artist was equivalent to a prophet whose destiny was to communicate the divine—the heavenly order—to the public. Modern art, explained Kandinsky, might seem disharmonious, but that was a reflection of the struggle to balance the use of the external or visible forms of nature and the inner cosmic vision. For maximum effectiveness and involvement of the spectator,[52] the work of art should not be literal but suggestive. The concepts of *innere* and *aussere* were more fully developed in *On the Spiritual in Art* which not only justified the movement away from naturalism but also celebrated the transcendental quality of abstract art.

Kandinsky, "Foreword," *Neue Künstler Vereinigung* exhibition catalogue

. . . We proceed from the belief that the artist, apart from the impressions he receives from the external world, Nature, continually collects experience within an inner world. We search for artistic forms that reveal the penetration of these collected experiences, for forms that must be freed from all irrelevance, in order to forcefully express that which is essential, in short, for artistic synthesis. This search seems to us the thing that is uniting in spirit increasing numbers of artists.

Kandinsky, from *The Struggle for Art* . . .

Man, like the world, like the cosmos, consists of two elements: the internal and the external.

The external element of man, or the outer person, remains in continuous contact with the external aspect of the world that surrounds him. There are no means capable of dissolving this continuous contact. The environment is at the same time the source of life of the outer person.

The interior element of man, or the inner person, remains in continuous contact with the internal aspect of the world that surrounds him. This contact is inescapable. It is at the same time the source of life of the inner person.

To put it schematically, his external element is the means by which modern man is able to remain in contact with the life of the internal aspect of the world, and to draw from it his life force.

Thus, every internal, spiritual force also needs its external element.

The greatest internal, spiritual force is art.

Thus art also has two elements: the internal and the external.

These two indispensable elements are reflected in every work of art.

The complete harmony of the work of art is therefore the ultimate balance between the internal and the external, i.e., between content and form.

Therefore, all artistic content seeks its particular form.

Thus, form changes in order to conform to the inner nature of the artist.

Thus, too, form changes in order to conform to the internal nature of its own epoch.

The connection between the work of art and the artist impresses upon the former the stamp of the artist's personality, his style.

The connection between the work of art and its epoch impresses upon the former the mark of the period and its style.

Thus, in every work of art two styles are to be found: that of the "individual" and that of the "school."

The now-dawning twentieth century is the century of the "internal," in contrast to the nineteenth, which was that of the "external."

The once "lost" and now "found" inner life reestablishes in the "new" art, which already exists today, the lost balance of the two elements: the internal and the external. A "new" harmony or beauty is arising, which, as always, will at first be called disharmony (ugliness).

This harmony will consist of the perfect conformity or, subsequently, subordination of the external element (that of form) to the internal (that of content), without regard for any other considerations, including those of the "natural."

Since our inner life (like any visible form of life) is ordered according to plan and purpose, the expression of this life demands a planned and purposeful form.

Thus, even today the absolute necessity in art of plan and purpose— i.e., of construction—is quite clear. Every contemporary artist must inevitably make his creation meet this requirement.

After music, painting will be the second art to be, to become unthinkable without structure, which is not the case today.

Thus painting will reach the higher level of **pure art**, upon which music has already stood for several centuries.

This will be the great aim of all "youths" or "wild ones" of every spiritually great country. And there is no power capable of halting this progress of art.

Before this lofty striving, every obstacle is like a leaf in the storm.
Munich

11. Kubin-Kandinsky letters, May 5, 1910, and August 13, 1911*

Alfred Kubin (1877–1959) was born in Austria but began studying art in Munich in 1898, two years after Kandinsky moved there. He participated in the last Phalanx exhibition, which Kandinsky organized in 1904, and he was a steadfast member of the NKV and the Blaue Reiter. The correspondence between Kubin,[53] who is best known for his dreamlike, often erotic, drawings and prints, and Kandinsky is full of philosophical discussions, tales of personal struggle, and news of successes and failures about their goals. The selections included here are from the time just prior to the formation of the Blaue Reiter when both artists were members of the NKV.

In his letter Kubin praised Kandinsky's development of the "abstract" side of art and described it as a beginning of a new artistic era. Although he referred to his own experiments with "free combinations of color" made under the inspiration of microscopic studies and mentioned his fear of creating ornament, neither Kandinsky's work of 1910 nor Kubin's of that time were abstract as we use the term today to mean absence of identifiable imagery. Kandinsky used amorphous, thick colors to obscure his images, to hide their mundane, external qualities, and many of his paintings of this period contain carefully veiled apocalyptic and paradisiacal images.[54]

Kubin's reference to reading mystical writings is a reminder that he and Kandinsky turned to unorthodox, often heretical philosophy

*Alfred Kubin letter to Kandinsky, May 5, 1910 and Kandinsky letter to Kubin, August 13, 1911; from Kubin archiv and Gabriele Münter-Johannes Eichner Stiftung, Städtische Galerie, Munich. © 1989 edition spangenberg, D-München 40.

in their search for alternatives to established thought. Kubin was interested in Meister Eckart, and read the Kabbalah, neo-Platonic writings and other "gnostic" or secret texts. Kandinsky shared this interest, and referred in *On the Spiritual in Art* to Theosophical writings, especially those of Helena Blavatsky and Rudolph Steiner,[55] to underscore his belief that a new utopian age was dawning to which the painter had an obligation to lead the spectator.

May 5, 1910

Dear Kandinsky

Thank you so very much for the wonderful prints. It has taken me quite some time but I could hardly have enjoyed them earlier because until only a few days ago, things were going rather badly for me. (I suffered chiefly from loneliness since my wife has been in a sanitarium in Baden-Baden for more than two months now.) For the past week, however, I have been alright again in spite of the constant rain. I can work and am in good spirits. My dear friend, you must feel on the whole really splendid because, with regard to the abstract side, you have developed an entirely new possibility for art and stand there unequaled and unique. Of course you will meet with misunderstanding because people are nowadays still too backwards, but you will always find in me one who gratefully appreciates you. I sense in your work primary things of long ago which are wedded to mysterious "vibrations" of future spiritual possibilities. Certainly there must be more people who are feeling as I do, therefore success cannot be long in coming. Your way is mad and sensually enticing. Four years ago when I was disgusted with the eternal treadmill of painting and tired by the mountain of all that was already achieved, my microscopic studies led me to make some color experiments. They were fragments, free combinations of forms. Their success was but modest—and I abandoned them soon. The danger for me at that time was—the ornament.— You, however, avoid this snag brilliantly, your art remains illusionistic. In this I see what is sane and wonderful,—merely ornamental painting would not **give** any final *satisfaction*!—So good luck!—I am very active after a pause of nine weeks, as usual I am doing pen-and-ink drawings, right now I am illustrating. I have many commissions which tax all my strength and don't know yet whether I'll be able to finish something of real value for our next exhibition. What about our present collection, *I haven't heard anything about it*?? Moreover, I need the frames for the next one. I'll exchange the drawings in Munich.—My experiences of mystic

things have been *tremendous* and still are. I experience exalted states of mind one after the other, also a great deal of evil, but my letter would need 1000 pages for this, which is impossible. Therefore best regards to Miss Münter and don't forget your old Kubin. The promised book must appear very soon. What are the others doing?

P.S. I am convinced that in many people a language of forms which is *similar* (not a good word) to yours, lies like a hidden treasure. Everybody has his own personal rhythm. Perhaps one will later recognize in your work the beginning of a new epoch in art.—I wish that my destiny would bring me also to the day when I could objectify my deepest secrets artistically; so far I am the least synthetic one of the entire N.K.V.M.E.V.[56] I am always looking for the suitable form which is inherent in myself. Such a thing must slowly grow and ripen in an organic way and then one fine day stand before the inner eye as magnificent vestiges of visions. As you know yourself, you already have all this today. That is why your work is so exciting for me.—But Redon, Munch, Ensor and I are still too biased by subject-matter and depend partly on earlier achievements. I know some of Nolde's successful solutions. (I don't know the latest Frenchmen nor do I know what Bonnard and Vuillard are doing these days!) Grossmann and Walde are certainly artists but not the mystic kind in *our* sense. The same goes probably for the Frenchmen.

Murnau, Upper-Bavaria, August 13, 1911

My dear Kubin!

I was very glad to hear from you again. These hot days gave me only a few moments which, however, I shall not forget soon. We poor residents of Bavaria have gradually become quite estranged from the sun. Now all of a sudden it is shining without interruption for weeks—almost for months. Finally it seemed that it would not disappear from the sky even at night. And then some moments of fear overcame me. The blue sky looked white to me in the end. According to my theory of colors (which is still clamoring for a courageous publisher),[57] white is the color of silence—of possibilities, the hidden beginning, the birth. This color inspires me more and more, it is the one I have especially cultivated in my last paintings. Thus, it will be assigned an important part in a large painting I have been contemplating all summer (actually in the spring also). In this painting, white must take the part of terror. My emotions (= inspiration) told me so. My head (which is usually stupid . . . not only mine) put a big question-mark over this part. Now you will understand what I owe to our unmercifully beautiful summer. I have no idea when I'll start this painting. I make many sketches and have these ideas in mind even while

I am working in the garden . . . and doing many other things which occupy me sometimes volens, sometimes nolens.

Miss Münter has been away for almost 2 months, and now she will return in only 10 days. Apart from Berlin she visited almost all of the Rhineland, the newly developing art country.

I am also much in favor of exhibiting together in the New Secession. It is time to deliver the first blow right in Berlin. Things are happening now surprisingly (and alarmingly) fast. My God! I knew it. Now the hour, partly longed-for but mainly threatening, is at the door. And the door will inevitably open. Woe not only to the vanquished!!—Has your monograph been published? Cordial greetings. Live actively and stay well.

Your Kandinsky

12. Wassily Kandinsky and Franz Marc, preface (not printed), ca. October 1911, for the *Blaue Reiter* almanac; Franz Marc, subscription prospectus, January 1912, for the *Blaue Reiter* almanac*

The *Blaue Reiter* almanac was published in May 1912, the result of a nearly year-long collaboration between Kandinsky and Marc (1880–1916) to create a book that would powerfully present their messianic vision of the coming new age. The selections here clearly reflect the utopian fervor of the two artists. They reveal the editors' determination to battle the commercialization of a society they described as "polluted" and "hollow" by developing, as Marc explained, "*symbols* for their own time, symbols that belong on the altars of a future spiritual religion. . . ."[58]

Committed to making ordinary people receptive to change, both artists wanted to stir up a critical attitude toward established thought and phenomena. As a result, they drew upon an international array of artists, musicians, and writers who could represent all that was new and unconventional in the various arts. Reproductions of their paintings and those of their contemporaries in France and Russia as well as Germany were placed next to examples of tribal art, children's art, and folk art to emphasize that academic and traditional notions

*W. Kandinsky and F. Marc, preface (not printed), c. Oct. 1911, and Franz Marc, subscription prospectus, Jan. 1912: reprinted in Klaus Lankheit, ed., *Der Blaue Reiter*, documentary edition (Munich: R. Piper & Co. Verlag, 1965), 313, 315, 316.

of beauty and harmony were no longer necessary. Although both Kandinsky and Marc associated naturalism with commercialism and abstraction, or protoabstraction, with the transcendent and the universal, they were not committed to one fixed style. They urged freedom of choice for individual artists as long as they were guided by reference to underlying natural law rather than by superficial rules artificially imposed by an academy or school. Kandinsky and Marc, as did several of the composers writing in the almanac, advocated a search for forms, colors, and sounds that reflected the tension and discord of their age as the strongest stimuli for change. For the cover of the almanac (fig.6), Kandinsky created a partly abstracted horse and rider, based upon German and Russian folk depictions of St. George, who was famous for his conversion of heathens to Christianity. Simplifying and veiling the image with the color blue was intended to suggest the sacred as well as to create a tension, a discord, which they hoped would lead the viewer to meditate upon the meaning of the image—salvation or transfiguration—and thus upon the meaning of the almanac itself.

Kandinsky and Marc wanted to prepare another edition of the almanac, which would include essays by scholars such as Worringer and Carl Einstein. But in 1914 they had a second printing made of the original edition. The editors wrote separate prefaces, mourning to some degree the lack of change in the public's response to them and their views. Nonetheless, they reiterated very clearly that their interest in breaking from past artistic conventions was not for the sake of creating new forms but for communicating a new vision. During the next ten years, numerous groups associated with Expressionism would echo their utopian fervor and their commitment to the unconventional.

Kandinsky and Marc, preface

A great era is beginning and by this time has begun: the spiritual "awakening," the emerging inclination to regain "lost balance," the inevitable necessity of spiritual cultivation, the unfolding of the first blossoms.

We are standing at the threshold of one of the greatest epochs that mankind has ever experienced, the epoch of Great Spirituality.

In the nineteenth century just ended, when the flowering—the "great victory"—of the material seemed most intense, the first "new" elements

of a spiritual atmosphere were formed almost unnoticed. They will give and have given the necessary nourishment for the flourishing of the Spiritual.

Art, literature, even "exact" science are turning in varying degrees toward this "new" era; they are all governed by it.

Our first and most important goal is to reflect artistic events directly connected with this change and the facts needed to shed light on these events, even in other fields of the spiritual life.

Therefore, the reader will find works in our series that bear an *inner* relationship to one another in the aforementioned context, although they may appear unrelated on the surface. We honor and attend, not to the work that has a certain recognized, orthodox, external form (which usually is all there is), but to the work that has an *inner* life connected with the great change. And that is only natural, since we don't want the dead but the living. Just as the echo of a living voice is only a hollow form, which has not arisen out of a distinct *inner necessity*, there have always been and will increasingly be works of art that are nothing but hollow reverberations of works rooted in such inner necessity. They are hollow, aimless lies that poison the spiritual air and lead wavering spirits astray. By deception they lead the spirit not to life but to death. And we want to try to expose the emptiness of this deception with all available means. This is our second goal.

It is only natural that in questions of art the artist is called upon to speak first. Therefore the contributors to our volumes will be primarily artists, who will now have the opportunity to say openly what they previously had to hide. We are therefore asking those artists who feel our goals inwardly to turn to us as *brethren*. We grant ourselves the use of this great word because we are convinced that in our case the authoritative usage will automatically disappear.

It is equally natural that the people for whom the artist essentially works, who are called laymen or the public and who as such have hardly any opportunity to speak, should have an opportunity to voice their feelings and their ideas about art. So we are ready to provide space for any serious remarks from this quarter. Even short and unsolicited contributions will be published in the "opinions" column.

Nor, in the present situation of the arts, can we leave the link between the artist and the public in the hands of others. This is criticism which harbors something unhealthy. Because of the growth of the daily press, many disreputable elements have crept in among the serious interpreters; with their empty words they are building a wall in front of the public instead of a bridge. In order that not only the artist but also the public gets to see the distorted face of contemporary art criticism in a strong

light, we will devote one special column to this regrettable, damaging force.

Since our works occur at irregular intervals, and life events cannot be arranged according to human schema, our series will not appear at fixed times but rather spontaneously, whenever there is enough important material.

It should really be unnecessary to emphasize that in our case the principle of internationalism is the only one possible. However, in these times even this must be noted: that an individual nation is only one of the creators of the whole; alone one can never be seen as the whole. Like the personal, the national is automatically reflected in each great work. But in the final analysis this national coloration is of secondary importance. The whole work, called art, knows no borders or nations, only humanity.

The Editors:
Kandinsky, Franz Marc

Marc, subscription prospectus

Today art is moving in a direction toward which our fathers would never even have dreamed. One stands before the new works as in a dream and hears the horsemen of the Apocalypse in the air. An artistic tension is felt all over Europe. Everywhere new artists are greeting each other; a look, a handshake is enough for them to understand each other!

We know that the ideas underlying what is felt and created today have existed before us, and we are emphasizing that in *essence* they are not new. But the fact must be proclaimed that everywhere in Europe new forms are sprouting like a beautiful anomalous seed, and all the places where new things are occurring must be pointed out.

The idea of the *Blaue Reiter* grew out of the awareness of this secret relationship between all new artistic production. It should be the call that summons all artists of the new era and rouses the laymen to hear. The books of the *Blaue Reiter* are written and edited exclusively by artists. We are now announcing the first book, which includes the latest movements in French, German, and Russian painting and will be followed at indefinite intervals by others. It reveals its subtle connections with Gothic and primitive art, with Africa and the vast Orient, with the highly expressive, spontaneous folk and children's art, and especially with the most recent musical movements in Europe and the new ideas for the theater of our time.

13. Franz Marc, letter to Reinhard Piper, April 20, 1910, and to Wassily Kandinsky, October 5, 1912*

Marc's death in 1916 at the age of thirty-six, a year and half after World War I began, gave his works mythic proportions in the context of Expressionism. Although he did not publish as widely as Kandinsky, he thought of himself as a philosopher and theologian as well as a painter and in his essays and letters took great pains to explain the new direction that painting had taken in Europe. An internationalist, he wrote to Kandinsky, from the front, that he felt more European than German and was saddened by the nationalism that war resurrected.[59]

The Marc–Kandinsky friendship was unusual in the degree of support and encouragement the men gave each other. For Marc, the paintings of Kandinsky reawakened his interest in the symbolic use of color with which he had been struggling since his 1907 trip to Paris. Marc vividly acknowledged his debt to Kandinsky, calling him "the only true prophetic voice."[60] For Kandinsky, Marc meant not only recognition from a young German artist but also someone who labored to promote his works in Germany. Through Marc he met August Macke and Macke's uncle, Bernhard Kohler, whose financial support was crucial for the *Blaue Reiter*. Marc's contact with the publisher Reinhard Piper was also important for the almanac and for the publication of Kandinsky's *On the Spiritual in Art* as well.[61]

Marc had met Piper in 1909 when the publisher purchased one of his lithographs from his first one-man exhibition at the Brakl Gallery in Munich. As his support for the publication *The Struggle for Art* testifies, Piper was committed to international modernism, which Marc described in the letter included here as the attempt to depict the "organic rhythm of all things." In this particular letter, Marc asserted that he wanted to communicate the primal basic force that connects animals with the universe. To avoid both the sentimental and the particular, he advised simplification of forms, repetition of lines, and intensification of color. Like Kandinsky,

*Franz Marc letter to Reinhard Piper, April 20, 1910; reprinted in Reinhard Piper, *Briefwechsel mit Autoren und Künstlern, 1903–1953* (Munich: R. Piper & Co. Verlag, 1979), 29–30; © R. Piper & Co. Verlag, München 1979. Franz Marc letter to W. Kandinsky, Oct. 5, 1912; reprinted in *Wassily Kandinsky/ Franz Marc Briefwechsel*, ed. Klaus Lankheit (Munich: R. Piper & Co. Verlag, 1983) no. 137, p. 193–94. © R. Piper & Co. Verlag, München 1983.

Marc viewed the world as one filled with apocalyptic tensions between material, commercial forces and purified, spiritual ones.[62] Animals were a sign of innocence, a Rousseauian image of the primeval, a Nietzschean prerational force. By 1914 the sense of timelessness that had led him to animals was moving him toward abstraction.[63]

Sindelsdorf, IV.20.10.

Dear Mr. Piper,

Perhaps you may think that it must be very easy for me to state what is the "characteristic of my artistic activities. . . ." I will make an attempt and where the concepts fail, "words" will have to come to the rescue.

My goals are not in line with animal painting per se. I am looking for a good, clean, and light style which will completely absorb at least part of what we modern painters want to say. And that would perhaps be a feeling for the organic rhythm of all things, it would be a pantheistic penetration into the pulsating flow of blood in nature, in trees, in animals, in the atmosphere. . . . It is the making of a "picture" with new movements and with colors that defy the old easel painting. In France this theme has been studied for more than half a century. A straight line leads from Delacroix and Millet by way of Degas and Cézanne to van Gogh and the Pointillists; the younger Frenchmen are engaged in a wonderful race toward this goal. Strangely enough they very carefully avoid the most natural model for this art: **the animal picture**. I cannot find a more suitable means for the "**animalization** of art" than the animal picture. This is why I seize it. What we aim for could be called an animalization of the experience of art; with a van Gogh or a Signac everything has become animalistic, the air, even the boat resting on the water and above all, the painting itself: these pictures no longer resemble what used to be called "pictures." My sculpture is a tentative effort in the same direction. The circulation of blood in the bodies of both horses is expressed through the diverse parallelisms and oscillations of the lines. The viewer should not be able to ask about the "type of horse" but should feel instead the inner, pulsing life of the animal. I have intentionally tried to remove any indication as to type and breed from these horses. Therefore, for example, the vigorous proportions of the limbs are somewhat unhorselike.

Perhaps you will succeed in paring this scribble down to something that will express my vague ideas more precisely. After all, these ideas torment me much less than it may seem from this letter.

I think the reproduction is very good. Would it be unseemly to ask you to send a few copies to me separately at the time of printing? I would be very grateful for them since I do not have the original plate of the photo.

I am very curious to see your text!

Best regards from

yours sincerely,
Fz. Marc

Please give my best to Mr. Hammelman and thanks for sending the letter.

Bonn, October 5, 1912[64]

Dear Kandinsky,

We have now safely returned from our trip to Paris. Besides the very deep impressions which I took with me from museums (e.g. Trocadero, African sculptures) and private collections, our fondest memories are of the lovely evening at Mrs. Epstein's[65] in Montmorency and an evening at Delaunay's. . . .

Delaunay interested me intensely. He is a Frenchman through and through, but open and clever. It disturbs him to know his large Tour Eiffel is at Kohler's; he does not want to exhibit single pieces; for him these pictures are something false that he has totally overcome; he strives to work his way through to truly structural pictures; pictures free of any concern for objects, one could say purely tonal fugues. It seems to me, however, that he still relies too much on complimentary colors and prismatic effect; but his things undoubtedly show talent and (he) is full of great aspiration,—in contrast to the Cubist room of the Salon d'Automne, which I find dreadful, pedantic and superficial and totally idiotic; including Le Fauconnier.

We were in the Salon before the meeting and had no idea that the large picture was his. Later he arrived and dragged me to it; I didn't understand anything; whereupon he began to explain (not about painting, mind you, nothing of the sort) but: "look at the bears, on the left then over there the mountaineers who are shooting,—here, a child—do you see it? And another bear, there, in the corner,—do you see, his paw etc." I didn't say much but I was as furious as I was sad. Le Fauconnier gave me the impression of a tired, vain man without ability. I still like his earlier works (now he has turned to *color*), only I do feel this wilting fatigue in them that seems to represent his whole person. Now I believe that I know how these pictures could come into being.

I have already written to you about Picasso, I believe. To me, his latest works are purely impressionistic, i.e., not a trace of inner structure, but a

refined surface, observed exactly and precisely naturalistically in Parisian streets and cafes; an art of mirrors and prisms, showcase windows where light refracts on the glass, and on top of that, the telephone numbers and company letters which are glued to the showcase. In Cologne Picasso seemed more serious, more mysterious, especially because of his earlier works and his pyramidal constructions (l'homme a la mond [sic] . . .). He personally seems to attach great value to the fact that one can "read" his pictures, i.e. that one sees where the mustache and where the drawer etc. is. But in one area he excels above all others: his *painterly skill*. That means a lot in Paris these days. Braque, basically, is more structural, tries to be at least, as I see it, but he is a deadly bore as a painter.

Enough for now, more some other time. We will be back in Sindeldorf in the middle of October. Have a good trip. Hopefully you will find more in Russia than I did in Paris. Best regards from all of us.

<div style="text-align:right">

Yours
F. Marc

</div>

14. Paul Klee, "Exhibition of the Modern League in the Zurich Kunsthaus," *Die Alpen*, 1912*

Born in Switzerland, Klee (1879–1940) began studying art in Munich in 1899 and settled there in 1906. Kubin was the first to admire his works; he met Kandinsky in the fall of 1911,[66] and became an associate of the Blaue Reiter soon after. By 1913 his drawings began to appear in Der Sturm (fig. 7).

The Modern League, formed in October 1911, included Klee and the Swiss artists Walter Helbig and Oscar Luthey, and the Alsatian Hans Arp, who like Klee became an associate of the Blaue Reiter. The second exhibition of the League in Zurich in July 1912 followed the internationalism of the Blaue Reiter and the Sonderbund in its choice of artists and point of view. In addition to the Swiss artists, members of the Blaue Reiter and the French painters—Matisse, Delaunay, and Le Fauconnier figured prominently in the exhibition.

The essay on the Modern League Exhibition reflects Klee's attempt to clarify for his native countrymen the basic tenets of modernism, which he called Expressionism.[67] He praised Expressionism's multi-

*Paul Klee, "Die Ausstellung des Modernen Bundes im Kunsthaus Zurich," *Die Alpen* 6, no. 12 (August 1912): 696–704. esp. pp. 696–701.

ple directions and described Cubism as a branch of Expressionism, a concept that became increasingly accepted in Germany during the war years. Klee also discussed the impact of children's art on Matisse and Münter. His comments on the enriching power of children's art, which he described as a return to the elemental, are expanded in other essays. In his diary Klee praised not only children's art but also the art of the mentally ill, finding in both forms freed from "corruption"[68] that could be used in the reform of contemporary art. His views had special significance for Hugo Ball and others who were to transfer Expressionistic concepts of synthesis of the arts and primitivism into the mystique of Dada.

. . . .

The Modern League is an organization of Swiss artists who seek to express their personalities in a recently vastly expanded field of art, namely the field of Expressionism. As far as can be seen from their work, they are not now pioneering geniuses but simple members of a movement that originated in Paris and is already quite widespread. They have adopted ideas, tried them out on themselves, and found the results to be worth presenting publicly. . . . The movement was not only initiated, but also firmly grounded by a number of important artists such as Cézanne, van Gogh, Gauguin, Matisse, Picasso, Braque and others. The Zurich exhibition is therefore not an experiment to shake up our quiet Swiss citizens but an acknowledgment of what had already been accomplished elsewhere. . . . The Modern League succeeded in securing from Paris a wonderful selection of Matisse, Le Fauconnier, and Delaunay and in receiving from Munich a noteworthy collection of the "Blaue Reiter." After such a decisive beginning has been made, one should, at least in Zurich, summon up the courage to have other exhibitions follow this one.

. . . .

A major consequence of the Expressionist creed has been the emphasis on the structural, namely the elevation of structure to an expressive means. Impressionism, at its most characteristic, no longer even recognized structure. It simply reproduced phenomena of a colorful outer world according to the temperment of the artist with one or another emphasis. In earlier epochs, on the other hand, structure, was more than just an aid, it was the definitive thing.

The reworking of representations is also bound up with a return to painting from memory. . . . Nevertheless, representation removed from nature becomes the norm and structure gains significance even as a technical aid. . . .

Cubism is a special branch of Expressionism. This school for philosophers of form, for speculative natures among artists, had to suffer particularly under the misconceptions of the critics. And yet to think of forms in terms of measurements expressible by numbers is not entirely new. . . . The Cubists fixed these measurements very definitely and in detail, some more with flat measurement, like Le Fauconnier, others with the measure of light and color like Delaunay. If after this process, a picture looks like a crystallization or like a combination of cut stones, it is not a frivolous matter; it is the natural consequence of formal cubistic thinking, consisting of the reduction of all proportions and leading to primitive formal projections such as the triangle, the square, and the circle.

For landscape Cubism has probably already found an appreciative audience, while figure painting does not seem to be able to escape ridicule. I am mentioning this because I for one am disturbed by certain incongruities but above all I want to explain the justification of the ultimate step, namely the elimination of the object. Pure landscape can indeed tolerate more—and also less—if for example the proportions of the things in it are simplified first, reperceived, then rethought in relationship to their fixed size on the retina. The result remains nevertheless a landscape. Animals and human beings who are there in order to live lose their viability with every revision. Or, even, when they have to be fit into a heterogenous pictorial organism, or—as in Picasso—cut up into individual motifs and then placed according to pictorial requirements. Destruction for the sake of construction? Indifference toward the object and at the same time a promotion of it by means of flagrantly intrusive painting? The problem of this incongruity has been solved in an amazingly simple manner by Delaunay, whose labors addressed this aspect in particular. This artist, one of the most intellectual of our time, has created the model of an independent picture, one that can lead an abstract existence of form without taking its motif from nature. It is a being with a plastic life, be it noted, almost as far removed from a carpet as from a fugue of Bach. The *View from the Window*, second motif, first part, a closely related link to this last creative period of Delaunay, was seen in Zurich.

I have dealt with the Cubist approach to eliminating the object first because it seemed most plausible to me in spite of the fact that the other, non-cubistic Expressionist approach appeared somewhat earlier. Kandinsky, although never especially disposed to the forms of the living world, yet without the logical compulsion and inhibitions of the refined Frenchman described above, arrived essentially at the same result by means of a powerful instinct and a passionate drive for freedom. . . . His works are his thought's children, who resemble one another. Free forms, best suited for creativity, reach out for each other. There is great wealth and he has no need to skimp. Form meets form, constructive ideas link up but do

not dominate. There is nothing despotic, there is freedom to breathe. And yet they are thoroughly national works of a true child of his people.

What I have written has been dictated by my conviction about the rights of such personalities to assert themselves in their quest for their cubistic or otherwise radical beliefs. It could not be further from my mind to extend this last conclusion to other individuals. Art is not a science, furthered step by step by many actively researching participants; it is, in contrast, a world of variations. Each personality in command of the expressive forms in its purview is of value here. Only the weak one, who learns from others instead of from himself, will have to step back. Modernity facilitates individuality, since in new areas, even repetitions can become new forms for the self. We cannot talk of weakness here with so many gathered in one place, since everyone feels the drive to become one's own distinctive self.

Matisse was at one time a moderate Impressionist, parallel to van Gogh. As an Impressionist he could have quietly pleased many a patron without, however, ever gaining a wider following for himself. Suddenly, though, he was there as a new and strong entity. Equipped with the achievements of Impressionism, he now turned far back to the childlike phases of art and gained access to extraordinary effects. . . . Similar moderation is being practiced by Munich's **Marc**, who has taken a sudden leap into the new style from an Impressionism for which he was not particularly suited. His present progress from softer to harsher forms is very promising. The Modern League is showing two characteristic examples of these two approaches. **Gabriele Münter**'s work sometimes directly recalls children's art. In this approach, she also has found the appropriate expression of her personality. . . .

IV. DER STURM

INTRODUCTION

The journal *Der Sturm* stands out as the major disseminator of Expressionist art in Germany. Although more than fifty journals supported various aspects of the new art and literature between 1912 and 1922,[69] only one other journal *Die Aktion* (1911–32),[70] came close to *Der Sturm* in its longevity and continued support of artists and writers associated with Expressionism.[71] But *Der Sturm* was more than a journal; it was also a gallery, a publishing company, and an art school.[72] Through an extremely active schedule of traveling exhibitions, which began as a commemoration of the hundredth issue of the magazine in March 1912, Sturm spread the spirit of international modernism across Germany, continuing transnational displays during the war years and into the twenties. Beginning in September 1916, recitals and lectures called "Sturm-art evenings" were scheduled weekly at the Sturm Gallery in Berlin, and early in 1917 a "Sturm-school" was established. Artists associated with the Sturm circle such as Kandinsky, Klee, Lyonel Feininger, George Muche, and Lothar Schreyer provided Walter Gropius with many of his first appointments for the Bauhaus.

The journal was founded in 1910 by the multitalented Herwarth Walden (fig. 8), and it was the first to reproduce, discuss, and defend works by Oskar Kokoschka, the Brücke artists, and the Blaue Reiter. The journal and, after 1912, the gallery, introduced into Germany the Italian Futurists, as well as major and minor Fauvists and Cubists from France, Russia, and various parts of the Austro-Hungarian empire. During the war years, Walden represented Feininger, Chagall, Léger, and Arp and after the war, Archipenko, Schwitters, and Moholy-Nagy. Among the journal's major literary contributors were Else Lasker-Schüler (Walden's first wife), Karl Kraus, Paul Scheerbart, Alfred Döblin, August Stramm, and Walter Mehring.

As its name indicates *Der Sturm* (storm, struggle) was founded in oppo-

sition to the conventional values of the Wilhelmine empire. It envisioned international modernist culture as an antidote to the repressive philistinism of Wilhelmine Germany. But unlike *Die Aktion*, whose name indicates a similar commitment to engagement, *Der Sturm* did not take a clear-cut stand on the war or the November Revolution. In 1919 Walden's evangelical zeal became channeled toward political as well as literary and artistic activity.[73] As Expressionism lost its primacy in artistic matters, the gallery lost many of its well-known artists, the size of the journal was reduced, as was its list of contributors, and it more and more became an organ for Walden's personal interpretation of communism. The journal ceased publication when Walden emigrated to the Soviet Union in 1932.

15. Herwarth Walden, "Introduction," *First German Autumn Salon*, 1913, and letter from August Macke, April 21, 1913*

Herwarth Walden (1878–1941), the energetic publisher of *Der Sturm* and the founder of its gallery, was committed to the concept of culture as a moral force, as a potential transformer of values. Born Georg Lewin in Berlin and trained as a musician, Walden adopted his pseudonym around the turn of the century. In 1904, with the formation of the Association for Art (Verein für Kunst) dedicated to exposing new literature and music to a wider public, he began to establish a reputation as an impresario.[74] Walden became an aggressive proselytizer for the visual arts with the founding of *Der Sturm*.[75] Writing under another pseudonym—Trust, he pointed to the new art's international heritage in the works of Gauguin, van Gogh, Hodler, and Munch[76] and published several defenses of Expressionism that have since attained classic status.[77] During the war, Walden increasingly used the term "Expressionism" in gallery catalogues as a synonym for modernism.

The First German Autumn Salon represents a high point in the introduction of international modernism to Germany. Organized with the help of August Macke (whose letter to Walden about this exhibition is included here) and others from the Blaue Reiter circle,

*Herwarth Walden, "Vorrede," *Erster Deutscher Herbstsalon* (Berlin: Der Sturm, 1913), 5–8; letter from August Macke, Walden estate, *Staatsbibliothek Preussischer Kulturbesitz*, Berlin.

Walden took the name for his exhibition from the Paris Salon d'Automne. Although many of the artists had participated in the Cologne Sonderbund, the introduction of new artists from Italy, Russia, and France testifies to Walden's desire to represent creative forces emerging in all parts of Europe.[78] For Walden, originality and innovation were the signs of greatness since he equated conventional art—imitative of past painting or of nature—with the conformity and repression of the Wilhelmine system of government.

This first German Autumn Salon gives an overview of the new movement in the visual arts of all countries. At the same time, this overview will expand the horizons of contemporary viewers. Most of today's viewers are too proud of their eyes, with which they have not yet learned how to see. They demand that the artwork reproduce their own optical impressions, which are not even their own. If they had that sensibility, they would be artists already. Being an artist means to have one's own point of view and to be able to give it form. The unity of viewpoint and form is the essence of art, it is art. The great innovators of the nineteenth century left a twofold heritage, a material one which went to their heirs who anxiously held onto it, and a spiritual one, which is shown at this exhibition. The heirs of the former cling to forms which were created by greater artists. Instead of creating their own, they imitate the forms of past paintings. In fact they imitate just the paintings, not even nature, which has been called upon so pitifully often. Imitation can never be art, whether it is of pictures or of nature. This ability to ape others is missing from the artists of the present, who have assumed the spiritual heritage of the great innovators. The talk is about the lack of form, but it should be about the lack of uniformity. All of us are human, but not one body resembles the next one. Sameness is achieved only through a uniform. One stays himself even if fashion changes the uniform. Even changing back to Biedermeier skirts, Roman togas, or Greek pleated dresses does not change anything about the body. Only the spirit, which the body serves, can change it. Of course, spirit cannot be painted, but painting the body without spirit is really no art at all. Art is the personal shaping of a personal experience. The only thing that binds the artist and gives him support is the material of his art. Every conventional form, however, is a scaffold for a collapsing building or a corset for a sagging body. Art is presentation, and not representation. To enjoy a precious fruit the skin has to be sacrificed. Even the most beautiful surface cannot disguise the internal superficiality. The painter paints whatever he sees with his inner-

most senses, the expression of his being; everything fleeting is only a metaphor to him; his instrument is life; every impression from the outside to him becomes an expression from the inside. He is the carrier of his visions and he is carried by them, his inner apparitions. Can he help it when faces look different? Did the Ninth Symphony resound out toward Beethoven from the most beautiful landscape? Did his rhythm march out before him? But he did let human armies storm, win, or fall according to his will. Grünewald and Greco reshaped humanity after their paintings. The school of painting just passed set humanity up in costume balls. The artist was no longer educated, but was taught instead. The true artist has to be the creator of his forms. And all educated people should finally decide to look up from the passivity of education to the activity of painting.

I feel I have the right to hold this exhibit because I am persuaded of the value of the artists represented here. Because I am a personal friend of the most important artists of this new movement, through a friendship arising from similar artistic ideas and sensitivities. This international exhibition became a physical reality thanks to the material support and actual service of a true artistic friend of this movement. This is not the place to critically-analytically justify in detail my conviction about the value of those represented. That occasion will come during the exhibition through lectures and guided tours. True connoisseurs have promised me their support in this. I am sure that the nonartistic part of the public is going to laugh at this exhibit and at me. And also a good part of the public that regards itself as artistic, without justification. I especially want to warn these people. After ten years of the Society for Art, we already have a precedent in literature. These gentlemen and also the mediocre critics made fun of Thomas Mann, Alfred Mombert, Karl Kraus, and Else Lasker-Schüler. The artistic importance of these writers has been confirmed after only ten years or less, even by the most harmless daily newspapers, which, of course, does not mean anything, either for the artists or the papers. I am naming here only the most important names that were first brought to the larger public through the Society for Art. But there are already precedents in fine arts as well. When Oskar Kokoschka's prints were shown in every issue of the first year of the magazine *Der Sturm*, the connoisseurs laughed, and even the worthy art critic, who now no longer knows where we are going, made fun of the scrawlings. Today, after three years, everybody scrambles for the prints that were ridiculed. Even now naive people maintain that painters today paint "in this manner" for business reasons, and that *Der Sturm* represented these painters for business reasons and not from artistic conviction. I gave one of these gentlemen—a critic—occasion to bring the evidence he proffered into a court of law. He wants to prove nothing less than that Kandinsky has

joined this futuristic direction in art only out of business considerations. With such madness, hatred of art has gone too far. But such things cannot divert or hinder my friends and myself in our strivings.

We do not live for art. But art is our life.

Letter from August Macke to Walden

Bonn, April 21, 1913

Dear Mr. Walden,

It's really a shame that the Berliners don't cooperate. After all, for whom should one consider oneself an artist when artists fall so deplorably for something which they have earlier so much despised? In any case I am rather fed up with "cooperation."

Munch wrote an extremely nice letter saying that he would like *very* much to exhibit together with us but that he is unfortunately already committed to the Secession where he shows his large ornamentations. Does Nolde not exhibit in Berlin on principle? I would like to write him but don't have his address. Please send it to me. I'll give Heckel, however, a piece of my mind.

. . . .

I noted down the following names. Please let me know who will not participate, or rather check[79] those who are certain. I would like to know whether this is correct. We can only rely on the painter's direct acceptance.

Heckel	Kirchner	X Metzinger	X Werefkin
Nolde ?	Kubista	X Campendonk	Derain
Pechstein	Schmidt-Rottluff	X Helbig	Filla
X Kandinsky	X Bechtejeff	X Klein	X Bloch
X Marc	X Le Fauconnier	X Melzer	X Bolz
		X Morgner	X Mogilewsky
X Picasso	Jawlensky	Müller	Duchamp
X Matisse	Braque	X Richter	X Kïlschbach
X Huber	X Laurencin	X Segal	Rohlfs
Thorn-Prikker	X Nauen	X Tappert	X Lüthy
X Kokoschka	X Macke	X Bossi	X Arp
Munch	X Leger	X Erbsloh	X Turnow
		X Kanold	X H. Macke
X Delaunay	X Gleizes	X Münter	X Mense
X Klee	X W. Burljuk	Korns	X Brankousi

X D. Burljuk	X Soller	X Archipenko	Floris-Verster
X Steinhardt	Meidner	X Epstein	X Kubin
Kogan	X Ginni	X Carra	X Boccioni
			X Rousseau

I wrote to those who are underlined and am waiting for their answer. Cassirer wrote three long letters. You see how he works. That's all. Greetings to both of you.

Your,
August Macke

16. Adolf Behne, "German Expressionists, Lecture for the Opening of the New Sturm Exhibition," *Der Sturm*, 1914*

Shortly after Adolf Behne (1885–1948) received his Ph.D. in 1912 from the University of Berlin, where he studied with Heinrich Wölfflin and Adolf Goldschmidt, he began to write art and architectural criticism for *Der Sturm*. One of his first essays was on the architect Bruno Taut, whom he had known since 1904 when both were part of a circle of intellectuals and artists living in a communal retreat outside of Berlin.[80]

The article included here was given initially as a lecture for the opening of a Sturm gallery exhibition, which included members of the Blaue Reiter as well as Kokoschka. Behne, who is better known for his work as membership secretary for the short-lived Arbeitsrat für Kunst (Working Council for Art, 1918–21), was at the time of the essay, clearly knowledgeable about Expressionist painting and poetry.[81] In the essay, Behne not only referred to the familiar polarization of Expressionism vs. Impressionism, but he also attempted to expand on the association of Expressionism with the German Gothic.

As a socialist committed to international cooperation and understanding, Behne took great pains to include Cubism and Futurism as part of Expressionism. In his article Behne explained that Cubism, like Expressionism, had a "mystical" foundation and its crystalliza-

*Adolf Behne, "Deutsche Expressionisten: Vortrag zur Eröffnung der neuen Sturm-Ausstellung," *Der Sturm* 5, no. 17–18 (December 1914): 114–15.

tion of form was emulated by many Expressionists. Instead of writing from a nationalistic point of view that Expressionism was superior to Cubism and Futurism, Behne viewed all three in unison as opposed to the specificity and rigidity of Impressionism. By including Cubism and Futurism as part of Expressionism, Behne contributed to broadening the stylistic possibilities of modernism in Germany.

Ladies and Gentlemen!

At the request of the organizer, I will guide you through this exhibition which is called "German Expressionists." There is no need to say much about the concept "German." Only this: with regard to the painters represented here, such as Campendonk, Franz Marc, and Kokoschka, it is best to think not so much of Ludwig Knaus and Paul Thumann who, of course, are also German-born; rather think of the painters of our Gothic, perhaps the creator of the Strasbourg glass windows, of the masters of Cologne or Westphalia or, to name a great spiritual relative of a later time, of Mathias Grünewald. German—here it does not mean pseudo-Gothic style, sentimental poetry, and saccharine painting, but passion in presentation, urgency of imagination, the sovereignty of the spirit.

The artists of our time do not see their models for creative work in those early masters. Not a trace of archaism is to be found in their art. Nevertheless they recognize in the Gothics their rightful ancestors. What unites them is their love of expression. Nothing else is meant by "Expressionism." The builders, the sculptors, the painters, and the draftsmen of the Gothic were Expressionists, as were the Egyptians and the Greeks of preclassic times. Expressionist art, which some are fond of burdening with the stigma of seasonal faddishness, is in reality the reawakening of those inclinations that have always prevailed in art's happiest times. If the love for the Gothic—professed in such suspicious haste by so many today—were authentic, then Marc, Kokoschka, Heemskerck, and Mense would have reaped long ago the honors to which they are entitled.

But why are these pictures so strange? Because these painters treat art with gravity and precision. Because they have finally once again set priorities for their creative work according to artistic concerns, instead of scientific, literary, or commercial concerns. This has been faulted as pure formalism and bloodless estheticism. However, that is not the issue at all. Expressionism knows no form which is without spirit, without expression. Here, form is in the service of expression. But this expression should be a purely artistic one—the purer the better! Whoever is afraid that absolute purity of artistic expression will make a work sterile reveals that

he had previously appreciated in art only what was non-art—obscurities and filler.

Expressionism has finally once again made artistic concerns the focus of creative production. What that means becomes clear when we compare an Impressionist work with a modern one in our minds, since Impressionism is the prototype of an art that has lost its focus.

Every work of art worthy of the name is an organism. An inorganic work of art is a contradiction in terms. To produce a thing organically is the essence of artistic creation and the capacity for getting spiritual things to grow organically is what ultimately separates the artist from the non-artist. The true work of art is something that has grown and developed. The phrase of the biologist Uexküll: "Only machines are made but organisms evolve," also applies to art. Therefore it is the first responsibility of the artist to exclude from the creative process anything that could impede the growth of colors, forms, and lines.

. . . .

Two things are part of the organic principle: purposefulness in regard to a certain goal, lively activity of interrelated functions. We have recognized the goal of the Expressionist picture is the expression of an experience. The Impressionist was satisfied with the impression, with the surface, the appearance. The Expressionist wants the spiritual quintessence of an experience. For those artists represented here, Cubism is the means to achieve it.

Cubism, although it has the reputation of being a cold intellectual methodology, in reality emerges from feeling and aims exclusively at satisfying the demands of feeling. Not of course the sense as to whether a particular section of canvas represents satin or wool, but the feeling for the profound relationship of things, a cosmic world feeling. Cubism is not self-serving. The painter, the sculptor, the architect is not a Cubist for Cubism's sake, but only because certain things can be said only in that language.

What led to the formation of this language was the desire to give the picture the kind of functional life that necessarily belongs to the nature of a true organism. The Impressionist picture, torn out and isolated, was rigid. The Expressionist picture, a living cosmos, and therefore imbedded in everything cosmic, takes part in the universal flux of the world. Therefore its forms are not rigid but fluid. The form does not appear, complete, before me, but grows and evolves. Obviously, this art has no room for perfect objects. What a sign of poverty it would be for modern art if it remained bound to objects even after our thinkers have recognized that thinking in terms of objects is useless for any kind of deeper reflection.

The Cubist can only give his forms a sense of transformation, a functional life, by giving multiple meanings to separate elements of form. In the Impressionist picture every single item was something specific: tree

trunk, foliage, walls, cloud, etc. Hence the rigidity. If the Cubist wants to let the form **evolve**, then he cannot close it off; he has to let it move out, flow out from the whole. . . . Wisely, the expression Cubism means only that for the modern painter certain elements present themselves for the construction of forms which, because of their remotely geometric character, permit the crystallization of expression. Therefore Cubism is no more a geometric science than Pythagorism was a method of calculation. Cubism, like Pythagorism has **mystical** underpinnings.

The presence of the Futurist picture gives us the opportunity to become acquainted with the origin of Cubism's language of form. It is obvious that the impetus to the creation of this language was a feeling. The Futurist wanted to transmit the strongest possible expression of life, its variety, its endlessness, its intensity, and the richness of its relationships. As a result out of inner necessity, he achieved an ambiguity of form in which for him only a small amount of materialism remained.

So let us summarize: Expressionism designates the goal. Modern art wants to be an art of expression. Cubism is the language used by many, not all, Expressionists. Futurism is a name for streams of feeling which have played the role of catalyst.

Now, however, I no longer want to stand in the way of your enjoyment of the individual pictures.

17. [Rudolf Blümner], from *Der Sturm: An Introduction*, 1917*

Although unsigned, this booklet is recognized as the work of Rudolf Blümner (1873–1946), a lawyer turned actor, who was the only person besides Walden involved with *Der Sturm* for its entire existence.[82] Like Walden, whom he met in 1905, Blümner was a product of the utopian-minded intellectual life in Berlin at the turn of the century.[83] His artistic specialty was poetry and recitation, and he used his theatrical experience—emphasizing tonal inflection, rhythmic cadence, and physical gesture—to present the poetry of Lasker-Schüler, August Stramm, Walden, and others at Sturm-sponsored evenings.

In the booklet, Blümner asserted Sturm's preeminence among Expressionist journals and galleries and stressed Sturm's understand-

*[R. Blümner], "Einführung," "Die expressionistische Malerei," "Kunst Der Sturm," *Der Sturm: Einführung*, Berlin [1917], 1, 4–5, 10.

ing of Expressionism as international and transhistorical. Given the competition between *Der Sturm* and *Die Aktion*, the publication of this brochure during 1917, the one year *Die Aktion* attempted to establish an art gallery and a bookstore, cannot be coincidental.

Introduction

In the course of recent years Expressionist art has met with growing interest and understanding. Even those who once turned away from this new art with great vehemence are beginning to recognize that it owes its origin and its strength to a longing inherent in our time.

A consequence of the spread of Expressionist art has been that more and more artists and artworks which actually have nothing to do with Expressionism are thought to be, or are presented as, expressionistic. Most of all, art criticism has so far failed to comprehend clearly the essence and significance of Expressionism and to exclude from it all those who are imitative and derivative or even those who are working in the styles of the past decades.

In view of the obvious attempts of some literary and artistic groups to lay claim unjustifiably to the name Expressionism, and in the interest of simply distinguishing between artistic values and artistic development, it is important to indicate **that all artists significant for Expressionism have one thing in common. That is "Der Sturm."**

Expressionist Painting

The painters of Sturm are not an association or a group that paints according to certain teachings or methods. They live and work separately and independently of each other. Historically, the simultaneous yearning for a new way of creating pictures developed in almost all parts of Germany and the rest of Europe and led toward a new for painting.

After Impressionism produced its last great masters in Cézanne, Hodler, and Munch, after Neo-Impressionism (Pointillism) made its futile attempt at further development, the struggle of independence from traditional painting began. Its leaders were the Futurists and Cubists.

The Futurists are a group of Italian painters, whose most important representatives are Boccioni, Severini, Carrà. Their efforts were directed at painting the object not as a stationary object but as a moving one. Furthermore, they did not see the function of painting as the reproduction

of the object, but they envisioned it as producing a painterly surface of color and form relationships, to which the object must subordinate itself.

The Cubists have taken this understanding so far that they have reduced the object almost past the point of recognition. Above all, they gave up spatial illusion and depicted pure, physical surface. By doing this, they rejected three-dimensional representation, the superficial technique of illusionary perspective, and the concept of fore-and background. The most important representatives of Cubism are the French artists Metzinger and Gleizes, Léger, and Delaunay.

Expressionist painting has come to the liberating conclusion that painting can totally relinquish the representation of the object and paint only colors and forms. Thus painting becomes the equivalent of music, which does not portray anything either, but produces its effects with tones and rhythm. The most important representative of this absolute painting is Kandinsky. Independent of him, Georg Muche, Rudolf Bauer, and Nell Walden are among the younger artists who turned to this absolute painting on their own. It is erroneous, though, to think that Expressionist painting is defined by the missing object. The painted object merely has to subordinate itself to painterly principles. The picture should not captivate the viewer (as in earlier painting) through the subterfuge of concrete concepts but through expressive means of painterly color and form. Besides Franz Marc, Campendonk, Klee, and other artists, above all Marc Chagall, have, by devaluing the objects, created pictures that reveal the wealth of color-and form-relationships essential to absolute painting.

Carl Mense is the most important of the Sturm painters closely connected to Futurism. Jacoba van Heemskerck, Lyonel Feininger, and Fritz Stuckenberg form the strongest link to Cubism. Additional well-known Expressionists are Georg Schrimpf, Arnold Topp, Albert Bloch, Max Ernst, and Maria Uhden.

The art school—Sturm

The art school—Sturm—is for the education of the younger generation in all aspects of Expressionist art. It teaches art as formulation of personal experience. Above all it teaches the essence and technique of expressive means and it advocates independent work.

The art school—Sturm—teaches stage design, drama and public speaking, painting, poetry, and music. Unity of art requires knowledge of all the arts as well as integrated instruction, but differences in expressive means also require the school to separate into individual art departments.

The instructors are Lothar Schreyer for stage design, Rudolf Blümner

for drama and public speaking, Rudolf Bauer, Campendonk, Paul Klee, Jacoba van Heemskerck, Gabriele Münter for painting, and Herwarth Walden for poetry and music.

Lothar Schreyer will speak about Expressionist poetry and Expressionist theater in a series of public lectures.

Notes to Part One: Early Manifestations

1. [Lovis Corinth], "Vorwort," Katalog XXII Berliner Secession 1911, 11. For a survey of the use of the terms *Expressionisten* and *Expressionismus* in Germany, see Victor H. Miesel, "The Term Expressionism in the Visual Arts (1911–1920)," in *The Uses of History*, ed. Hayden White (Detroit: Wayne State University Press, 1968), 135–51, and also Marit Werenskiold, *The Concept of Expressionism: Origin and Metamorphoses* (Oslo: Universitetsforlaget, 1984).

2. Max Osborn, "Berliner Sezession, *Kunstchronik* 22, no. 25 (May 5, 1911): 386–90.

3. Walter Heymann, "Berliner Sezession, 1911," *Der Sturm* 2 (July 15, 1911): 543.

4. See, for example, Trust [Herwarth Walden], "Neue Sezession," *Der Sturm* 1 (October 1910): 255–56.

5. A. R. Schönlank [Max Raphael], "Die neue Malerei, Neue Sezession," *Der Sturm* 2, no. 58 (April 1911): 463.

6. Henri Matisse, "Notizen eines Malers," *Kunst und Künstler* 7 (May 1909): 335–47. For a discussion of the term *Ausdruckskunst* and its relationship to the acceptance of the term *Expressionismus* in Germany, see Ron Manheim, "Expressionismus—Zur Enstehung eines kunsthistorischen Stil-in Periodenbegriffes," *Zeitschrift für Kunstgeschichte* 1 (1986): 73–91.

7. Werenskiold, *The Concept of Expressionism*, 35–39, 215–17.

8. For a discussion of the varied directions the literature on German Expressionism has assumed, see Rose-Carol Washton Long, "Scholarship: Past, Present, and Future Directions," in *German Expressionist Prints and Drawings*, vol. 1 (Los Angeles: Los Angeles County Museum of Art, 1989), 183–205.

9. See Peter Paret, *The Berlin Secession, Modernism and its Enemies in Imperial Germany* (Cambridge: The Belknap Press, 1980), 182–99.

10. Paul Schultze Naumburg, who contributed a statement to *Ein Protest deutscher Künstler* (48–50), would in the twenties write a pseudoscientific diatribe against modernism providing a bizarre biological justification for the Nazi vilification of modern art; see document 81.

11. Wilhelm Worringer, *Abstraktion und Einfühlung*, 3d ed., reads "für den um neue Ausdrucksziele ringenden ausübenden Künstler." See also the English translation by Michael Bullock (Cleveland: World Publishing Co., 1967), xiv.

12. In this essay, Worringer defines "primitive" in general terms in opposition to the classical Renaissance tradition. However, in *Form and Gothic*, he offers a much more specific definition referring to primitive man as "before all experience, before all tradition and history"; see the authorized translation (New York: Schocken Books, 1964), 14.

13. For a discussion of Riegl's theories and their impact on Worringer, see Geoffrey Perkins, *Contemporary Theory of Expressionism* (Bern and Frankfurt: Verlag Herbert Lang, 1974), 32–39, 50–55.

14. Since the turn of the century, van Gogh had a special impact on German artists and critics, especially Meier-Graefe; see Carol M. Zemel, *The Formation of a Legend, Van Gogh Criticism, 1880–1920* (Ann Arbor, Mich.: UMI Research Press, 1980), 105–6, 108–19. See also Kenworth Moffett, *Meier-Graefe as Art Critic* (Munich: Prestel-Verlag, 1973), 27–28.

15. Although Walden cited Van Gogh, Hodler, and Munch, as well as Gauguin and Cézanne as sources for German modernism, he stressed their common heritage rather than identifying their national background; see Trust [Walden], "Neue Sezession," *Der Sturm* 1:255–56. However, in this essay as well as in his review of the Cologne Sonderbund, Schmidt emphasized van Gogh's Netherlandish heritage and also Munch's influence on the new directions; see "Internationale Ausstellung des Sonderbundes in Köln 1912," *Zeitschrift für bildende Kunst* 23, no. 10:229, 234.

16. Literally, "storm and stress," an idiom commonly used to refer to the tormented mood that pervaded Romantic literature.

17. For an introduction to Osthaus's interest in French "modernism," see Johann Heinrich Müller, "Die Kunstsammlungen des Folkwang 1900–1914," and Herta Hesse-Frielinghaus, "Ausstellung des Folkwang-Museums . . . , Hagen; 1902–1922," in *Der westdeutsche Impuls 1900–1914, Kunst und Umweltgestaltung im Industriegebiet, Die Folkwang-Idee des Karl Ernst Osthaus* (Hagen: Karl Ernst Osthaus Museum, 1984), 29–49, 49–61. See also Jill Lloyd, *German Expressionism: Primitivism and Modernity* (New Haven and London, Yale University Press, 1991), 8–12.

18. Reiche was at this time also director of the Barmen Museum in North Rhine Westphalia; see Hans Wille, "Der Barmen Kunstverein, die Ruhmeshalle und Richart Reiche," *Jahresbericht des Kunst-und Museumver-ein Wuppertal* 1961/62; and Gunter Aust, "Kunstvereine und Kunstmuseen in Barmen und Elberfeld," *Das von der Heydt-Museum in Wuppertal* (Recklinghausen: Aurel Bongers, 1977), 319–23.

19. Reviews of the 1911 exhibition in Germany singled out Picasso, van Dongen, Braque, and Derain as "expressionists"; see, for example, G. Howe, "Ausstellung des Düsseldorfer Sonderbundes," *Die Kunst für Alle* 26 (June 1911): 476. See also Gunter Aust, "Die Ausstellung des Sonderbundes 1912 in Köln," *Wallraf-Richartz Jahrbuch* 22 (1961): 276–79 and also Peter Selz, *German Expressionist Painting* (Berkeley: University of California Press, 1957), 1974 pb. ed., 240–49.

20. From France, Reiche included Picasso, Braque, Matisse, Derain, Denis, and Signac; from Austria—Schiele and Kokoschka; from Switzerland—Amiet. From the major German centers—Berlin, Munich, Dresden

and the Rhine region, Reiche included artists such as Kandinsky and Jawlensky, representing the Blaue Reiter and the Neue Künstler Vereinigung; all the Brücke artists; Tappert and Klein from the New Secession; and Nauen and Macke from the Rhine area.

21. Werenskiold, *The Concept of Expressionism*, 18–25.

22. The El Greco was from the collection of Bernhard Kohler, a major supporter of the Blaue Reiter; see Moffett, *Meier-Graefe as Art Critic*, 176.

23. Scheffler however did not regard the Brücke artists in a favorable light, but he called attention to their experiments with color in painting and to their prints; see K.S., "Berlin," *Kunst und Künstler* 8 (July 1910): 524–25.

24. See for example, Trust [Walden], "Neue Sezession," *Der Sturm* 1:255–56.

25. For a discussion of their initial plans, see Georg Reinhardt, *Die frühe Brücke, Beitrage zur Geschichte und zum Werk der Dresdner Künstlergruppe "Brücke" der Jahre 1905 bis 1908* (Berlin: Brücke-Archiv 9/10, 1977–78), esp. 18–24. Reinhold Heller suggests the Brücke was formed as early as 1903; see Reinhold Heller, "Brücke: Preliminary Observations," *Brücke: German Expressionist Prints from the Granvil and Marcia Specks Collection* (Evanston, Ill.: Mary and Leigh Block Gallery, Northwestern University, 1988), 4, 10–11.

26. Bleyl resigned from the Brücke in 1909. See Günter Krüger, *Fritz Bleyl. Beitrage zum Werden und Zusammenschluss der Künstlergruppe "Brücke,"* in Berlin, Brücke-Archiv 2, 1968–69, 27–53.

27. Reinhardt, 28–31; see also Donald E. Gordon, *Expressionism: Art and Idea* (New Haven and London: Yale University Press, 1987), 14–19, 22–23, 29–31, and in addition, Lloyd, . . . *Primitivism* . . . , 17–20.

28. See Reinhold Heller, "The City Is Dark," *Expressionism Reconsidered*, ed. Gertrud B. Pickvar and Karl E. Webb (Munich: Wilhelm Fink, 1979), 42ff.; Lloyd, . . . *Primitivism* . . . , 87–101, 130–59; and Charles W. Haxthausen, " 'A New Beauty': Ernst Ludwig Kirchner's Images of Berlin," *Berlin: Culture and Metropolis*, ed. Charles W. Haxthausen and Heidrun Suhr (Minneapolis: University of Minnesota Press, 1990): 58–94.

29. See Charles S. Kessler, "Sun Worship and Anxiety," *Magazine of Art*, November 1952, 304–12; Gordon, *Expressionism* . . . , 52–55; and Lloyd, . . . *Primitivism* . . . , 107–29.

30. Kirchner's perception that Nolde joined the Brücke in 1905 instead of the following year is one of numerous misinterpretations; see Lloyd, . . . *Primitivism* . . . , 23, and document 8, for an assessment of Heckel's objections.

31. Karlheinz Gabler, *E.L. Kirchner Dokumente: Fotos, Schriften, Briefe*, Museum der Stadt Aschaffenburg, 1980, 64. Gordon, "German Expressionism," in *"Primitivism" in 20th Century Art: Affinity of the Tribal and the*

Modern, vol. 2, New York, Museum of Modern Art, 1984, 371–74; and Lloyd, . . . *Primitivism* . . . , 21–38, 59–60.

32. Kirchner had studied with the Jugendstil artist Hermann Obrist in Munich in 1903.

33. For reproductions of the drawings from these sources inscribed on the letter, see Annemarie Dube-Heynig, *Ernst Ludwig Kirchner: Postkarten und Briefe an Erich Heckel im Altonaer Museum in Hamburg* (Cologne: DuMont Buchverlag, 1984), 79–81.

34. Paul Cassirer, art dealer and publisher, had a long-term involvement with the Berlin Secession; see Paret, *The Berlin Secession*, 76–78, 219–21, 230–31.

35. Schapire, who was a friend and supporter of Schmidt-Rottluff all her life, wrote a catalog of his prints, *Karl Schmidt-Rottluffs graphisches Werk bis 1923* (Berlin: Euphorion-Verlag, 1924).

36. Karlheinz Gabler listed 1912/13 as the period when the letters were written; see, Karlheinz Gabler, *Erich Heckel: Zeichnungen, Aquarelle, Dokumente* (Stuttgart and Zurich: Belser Verlag, 1983), 109–15. Four of the five letters reprinted in this volume could be dated to April–May 1912 on the basis of internal evidence. Marc's essays, to which Heckel refers in the first letter included here, appeared in *Pan* on March 7, 21, and 28, 1912. The second letter printed here, refers to the Futurist exhibition at the Sturm Gallery in April–early May 1912. In the third letter Heckel refers to Marc's letter of April 11 and also to the Brücke separation from the New Secession, which occurred early in 1912. The fourth letter refers to Reiche's invitation to Heckel to the 1912 Cologne Sonderbund, which opened May 25, 1912. The fifth letter refers to the decline of the Sonderbund after the closing of the Cologne exhibition on September 30, 1912. For discussion of the various secession groups see Paret, *The Berlin Secession*, 210–22.

37. Marc referred in several letters to Heckel and the Brücke; see *Wassily Kandinsky, Franz Marc, Briefwechsel*, ed. Klaus Lankheit (Munich: R. Piper & Co. Verlag, 1983), esp. pp. 122, 130, 167–68.

38. See document 23 of this volume for excerpts from the essays of Marc and Beckmann in the journal *Pan*.

39. See also Krüger, "Die Jahreszeiten, ein Glasfensterzyklus von Max Pechstein," *Zeitschrift des Deustshen Vereins für Kunstwissenschaft* 19, nos. 1/2 (1965): 92.

40. See previous letter where Heckel refers to "the Villa of Sturm."

41. Sidi Riha was Heckel's dancer friend; she later became his wife.

42. For a reproduction, see Lloyd, . . . *Primitivism* . . . , 59.

43. Paul Fechter in *Der Expressionismus* (Munich: R. Piper & Co. Verlag, 1914, 24) also named Kandinsky as representative of a more abstract form of Expressionism; see document 19.

44. See for example, Pechstein's letter to Erich Heckel, Berlin, September 21, 1911, Altonaer Museum, Hamburg.

45. Ellipsis in original text.

46. See the documentary edition by Klaus Lankheit, *The Blaue Reiter Almanac*, ed. Wassily Kandinsky and Franz Marc (London: Thames and Hudson, 1974).

47. See Rose-Carol Washton Long, "Occultism, Anarchism, and Abstraction: Kandinsky's Art of the Future," *Art Journal* 46, no. 1 (Spring 1987): 38–45.

48. The second exhibition included works by the Brücke artists— Heckel, Kirchner, and Pechstein; the New Secession artists—Georg Tappert and Moriz Melzer; the Swiss Modern League artists—Paul Klee and Hans Arp; the Russian artists—Mikhail Larionov and Natalie Goncharova; as well as previous contributors to both the NKV and the first Blaue Reiter exhibitions—André Derain, Pablo Picasso, and Robert Delaunay. See *Der Blaue Reiter im Lenbachhaus München*, ed. Rosel Gollek (Munich: Prestel-Verlag, 1982), 388–413, for lists of contributors to these exhibitions.

49. Franz Marc, "The 'Savages' of Germany," *The Blaue Reiter Almanac*, English documentary edition, 61–64.

50. Kandinsky, *Über das Geistige in der Kunst*; English translation in *Kandinsky: Complete Writings on Art*, ed. Kenneth C. Lindsay and Peter Vergo (Boston: G. K. Hall, 1982), 1:114–219.

51. Kreis für Kunst Köln im Deutschen Theater, *Kandinsky-Ausstellung*, January 30–February 15, 1914, unpaginated.

52. See Rose-Carol Washton Long, "Involving the Viewer," *Kandinsky: The Development of an Abstract Style* (Oxford: The Clarendon Press, 1980), 42–51.

53. The correspondence belongs to the Kubin archiv, Städtische Galerie im Lenbachhaus, Munich.

54. For discussion of Kandinsky's hidden images, see Long, *Kandinsky . . .* , passim.

55. See Sixten Ringbom, "Die Steiner-Annotationen Kandinskys," *Kandinsky und München: Begegnungen und Wandlungen, 1896–1914* (Munich: Städtische Galerie im Lenbachhaus, 1982), 102–5.

56. Neue Künstler Vereinigung München.

57. A reference to *On the Spiritual in Art*, which by September had found a publisher, Piper, who was also handling the almanac.

58. Marc, "The 'Savages' of Germany," *The Blaue Reiter Almanac*, English ed., 64.

59. Marc to Kandinsky, October 24, 1914, *Wassily Kandinsky–Franz Marc, Briefwechsel*, 263–64. Believing that war could cleanse the modern era of its slothfulness, Marc had volunteered for military service. He soon grew pessimistic and wrote of the meaninglessness of war. See, Ida K.

Rigby, "Franz Marc's Wartime letters from the Front," *Franz Marc: 1880–1916*, ed. Mark Rosenthal (Berkeley: The University Art Museum, 1979), 55–62.

60. Marc to Piper, June 13, 1911, in Reinhard Piper, *Briefwechsel mit Autoren und Künstlern, 1903–1953* (Munich: R. Piper & Co. Verlag, 1979), 123. See also Franz Marc, "Zur Ausstellung der 'Neuen Künstlervereinigung' bei Thannhauser," September 1910, *Franz Marc—Schriften* (Cologne: Dumont Buchverlag, 1978), 126–27.

61. In the letter to Piper of June 13, 1911 (*Briefwechsel . . .* , p. 123), for example, Marc castigated Piper for misunderstanding Kandinsky and stated that comprehension of his own work depended on the publication of Kandinsky's work.

62. See Frederick Spencer Levine, *The Apocalyptic Vision: The Art of Franz Marc as German Expressionism* (New York: Harper and Row, 1979), passim.

63. Letter to Maria Marc, April 12, 1915, in *Franz Marc: Briefe aus dem Feld*, ed. Klaus Lankheit and Uwe Steffen (Munich: R. Piper & Co. Verlag, 1982), 65; in English in Herschel B. Chipp, *Theories of Modern Art* (Berkeley: University of California Press, 1968), 182.

64. Envelope extant, addressed to Odessa, c/o Mr. Kojevnikoff.

65. The painter Elizabeth Epstein exhibited two works in the first Blaue Reiter exhibition; she was a close friend of Sonia Delaunay and translated portions of *On the Spiritual in Art* into French for Robert Delaunay.

66. *The Diaries of Paul Klee, 1898–1918*, ed. Felix Klee, authorized translation (Berkeley: University of California Press, 1968), 212, 250, 264–65. For discussion of Klee's relationship with the Blaue Reiter, see Marcel Franciscono, *Paul Klee: His Work and Thought* (Chicago: The University of Chicago Press, 1991), 139–153, 165–175, 197–202. See also O. K. Werckmeister, *The Making of Paul Klee's Career, 1914–1920* (Chicago: The University of Chicago Press, 1989), 44–48, 67–72, 89.

67. See Charles W. Haxthausen, *Paul Klee: The Formative Years* (New York: Garland Publishing, 1981), 362–73, and also Jim M. Jordan, *Paul Klee and Cubism* (Princeton: Princeton University Press, 1984), 57–62.

68. *The Diaries of Paul Klee*, 266.

69. See Paul Raabe, *Die Zeitschriften und Sammulungen des literarischen Expressionismus* (Stuttgart: J.B. Metzlersche Verlagsbuchhandlung, 1964) and Raabe, *Index Expressionismus*, 18 vols. (Neudeln, Liechtenstein: Kraus Thomson, 1972).

70. See Raabe, "Schluswort," *Die Aktion* (Munich: Kosel Verlag, 1967).

71. Although an overlapping contingent of writers (Scheerbart, Rubiner, and Karl Kraus, for example) and artists (Georg Tappert, for example) appeared in both journals before the war, *Die Aktion* did not include visual

material until 1912 and then focused almost entirely on German artists. Georg Tappert appeared in both by the end of 1914. In 1917, Franz Pfemfert, *Die Aktion*'s editor, opened a bookstore and gallery, but it lasted only one year. For a concise overview of both periodicals, see Roy F. Allen, *Literary Life in German Expressionism and the Berlin Circles* (Ann Arbor, Mich.: UMI Research Press, 1983), 93–152.

72. See M.S. Jones, *Der Sturm: A Focus of Expressionism* (Columbia, S.C.: Camden House, 1984), and Georg Bruhl, *Herwarth Walden und "der Sturm"* (Cologne: Du Mont Buchverlag), 1983.

73. See Jones, 8.

74. See Janos Frecot, "Literatur zwischen Betrieb und Einsamheit," *Berlin um 1900* (Berlin: Akademie der Künste, 1984), 325–31, 337–38, and Erika Klüsener, *Else Lasker-Schüler* (Reinbek bei Hamburg: Rowohlt, 1980), 44–68.

75. See Monica Strauss, "Kandinsky and 'Der Sturm,' " *Art Journal* 43, no.1 (Spring 1983): 31–35 and Jones, *Der Sturm . . .* , 2–29.

76. See Note 15.

77. See Wilhelm Worringer's essay and Paul Ferdinand Schmidt's essay, documents nos. 2 and 3.

78. See Selz, *German Expressionist Painting*, 265–73; Andreas Hünecke, "Das Leben unseres Ich ist der Funke an der Zündschnur—'Der Blaue Reiter' und der 'Erster Deutcher Herbstsalon,' " *Expressionisten* (Berlin: Staatliche Museen, 1986), 31–36, and 122–24; Magdalena M. Moeller, "Erster Deutscher Herbstsalon, Berlin 1913," *Stationen der Moderne, Kataloge epochaler Kunstausstellungen in Deutschland 1910–1962*, ed. Eberhard Roters, commentary volume (Cologne: Walther König, 1988), 63–76; and Mario-Andreas von Lüttichau, "Erster Deutscher Herbstsalon," *Stationen der Moderne Die bedeutenden Kunstausstellungen des 20. Jahrhunderts in Deutschland* (Berlin: Berlinische Galerie, Museum für Moderne Kunst, Photographie und Architektur, 1988), 130–153.

79. The letter translated here is from the Sturm archive [Pr. Staatsbibliothek, Berlin]; accordingly, the checkmarks are from Walden.

80. Adolf Behne, "Bruno Taut," *Der Sturm* 4, no. 198/99 (February 1914): 182–83. See also Iain Boyd Whyte, *Bruno Taut and the Architecture of Activism* (Cambridge: Cambridge University Press, 1982), 7–13.

81. When the poet Paul Scheerbart, whom Walden characterized as "the first Expressionist poet," died, Behne wrote a eulogy for the journal, *Zeit-Echo*; see no. 5 (1915–16).

82. Paul Raabe, *Die Autoren und Bücher des Literarischen Expressionismus* (Stuttgart: Metzler, 1985), 66.

83. Jones, 39–40.

Part Two

The Expansion of Expressionism

I. GERMAN CRITICISM THROUGH WORLD WAR I

INTRODUCTION

While journalists, artists, and the public continued to attack Expressionism as a foreign art form and as a diseased product of urban disorder, the supporters of Expressionism increasingly sought to present theoretical justifications for the new artistic directions. Although during the twenties and thirties many of these theorists developed widely divergent opinions about the relation of art and society, during the teens the defenders of Expressionism were united in their disdain for the Wilhelmine government. Envisioning a less authoritative and repressive structure, they regarded the industrialist and materialist culture of imperial Germany with great suspicion. They equated rationalism with positivism and viewed reason and respectability with contempt. Intuitive thought, spontaneous gestures, esoteric religions, mysticism, and anarchist theorizing were highly regarded by many of those artists and critics who believed their work could help change the monarchy into a more democratic type of government.

They admired art from a preindustrial age and saw it as an alternative to officially sponsored academic art. They often praised Gothic as an indigenous form of preindustrial art, partly because of its Germanic associations, but also because they considered its art forms both communal and religious.[1] In their efforts to uncover art forms suggestive of a simpler and less commercial period, they also heralded primitivism as an alternative to Western rationalism.

Some of the critics included here link their attacks on positivism and materialism with attacks on capitalism. Seeking ways to change their society, they stress a long-standing view of the artist as having prophetic powers. Hermann Bahr, for example, referred to the new art as stimulat-

ing a change of attitude among its viewers because of its disturbing qualities. Bahr and others sought to demystify the new art by explaining its goals and techniques. Each of the critics sanctioned antinaturalism as more creative, purer, and less materialistic than classical art or naturalism. They also praised it for abandoning the classical Renaissance tradition of specificity and in so doing evoking a communal and metaphysical sensibility. To them, the appeal of abstraction, frequently described as one direction of Expressionism, was its antimaterialism and its evocation of the transcendental and the cosmic.

18. Ludwig Rubiner, "Painters Build Barricades," *Die Aktion*, 1914*

The poet and critic Ludwig Rubiner (1882–1920), was involved with the circle around *Die Aktion* and its editor Franz Pfemfert, when this article appeared (fig. 9). In keeping with the subtitle of Pfemfert's journal, "Wochenschrift für Politik, Literatur und Kunst" (a weekly for politics, literature and art), Rubiner calls for painters to enter the political world and lead the way to revolutionary change.[2] Recalling Heinrich Mann's 1910 essay "Geist und Tat,"[3] which urged intellectuals to oppose the military and authoritarian powers of Wilhelmine Germany in order to establish justice and dignity for all men, Rubiner describes the Wilhelmine establishment as exploitive, complacent, and stultifying. Like Pfemfert he equates radical political views—"the great German left"—with radical artists' views. Rubiner was not interested in following a specific political party nor in defining a particular style (especially since he equated style with taste and capitalism), but in this article he clearly indicates that he is against art for art's sake, imitative and decorative painting. His main concern is that painters recognize that they have political responsibilities to translate the spiritual and the transcendental into the world.

Although Rubiner does not call the artists he praises Expressionists, he had a number of them in mind when he wrote this article. He refers primarily to the artists of the Berlin New Secession and woodcuts by some of its members—Wilhelm Morgner, Hans Rich-

*Ludwig Rubiner, "Maler Bauen Barrikaden," *Die Aktion* 4 (April 25, 1914): 353–64.

ter, Moriz Melzer, and Karl Schmidt-Rottluff—appear next to his text. He also praises artists working outside Germany, especially Picasso and Delaunay. Rubiner's artistic choices do not deviate very much from the group of international modernists whom Reiche assembled for the 1912 Sonderbund and called Expressionist.

During the war, Rubiner moved to Switzerland and published the journal *Zeit-Echo* from Zurich. After the war, he collected poems for two anthologies, *Kameraden der Menschheit* and *Die Gemeinschaft*, which he felt would inspire actions to bring about a better future. Published in 1919, these anthologies reflect the euphoric utopian vision of early Expressionist art.

. . . .

Painting does not exist so that paintings will be made. But neither does it exist to be enjoyed by the poor or to provide decoration for the rich. A true exhibition is always a true polemic, and politics means the greatest talent, the deepest commitment to cultivating our initiative on Earth. To play a role within a particular idea of world history is not the point. . . . The point is to possess every second of our lives with the immediacy and innocence of the first day. In comparison nothing counts in this time-bound world in which one sun and one moon always need days that are much too long to rise and decline. How can the bliss of our telephone calls compare in intensity with this upheaval, with the dawning of the first day! For this to become space for us, to find its space at all, is the vast, perpetual revolution through all times. It is revolution everywhere, among all the peoples, the poets, the musicians. The painters. The paint-ers must create this spiritual visionary space. That is, according to the creative force of the eye. Picasso is visionary in spite of his being an academician. Beardsley and Gauguin are not visionaries today, but only illustrators of their immediate sensitivities; already kitsch. Delaunay is visionary although he does paint posters . . . Kokoschka is visionary. . . .

Painters, know that you are spiritual beings or leave us alone! You make a place in the world for our spirituality, from which we all spring, using the gift of the eye. Whoever does that—or whoever only attempts it—is so powerful that he can blow to bits this world around us, this world of existence, this world of the overwhelmed, the bogged down, the spiritu-ally muddled, the fallow. Again and again. Painter, you have a will: you topple the world; you are a politician! or you remain a private person.

. . . .

The German has invented a surprisingly telling symbol for himself: the indoor rowing apparatus. One rows, rows, rows, and does not get any-

where. One rows until one becomes quite stupid. Rowing is said to be healthy. Germans get it confused: becoming stupid makes you healthy.

Painting for painting's sake is the indoor rowing machine. Capitalism is not just a condition: it is also a mode of action. Exploitation of whatever is present in the world that did not come from our own organism. In art the capitalist behavior hides behind the concepts "tradition" and "style." But when after having been away, one returns to Germany again, one can see that high capitalism does not even dominate this art. It is really a business for the most paltry middleman: decoration and imitation. The decorative painter is the one with the sensibility of a waiter: "What would you like?"—"Decorate my home!" The imitator: "I'll be right over as soon as I receive a postcard!"

But I don't have to explain any more to the Secessions that their protective name should mean "the people marching onto the sacred mountain.". . .

. . . The march has nothing to do with the art trade. Because the people are us, and the Secession makes sense only if the mountain onto which we climb is truly sacred: if it shakes the world of relations, habits, the world of resting and enjoying, the world of tradition, decoration and imitation.

. . . .

The Secessions have nothing to do with younger or older generations. But simply with shaking up, tearing down, changing the world. They are not concerned with different painters seeing in different ways, because "different ways of seeing" means that all painters are stuck with one and the same transitory and disorganized material, and everyone is committed to a different corner. . . .

. . . .

. . . Liebermann's old Secession is called the "Free Secession." In order not to deteriorate completely, it admitted painters (from the "New Secession") whom it dislikes very much. . . .

. . . .

Several German painters today are standing at the beginning. By looking at the "New Secession," in the middle of the backward, overfed, contentedness of Berlin, one sees how far they can get in Germany now. . . .

But if we are to speak here about the paintings of the "New Secession," it cannot be done by distribution of praise and reproach, . . . Because this is not about studio secrets, but the scaffold of creation. This is about the spirit and the will. And all those who are cowards should not stand with us.

19. Paul Fechter, from *Der Expressionismus*, 1914*

In 1914 R. Piper & Co. published Paul Fechter's (1880–1958) *Der Expressionismus* (fig. 10), the first book-length treatment of the subject. The excerpt here is from the main chapter of the book, in which Fechter discusses Expressionism as part of a Pan-European reaction against Impressionism and naturalism. In two subsequent sections, he discusses the role of Cubism and Futurism in this reaction. In the portion included here, Fechter focuses on Expressionism's roots in the Gothic metaphysical tradition.[4]

Fechter, who had received his Ph.D. in 1906, began his professional career that year as an art editor for the *Dresdener Neuesten Nachrichten*. Working for this newspaper until 1911, Fechter frequently commented on the artists of the Brücke, who were roughly the same age as he. From 1911 to 1914 he wrote for the *Vossische Zeitung* in Berlin, where most of the Brücke had moved as well. Not surprisingly, Fechter identified Pechstein of the Brücke as one of the main figures of Expressionism. He selected Kandinsky (fig. 11) as the representative of the other, more abstract direction. Describing these two poles as "extensive Expressionism"—using references to nature to evoke a higher state—and "intensive Expressionism"— renunciation of nature to suggest the transcendental, Fechter emphasized that both poles rejected the Renaissance rationalist, materialist tradition in favor of the communal, metaphysical sensibility of the Gothic.[5]

Earlier critics such as Paul F. Schmidt and Richart Reiche had pointed to German sources for the new movement, but Fechter's treatise made the Germanic soul the well-spring of Expressionism. The heightened chauvinism and isolation engendered by the war served to overemphasize the nationalistic aspect of his interpretation.

The protest against Impressionist naturalism started at the right point insofar as it was directed against the emphasis on nature as the sole orientation for art. By itself, the call: "abandon nature!" was fully justified. But its combination with the call: "back to the picture!" was contaminated

*Paul Fechter, from chapter 3, "Die Späten Gegenbewegungen," part 1 "Der Expressionismus," *Der Expressionismus* (Munich: R. Piper & Co. Verlag, 1914): 21–29. © R. Piper & Co. Verlag, München 1914.

to the core, and thus inevitably led to the ills of decorativeness in painting. The turning away from the representation of external appearances became truly meaningful only when the life changes it implied had been fully realized, down to the last consequences. Given an emphasis on pictorial criteria, the call to "abandon nature!" necessarily led to decorative stylization; it could lead to art again only after it responded to the directive "back to emotion!" As justified as many things were, even in the early states of the countermovement, the project became truly meaningful in terms of art only after it was possible to see that art does not come from artistic skills alone (since "what is mastered is no longer art"). Rather, art is based on a special disposition of the soul, on a kind of will, or rather a compulsion and need. The essential meaning of art always consists in expressing in a concentrated, direct way—the only possible way—the emotion arising from human existence on earth.

The significance of Expressionism lies in this insight. . . .

. . . .

These are approximately the basic outlines of what one could term "Expressionism" in its true sense (apart from the fact that in the final analysis all present art movements are expressionistic). Within this broad tendency, two different streams can easily be distinguished: they could be characterized as "intensive" and "extensive" Expressionism, or if personal rather than general characteristics are preferred, by the names Kandinsky and Pechstein. These two streams arise almost automatically from the two directions in which the will to express emotions can exert itself. Kandinsky, whose work can be characterized as intensive Expressionism, has as his goal nothing other than the expression of his inner self. What he wants to present is the existence of human emotion, isolated from the environment, from every tie to nature and its forms. He finds appropriate material for art, pure and unadulterated, only within himself. He finds pure spiritual substance only in the depths of his own soul—where neither idea nor reasoning has access, where a chaos of color reigns, where experience is still unformed, shapeless, remote from conceptual reasoning and from entering any net of causal projections. A soul perhaps predominantly receptive to music may sink into its depths beyond any categorizations, into the realms where immediate experience still roams free of traces of materiality; it tries to come as close as possible to the limits of transcendence by excluding everything external in order to express the emotions there in pure form and color without the roundabout symbolism of significant objects. Thus landscapes of souls are created without any landscape features, musical states are transposed into colors and lines; the distance between emotions and expression is shortened here to its minimum. What van Gogh experienced in his self-consuming creative rage is accomplished here inside the person; the visual orientation is

reversed from outward to inward, the environment is totally abandoned. . . . But, because he pursues the possibilities for extending self-expression in painting to their fullest measure, his undertaking, even if it should remain fruitless, takes on a significance that goes beyond personal values toward universal importance.

The purest example and strongest representative of extensive Expressionism is Max Pechstein. In contrast to Kandinsky, he not only maintains a relation to the world, but intensifies it to the highest possible degree only just attainable by him. . . . He thus expresses his own life as this felt existence of things, at the same time revealing their profoundest essence. Like Kandinsky, he makes contact with transcendence, but at the opposite pole. He takes the longer path, so to speak, since he first passes through the world and only then gets in touch with his inner being; Kandinsky tries to do it directly. Kandinsky experiences the essence of reality only by focusing his attention on his own self; Pechstein, in extending himself to the whole of existence. He grasps life wherever it streams out as a pure emotion unhindered between heaven and earth, and becomes the symbol and key for his own feeling and will.

Pechstein also moved away from the decorative, although not out of a conceptually defined protest against Impressionism, but out of a very close bond to all living beings and action. . . . His path stretches further and further from decorative craftsmanship to the distillation of what is altogether human, to the formulation of the contemporary acceptance of this world and of human life. But beyond all of this, he slowly ascends from the sensual concerns of the soul to a general spiritual feeling about the cosmos from which, perhaps, religious painting—in the contemporary sense of this word—could emerge once again. These words could also apply as a whole to the main goals of Expressionism. However, Pechstein is the strongest representative of all of these tendencies, which move toward new goals without fully abandoning their link to nature. It was no coincidence that he was the leader of the "Brücke" in Dresden, a city which may justly claim to be the birthplace of Expressionism. Erich Heckel and E. L. Kirchner, Schmidt-Rottluff, who went along with him at the time, produce fundamentally the same thing, with slight variations. Franz Marc goes his own way in his attempt to find new possibilities for the expression of feelings in the untroubled sensual existence of animals. Of the Munich group, he is the purest painter in spite of his latest attempts at imposing structural order on what is seen, without making it decorative or arts and crafts in the process. Oskar Kokoschka, who adds an intensification of linear and tonal elements to that of color, also emphasizes his relations to the painters of the past, to those he sees as the actual precursors of German art, namely, to the Gothic masters and to the masters of the late fifteenth century, above all to Grünewald.

For the aspiration manifestly at work in the efforts just described is basically nothing new, but the same drive that has been at work in the Germanic world since time immemorial. It is the old Gothic soul, which, in spite of the Renaissance and of naturalism, continues to live. It bursts out again everywhere in the German Baroque—some people believe they still feel it in the Rococo—and irrepressibly, in spite of rationalism and materialism, rises up again and again. The ancient need of the German people for metaphysics has survived unscathed through even the Kantian critiques and countered them, with subtle irony, with Fichte, Schelling, Hegel, and Schopenhauer. It has not been hurt even by the superstitions of the natural sciences of our century. The whole recent movement in the visual arts proves this, as do the newest experiments in the purely spiritual realm. The Gothic has become fashionable again for good reasons, after it was first recognized, obscured within Jugendstil's decorative experimentations, at the close of the nineteenth century. Expressionism, in all its different guises, is basically only the liberation of inherent spiritual energies of the soul from the bondage of narrow-minded, crude intellectualism. This intellectualism, too weak to rise to a genuine spiritualization, dragged its victims into literary or academic pursuits and paralyzed the truly productive expressive powers so they did not produce anything that could be formulated or conveyed. In fact, Expressionism is not a matter of intention, but a destiny. . . . The very fact of its existence is more significant than the artistic value of a work, the stream is more important than the individual wave. Perhaps the kinships between the works of the individual artists involved in it don't follow from a school context or from a common goal. Perhaps there is a deeper meaning in it, namely, that here art is again beginning to emerge from shared spiritual conditions, that the personal drops into the background in favor of the great anonymity of the collective. We cannot make any pronouncements yet today, but must force ourselves to remain patient. We seek clarification not through dialectical constructions of what may be possible, but through careful analysis of what has already happened.

20. Theodor Däubler, "Expressionism," *Der Neue Standpunkt*, 1916*

The poet and critic Theodor Däubler (1876–1934) was well known in Germany for his art criticism. He wrote for numerous periodicals,

*Theodor Däubler, "Expressionismus," *Der Neue Standpunkt* (Dresden-Hellerau: Hellarauer Verlag, 1916), 179–90.

among them *Der Sturm, Die Aktion, Neue Blätter für Kunst und Dichtung, Die Weissen Blätter*, and *Das Kunstblatt*. From 1908 to 1914 Däubler divided his time between France, Italy, and Germany; his exposure to French Cubism and Italian Futurism is reflected in this essay, especially when he relates Expressionism to simultaneity, forcefulness, and speed. A mystic universalist, a utopian pacifist, a believer in the brotherhood of mankind,[6] Däubler was committed to explicating all of European modernism. He wrote about a wide range of artists, including Klee, Picasso, Marc, Barlach, and Grosz. In turn, his imposing physique and full beard served as a model for a number of Expressionists, including Ludwig Meidner (fig. 12).

In his essays Däubler used qualities characteristic of much Expressionist poetry and prose and avoided long, Germanic sentences punctuated with many commas in favor of short staccato phrases punctuated with periods. He was not concerned with systematic classifications or exact chronology. In different essays in *Der Neue Standpunkt*, Däubler designated both Delaunay and van Gogh as the "first Expressionist,"[7] described Barlach as having cubistic compositions and expressionistic goals,[8] and in a 1917 essay referred to George Grosz as having a futurist temperament and expressionistic compositions.[9] Despite these seemingly contradictory remarks, Däubler helped to popularize the concept of Expressionism as encompassing the entire world of international modern art.

There is a saying: When somebody is hanged, his whole life will flash before him in the last moment. That can only be Expressionism!

The preconditions of this style are speed, simultaneity, and intense concern with the interconnectedness of what has been seen. The style itself is the expression of the idea.

Expressionism in any style is a vision wanting to present itself in a highly condensed form, in a context of extreme simplification.

Color without characterization, drawing and no explaining, a noun established in rhythm without an adjective: we conquer our Expressionism!

All experience culminates in something spiritual. Every happening becomes its type. When the need to express oneself comprehensively becomes intense enough, engaging many minds, we get a style. Generally it will be binding and will foster and expedite the expression of the most personal things. Our need to act in one particular way and in no other is certainly not to be considered inevitable fate but in the sense of: one thing is needed! Hence an awareness of freedom. Artistic assertion. The things

we create should have something of ourselves: not our point of view put into deeper perspective, but crystallized out of ourselves. The center of the world is in every 'I'; even in the self-justified work. . . .

Cubism is intended perspectively as a view from up high. . . . There things unfold beneath us as from a bird's-eye view. An eye in an airplane looks, in a sense, into Cubism. Then going still further: things inherently displayed their inner geometries. They radiated the presence of a soul. Hence again mystical perspective, prelude to a hierarchy. A streaming back into the crystal ego.

The movement began in Paris, pretty much simultaneously in various creative people; Gleizes, Picasso, Braque, Metzinger drew their conclusions from Derain's clarification of Cézanne's secrets. Delaunay is the first conscious Expressionist. Let's view his most complete painting, the Eiffel Tower. It's already the face of the iron tower. The grill work is in disarray. The structure could as well have fallen from the stars as have been built up from the ground. It is the same in the spiritual. . . . Such a tower therefore has no plumb line. It gives in under the weight of the stars, thus the tower is buckling everywhere. It is an accordion, anchored from the top as well as from the bottom. Constellations play on it. A house might be the same, but the Eiffel Tower has become the sign of a modern building. That is why it is even more detached from space than any other building. It is scaffold and skeleton of the future. . . .

. . . .

In a way, Paul Klee pastes the absolute results of his color-reworkings onto his paintings. Often they just scurry off and away almost like a gentle breath: as if over a flame. However, Klee achieved a more concentrated stability in his colors than Delaunay. That's why he often squeezed out the secret breath of his colors with graphic symbols. Something still Tunesian-unknown, something like an airborn script of the future spreads magic around his creations.

In his last paintings August Macke had gone very far toward making color skip and jump freely. Especially surprising here: he really held fast to concrete objects. He spirited men and plants as if out of an astral rainbow into the valley of actual facts. With Macke we glow or recede into the background, participating in the absolute color, as if through illuminated prisms. We almost take on an existence from another world that we ourselves dreamed upon the earth.

Wassily Kandinsky stands for the decisive entrance into a new epoch. . . . With Kandinsky in his deepest dream-magic. He shows a glazing over of distinctions. Crystal balls. Blue proclamations of decisions before their embodiment in deeds. He even brings us, stimulated by yellow, into the adventure of an earthly confirmation of a lilac-souled birth of wishes.

. . . .

Whereas with Kandinsky a Mongolian cloud envelops us in a mystically colored chaos or defines a cosmos, Léger remains European: West European. His elements are smoke and the giving of form. Two opposites that only he could bind into each other, let's say rig up into the plumb line. . . .

. . . .

Oskar Kokoschka is the truest Expressionist. For if expression means the clearest language of spirituality, Kokoschka towers over all others. In every portrait he catches the animal likeness of everybody with a black-white magic, marvelous to see. But every time uncannily discreet. He is a chiromancer. He can read the palm of the hand. That means, every face is read from its lines as a palm would be. He can read the runes of the forehead like no other. . . .

. . . .

The ethical vertical is supposedly reinstated in sculpture. Fantasy had to stretch upwards yet again: the timid sensibilities had to fly out of themselves. But much soul can be grasped only with strong style, because soul overflows, spreads out, and at the same time loves the form out of which it can sparkle. We are talking about Wilhelm Lehmbruck. His *The Fallen One* (fig. 13) is the prologue to Expressionism in sculpture. It is no longer praying, but a devotion, a belief in the vertical that must come. . . .

. . . .

The most airborne sculptor is Archipenko. His crouching woman is pregnant with eternal geometries. We all became human beings in order to lift spiritually seen cubes upward to the stars. We embody our constellations. . . . With Archipenko souls are hurled, as stones against the planets, stone fragments of the constellation, Hercules. The individual as a receptacle for spirituality. His enduring suffering in existence: a nest from which the starchild will fly throughout eternity! So says Archipenko! Such is Expressionism!

21. Hermann Bahr, from *Expressionismus*, 1916*

Hermann Bahr's *Expressionismus* was widely read and went into three editions before 1920. Bahr (1863–1934), who was born in Austria, was a playwright and critic familiar with intellectual circles in Vienna, Berlin, Munich, and Salzburg. Although he had been interested in the Austrian Pan-German movement in his student days, he viewed Expressionism as an international development among all

*Hermann Bahr, *Expressionismus* (Munich: Delphin-Verlag, 1916), 43–45, 53–56, 74–75, 79, 101–2, 122–23.

artists rejecting Impressionism. Bahr was aware that the average viewer found Expressionism difficult to comprehend, and in his book he describes it as an unprecedented new philosophy and religion, which relies on shock tactics to gain both attention and greater understanding. He parallels the renewal in art with the emerging philosophies of Martin Buber and Rudolf Steiner. Bahr writes at great length about the Expressionists' rupture with nature, basing many of his theoretical explanations on concepts derived from Riegl, Worringer, and Kandinsky. He views impressionism as a mirror of the external world of appearances and as a record of bourgeois order. Describing the Expressionist departure from nature as crude and violent, he praises the resulting shock effects as a more accurate reflection of the despair of his age. The conflicts and tension implicit in Expressionist works, he feels, will stimulate mankind to move beyond the artificiality and superficiality of the veneer of Western civilization.

Bahr's concept of Expressionism as an alarm, a cry that will serve mankind, was much repeated immediately after the war.

. . . .

Certainly I cannot deny feeling uneasy when Expressionists theorize; they like to talk in a fog. Nothing at all is more of a public danger than a painter with a program. And even in the rare case where the program halfway suits the painting, nothing is proven; the program is created afterward. The artist does not create out of a program—instead he first wants to explain to himself his own work, in front of which he often stands just as speechless, as astonished, as others. If the Expressionists' declarations indulge in obscurity, a basis for it can be found in our entire era, which everywhere takes pleasure in obscurity. I don't know if it is right or wrong. But I just now noticed it again with Buber.

Hardly any other German writer has attracted me so strongly—held me so firmly—during the last years as Martin Buber. What I have read by him appeared to me as a positive message, as a sign that perhaps humanity is turning around again. He, Johannes Müller, and Rudolf Steiner, these three above all, proclaim it. Mankind has the habit, whenever it has turned completely to the visual and stood for a time totally in the realm of the sensually perceivable—so totally that everything invisible disappeared—to turn around again suddenly to the invisible, so much so they do not want to see the visible any more. . . .

. . . .

Then, would Buber, Simmel, the Expressionists be right? Is the mystagogical fog an indispensable resource for us? Then would the somber speech be necessary because only in darkness would the reader let his own light shine? For perhaps we are raised so improperly that somehow we have to be shocked into understanding the meaning of words. As long as speech does not scare us, we do not listen. Thesis for a German seminar: scare tactics as a necessary element of today's literary style.

All the Expressionists' speeches tell us only that what the Expressionist searches for is without precedent in the past: a new art is dawning. And whoever sees an expressionist painting by Matisse or Picasso, by Pechstein or Kokoschka, by Kandinsky or Marc, by Italian or Bohemian Futurists agrees: he finds them without precedent. This is all these groups have in common. For the newest school of painting consists of small, candid factions who curse each other. They are all turning away from Impressionism, indeed against it. (This is why I call all of them Expressionists, even though this is initially only the name of one faction and the others will protest against it.) Where Impressionism always wants to simulate a piece of reality, to work toward illusion, they are all rejecting this. They all passionately resist any demands we are accustomed to place upon a painting in order to even accept it as a painting. Even if we do not understand any of these paintings we are certain about one thing: they violate reality, they violate appearance, they violate the world of the senses. That indeed is the real reason for the general indignation: everything that has meant painting since there has been painting at all seems to be denied, and something that has never been tried before is being attempted. So it seems to the viewer, and the Expressionist himself will agree. Only the viewer maintains that whatever is not authenticated through nature, indeed intentionally resists nature, could never be art, while the Expressionist claims exactly this to be art, to be his art. And when the viewer heatedly retorts that the painter should paint only what we see, the Expressionist assures him: we too paint only what we see! But they are unable to agree. They are unable to agree on seeing. When they speak about seeing, they each mean something different. What is seeing?

. . . .

. . . Artistic seeing is based upon an inner decision: turning the eye of the body (to speak once again like Goethe) into the eye of the spirit; and how the artist settles this struggle is the only way in which he truly becomes an artist. . . . The artist, who achieves complete seeing, that neither violates mankind through nature nor nature through man, but allows each their rights in both nature's work and human deeds, is one formed either in times of onesidedness, suddenly overcome by another onesidedness

(Grünewald, Dürer, Cézanne), or when the artist is willful enough to resist the onesidedness of the times equally strongly (Greco, Rembrandt).

(I want to tell the reader who has not noticed yet that I have our late, great explorer Alois Riegl to thank for many of my opinions, and especially Wilhelm Worringer's writings *Abstraction and Empathy* and *Form Problems of the Gothic*; and that Chamberlain's book about Goethe made me understand Goethe through Kant.)

. . . .

But Riegl . . . was the first to recognize that before him all of art history was subjective, inasmuch as it approached all contemplation of art with prejudice, that is with the prejudice of a taste, trained on works declared classic and blinded by them. . . .

. . . .

When painters, who let the eye of the spirit predominate, happen to show their works to a public accustomed to trusting the eyes of the body or vice versa, one can imagine the confusion. Someone who has never become conscious of his own seeing is in any case inclined to think of the eye as a window into which the world looks. Add to that our being educated in classical art, an art always looking out sucking in the world. Impressionism is only the last word of classical art; it completes and fulfills it in its entirety by intensifying the outer seeing to the utmost and thereby excluding the inner seeing as much as possible. . . . But now it seems that in the rising youth the spirit vehemently announces itself again. . . .

. . . .

This is the point: that mankind wants to find itself again. . . . Everything we experience is only this tremendous struggle for mankind, struggle of the soul with the machine. We don't live actively, we live passively. We have no freedom any more, we are not allowed to decide for ourselves, we are finished, man has lost his soul, nature is dehumanized. Just as we were congratulating ourselves on still being her Lord and Master, her jaws swallowed us. If only a miracle would happen! This is the point. Whether through a miracle the soulless, sunken, buried man will rise again.

Never was there a time shaken by such terror, by such dread of death. Never was the world so deathly silent. Never was man so insignificant. Never was he so afraid. Never was happiness so distant and freedom so dead. Misery cries out, man cries out for his soul, the entire time is a single scream of distress. Art too cries into the deep darkness, it cries for help, it cries for the spirit. That is Expressionism.

. . . .

If Expressionism at the moment behaves now and then in a rather unruly, even frenzied manner, its excuse lies in the prevailing conditions it finds. These really are almost the conditions of primitive man. People don't

know how right they are when they jeer at these pictures and say they might be painted by savages. Bourgeois rule has turned us into savages. . . . So, brought very near the edge of destruction by "civilization," we discover in ourselves powers which cannot be destroyed. With the fear of death upon us, we muster these and use them as spells against "civilization." Expressionism provides the symbol of the unknown in us in which we confide, hoping that it will save us. It is the mark of the imprisoned spirit that tries to break out of the dungeon, a sign of alarm from all panic-stricken souls.

. . . .

22. G. F. Hartlaub, "Art and the New Gnosis," *Das Kunstblatt*, 1917*

Hartlaub's article is one of the clearest examples of the point of view connecting Expressionism with occultism and mysticism. When it was published, Gustav Hartlaub (1884–1963) was working at the Mannheim Kunsthalle as assistant to its director, Fritz Wichert. Before moving to Mannheim in 1914, Hartlaub, who had studied art history and received his doctorate in 1910, had worked for two years as Gustav Pauli's assistant at the Bremen Kunsthalle. It is not clear when he became interested in Theosophy and Rosicrucianism, but his awareness of the thought of the Christian Theosophist Rudolf Steiner is clearly evident in this essay. By the time his *Kunst und Religion* was published in 1919, however, Hartlaub considered Steiner a charlatan. Although he continued to maintain the importance of connecting art and religion and expressed interest in occultism and alchemy all his life, his 1919 book questions the effectiveness of Expressionism.

In the 1917 essay Hartlaub still holds that the experiments of Expressionism in the visual arts and in poetry are akin to the "expanding consciousness" of the "New Gnosis" that was emerging from Theosophy, Rosicrucianism, medieval mysticism, and the Kabbalah. Describing these tendencies as a rejection of Kantian rationalism, Hartlaub portrays the new directions in art and religion as descending from the German idealist tradition, from Fichte to Nietzsche. He refers to the interest of artists such as Nolde and Klee

*G. F. Hartlaub, "Die Kunst und die neue Gnosis," *Das Kunstblatt* 6 (June 1917): 166–79.

in primitivism and children's art as part of the rejection of superficial rationalism and repression. He compares the free colors and forms, which he describes as suggesting a space of "expanded dimensionality," in the paintings of Kandinsky, Marc, Klee, and Chagall to the occultists' vision of the cosmos. Perhaps most significant for the apotheosis of Expressionism during the war is Hartlaub's point that the individual Expressionist's work intensified the experience of the transcendental and the cosmological.

Surely it is symptomatic that a journal such as the *Kunstblatt*, dedicated to recent art, will from time to time reprint samples of old mystical texts, assured that such texts will have a substantial stimulating effect even on the artist today. This has to do with the curious spiritual upheaval within a certain cultural stratum of Europe, whose slow emergence, even though somewhat accelerated by the war, can be observed in scientific, ideological, and religious phenomena. Yet nowhere is it as evident as in the experiments of Expressionist art. . . .

. . . .

It seems to me that the play with overly direct analogies to medieval mysticism (even medieval art!) is dangerous for the following reason too. There we are dealing with the statements of a closed religious awareness, in a way, with the mystic-aesthetic emanations of such a firm core of beliefs. But I doubt if a similar awareness is present among most of our artists today. . . . Colors—. . . are symbols for feelings, sometimes for thoughts too, direct revelations of inner states of being, even if naturally awakened by the seen, felt experience of the sensual world, like sounds in music. Munch was the first one to grasp them in this sense. Today such a grasp is almost common property of a generation of artists— one need only glimpse at the paintings of Marc, Kandinsky, Kokoschka, Muche, Chagall, Metzinger, or Klee. Forms however, if they don't move through space as colors do, as free fragments, but instead are supposed to designate an object, can still burst the physical limitations of an object and become ecstatic gestures of the soul. Otherwise, they indicate only the near-transparent skeleton of things (more or less the way it looks conceptually, its structural plan), while everything that gives these arrangements substance, above all the dark, modeling shadows, which makes them weighty, round, and tangible, flies away on the wings of light into the empire of the pure, disembodied world of absolute colors. Of course, the space in which these abstract color-and form-events take place cannot be the external world of three-dimensional perspective but must somehow suggest the space of inner spiritual consciousness: there-

fore space is not flat in the sense of something "decorative" for instance, but on the contrary it is infinitely deep, prismatically partitioned into countless fractions of space, notions of an expanded dimensionality. . . .

. . . .

The conscious primitivism of many modern artists is nothing other than the attempt to get away from the object in its scientifically specific external aspect and to replace it with a spiritual symbol. . . . If a Nolde chooses marionettes and masks as stylistic foundation, as a sort of A B C of his formal language, if Paul Klee and George Grosz choose children's drawings, if Negro sculptures are the much-heeded model, then I do not see this as self-conscious fancy, nor as an archaism, but as the impossibility of doing anything else. . . .

. . . .

. . . What is offered to us today in Expressionist art and poetry is what we may recognize as a manifestation analogous to a neo-gnostic orientation. Entirely without direct contact, something is being realized on the aesthetic plane that corresponds to every occult cultural phenomena so far: and that is the gradual growth of a new and expanded consciousness!

. . . .

Here we neither wish to take a stance nor expand on the complexity of neo-gnostic concepts. For most of us non-Theosophists much will have been gained in temporarily suspending all prejudice and hasty judgment and in letting our soul spirits be invaded by the rich thought processes of Theosophy. But just to be on the safe side, let us mention that the Theosophical science of the soul, if understood correctly, has nothing to do with such phenomena as spiritism, telepathy, and similar occult operations mainly because these phenomena are comparatively irrelevant. . . . Under these circumstances, one is obliged to look for a possible parallel with Expressionist art.

After suggesting these parallels do we still have to bring in individual examples to clarify them?

The experience of an inner commonality[10] is felt in a deeply moving way when one comes away from the grand, cosmogonic-astrological idea-structure of Däubler, that poet and visionary in one, with his zest for a real mythology and his mystical apprehension of language so incredible for contemporary poetry. The inner commonality is also felt when one explores a world of knowledge arising from an entirely different way, such as Steiner's, which in spite of its total independence generates hundreds of analogies. One recognizes the metaphysical unity of such contemporary revelations by noting that in both cases a delving into the inner self has become creative, by paying attention to the role this atavistic yet totally self-willed recall of ancient states of consciousness plays in the production of our Expressionists as well as in the ideology of fully devel-

oped Theosophists. Let us compare Franz Marc's cosmic animal world to Steiner's experiences in the ethereal and astral plane. The aura of Munch's and Kokoschka's spiritual portraits, the astral color world of Klee and Muche, Chagall's mythical dreams, the way a Kandinsky experiences elementary aspects of water, air and earth in inner color—all of this must seem clairvoyant in the occult sense to the Theosophist. Color also appears to the Theosophist to be the direct manifestation of spiritual essences within the astral plane.

But how does this "clairvoyant" quality come about in the artist? We have no interest in turning the artist into a magician, just as we want to guard ourselves in particular against any immediate confusion of art and mysticism. Rather the artist remains completely in the aesthetic realm, if out of purely artistic considerations, without even knowing about the occult, he redirects his attention from the physical object, from visual content, to "seeing" itself as an inner act of the soul. It is exactly this, however, if we may believe the initiates, that always leads to a kind of colorful, astral clairvoyancy (even within the realm of art one may speak only figuratively).

Such comparisons can easily be carried further. However perhaps for us as historians, psychologists, and friends of the arts, what has been said is sufficient to make us realize the inner connections. But is this kind of understanding also important for the artist? Should our artists perhaps become Theosophists? I believe: no more than they consciously or unconsciously already are! . . . For him [the artist], it may be enough to know that his will (even with all the uniqueness of his creative capacity) does not stand alone and solitary in the present, but that it is embedded in broader, although subterranean, currents of unity.

II. PAINTING

INTRODUCTION

Expressionist painters were conscious that their experiments with intensification of color and form set them apart from the multitude of artists in Germany. They were also well aware that most of the public was bewildered by their work. Many felt compelled to explain their approach in essays, tracts, and manifestoes. Artists like Franz Marc and Ludwig Meidner tried to situate the antinaturalistic, seemingly individualistic direction of their work within the context of a cosmic utopianism or a transnational contemporary urbanism.

Expressionist painters also gave special attention to spatial and textural issues in their essays to emphasize the difference between their oils and the flat patterns of crafts and applied arts. For most German artists and critics, it was crucial to maintain a distinction between high art and applied art. Kandinsky in *On the Spiritual in Art* explained that flatness belonged only to the first stage in the battle against naturalism and explored at great length the importance of creating a new kind of spatial illusion through contrasts of color and line.[11] In response to the Berlin Secession artist Max Beckmann's critique of Blaue Reiter works as too decorative and similar to applied art, Marc related the spatial complexity of their paintings to Cubist constructions.

After the war, discussions of Expressionism continued to focus on abstraction as the least materially specific of styles and, as a result, the most metaphysical. Johannes Molzahn's essay is but one of several that relied on mystical and erotic metaphors to convey the universalism of Expressionist creativity. But such essays were frequently viewed as inscrutable not only by the public but by artists as well, and unwittingly contributed to the renewed interest in a more naturalistic and politically charged art form that emerged in the Weimar Republic.

23. Essays by Franz Marc and Max Beckmann in *Pan*, 1912*

At the time these essays were written,[12] Max Beckmann (1884–1950) was a member of the Berlin Secession and Franz Marc was associated with a newly formed alternate exhibition group, the New Secession. In Marc's defense of the "new painting," he attempts to explore the public's bewilderment over "today's moderns." He points to the artists' inspiration in nature and pays tribute to French antecedents, especially Cézanne. He carefully emphasizes however that his work draws from a tradition that goes beyond any one country or period. Beckmann, on the other hand, attacks the "new painting" for its two-dimensional and decorative quality, associating the works with the applied arts rather than the "fine" arts of painting. For Beckmann and other artists of the Berlin Secession who were competing with the New Secession for the public's attention, the apparent lack of spatial dimensions and the reflection of primitive art disqualifies these works from serious consideration. Although a year earlier references to flatness and rhythmic repetition could be found in a few defenses (based on Symbolist theory) of the new painting, many critics used the label of decorative art to denounce the works of Marc, Kandinsky, and other New Secession artists. Marc's reference to Cézanne and Cubism as interpreters of a "new construction" and his subsequent mention of the plasticity of these works in his rebuttal to Beckmann, was most likely a reference to the painterly heritage that Marc felt he was continuing.

Marc, "The New Painting," *Pan*, March 7, 1912

The nineties of the past century remain the most noteworthy years in the modern development of art, during which French Impressionism consumed itself in its own fire, while out of its ashes, phoenix-like, a swarm of new ideas arose, birds colored with feathers and mystical beaks.

*Franz Marc, "Die neue Malerei," *Pan* 2, no. 16 (March 7, 1912): 468–71; Max Beckmann, "Gedanken über zeitgemässe und unzeitgemässe Kunst," *Pan* 2, no. 17 (March 14, 1912): 499–502; Franz Marc, "Anti-Beckmann," *Pan* 2, no. 19 (March 28, 1912): 555–56. Translated by Barbara Buenger in "Max Beckmann's Artistic Sources: The Artist's Relations to Older and Modern Traditions," Columbia University dissertation (1979; revised 1990). By permission of Barbara Buenger and courtesy of Mayen W. Beckmann.

In art there arose a pressure without equal. It killed the poor, strong van Gogh; Gauguin fled to Tahiti; and Seurat still owed the world his best pictures. Cézanne alone remained strong and fully great and as the mediator between two periods nevertheless created perfected works. But how must he have suffered at this task!

The intelligent Matisse, a character similar to Hodler, avoided this hazard. Neither heeds the anxiety of his period, but both show how the anxiety can heal itself quickly and simply. They do not look far into the future, and underrate the character of the youth whose path today is stony and difficult to follow. Those also did not go too far with Matisse and Hodler, but flocked around Picasso, the Cubists, and the logical interpreters of Cézanne. For in the latter's enchanting works lie latent all the ideas of Cubism and of the new construction with which the new world is struggling.

. . . .

The disagreement begins on this point: who believes he is closer to the heart of nature, the Impressionists or today's moderns? There is no standard by which one could measure this; it stands, though, to substantiate the fact that we believe ourselves in our pictures to be at least as close to the heart of nature as Manet when he sought, in artful rendering, to reveal the outward form and color of the peach or the scent of the rose, and to make their inner secrets perceptible. We even believe that toward this end his means were very insufficient. Cézanne already mused about new means of looking deeper into the organic structure of the object and of ultimately revealing its inner, spiritual meaning.

. . . .

With all respect and deep love for the great Impressionists and plein-airists of the nineteenth century, we even believe that our current ideas of art have precedence in an older tradition and schooling just as much as any. Today we seek under the veil of appearances things hidden in nature that seem to us more important than the discoveries of the Impressionists. . . .

. . . Today the new movement emerges from all quarters with fundamental power and unanimity. It is not a Parisian event, but a European movement.

. . . .

. . . We stand at the beginning of the movement. Only the coming decades, possibly centuries, will teach how deep this effect was.

Doubtless art has lost its actual, everyday character because of this. The man of another profession, who is not constantly preoccupied with these ideas, runs out of breath when he wants to follow art. That is the reason for the often raging mood against us and the spiritual tempo that is taken

in art. This angry mood is deeply painful to us, but it is not within our powers to stem it. We look expectantly towards the coming generation, which will understand and follow us without effort. They will not feel what we have done to our contemporaries: that with one cut we destroyed that entangled knot in which the art concepts of the nineteenth century had become caught. At least we are told we have destroyed this; I believe rather that it fell to pieces itself.

In our time we can only repeatedly protect ourselves against the harsh reproach that attacks the good faith of our creations and considers that we "made" the movement, that we created like the department store artist who always strives for a new sensation for the display window. Does one then seriously believe that we new artists do not produce our forms out of nature, that we do not derive them from nature, just like each artist of every period? There is scarcely a more laughable and ignorant way of putting off our efforts than just this: to reproach us with arrogance and coldness before nature. Nature glows in our paintings as in all art. Only an eye that refuses to see and ignores all memories of art can so grossly misunderstand us.

. . . .

We have another way of fighting against the world of the philistines that will certainly help us to become victorious: we shall set such a wealth of pictures before them that they will soon become shame-faced and dumb.

And where will we obtain these riches?

From all corners of the earth. Art itself comes to our aid: it shows us daily that our ideas and pictures are only instruments of a great new growth that is stirring all over, in places and in lands that never have seen a Picasso or Cézanne. The wind carries these new ideas across the continents. It is of no use to turn against it, for our children come into the world with it, and will stand witness against their fathers.

And the discerning?

Why do they want to force art into definite paths? Can they dictate directions to the free winds? At most they can build refuges—academies—that would afford security to the freezing, aging race. The young will continually bare their breasts to the wind.

Or, speaking without a figure. Nature is everywhere, in us and outside us. However, there is something that is not wholly nature, but rather something that is more its domination and interpretation, whose strength emanates from a stronghold unknown to us: art. Art was and is in its make-up, in every period, the boldest departure from nature and "simplicity," the bridge into the realm of the spirit, the necromancy of mankind. We understand anxiety and incomprehension in the face of its continually new forms, but not criticism.

Beckmann, "Thoughts on Timely and Untimely Art," *Pan*, March 14, 1912

In the last number of *Pan*, Herr Marc spoke not without self-consciousness about painting that he called new.

I happened to recall something said by Cézanne, whom he hails as his special patron-saint, that scarcely agrees with his essay. It is published in Bernard's "Reminiscences" of Cézanne, *Kunst und Künstler*, 1908, p. 426: "He spoke especially disapprovingly of Gauguin, whose influence appeared harmful to him. 'Gauguin loved your painting very much,' I said, 'and often imitated it.' 'Yes, yes, but he did not understand me,' he answered angrily. 'I never wanted that lack of plasticity and modulation, and will never be able to reconcile myself to it; it is nonsense. Gauguin was not a painter, he only painted Chinese pictures.' "

. . . .

I myself worship Cézanne as a genius. In his paintings he was able, in a new manner, to express the mysterious perception of the world that had inspired Signorelli, Tintoretto, Greco, Goya, Gericault, and Delacroix before him.

If he succeeded in doing this, he only had to thank his own efforts of heeding his coloristic visions of artistic objectivity and the feeling for space, those two principles of the plastic arts. Only because of this did he understand how to preserve his good pictures from the dangers of the flatness of the applied arts. His weak things differ little from a tasteful wallpaper or tapestry, whereas his good pictures are magnificent for their greater objectivity and the spatial depth that is dependent on this, and simultaneously contain eternal human values that are typical of the time and place in which he lived.

. . . .

What is weak and too aesthetic about this so-called new painting is that it no longer differentiates between wallpaper or a poster and a "painting." Certainly, even I have pleasant and—if I want and am in the right mood— even mysterious feelings when looking at a beautiful wallpaper. And I also would certainly not deny that a man who designs wallpaper and posters is also inspired in this by nature. But there is a serious difference between this feeling and those that one has before a painting. With the one I have a very general aesthetic pleasure, which a pretty dress, a fine cabinet, or lamp might give me. But a painting suggests to me an individual, organic, and entire world of its own.

Ha, they say, but how can one decide where painting leaves off and applied art begins. With this objection all tedious critics are always most effectively stopped cold.

There is something that repeats itself in all good art. That is artistic sensuousness, bound up with artistic objectivity and the reality of the objects to be represented. When one abandons this, one ends up without fail in the domain of the applied arts.

All great artists, from Signorelli through van Gogh and Cézanne, have always understood how to maintain quality.

And now I also want to speak about quality. Quality, as I understand it. The feeling, namely, for the peach-colored shimmer of skin, for the shine of a nail, for the artistic sensuousness that lies in the softness of the flesh and in the depth and gradation of space, not only on the surface but also in depth. And then above all in the fascination of the materials. The enamel of oils, when I think of Rembrandt, Leibl, Cézanne, or of the brilliant strokes in Hals.

And then I would like to return again to one of the boastings for this art, namely, the one that always represents it as new. I do not consider Gauguin to be an impressive innovator, but nevertheless a person with taste, who understood how to use Cézanne and island motifs to create decorations that were momentarily amusing. What I find weak is his dependency on old primitive styles, which in their time grew organically out of a common religious and mystical national feeling. I find it weak because he was incapable of developing types out of our unclear and torn times that could be for us what the gods and heroes were for those people. Matisse is an even sorrier representative of this ethnology/museum art, Department of Asiatics. And he takes this, second-hand, from Gauguin and Munch. I have already discussed above where I stand on Picasso's Cubism.

. . . .

Only when these united troops for art and arts and crafts have made their framed Gauguin tapestries, Matisse-fabrics, Picasso-chessboards, and Siberian-Bavarian memorial posters for another ten years will it perhaps some day dawn on them that *new personalities* do exist, which, alas, are scarcely modern or timely.

I intentionally say new personalities for that is the only new thing there is. The laws of art are eternal and unchangeable, like the moral law within us.

Marc, "Anti-Beckmann," *Pan*, March 28, 1912

Herr Beckmann has made a reply to my article about "The New Painting"; his ideas, regretfully, do not invite searching discussion. Rather, it gives the impression that Herr Beckmann hardly read my remarks. As evidence I can cite practically every line: for instance, the narrative about Cézanne's judgment of Gauguin, which is well-known to me. However,

I have not cited Gauguin, but rather Picasso and his circle, as the successors of Cézanne. Picasso's entire production emerges as an unceasing study of plasticity and modulation, which was Cézanne's effort as well.

24. Ludwig Meidner, "An Introduction to Painting the Metropolis," *Kunst und Künstler*, 1914*

In November 1912 the Sturm exhibition of the "Pathetiker," the group Ludwig Meidner (1884–1966) formed with Richard Janthur and Jakob Steinhardt, brought Meidner significant attention from the press. While much of it was hostile, the notices from the critics and poets associated with Expressionism were laudatory. Meidner's Berlin studio soon became a focal point for a number of young poets and painters, among them Conrad Felixmüller, Wieland Herzfelde, and George Grosz.[13] Meidner's drawings (fig. 14) and prints appeared in *Der Sturm, Die Aktion, Die Weissen Blätter*, and other Expressionist periodicals.

In this essay, written for an issue of *Kunst und Künstler* devoted to statements from contemporary artists (Heckel and Macke among them) about their goals, Meidner urges artists to focus on the urban environment to find new techniques and subject matter. Influenced by the Italian Futurists as well as the French Cubist Robert Delaunay,[14] Meidner explains that the modern artist has to use creative techniques such as emotive colors, geometric constructions, and diagonal lines to capture the vitality and complexity of the metropolis. Meidner's essay forecasts the emphasis on urban life that would dominate the painterly and graphic output of late Expressionism.

The time has come at last to start painting our real homeland, the metropolis that we all love so much. Our feverish hands should race across countless canvases, let them be as large frescoes, sketching the glorious and

*Ludwig Meidner, "Anleitung zum Malen von Grosstadtbildern," from "Das Neue Programm," *Kunst und Künstler* 12, no. 5 (1914): 312–14; English translation by Victor H. Meisel, *Voices of German Expressionism* (Englewood Cliffs, New Jersey: Prentice-Hall, Inc., 1970), 111–15.

the fantastic, the monstrous and the dramatic—streets, railroad stations, factories, and towers.

A few pictures of the '70s and '80s represented big-city streets. They were painted by Pissarro or Claude Monet, two lyricists who belonged out in the country with trees and bushes. The sweetness and fluffiness of these agrarian painters can also be seen in their cityscapes. But should you paint strange and grotesque structures as gently and transparently as you paint streams; boulevards like flower beds!?

We cannot solve our problems by using Impressionist techniques. We have to forget all earlier methods and devices and develop a completely new means of expression.

First: we must learn how to see more intensely and more honestly than our predecessors. We cannot use the vagueness and fuzziness of Impressionism. Traditional perspective inhibits our spontaneity and is meaningless for us. "Tonality," "colored light," "colored shadows," "the dissolving of contours," "complementary colors," and all the rest of it are now academic ideas. Second—and this is just as important: we must begin to create. We can't simply carry our easel into the middle of a furiously busy street in order to read off blinking "tonal values." A street isn't made out of tonal values but is a bombardment of whizzing rows of windows, of screeching lights between vehicles of all kinds and a thousand jumping spheres, scraps of human beings, advertising signs, and shapeless colors.

. . . .

It is emphatically not a question of filling an area with decorative and ornamental designs à la Kandinsky or Matisse. It is a question of life in all its fullness: space, light and dark, heaviness and lightness, and the movement of things—in short, of a deeper insight into reality.

Above all, three things help us to structure a picture: light, point of view, and the use of the straight line.

Our next problem is how to use light—but not exclusively because we don't react to light as the Impressionists did. They saw light everywhere; they distributed brightness over the entire picture; even their shadows were bright and transparent. And Cézanne went even further. He created a hovering solidity that gave his pictures that Great Truth.

We don't perceive light everywhere in nature, we often see, close up, large planes which seem unlit and motionless; here and there we feel weight, darkness, and static matter. The light seems to flow. It shreds things to pieces. Quite clearly we experience light scraps, light streaks, and light beams. Whole groups undulate in light and appear to be transparent—yet in their midst, rigidity, opacity in broad masses. Between high rows of houses a tumult of light and dark blinds us. Simple planes of light rest on walls. Light explodes over a confused jumble of buildings. . . .

. . . .

The focal point is vital for the composition. It is the most intense part of the picture and the climax of the design. It can be located anywhere, at the center, right or left from the center, but for compositional reasons one generally puts it a little below the center of the picture. You should also make sure that all things in the focal point are clear, sharp, and unmystical. In the focal point we see those lines which are upright as vertical. The farther these lines are from the focal point the more these lines become diagonal. For example, if we stand looking straight ahead in the middle of the street the buildings at the end of the street all appear to be perpendicular with their windows corresponding to ordinary perspective. But the houses next to us—we see them with only half an eye—they seem to totter and collapse. Here lines, although actually parallel, shoot up, steeply cutting across each other. Gables, smokestacks, windows are dark, chaotic masses, fantastically foreshortened and ambiguous.

In the focal point area use a small brush and paint short, violent lines. They must all hit the mark! Paint very nervously, but as you get closer to the edge of the picture paint in a more broad and general fashion.

Formerly people kept saying: there are no straight lines in nature, free nature is unmathematical. People had no use for the straight line and Whistler dissolved it into many small parts. . . .

But modern artists are the contemporaries of the engineer. We see beauty in straight lines and geometric forms. Incidentally, the modern movement of Cubism has a pronounced preference for geometric forms. In fact they consider these to be more important than we do.

Our straight lines—especially those used in prints—should not be confused with the lines which master masons make with T-squares on their plans. Don't be fooled. A straight line is not cold and static! You need only draw it with real feeling and observe closely its course. It can be first thin and then thicker and filled with a gentle, nervous quivering.

Are not our big-city landscapes all battlefields filled with mathematical shapes. What triangles, quadrilaterals, polygons, and circles rush out at us in the streets. Straight lines rush past us on all sides. Many-pointed shapes stab at us. Even people and animals trotting about appear to us as so many geometric constructions.

Take a big pencil and cover a sheet with vigorously drawn straight lines. This confusion, given a little artistic order, will be much more vital than the pretentious little brushings of our professors.

There isn't much that has to be said about color. Take back all the colors of the palette—but when you paint Berlin use only white and black, a little ultramarine and ochre, and a lot of umber. Don't bother about "cold" or "warm" tones, about "complementary colors" and such humbug—you aren't Divisionists—but let yourself go—free, uninhibited, and without a care in the world. What really matters is that tomorrow hundreds of

young painters, full of enthusiasm, throw themselves into this new area of expression. I have offered only a few suggestions and ideas here. One could just as well do it in a different way, perhaps better and more convincingly. But the metropolis has to be painted!

The Futurists have already pointed this out in their manifestoes—not in their shabby goods—and Robert Delaunay three years ago inaugurated our movement with his grand visions of the "Tour Eiffel." In the same year, in several experimental paintings and in a few more successful drawings, I put into practice what I advocate here in theory. And all the younger painters should get to work immediately and flood all our exhibitions with pictures of the metropolis.

Unfortunately, all kinds of atavistic ideas confuse people these days. The stammerings of primitive races have impressed some of the young German painters and nothing seems more important to them than Bushman painting and Aztec sculpture. Some also echo the pompous speeches of sterile Frenchmen about "absolute painting," about "the picture," etc. But let's be honest! Let's admit that we are not Negroes or Christians of the early Middle Ages! That we are inhabitants of Berlin in the year 1913, that we sit in cafes and argue, we read a lot and know quite a bit about art history; and we all have developed out of Impressionism! Why then imitate the mannerisms and points of view of past ages, why proclaim incapacity a virtue? Are these crude and shabby figures that we now see in all the exhibits really an expression of the complicated spirit of modern times?!

Let's paint what is close to us, our city world! the wild streets, the elegance of iron suspension bridges, gas tanks that hang in white-cloud mountains, the roaring colors of buses and express locomotives, the rushing telephone wires (aren't they like music?), the harlequinade of advertising pillars, and then night . . . big city night. . . .

Wouldn't the drama of a well-painted factory smokestack move us more deeply than all of Raphael's "Borgo Fires" and Battles of Constantine?

25. Johannes Molzahn, "The Manifesto of Absolute Expressionism," *Der Sturm*, 1919*

Johannes Molzahn (1892–1965) was part of the Sturm circle during the war and immediately thereafter. This essay, written for a Sturm exhibition in the fall of 1919, reflects Molzahn's erotic mysticism.

*Johannes Molzahn, "Das Manifest des absoluten Expressionismus: zur Ausstellung Oct. 1919," *Der Sturm* 10 (1919/1920), no. 6, 90–93.

It calls upon artists to capture the pulsating energy of the universe and to become a symbol of the "cosmic will." Molzahn believed that art must manifest Earth's cycles of creation and destruction, and in his predominantly abstract paintings (fig. 15), he used signs such as arrows and swords obscured by painterly colored circles radiating diagonally from the center of the paintings to convey the vital energy of the universe.

Like many painters caught up in the utopian optimism of the time,[15] Molzahn answered the invitation from Walter Gropius, Bruno Taut, and Adolf Behne for both architects and non-architects to exhibit together visionary drawings for monumental temples of the future. Molzahn's drawing of a crystalline tower shape (fig. 36), which appeared in their April 1919 Exhibition of Unknown Architects, is often reproduced as an example of the interchange among the various arts at the beginning of the Weimar Republic. Molzahn lived in Weimar and occasionally produced a print for a Bauhaus portfolio but did not became a member of that school's faculty as did so many other Sturm artists.

<p style="text-align:center">****</p>

The earth quakes—sways—making space resound with its pulse. It is shaken to its very axis for—HE—the ETERNAL (ONE)—touched its body.

Centuries—millennia wither at the sight of HIM.—His blood has singled us out—pulled us forward.—HE the great Expressionist.—We—enraptured—by HIM—we rejoice in HIS path—.

Path HE was on.—

We rejoice for you!

The work—to whom we—as painters—sculptors and poets—are bound—is the immense energy of such events—it is cosmic will—ardor of ETERNITY.—Living arrow—aimed at all of you.—It should penetrate you—make your blood glow,—so that it may flow livelier and more quickly—glow more brightly into ETERNITY.

Suns and moons are our [inspirational] images—that we extend toward you. Starry banners of eternity—flowering toward you.—Between beginning and end—thrown between peak and abyss,—no heritage—no property—is worth our while.—We bear tidings of great joy.

An attempt was made to deceive us, like you, with idleness.—But we leapt free of this lie—this fraud.—The mirror—held up to us—We shattered it.—All idle magic;—the marks of defacement are hard to hide.—Distress is crying out all around us.

On ruins and shards we prepare our work—we want to make our way to the stars fighting.—

No longer is there an I—or a you—All purpose—goals—hinder the flow of ETERNITY.—The day now done—the hour past—nothing holds us there anymore.

Centuries—millennia—hammering—glowing toward us—driving their energies into ETERNITY!

Every work of art a flaming mark of the ETERNAL.—No work—could have been born—if not set aglow in the struggle.—Thus we praise the struggle—the wild thundering music of the fight.—The screaming blood.—The sword—singing and rejoicing through space—tense with destruction.

The redhot train of events—its axis—emptying out the depths.—Poles—that are within mankind.—All of this must be made manifest—by our pictures—our sculptures—our poetry.

The dead formula is our contempt—We want to point the way toward living growth, and so pull back a springboard to the ETERNAL. We rejoice in the elements—the ones we wrestle with—the ones that shake and consume us.—The striking energy of the poles—how they attract, and reject—each other—again and again.—

The pulsating orbits of the stars—their flaming energies—being consumed and reborn in everlasting catastrophes.—The quaking rotating earth—its creatures.—Races—colliding with one another like elements—caroling their daggers into the blood—tearing at the secret—knots—tying into destiny—like a sword—hanging threateningly overhead.—Living and consuming path.

We praise the splendid male giant—cutting space like a shaft.—Leap and pole.—redhot sword.—before which all seals open—which bores its point into the body—probing and thrashing at all depths—pulsating chaos—powerful quiver—receptive body.

We praise the mother—succumbing under the enormity of the event—under the burden of blood.—the bearing womb opened—expires—bearing the fruit to the ETERNAL [ONE],—her necessity dies.

No work of art—less profoundly, passionately alive—born from such distress.—Only through the path of blood can the work make the blood glow—grasp and hurl—tear at the ETERNAL.

We greet and praise the instinct of the world—the living events in man.—It is not our most elemental brother—the one rushing toward us? The great cosmic wave—which HE—flung into space—the earth—to overturn—to confront—mankind.

We want to pour oil into the fire—blow the sparkle into a spark and the spark into a flame—that will reach 'round the globe—make it beat more powerfully—and quake most forcefully—living, pulsating—steam-

ing cosmos.—We want to drive the wedge with growing force—drive on forever.—Mightier—more and more powerful we want to span the arc of energy—rip across the earth—whip the blood so it screams.

With the mark of the ETERNAL—man should be designated—marked with glowing stars.—By leaps and bounds into millennia.—Spiraling into ETERNITY.

This potent manifesto—this flaming banner—aimed for the stars—towering above!—We want to unfold it and stretch it across the pulsating earth—as the living symbol—of the cosmic will—of the energy streaming in the cycle of events.

We greet you—you, storming toward us.—We greet the stars.—The event of man—whose distress we grasp. We go, openly, through our work to meet you.

III. SCULPTURE

by Stephanie Barron

INTRODUCTION

Many of the best-known Expressionist artists experimented, albeit often briefly, with a plastic interpretation of their work, and many lesser-known second-generation Expressionists worked vigorously in the medium. Unfortunately many of the sculptures have been lost; some did not survive the wars; some were probably not even cast, since the artists lacked support for expensive bronze editions.[16] During the teens and twenties there were very few exhibitions that included sculpture by painters or printmakers, and only a few articles discussed this aspect of Expressionism. Most of the Brücke artists, for example, experimented with wood carving; yet only Heckel and Kirchner exhibited any of their sculpture.[17] Much of the woodcarving done by the Brücke or Blaue Reiter artists falls into the category of *kunsthandwerk* and was executed more for personal use and appreciation. Yet there once existed a body of large-scale carvings by Kirchner, Heckel, Schmidt-Rotluff, and Pechstein.

Following the November Revolution of 1918 and into the twenties, short-lived radical artist groups like the Novembergruppe or the Arbeitsrat für Kunst encouraged experimentation in all the arts. The combination of Expressionist, Cubist, and Futurist ideas promoted by several of these groups seemed to find a natural outgrowth in sculpture.

Expressionist sculpture usually involves the human image, often protesting against existing conditions. Much of the sculpture appears monumental in scale if not in actual size. The works are predominantly carved, frequently from found pieces of wood, rather than modeled or cast. Their forms are elongated and attenuated, and the sculptures are marked by their direct color, irregular outline, and rough textures. The sculptors shared with Expressionist painters an interest in the art of non-Western cultures, which they saw in the great museum collections in Dresden and

Berlin, or while traveling. Spiritual themes—the psychic turmoil of man, evocations of political and social chaos, and even specific religious concepts—were as important to the sculptors as they were to others of the Expressionist generation.

26. Ernst Barlach, excerpts from letters and diary, 1911–15*

Ernst Barlach (1870–1938), one of the best known of the German Expressionist sculptors, was also respected as a printmaker, playwright, and essayist. In his sculptures he transformed the human figure, particularly that of peasants and beggars, into heroicized monumental types. Although critics referred to Barlach's sculpture as Expressionist,[18] he rejected the label[19] because he equated it with abstraction, which he did not feel communicated universal, timeless feelings. He strove to evoke the primeval and the elemental in his work and turned toward Gothic[20] and non-Western sources after abandoning classicism and conventional naturalism. The 1911 letter to the collector Wilhelm Radenberg reveals with great clarity these attitudes and interests.[21]

During the war, the figures he sculpted, such as *The Berserk One, No. 3, The Avenger* (fig. 16),[22] and depicted in lithographs for Paul Cassirer's periodical *Kriegszeit* (War-time),[23] portrayed the suffering and emotional intensity of outrage, poverty, and human loss. His letters to his cousin, to the sculptor and printmaker August Gaul (who also contributed prints to *Kriegszeit* and to *Der Bildermann*), and to the millenarian Arthur Moeller van den Bruck reflect Barlach's concerns, indicating his progression from support of the war to disillusionment, and then to opposition.

*Barlach letters to Wilhelm Radenburg, Aug. 8, 1911; to Karl Barlach, Aug. 17, 1914; to August Gaul, Dec. 15, 1914; to Arthur Moeller van den Bruck, Mar. 9, 1915; reprinted in Ernst Barlach, *Die Briefe* 1 (1888–1924), ed. Friedrich Dross (Munich: R. Piper & Co. Verlag, 1968), 375–78, 431, 434–35, 438–39; diary entry from Sept. 5, 1914, reprinted in Ernst Barlach, *Prosa* 2, ed. Friedrich Dross (Munich: R. Piper & Co. Verlag, 1959), 43.

Letter to Wilhelm Radenberg

Gustrow 8-8-1911

My Dear Herr Doctor,

Of course I would be happy to send you some photographs. However, I'm a little hesitant about the seven sketchbooks, because there is a world of difference between my showing you the single pages to get a sense of each booklet and imagining you having to work your way through such a maze of half-finished and incomprehensible drawings. But I do believe the material is good, and I will send it to you, because I would like to demonstrate that I haven't simply taken my method over, finished, from somewhere, like the Japanese, as some people say. Although I neither can nor want to deny that Egyptian and Indian art have impressed me deeply, still all my significant inspiration comes from nature; and I am comfortable with the idea of absorbing a kind of inner condition from those periods in art with which one feels some empathy in tone and expressive manner. To really unburden myself about this I would have to write a whole essay.

However, I do admit that I feel uncomfortable with the "classical," because I've always found my deepest longings to be better fulfilled elsewhere, even if it be in Negro and Indian sculpture. Nature often combines solemnity and ease, the grotesque and the humorous all in one object and in one line. If you mistrust my perception, then I ask you to please compare the pencil sketch in my Russian notebook—the "Fat Beggar Woman"—with the sculpture it eventually became. I altered nothing that I saw, I simply saw it like that because I saw the repulsive, the comical, and (I'll say it boldly) the Godly at the same time.

. . . I would really like to express sculpturally in an elemental way what I remember from my earliest youth of the low-German breed of humanity, not the individual per se, except only occasionally, because they are all too conventional now—but their legacy of soul, their portion of the mythological, which extends to the heights and depths. Of course I admit that I hardly have the right connections to European liberalism. I actually feel more psychically akin to the Russian, the Asiatic who can only be understood mystically, than I do to a typical, educated contemporary person. The human phenomenon has always risen up before me in a terrifying way, an uncanny mystery. I saw in people the damned, the bewitched, but also the fundamental being. How can I depict these things with conventional naturalism? I sensed something like a mask in appearances and am attempting to look behind the mask, so how can I hold myself to the details of the mask? Of course I know that the mask grew

organically on the essential being, and so I am thrown back on it after all. So I had to find the means to represent the way I felt and what I suspected instead of what I saw, and still use what I saw as a means. You will say this overcomplicates things, and in fact I really did work for the most part without hesitations, trusting my good star, with only occasional thoughts like the above. In the end I had more and more to realize that the face does not reveal itself in all things if one doesn't show one's own face, nor can one change the fact with sly tricks and spying. In short, the visible became my vision, and I will freely admit that despite all the big words very little came of it. I am writing so much to you, even though I never permit myself such self-observation, because I am anxious to put these Eastern "sources" somewhat in the background, even though they, like the Gothic and the Etruscan, play their parts.

. . . .

Naturally I feel like a modern artist, but I could not dare to tell you in what way, it is enough that I feel the compulsion.

. . . .

. . . And I really believe with all my heart that I am chosen to portray a stylized humanity. Truly I feel that for sculpture mankind is the only possibility, which could be raised into the monumental, shaken by fate or surpassing itself through selflessness. In short, mankind could be set in some kind of connection with the great eternal concepts, which soar above the misery peculiar to any one time, and whose expression of joy and suffering can not be treated with condescension. However, I stand just at a beginning.

Would you please be so kind as to send the things back that I am enclosing after you have looked them over, but there is no hurry.

<div align="right">

Respectfully,
E. Barlach

</div>

Letter to Karl Barlach,

<div align="right">

Gustrow, Aug. 17, 1914

</div>

Dear Cousin,

. . . It is absolutely impossible to work in these times. All in all, I am fortunate not to have slept through them. To my way of feeling, it [the war] is a deliverance from the eternal ego concerns of the individual, thus an extension and elevation of the people.

Diary entry Sept. 5, 1914

News: nothing but confirmation and expansion. I was working on my storming *Berserk One* and he is beginning to be important to me. Could it be possible that a world war is being conducted and I forget it over a hundred-pound image in clay? For me, the *Berserk One* is war crystalized, the attack against all obstacles, so that one believes in it. I had already begun it once before, but abandoned it because the composition seemed to break apart, now the unbearable is necessary for me.

Letter to August Gaul,

Gustrow, Dec. 15, 1914

Dear Gaul,
 . . . Yes, it is with me as with you, one is not in one's right mind, so to speak, sculpture is also impossible for me as a daily occupation. . . .

. . . I am very happy that you are etching, for one because of the prints and then for your sake. I have found another way out, namely a literary one, and write, so to speak, a war chronicle of Gustrow, or better, my Gustrow observations and imagine that it will provide me much amusement in later days. One does such things instinctively and thereby comes upon that which is completely correct. . . .
 I should, according to Gold's[24] wish, draw a Christmas print, but nothing comes to me. *The Berserk One*, "*Holy War*," is after a sculpture, but not from the best angle. I had, however, to accommodate to the requirements of the format, otherwise I would have taken the side view. . . .

Letter to Arthur Moeller van den Bruck,

Gustrow, March 9, 1915

Dear Herr Moeller-Bruck,

Yes, the war, what is to be said? The slaughter must continue until the victim no longer struggles. The mammoth stands on three legs and hobbles, but it can still trample well enough and, above all, trumpet. I am annoyed with *Kriegszeit*. That I must let myself be bullied into participating completely against my own feeling is bad enough. That Mr. Gold then shelved my drawings for ten weeks does not amuse me. *A Mass Grave*,

which he has, he will not publish. He is afraid. On the other hand, he did the lousy Warsaw beggar woman with lightning speed, and left behind an Assault, of which I still have many, or could make a lot. In the meantime I have come to the opinion that for the present the war is no motif. The present time confirms my first opinion. The mountains totter in the struggle of the masses, and one should produce lithographs that are ready for the press, harmless to the censors!

27. Carl Einstein, from *Negerplastik*, 1915*

Carl Einstein (1885–1940), art historian, novelist, and critic, had close contacts with many of the major artists and writers associated with Expressionism. Before the First World War, Einstein frequented both Sturm and Aktion circles, although he published more frequently in *Die Aktion*. Marc and Kandinsky planned to have Einstein contribute an essay to their proposed second volume of the *Blaue Reiter* almanac. After the war, Einstein was involved with Berlin Dada and contributed to the illustrated semi-monthly *Die Pleite* (Bankruptcy) and also coedited the short-lived satirical weekly *Der Blutige Ernst* (Deadly Earnest) with George Grosz.[25]

Einstein had studied art history, philosophy, and history in Berlin from 1904 to 1908 and established his reputation as a novelist with the publication of *Bebuquin* in 1907. In 1914 he produced the first German edition of van Gogh's letters. Einstein is best known for his 1915 treatise *Negerplastik*, which was the first book in Germany to examine the aesthetic and exotic power of African sculpture. Visits to the Museum für Völkerkunde in Berlin and short trips to Paris, where he met Picasso, Braque, and the dealer Daniel Henri Kahnweiler, strengthened his interest in tribal art. Einstein viewed the sculpture of Africa as a carrier of metaphysical and magical properties.[26] Determined to explain how the lack of naturalism enhanced the transcendental quality of these sculptures, he examined the cubic, spatial, and compositional elements that contributed to the emotive power of the African works.

*Carl Einstein, *Negerplastik*, 1st ed. (Leipzig: Verlag der Weissen Bücher, 1915); 2d ed. (Munich: Kurt Wolff Verlag, 1920) [translated by Joachim Neugroschel]. Excerpted from Stephanie Barron, *German Expressionist Sculpture* (Chicago: The University of Chicago Press and Los Angeles: Los Angeles County Museum of Art, 1983). © 1983. Neugroschel © 1983. All rights reserved.

Religion and African art

African art is, above all, religious. The Africans, like any ancient people, worship their sculptures. The African sculptor treats his work as a deity or as the deity's custodian. So, from the very beginning, the sculptor maintains a distance from his work, because the work either is or contains a god. The sculptor's labor is adoration from a distance. And thus the work is, a priori, independent. It is more powerful than its maker, who devotes his full intensity to the sculpture and thus, as the weaker being, sacrifices himself to it. His labor must be described as religious worship. The resulting work, as a deity, is free and independent of everything else. . . .

. . . .

A characteristic feature of African sculpture is the strong autonomy of their parts. This too is determined by religion. The sculptures are oriented not toward the viewer but in terms of themselves; the parts are perceived in terms of the compact mass, not at a weakening distance. Hence, they and their limits are reinforced.

We also notice that most of these works have no pedestal or similar support. This might come as a surprise, since the statues are, by our standards, extremely decorative. However, the god is never pictured as anything but a self-sufficient being, requiring no aid of any kind. He has no lack of pious, venerating hands when he is carried about by the worshiper.

Such an art will seldom reify the metaphysical, which is taken for granted here. The metaphysical will have to be manifested entirely in the complete form, concentrated in it with amazing intensity. That is to say, the form is treated in terms of extreme self-containment. The result is a great formal realism. . . . Formal realism, which is not construed as imitative naturalism, has given transcendence; for imitation is impossible: whom could a god imitate, to whom could he subjugate himself? The result is a consistent realism of transcendental form. The artwork is viewed not as an arbitrary and artificial creation, but rather as a mythical reality, more powerful than natural reality. The artwork is real because of its closed form; since it is self-contained and extremely powerful, the sense of distance will necessarily produce an art of enormous intensity.

. . . .

For the artwork to have a delimited existence, every time-function must be omitted; that is, one cannot move around or touch the artwork. The god has no genetic evolution; this would contradict his valid existence. Hence, the African has to find a depiction that, without the use of surface

relief, shows a pious and non-individual hand and instantly expresses it in solid material. The spatial viewing in such an artwork must totally absorb the cubic space and express it as something unified; perspective or normal frontality is out of the question here, they would be impious. The artwork must offer the full spatial equivalent. For it is timeless only if it excludes any time-interpretation based on ideas of movement. The artwork absorbs time by integrating into its form that which we experience as motion.

Viewing cubic space

African sculpture presents a clear-cut establishment of pure sculptural vision. Sculpture that is meant to render the three-dimensional will be taken for granted by the naive viewer, since it operates with a mass that is determined as mass in three dimensions. This task appears to be difficult, indeed almost impossible at first, when we realize that not just any spatiality, but rather the three-dimensional, must be expressed as a *form*. . . .

Frontality almost cheats us of the third dimension and intensifies all power on one side. The front parts are arranged in terms of one point of view and are given a certain plasticity. The simplest naturalistic view is chosen: the side closest to the viewer, orienting him, with the aid of habit, in terms of both the object and the psychological dynamics. The other views, the subordinate ones, with their disrupted rhythms, suggest the sensation that corresponds to the idea of three-dimensional motion. The abrupt movements, tied together mainly by the object, produce a conception of spatial coherence, which is not formally justified.

. . . .

Clearly, form must be grasped at one glance, but not as a suggestion of the objective; anything that is an act of motion must be fixed as absolute. The parts situated in three dimensions must be depicted as simultaneous; that is, the dispersed space must be integrated in the field of vision. The three-dimensional can neither be interpreted nor simply given as a mass. Instead, it has to be concentrated as specific existence; this is achieved when that which produces a view of the three-dimensional and is felt normally and naturalistically to be movement is shaped as a formally fixed expression.

. . . .

The African appears to have found a pure and valid solution to this problem. He has hit upon something that may initially strike us as paradoxical: a formal dimension.

The concept of the cubic as a form (only with this concept should sculpture be created, not with a material mass) leads directly to determin-

ing just what that form is. It is the parts that are not simultaneously visible; they have to be gathered with the visible parts into a total form, which determines the viewer in a visual act and corresponds to a fixed three-dimensional viewing, producing the normally irrational cubic as something visibly formed. . . .

. . . .

Such a sculpture is strongly centered on one side, since this side manifestly offers the cubic as totality, as a result, while frontality sums up only the front plane. This integration of the sculptural is bound to create functional centers, in terms of which it is arranged. These cubic *points centraux* [central points] instantly produce a necessary and powerful subdivision, which may be called a strong autonomy of the parts. This is understandable. For the naturalistic mass plays no part, the famous, unbroken, compact mass of earlier artworks is meaningless; moreover, the shape is grasped not as an effect, but in its immediate spatiality. The body of the god, as dominant, eludes the restrictive hands of the worker; the body is functionally understood in its own terms. Europeans frequently criticize African sculpture for alleged mistakes in proportion. We must realize that the optical discontinuity of the space is translated into clarification of form, into an order of the parts, which, since the goal is plasticity, are evaluated differently, according to their plastic expression. Their size is not crucial; the decisive feature is the cubic expression assigned to them and which they must present no matter what.

28. [Rudolf Blümner], "Expressionist Sculpture," 1917, and Oswald Herzog, "Abstract Expressionism," 1919*

In the special promotional pamphlet Rudolf Blümner wrote for Walden's *Der Sturm*, he divided the achievements of Expressionism into separate catagories, by medium. In addition to segments on painting and on the poetry reading evenings, Blümner included a segment on sculpture. He explains that Expressionist sculpture, like Expressionist painting, is not concerned with the imitation of na-

*[R. Blümner], "Die expressionistische Plastik," *Der Sturm: Eine Einführung* (Berlin: Der Sturm, 1917), 6. Oswald Herzog, "Der abstrakte Expressionismus," *Der Sturm* 10, no. 2 (May 1919): 29.

ture. Instead it follows transnational principles that derive from Egyptian, African, and other primitive sources. Blümner's singling out Alexander Archipenko, the Russian artist living in Paris, as the most characteristic Expressionist sculptor is a clear reminder of how critics in Walden's circle did not consider Cubistic and Futuristic shapes as separate and distinct from Expressionism.

Blümner identified Oswald Herzog (1881–?) as the major Expressionist sculptor (fig. 17) in Germany.[27] Herzog had contributed woodcut illustrations to *Der Sturm* in 1917 and 1919 and was a member of the Novembergruppe. In the text reprinted here, Herzog focuses on what he sees as the final stage of Expressionism, its abstract phase. According to Herzog, abstract expressionism evolved from naturalism by way of Cubism and primitivism. Herzog belongs to the line of German critics for whom Cubism and Futurism were viewed as steps leading to Expressionism and abstraction. He also belonged to the Germanic tradition stemming from Alois Riegl in which the artist's choice of forms was understood to be guided by the metaphysical will of an age.

[Rudolf Blümner], "Expressionist Sculpture," 1917

Expressionist Sculpture, too, strives not to imitate forms in nature, but to create absolute forms instead. Just as painting relies on the flat surface as the basis for artistic creation, so sculpture also requires corporeal form as a foundation. Its process, however, does not lie in the imitation of nature, but in the interrelation of individual sculptural forms.

The first Expressionist sculptor of great significance is Alexander Archipenko. His figures and groups do not represent the human figure. Although they are derived from the concrete human shape, they are simplified or altered according to the higher principles of plastic formal relationships, which the Egyptians, the primitives, and the Africans also used to create their masterworks.

Germany, too, has in Oswald Herzog a sculptor who, for the first time in centuries, is reviving the great plastic traditions.

Oswald Herzog, "Abstract Expressionism," 1919

Expressionism is expression of the spiritual in form. Form is the rhythm of movement. The formal qualities of the visual arts are: line, plane, and

color. Abstract Expressionism is perfected Expressionism—the purity of creation. It creates substance from spiritual events, it creates objects and does not use objects—as such. Objects in themselves are already whole complexes of expressive acts of movement.

The object still serves as a form for material Expressionism, which abstracts the essence of an object by eliminating everything non-essential, thus achieving purity and greatness. It is the aftereffect of an object—the creative process in the past tense. Abstraction reveals the will of the artist; it becomes expression. With his will the artist forces participation.

Abstract Expressionism is the creation of events—life as such; it is creation in the present tense. The artist's intuition has no vision of objects. Life demands only creative action. The artist gives birth to forms that are and must be bearers of his experience. Nothing is whim, all is will. Will is art.

Creation of events in abstract form is nature giving birth. It is an evolving of objects that have not been taken from nature but are related to nature. This relationship comes from the unity of all encompassing life— the rhythm of life. Never will objects be created that have no relationship to nature whatsoever. Even the most uninhibited creative form—the creation of the object in itself—the play of fantasy—an intellectual Impressionism—will always find its objective correlative where natural life has been destroyed—in chaos—where the will has been annihilated and where each is left to his own devices. Intellectual Impressionism is the game artists play with forms in whimsical fashion. It is a purely personal matter that does not demand participation; the form-giving conviction is missing. To sense beauty in the freedom of fantasy is a flattening out of art, something we have just recently experienced in Realism. Beauty in a general sense is decorative—superficial—spirituality. Absolute beauty is in the will. Where there is no will there is chance: chance is chaos— disorder—the lack of organic life. Every great art epoch has its creative will—in the form of creative innovation.

Abstract Expressionism is the evolution of Naturalism, which is derived from the revolution of Cubism and Primitivism. Any escape into previous art forms was an artistic whim—fashion—and not art. Solely the reaction to Naturalism produced Cubists and Primitivists. In reliving older forms of art they become one-sided stylists. If one wishes to relive art, then one cannot simply decide to ignore the art of the Baroque and Rococo. Or is it being reserved for a grander artistic whim? The rhythm of Baroque and Rococo is really a form just as powerful as the rhythm of Egyptian and Archaic art. The one-sided reliving of previous art forms does not have much in common with the spiritualization of art. Futurism evolved from a purely spiritual creative impulse. It seeks form-giving expression through objects. Objects, however, are already formed. Therefore the parable—

the emblem—is used; Futurism is narrative but does not exist in itself. Art itself creates events.

29. L. de Marsalle [E. L. Kirchner], "On the Sculpture of E. L. Kirchner," *Der Cicerone*, 1925*

Louis de Marsalle was the pseudonym adopted by Ernst Ludwig Kirchner for several essays and articles he wrote about his own work.[28] Kirchner created a French critic who openly admired his German style. Although he never revealed his reasons for adopting this disguise, it is generally thought that it was a conscious attempt to counter the widely held Francocentric view of modern art. Although Kirchner had begun making wood carvings (fig. 18) before this article, he had rarely exhibited his sculptures and they had not been included in Kirchner literature.

Kirchner moved to Switzerland in 1917, where he continued to carve not only sculptures but also furniture for his house in Davos. He found a receptive audience for his work among the young artists in Basel, who formed a group *Rot-Blau* (Red-blue) in the image of the Brücke. In 1925 this group, whose chief members were Hermann Scherer and Albert Müller, held an exhibition of their paintings and painted wood carvings.[29] Perhaps anxious that the public would not realize who was the master and who were the students, Kirchner employed his pseudonym once again when he wrote about his sculptures in *Der Cicerone*.

When one frequents the workshops of creative artists, one often experiences surprises. When I visited the studio of E. L. Kirchner one day, I found there a number of sculptures of all sizes and of different kinds of material—sculptures Kirchner was using to explain his idea of sculptural form to a young artist.

Although some museums and private collectors own a few of his pieces, Kirchner's plastic work is almost unknown, and I believe it is finally time

*L. de Marsalle, "Über die plastischen Arbeiten von E. L. Kirchner," *Der Cicerone* 17, no. 14 (1925): 695–701. Excerpted from Stephanie Barron, *German Expressionist Sculpture* (Chicago: The University of Chicago Press and Los Angeles: Los Angeles County Museum of Art, 1983). © 1983. Neugroschel © 1983. All rights reserved.

to publish something in relation to it. Kirchner's sculpture is not only of great importance in regard to his own work but during the past years has also had a stimulating effect on a number of young artists. Thus it seems to be in a position to initiate a new movement in the very backward sculpture of our time. As far as I know, Kirchner is in our day the only sculptor whose forms cannot be traced back to classical antiquity. Just as in his paintings, he gives his experiences direct form in characters taken from contemporary life. His sculpting began simultaneously with his painting, thus going back to the year 1900. Both modes of artistic expression ran so closely parallel to one another and so completed each other that, in many cases, the same problem is addressed in the paintings as in the sculptures. Kirchner's still lifes and interiors often contain figures that he has sculpted earlier. Thus he transposed a form from one mode of artistic expression to another, until he found the solution offering the strongest expression. In this manner Kirchner gained the insight that the intensive study of nature and the assistance of the imagination could create a new form far stronger and of more intense effect than a naturalistic rendition. He discovered the hieroglyph and enriched our modern period with an important means of expression, just as in their own time Seurat invented the *touche*, the breaking up of color, and Cézanne the system of the cylinder, cone, and sphere.

Kirchner's sculptural efforts, which extend over a period of twenty-five years, very clearly show his development in this respect. . . .

It is most significant that from the very beginning Kirchner rejected as inartistic a working method generally practiced by sculptors today: namely, proceeding from a clay model by way of a plaster impression to the actual material. He creates his figures directly out of the material. One has to realize that in the case of the old working method, only the clay model is actually created by the artist, whereas the end result and all work toward it are done by other hands. In light of this, the dismal uniformity of our sculpture exhibitions becomes readily comprehensible, and in viewing the sculptures one often asks oneself for what in these works of art the artist is actually still responsible. In the case of sculpture the material is far more decisive than in painting; and the sculptor leaves it to other hands to fashion this material. How different that sculpture appears when the artist himself has formed it with his hands out of the genuine material, each curvature and cavity formed by the sensitivity of the creator's hand, each sharp blow or tender carving expressing the immediate feelings of the artist. . . .

What would one have to say concerning paintings for which the painter provided only outlines, specifying which colors were to be applied within them, but leaving the execution to an assistant? For in painting, this would be analogous to what is today standard practice in sculpture.

In sculpture Kirchner discovered very important laws: above all, the

overriding importance of the large, total form and its creation from the proportions of the individual forms. He sculpts the wood block according to its nature, forming the small form out of the large. He finds a method by which the changed proportions may remain subservient to the overall composition. . . .

. . . .

He also places color in the service of his sculpture. With complete freedom and detachment from imagery, it is employed to heighten and accentuate the sculptural idea. . . .

Kirchner's sculpture works mainly with simple basic shapes: cylinder, cone, egg-shape, and sphere. Cube and oblong occur more indirectly as forms of composition. These simple forms do not originate from mathematical speculation, but rather from a drive toward monumentality. Kirchner desires and forms men and beings, not soulless artistic shapes. This alone distinguishes his works from the rest of modern sculpture, which, with a few exceptions, is oriented more or less toward arts and crafts.

Kirchner is one of the very few contemporary artists who is gifted enough to create new forms and a new style. But his works also have a spiritual message. That is their specifically German quality. They mean something, one may think of something when viewing them, yet they are not literary. A work such as *Friends* would be wonderful in a modern meeting room of modern men, because of its external shape as well as its spiritual meaning. The material that Kirchner most prefers is wood. He also likes to work in stone, and a few figures from his hand are cast as well.

IV. EXPRESSIONIST ARCHITECTURE

by Rosemarie Haag Bletter

INTRODUCTION

One of the earliest examples of Expressionist architecture is Bruno Taut's Glass House (fig. 19), a small pavilion designed for the 1914 German Werkbund Exhibition in Cologne. It was created under the influence of the Expressionist writer Paul Scheerbart as a metaphor for spiritual transformation. Taut was also inspired by contemporary Expressionist painting, in particular Kandinsky's abstractions.

As architecture is more obviously tied to materials and mass than painting, mystical abstraction or emotive expression was attained primarily in architectural drawings during and immediately after World War I, when there were few commissions and when architects consequently could give free rein to the imagination. In describing the new tendencies in architecture, Taut in his 1914 essay "A Necessity" used such terms as expression, dynamics, and rhythm. His close friend, the critic Adolf Behne, specifically contrasted Expressionism with Impressionism in architecture in an article of 1915, "Expressionist Architecture."[30] The most intense period of Expressionism in architecture occurred between 1918 and 1920, when even such an architect as Ludwig Mies van der Rohe was briefly touched by it. The result was his splendid designs for glass skyscrapers, published in Taut's magazine *Frühlicht* (Dawn), the only periodical to deal exclusively with Expressionist architecture.[31]

Immediately after the revolution of 1918, the tension between the Weimar Republic's high expectations for a new society and the stark realities of the period were responsible for Taut's utopian tracts and for the formation of such groups as the Arbeitsrat für Kunst and the Glass Chain (Gläserne Kette). While Taut was the polemical center of the Expressionist

movement, Eric Mendelsohn in a series of sketches created extraordinarily powerful architectonic forms.

It is difficult to pinpoint Expressionist architecture as a distinct set of formal procedures. Designs range from the geomorphic to the biomorphic. What truly tied the various factions together was a shared ideology, the desire to counteract the excesses of a prevailing materialism and positivism. Expressionist architecture is the first movement with a full-fledged critique of a progressivist, technocentric modernism.

The years between 1920 and 1923 were marked by a gradual transition back to normalcy and a realization that the revolution had not brought about a new world. The end of a destructively inflationary economy and the resumption of building activity occurred late in 1923. In the following period, known in painting as the Neue Sachlichkeit and in architecture as the Neues Bauen (New Building), Taut was able to apply some of the ideas from his social utopias to the design of highly urbanistic and pragmatic schemes for social housing. Colored glass and the ineffable transitoriness of Expressionist designs were turned into a brightly polychromed architecture and psychological responsiveness to its users.[32]

By the mid-twenties most avant-garde architects had turned to rationalism or functionalism, a development later encompassed by the term International Style. It became unfashionable to recognize any relationship between Expressionism and the Neues Bauen or to acknowledge that the anti-rational ingredient of Expressionism could in fact produce extremely sane solutions. A restrictive view of modernism, the progress of a machine-age rationalism, became incorporated into the standard view of modern architectural history in the publications of Siegfried Giedion and Nikolaus Pevsner. Only after skepticism about technocentric approaches was voiced by influential architects and after a kind of Neo-Expressionism emerged after World War II in the work of, for instance, Le Corbusier and Alvar Aalto, could historians begin to deal with Expressionism not just as an interruption of the main developments, but as a genuine contribution to the history of ideas and forms.

30. Bruno Taut, "A Necessity," *Der Sturm*, 1914*

Bruno Taut's (1880–1938) high school in Königsberg (then in East Prussia) was adjacent to the cathedral in which Immanuel Kant, the greatest of the German idealist philosophers, lay buried. In later life

*Bruno Taut "Eine Notwendigkeit," *Der Sturm* 4, nos. 196–97 (February 1914): 174–75.

he supposed that his reading of Kant influenced his own predilection for contemplative ideas. After a highly pragmatic training in a Bauschule (Building School), where classroom instruction alternated with on-the-job training, he was apprenticed to the South German architect Theodor Fischer, whose main interests centered on perceptual values and town planning. His architectural education was to make Taut aware of both experiential and social issues, but during periods of enforced inactivity he veered toward the idealism of utopian proposals.

Taut's "A Necessity" is the earliest manifesto calling for an Expressionist architecture. His terms for the new art and architecture—expression, intensity, religiosity, rhythm, and dynamics—describe a nascent Expressionism. Though his is a highly romanticized vision, Taut holds up the example of the Gothic cathedral as embodying the collective ideal he demands for the arts. The cathedral became a favored prototype for Expressionist architects because of its implication of religious, artistic, and social cohesion. Taut's belief that architecture provides a new unity for the arts, prefigures Walter Gropius's 1919 opening manifesto for the Bauhaus.

While he suggests glass, iron, and concrete for his ideal building, Taut adds immediately that such a structure must rise above mere functional architecture. His allusion to almost diametrically opposed notions, passion and plainness, is fairly characteristic of the Expressionist search for opposites—and quite different from the classical ideal of harmony, as Taut himself observes. The juxtaposition of extremes, here the rational with the anti-rational, abets an emotionally charged response.[33] Taut again refers to the Gothic cathedral as the guiding model for bringing together passion and practicality.

The hypothetical building he envisions is dedicated first to the arts and second to spirituality. It could be called a temple of the arts. Taut does not see a fixed set of forms, but insists on polymorphism and the stylistic open-endedness of Kandinsky's "spirited compositions."

It is a joy to live in our times and whoever does not sense this cannot be helped. Artists in all media have been gripped by an intensity, a religiosity, that is not satisfied with a weak impulse but strives for legitimate forms. Sculpture and painting are moving in purely synthetic and abstract paths and everywhere the discussion centers on the "construction" of pictures. This definition rests on an architectural idea of the picture, an

idea that is not only to be understood as a simile, but one that in the literal sense of the word also corresponds to architectural ideas. This is comparable to what took place in the Gothic period. The Gothic cathedral encompassed all artists, who, suffused with wonderful unity, found in the architectural structure of the cathedral a resounding collective rhythm.

And architecture wants to assist in this aspiration. It too—in good examples—is impregnated with a new deep intensity. Architecture, in the great works that rise above the commercial context, also wants to attain expression, a resonant rhythm, and dynamics. In simple, economically restricted buildings such an inclination toward an identical intensity manifests itself in the urge toward the greatest plainness conceivable and in the elevation of the most primitive form into symbol. One finds in this as well an affinity with the Gothic, the great works of which, on one hand, possess construction intensified into passion and, on the other, the search for what is most simple economically and practically and yet most expressive. Within this tendency lies a degree of constructive intensity that goes far beyond the self-sufficient classical ideal of harmony. Glass, iron, and concrete are the materials used by the new architect for the purpose of this intensification, carrying him beyond the realm of mere material and functional architecture.

There is a necessity implicit in this new art that requires the union of architecture, painting, and sculpture. Only to the extent that they recognize the need for this partnership will modern architects work creatively and traditionally in a higher sense. This cooperation does not mean that the external forms of painting will be adopted as architectural forms. Architecture is by its nature cubistic and it would be wrong, for instance, to use exclusively angular forms. The pictures of Léger combine the hard and the soft. The architect must be applying this assemblage only outwardly and thus misunderstanding it. He has to incorporate all possible structural forms into his work just as we find them expressed in a painterly sense in the spirited compositions of Kandinsky. This is so because architecture has to rest on a broad basis of all possible prerequisites—artistic, constructive, social, and financial—in order to be able to give a sense of permanence to its manifestations. The functions of the frame are by nature different from those of the picture surface. In addition, the architect must recognize to begin with that architecture contains the premise which the new painting has established for itself: namely, freedom from perspective and from the restriction of single viewpoints. The buildings of the great epochs in architecture were invented without perspective, but perspective produced well-known creations for stage sets.

It is good to be aware of this communalism and it is particularly stimulating for us architects. However, something palpable must also occur: the hypothetical architectural structure that will represent today's new art

must some day manifest itself in a visible structure. And it is a necessity that this take place.

Together let us build a stupendous structure! A building that is not only architecture, but in which everything—painting and sculpture—all together will form great architecture and wherein architecture once again merges with the other arts. Here architecture must be frame and content all at once. This structure does not need to have a purely practical purpose. Even architecture can free itself from utilitarian claims. It would be sufficient if a modern art collection were to give the impetus for the creation of a space to house such artworks and, in addition, create a hall that could serve a variety of artistic functions. A simple structural organism will be erected in open terrain near a metropolis so that in its external expression as well there is room to give it the appearance of an artistic organism. The building should contain rooms that will embody the characteristic manifestations of our new art: the light compositions of Delaunay in large glass window; on the wall cubistic rhythms—the paintings of Franz Marc and the art of Kandinsky. The columns of the exterior and interior should await the constructive sculptures of Archipenko, and the ornament will be created by Campendonck. The collaborators herewith are by no means finished. All independents should participate, entirely possible in a structural organism, so that the whole will form a splendid total timbre. With this a step would be taken to raise the arts from their salon setting, which they occupied because of prevailing aesthetics and practices. Then all the talk about the "applied-arts quality" in the new art would quiet down of its own accord.

Every thought of social intentions should be avoided. The whole project must be exclusive, just as all great art appears in the work of the individual artist. The public can then educate itself through it or can wait until its educators arise.

31. Paul Scheerbart, from *Glass Architecture*, 1914*

The Expressionist poet and novelist Paul Scheerbart (1863–1915), like Taut, was from East Prussia. After settling in Berlin, he was in close contact with a wide range of literary and anarchist figures of

*Paul Scheerbart, *Glasarchitektur*, Berlin, 1914; reissued in German in the Passagen series (Munich: Rogner & Berhard, 1971). Reprinted by permission of Greenwood Publishing Group, Inc., Westport, Conn., from *Glass Architecture by Paul Scheerbart and Alpine Architecture by Bruno Taut*, ed. Dennis Sharp, trans. James Palmes and Shirley Palmer (New York: Praeger Publishers, Inc., 1972). Copyright © 1972 in London, England, by November Books Limited.

the period. His friends also included the Swedish playwright Johan August Strindberg and the painters Edvard Munch and Alfred Kubin. Kokoschka drew his portrait (fig. 20) which appeared in *Der Sturm* in 1910. Scheerbart began using glass buildings and architectural flexibility as a metaphor for spiritual transcendence in his early works. Around 1912 he met Bruno Taut in the circle of *Der Sturm*.[34] Scheerbart's *Glass Architecture* was dedicated to Taut, and Taut's Glass House of the same year was in turn dedicated to Scheerbart. On the surface *Glass Architecture* seems to deal in a straightforward manner with the advantages of glass in buildings. While the text is liberally sprinkled with references to technological advances, however, technology serves merely as a stepping stone to attain a wholesale transformation of man and his world.

Inspired by light mysticism, Moslem architecture, the Gothic cathedral, and nineteenth-century greenhouses, Scheerbart calls for opulent and colorful glass structures. He believed that through its influence on the human psyche, glass architecture could propel society toward heightened sensory awareness. From small-scale glass buildings illuminated inside and out, he moves on to changes of enormous proportions—the illumination of whole mountain ranges—and flexibility achieved through mirrors, mobile reflectors, and even transportable buildings. Because the literary medium allows him to speculate freely, his proposals come closest to transmuting normally stable architecture into a kaleidoscopic abstraction, altering both nature and man-made constructions into an environment that is evanescent and without clearly visible outlines. It is an attempt to create an ambiguous, extra-dimensional space with finite means. In doing this, Scheerbart resurrects an esoteric Romantic tradition in which crystal, glass, and architectural flexibility connote the clarification of the soul.[35] Through citations of his writings in Taut's postwar tracts, Scheerbart exerted a formidable influence on Expressionist architecture. In an obituary in 1915 Herwarth Walden called him the "first Expressionist."

1 Environment and its influence on the development of culture

We live for the most part in closed rooms. These form the environment from which our culture grows. Our culture is to a certain extent the product of our architecture. If we want our culture to rise to a higher

level, we are obliged, for better or worse, to change our architecture. And this only becomes possible if we take away the closed character from the rooms in which we live. We can only do that by introducing glass architecture, which lets in the light of the sun, the moon, and the stars, not merely through a few windows, but through every possible wall, which will be made entirely of glass—of colored glass. The new environment, which we thus create, must bring us a new culture.

. . . .

46 Getting rid of the usual illumination effects

Glass architecture will be scornfully called "illumination architecture" by its opponents, who naturally should not be ignored. This contempt is unjustifiable, for nobody will want to illuminate a glass house the way a brick house is lit up today; when it is lighted inside the glass house is in itself an illumination element. When there are many such elements, the effect cannot be so harsh as the primitive elements of present-day illumination. By manipulating mobile reflectors, the floodlights can project a thousand beams of every conceivable color into the sky. Mirrors (used with discretion) and floodlights together will oust the usual illumination. The new illumination will be essentially for airship travel, to guide the aeronaut.

. . . .

54 Cars, motor boats and colored glass

Now let us transfer glass architecture to the world of movement—to cars and motor boats. In this way the landscape will become quite different; it has already been permanently transformed by the steam train—so transformed that for decades people could not grow used to the change. The colored automobile, with its glossy glazed surfaces, and the glass motor boat, however, will alter the landscape so pleasantly that mankind, let us hope, should adjust itself to the change more quickly.

. . . .

56 Nature in another light

After the introduction of glass architecture, the whole of nature in all cultural regions will appear to us in quite a different light. The wealth of colored glass is bound to give nature another hue, as if a new light were shed over the entire natural world. There will be no need to look at nature through a colored piece of glass. With all this colored glass everywhere in buildings, and in the speeding cars and air- and water-craft, so much new light will undoubtedly emanate from the glass colors that we may well be able to claim that nature appears in another light.

. . . .

71 Transportable buildings

Transportable glass buildings can be produced as well. They are particularly suitable for exhibition purposes. Transportable buildings of this type are not easy to make.

But one must not forget that, in a new movement, the most difficult step is often the first.

. . . .

104 The psychological effects of the glass architectural environment

The peculiar influence of colored glass light was already known to the priests of ancient Babylon and Syria; they were the first to exploit the colored glass hanging lamps in the temples, and the colored glass ampulla was later introduced into churches throughout Byzantium and in Europe. From these were developed the stained glass windows of the Gothic period; it is not to be wondered at that these make an especially festive impression, but such an impression from colored glass is inevitably inherent in glass architecture; its effect on the human psyche can accordingly only be good, for it corresponds to that created by the windows of Gothic cathedrals and by Babylonian glass ampullae. Glass architecture makes homes into cathedrals, with the same effects.

32. Bruno Taut, from *Alpine Architecture*, 1919*

Alpine Architecture was written during the last years of World War I but was not published until 1919. It is Taut's most utopian book and in almost every respect an illustration of Scheerbart's *Glass Architecture*. Like Taut's other books of this period, *Alpine Architecture* contains large conceptual sketches unencumbered by technical detail (fig. 21). The text is made up of captions handwritten onto the illustrations, further reinforcing the impression that we are dealing with totally spontaneous sketches.

The first part of *Alpine Architecture* shows architectural schemes as dramatic modifiers of nature, constructions whose function is not to offer shelter but to ornament space. Alpine peaks are recut into jagged crystalline formations, valleys are adorned with giant glass petals, and lakes contain floating ornaments. A crystal house at the top of the mountains is set aside for contemplation. In an almost

*Bruno Taut, *Alpine Architektur* (Hagen: Folkwang Verlag, 1919).

filmic progression Taut moves from the altered Alpine regions to global reworkings and, at the end, even to cosmic star systems. All of the proposed structures are intended primarily to induce a pantheistic awareness. Despite the utopian romanticism of these gigantic projects, they imply a subversive sort of antinaturalism. Like abstraction in painting, the suggestion to change nature into architectural sculpture at a deeper level connotes that the world is inadequate. Unlike the Romantics' immersion in nature, Taut's earthworks represent a critical discourse with nature.[36]

The only section of *Alpine Architecture* that is more than a caption is a one-page pacifist manifesto and call for communal engagement in peaceful work. "Peoples of Europe" is clearly a reaction against the ravages of war: in this mystical tract, pacifism and socialism become interrelated concerns. In his *The Dissolution of the Cities* (1920) Taut defines the social organization of his utopia in more detail.

Plate 2

Path to the Crystal House in the valley of the mountain stream.

The ravine is spanned by arches of heavy colored glass. They get narrower in the narrowing valley above the stream that grows more torrential and the arches there become more glowing and ever so much deeper in their color to where the narrowest part of the valley is closed off by an arched glass screen in all colors.

Harmoniously tuned aeolian harps are placed in this screen.

Plate 3

Crystal House in the Mountains.

Completely of colored glass-crystal. Devotion in the snow and glacier region. Indescribably quiet . . . Temple of silence. Path from the valley— masts of crystal are companions on the way. They sparkle in the sun, especially in the largest, which rotate in the light—crystal standards— plateaus for aerial landings.

This Crystal House is not supposed to be a "crown." Who would want to crown the cosmos! And not a "city crown."[37] Bruno Taut was not allowed to place the most supreme, the empty, above a city. Architecture and urban smog remain irreconcilable opposites. Architecture cannot be "applied." Not

even to ideals. Every human thought must cease where the highest urge to build, where art speaks—far from cottages and barracks.

PLANES EDGES VAULTS SPACE
. . . .

Plate 5

Columns and arches of emerald green glass rise up over a sea of clouds on the snowy summit of a high mountain. Architecture of scaffolds, of space opened up to the cosmos. Architecture and house are not inseparable concepts.

Plate 6

Valley as Flower.
Far below a lake with flowerlike ornament of glass in the water. This and the walls shine at night. Likewise the mountain peaks. They are surmounted by smooth crystal points. Searchlights on the mountains let these points shine brightly at night.
Walls of colored glass are placed along the slopes in fixed frames. The light which shines through them produces many changing effects, for those in the valley, for those who walk between the walls, as well as for the airborne. The view from the air will change architecture and also the architects.

Plate 7

The Crystal Mountain.
Above the vegetation line the rock is hewn and smoothed into manifold crystalline shapes.
The snowy summits in the distance are surmounted with glass-arch architecture. In the foreground pyramids of crystal needles. Across the abyss a lattice-work glass bridge.
. . . .
Plate 16

PEOPLE OF EUROPE!
CREATE FOR YOURSELF SACRED POSSESSIONS—BUILD! BE A THOUGHT OF YOUR STAR, THE EARTH, THAT WANTS TO ADORN ITSELF THROUGH YOU! . . .

A firm plan should be begun, circumscribed, and decided upon: Where the highest Alpine chain rises above the Italian plains from the Mont Blanc toward the Monte Rosa along the inner curve of the mountain chain—there beauty is to shine forth. The Monte Rosa and its foothills down to the green plains are to be rebuilt.

Yes, impractical and without utility! But have we become happy through utility? Always utility and utility, comfort, convenience—good food, culture—knife, fork, trains, toilets and yet also—cannons, bombs, instruments of murder! To want only the utilitarian and comfortable without higher ideals is boredom. Boredom brings quarrel, strife, and war: lying, rape, murder, poverty, million-millionfold flowing blood. Preach, be peaceful! Preach the social idea: "You are all brothers, organize your-selves, you can all live well, be well educated, and have peace!"—Your sermon falls on deaf ears, as long as tasks are lacking, tasks which require the utmost effort, the last drop of blood. Engage the masses in a great task, that fulfills everyone, from the humblest to the foremost. [A task] that requires tremendous sacrifices, of courage and blood and of millions but that is, however, palpably clear for all in its consummation. Each sees in the great communality clearly the work of his own hands: each builds—in the true sense. All swerve the idea of beauty—as thought emanations of the earth which supports them. Boredom disappears and with it strife, politics, and the infamous spectre of war. Gigantic tasks arise for industry and it will quickly adapt to them. Technology is always only servant—and now it shall no longer serve base instincts, the senseless products of boredom, but the aspirations of the truly active human mind. No one will need to speak of peace when there is no longer war. THERE IS ONLY CEASELESS, COURAGEOUS WORK IN THE SERVICE OF BEAUTY, IN THE SUBORDINATION TO THE HIGHER.

33. Erich Mendelsohn, letter to Luise Mendelsohn August 26, 1917, and extract from Arbeitsrat lecture, "The Problem of a New Architecture," 1919*

Erich Mendelsohn (1887–1953), like Scheerbart and Taut, was born in East Prussia. He studied architecture at the Technische Hochschule in Berlin and Munich. His most important teacher was

*The English translations are from *Eric Mendelsohn: Letters of an Architect* (London: Abelard-Schulman, 1967), 41–42 and 45–50. The full German text for this lecture appears in Erich Mendelsohn's *Das Gesamtschaffen des Architekten: Skizzen, Entwürfe, Bauten* (Berlin: Rudolf Mosse, 1930), 8–21.

Theodor Fischer, with whom Taut had been apprenticed some years before. In Munich Mendelsohn also met some of the leading artists of the Blaue Reiter group, among them Kandinsky and Klee.

Mendelsohn is among the most remarkable figures of Expressionist architecture.[38] Though he was no catalyst and polemicist like Taut, his sketches (fig. 22) made during and after the war possess a visual power that Taut's more cerebral drawings do not. Many of Mendelsohn's dynamic projects go far beyond the "lines of force" of Futurist schemes. He frequently allows the upper part of a design to jut out over the circumference of the plan. While the Futurists usually retained a pyramidal stability, Mendelsohn's structures appear to counteract gravity.

If not as consistently as Taut, Mendelsohn also transformed nature into an evolving architecture. In a series of "Dune" drawings of 1920, for example, he begins with the ever-changing sand dunes he had seen on a walk along the beach and develops them into architectonic fantasies. Where Taut harnessed the powerful imagery of jagged mountain tops, he turns to the eroded, softer-looking forms produced by wind and waves. In Mendelsohn's executed buildings, beginning with the Einstein Tower (1920–21) and his urban structures such as several department stores, a cinema, and a labor union office, the forceful energy of his sketches is maintained throughout the twenties.

Mendelsohn cannot be as overtly identified with Expressionism as Taut. Nevertheless, the nature of his drawings, his letters, and one of his few public statements, a lecture of 1919 given to the Arbeitsrat für Kunst (of which he was a member) early in 1920 make clear his kinship with the Expressionists. In his lecture he describes a revolution that is occurring simultaneously in politics and the arts. Based on it he predicts the appearance of a new collective life and new art forms. Glass, steel, and concrete, in his opinion, can rise above their purely industrial, technical character to help define this new form. He believes that the "dynamic tension" possible through the combination of concrete and steel is fundamentally different from the "load equilibrium" of ancient architecture. With reinforced concrete, he goes on, mass can rise to its own expression, allowing for the creation of "inner spaces."

Mendelsohn's ideographic sketches for buildings projecting out over their base could not actually be carried out in the twenties because this device depended on technical advances in cantilevering. Later, however, Frank Lloyd Wright, who met Mendelsohn in 1924,

was able to execute such designs in the Kaufmann house ("Falling Water") and the Guggenheim Museum.

Letter to Luise Mendelsohn, August 26, 1917

. . . When I think of my life, my development from dilettante dreamer to my present awareness seems to me a wholly fortunate sequence. . . . Despite all my confidence in the dynamics of masses and my intuitive grasp of form, I know that everything is in a state of flux and tension, which must repeatedly lead to conflicts, ordeals, and difficulties. I feel the full life. Quite apart from history and the momentary personal compulsion, however, I am continually aware of the repeated checks due to war, inactivity, and to the coming problems of the whole economic situation as necessary factors in my development. What compels me to create is certainly this inclusion of wide fields within the circumference of one's own personality. What dominates the artist in the present is at the same time the medium through which he dominates the future. And so the world compels him to shape the world. . . .

Extract from Arbeitsrat lecture: "The Problem of a New Architecture"

The inner agitation of the age, its drive toward new solutions in all fields of communal life, compels the artist, too, to stand before his own work and to champion his own intentions. . . .

. . . .

The simultaneous appearance of the revolutionary movements in politics and of the basic changes in human relations in industry and science, religion and art at once gives the right and authority to the belief in a new form; it testifies to the legitimacy of the new birth amid the stress of catastrophes in world history.

. . . .

Only with the discovery of concrete as filling material, and the combination of the two constructional elements, with concrete taking the compressive stresses and steel the tensile stresses, does steel throw off its hybrid, purely technical character and acquire the serried quality of a surface, the spatial quality of a mass. Only now does it have the possibility of presenting the problem of a new form.

Thereby it rises to its own expression, makes possible activity, great

eloquence and transcendental qualities. Thus come about inner spaces, before whose aesthetic peace the clatter of the looms falls back into itself as a rhythmical flow.

. . . .

A symbol of the human yearning to reduce infinity to the finite by means of form, to fit the immeasurable to our scale of measurement. So much is clear: out of the specialized techniques of purely functional and industrial building, a decisive artistic achievement seems to be growing to maturity.

. . . .

In the unconsciousness of its chaotic upthrust, in the primitiveness of its universal embrace, the future has only one new purpose for itself.

For, as every epoch that is decisive for the course of human history has united under its spiritual purpose the whole of the known world, so what we long for will also have to bring happiness to all peoples beyond our own frontiers and beyond those of Europe. In this I am by no means advocating internationalism. For internationalism signifies the rule of an aestheticism divorced from peoples, in a world of decay. Supra-nationalism, however, accepts national limitations as its first premise. It is free humanity, which alone can create a universal culture once more.

Such a great purpose unites all who are at work.

It results first of all and derives a sufficient faith first of all from the fusion of the previous achievements of all peoples.

We can do no more, then, than to contribute the modest volume of our own work in good faith and in a spirit of willing service.

34. From the Glass Chain letters: Bruno Taut, November 24, 1919; Paul Goesch, May 1920; Wenzil Hablik, July 22, 1926*

The Glass Chain was a small group of men, chosen by Bruno Taut, who engaged in an exchange of ideas, mostly via letters and drawings. The Glass Chain was initiated in December 1920 after Taut had become disillusioned with the Arbeitsrat für Kunst, in whose

*English translation from *The Crystal Chain Letters: Architectural Fantasies by Bruno Taut and His Circle*, ed. and trans. Iain Boyd Whyte (Cambridge: MIT Press, 1985), 19, 69–70, 122–25; Paul Goesch, "Allgemeine Kunst betrachtungen," was published in *Frühlicht* 10, supplement to *Stadtbaukunst alter und neuer Zeit* 1, no. 10 (May 1920): 158–59.

foundation he had also participated, as it had become too unwieldy to be the working cell Taut had sought. The goal of the Glass Chain was wide-ranging discussions among its members, rather then the public pamphleteering of the Arbeitsrat. Members of the Glass Chain guarded their privacy through an almost Masonic secrecy. Letters were signed with such romantic pseudonyms as "Glass," "Prometheus," and "Beginning." Most of the Glass Chain correspondents were trained as architects, some were painters, and nearly all had been members of the Arbeitsrat.

From Taut's opening letter it is clear that their theoretical debates were stimulated by the absence of practical work. The call to become "imaginary architects" is made with considerable trepidation by Taut. He would have preferred to build. Other members, such as Hermann Finsterlin and Wenzil Hablik, who worked primarily as artists, were less concerned with the unwelcome hiatus. Nevertheless, an intense period of contemplation and discussion was seen by all as useful preparation for future construction. Paul Goesch defined the difference between Impressionism and Expressionism much as Behne had done in 1915. Expressionism for Goesch consists of subconscious, intuitive responses. Others debated about the use of natural forms and advocated working with curving and crystalline shapes. Hablik's proposal for a film that would center on the construction of a mobile glass house demonstrates how Scheerbartian ideas after the war continue to affect the circle around Taut. The association ended in December of 1920, a date that also marks the end of the utopian phase of Expressionism.

Bruno Taut (Glass), November 24, 1919

Dear Friends,

I want to make this proposal to you: Today there is almost nothing to build, and if we can build anywhere, then we do it in order to live. Or are you lucky enough to be working on a nice commission? My daily routine almost makes me ill, and it is basically the same for all of you. As a matter of fact, it is a good thing that nothing is being built today. Things will have time to ripen, we shall gather our strength, and when building begins again we shall know our objectives and be strong enough to protect our movement against botching and degeneration.

Let us consciously be "imaginary architects"! We believe that only a total revolution can guide us in our task. Our fellow citizens, even our

colleagues quite rightly suspect in us the forces of revolution. Break up and undermine all former principles! Dung! And we are the bud in fresh humus.

The individual personality will disappear with commitment to a higher task—if architecture reappears then the master builder will be anonymous.

I can see the beginning of this in our tendency to join and fuse together as a first cell, without asking—who did it? Instead, the idea exists in the realm of endless joy, remote and autonomous. The purpose of my proposal is to strengthen this existing unity. It is as follows:

Quite informally and according to inclination, each of us will draw or write down at regular intervals those of his ideas that he wants to share with our circle, and will then send a copy to each member. In this way an exchange of ideas, questions, answers, and criticism will be established. Above each contribution will be a pseudonym. The mutual sympathy within the circle and the use of terse language will make it difficult for outsiders to understand us. Nevertheless, we must agree not to reveal anything to uncomprehending eyes. Any request to expand the circle or to expel a member of the group should emerge from the contributions themselves. A single vote will suffice for an expulsion, unless all the other members veto it in their next letters. Let it be a magnet, the snowy core of an avalanche! If nothing comes of the idea, if I am deluding myself, then at least it will be a beautiful memory for each of us.

By the way: Whoever leaves the group before the whole thing comes to an end is obliged to return all the contributions he has accumulated either to me or another member, or to destroy them.

If you agree, could you sign and return this to me as soon as possible, together with the desired pseudonym. I will let you have the result immediately and—the thing will be under way.

With color and glass greeting,
Glass

Paul Goesch (Tancred), "General Observations on Art," 1920

Impressionism and Expressionism: They stand in the same relationship to each other as knowledge and intuition. A philosopher should turn to the list of Kantian categories and look up the concepts of knowledge and intuition. He would then find out a lot about the two types of art, and would also be able to tell us about the art of the immediate future, which will perhaps correspond either to philosophical or to practical impulses.

. . . .

Very similar problems occur in abstract painting and architecture, but with the difference that representational objects are replaced by ideas, conceptual images, and feelings. Here too, the artist discovers powers within himself that modify the perceived beauty of something like a color harmony, or the configurations of stars or flowers. The resulting image is less beautiful, more ugly than the observed phenomenon. This, once again, corresponds to the modern tendency not to eliminate the instinct for ugliness but to set it free and ennoble it—that is to say, to enjoy it and thus give it life. The element of fear will then disappear from the notion of ugliness, and it will become noble (Theosophically: cultivation of the ethereal body or of the habits).

Wenzel Hablik (W. H.), July 22, 1920

Dear Herr Taut,

Delighted at your film idea, especially as I devised something similar about eight years ago. Unfortunately I had to let the matter drop because of a complete lack of understanding in the relevant quarters. Now is certainly a more favorable time for a film, and it could be produced much more easily in Berlin than here in the god-forsaken, icy, conservative North, with its obstinate yet hope-inspiring blockheads.

It would be marvelous if this project could really bring us together, for it seems to me that a personal discussion ranging from subject to subject is becoming more and more urgently necessary. Perhaps a suitable place for a meeting could be found, centrally situated for all of us—although I am not worried personally about being away for a longer period. Perhaps you could let me know what I would have to do for the film and how much freedom the collaborators would have. I would certainly be glad to build for the film the kind of town that my own inner impulse suggests, planned for the people of the not-too-distant future, that is to say for the sort of people we can reckon with for the next 100 years. I would, in addition, like to build some futuristic projects for individual dwellings, namely houses by the sea, in the sea (underwater), in the mountains, in the High Alps, on the plain, in quicksand, in rock (inside a mountain), and in the air (flying houses).

Then, for secondary, propaganda reasons, I would like to try to depict, for example, the construction of a glass house in individual stages. Let me know as soon as possible when the whole thing has to be completed, so that I can limit my other work to what I need to live on, or rather organize it so that it doesn't distract me too much. If you agree with my contribution, I will then start building models right away. I shall be at home for the next few months and will concentrate entirely on these

projects—for building to me means nothing other than the creation of the "Gesamtkunstwerk" [total work of art]—this has been my leading principle for twenty-five years. For me there is no other "work of art." Artists who do not create with a feeling for the cosmic and universal have nothing to do with real creation and will destroy themselves in the attempt to build, or fit in well as unskilled laborers.

The building of a glass house beside the sea

Through the breakers a ship is seen landing, cutting deeply into the sand of the beach as if digging itself in. Men leave it, carrying seven-pointed metal stars which are distributed to fixed points, laid down on the sand, and linked to a central control by electric cables.

Thin tubes connected to electric pumps in the ship are led to the individual stars (these could possibly be dropped by one or even seven airplanes). The pumps in the ship supply special dissolving and bonding fluids, which seep into the sand around the stars. A small airplane circles above the building site sending signals. From the ship's hull rises a glittering mast, showering sparks, and at the same time cascades of sparks spread from the stars in the sand. Craters of flowing fire develop around each star (the biggest around the largest star, the smallest around the smallest).

Radio signals from the circling airplane of the engineer.

An airship-workshop approaches and hovers a certain distance away. Hollow spheres are lowered into the molten, heaving craters in which the stars revolve, and attach themselves to the metal tubes. Immediately the glowing mass begins to take shape. Large bubbles rise up, iridescent in all the colors of the rainbow and as round as domes, and are absorbed by one another to form even larger bubbles (like soap bubbles).

. . . .

Some of the domes leave their foundations, rise up, and are then remolded and reattached again. Finally, a look into the interior of a globe-shaped dome. Glass furniture and so on.

A similar procedure would be shown for building underwater (in the sea, in lakes).

Airship greetings from your W.H.

V. PRINTMAKING

by Ida Katherine Rigby

INTRODUCTION

Printmaking was central to the German Expressionist artists' quest for the bold, emotion-laden forms that would immediately capture and directly convey their intense engagement with life.[39] The poet Rudolf Adrian Dietrich graphically described this relationship when he wrote: "Every cut with the knife is a slice into the innermost self. This wood is truly flesh of thy flesh."[40] The Expressionists found that the discipline and processes enforced by printmaking encouraged a synthetic, abstract style that powerfully expressed emotions, revealed inner truths, and influenced the development of their style of painting.

In their effort to renew German art, the Brücke artists turned to a medium they considered truly German, the woodcut. The art historian and critic Wilhelm Valentiner summarized the cultural and historical meanings that made the medium so highly charged: "From the time of the oldest timberwork architecture of the Germans, from the wooden sculpture of the German Gothic and Renaissance, from the art of the woodcut of Dürer's time, the German artist has preferred the use of wood for the expression of his ideas in architecture, sculpture, and printmaking. It is as though the structure of the rough trunk . . . were especially suited to the . . . German character."[41]

For the Brücke artists, who published their 1906 manifesto as a woodcut, printmaking was an important vehicle for spreading their ideas and supporting their activities. As part of their benefits, associate members (of whom 68 were listed in 1910), received yearly print portfolios. Influenced by the prints of Munch, Gauguin, Felix Vallotton, Jugendstil, and Japanese artists, and medieval and Renaissance artisans, the Brücke artists revived printmaking as an independent artistic pursuit. They designed posters for exhibitions and used prints to reproduce paintings for illustra-

tions in exhibition catalogues, and for their invitations and membership cards. They also made original prints to illustrate books.

Herwarth Walden published prints beside Expressionist poems in *Der Sturm*. In Munich the Blaue Reiter dedicated its second exhibition (February 1912) to prints, drawings and watercolors. During the war and immediately thereafter, the Expressionists contributed prints to such wartime journals as *Kriegszeit, Der Bildermann,* and *Die Aktion,* and to the myriad of periodicals that sprang up when Wilhelmine censorship was lifted. A number of powerful print portfolios emerged directly from the war experience itself. When postwar Expressionism adopted an activist stance, politicized artists designed quickly produced and speedily disseminated posters and prints in support of socialist and democratic causes.

35. Gustav Hartlaub, from *The New German Print,* 1920*

Gustav Hartlaub, who supported the Expressionist movement through his writings and his acquisitions as the assistant director of the Mannheim Kunsthalle, produced the first comprehensive study of Expressionist printmaking.

Hartlaub begins his study by paying homage to the woodcut and its mythic appeal for his contemporaries. Like other writers, he sees the woodcut as particularly well suited to expressing the German temperament and celebrates its potential for revealing the direct, symbolic, and gestural language of inner agitation, the quintessence of Expressionism. After briefly surveying the history of European printmaking and tying it to economic and social conditions and technological developments, he discusses the development of German Expressionist printmaking from its origins in the work of Gauguin and Munch to 1920. His concluding comments on postwar printmaking reflect the populism of those politicized times.

In the beginning was the woodcut. . . . They are like folk songs and folktales in which something of the sublime awe of the sagas still lingers. Mostly they are "crude"; materials and tools play almost as much a part

*Gustav Hartlaub, *Die neue deutsche Graphik* (Berlin: Erich Reiss Verlag, 1920), 3rd ed., 7, 8, 30, 31, 32. Courtesy Städtische Kunsthalle, Mannheim.

in the development of their form as does the will of the artist. Yet something of the grace that helped even the crudest craftsman during the Middle Ages to turn out his stammering to the praise of God still floats over them; in them the clumsy outlines grow out of the wood itself, their surfaces are divided and decorated in a somnambulistically sure, true, and fine fashion, pleasurable for the external senses, full of great meaning for the inner ones, at once ornament and symbol.

. . . .

Today it is already fairly clear that the woodcut will signify for our century what lithography signified for the nineteenth, etching for the seventeenth, and copperplate engraving for the sixteenth. In its form, prepared during Post Impressionism and today truly awakened with unanticipated passion, the woodcut is better adapted to the new expressive intention than any other technique . . . It is the most original stylistic product of the new art. If, of the work of the last fifteen years, nothing but the woodcut would be preserved for later generations, it would be sufficient to testify to the decisive changes in form and attitude since the beginning of the twentieth century. One would, above all, learn what is essential about Germany's role within this movement. Prints actually have always been the most appropriate, the most free and complete form in which the German spirit succeeded in becoming visible, in which German art won the worldwide recognition that had been so difficult for it to achieve.

. . . So too it now once again seems that Germany will make its most important contribution to the theme of "Expressionism" in the field of prints, especially in that of the woodcut to whose blocky, coarse, and yet spiritual and mysterious style it is driven by a combination of racial predisposition, age-old tradition, and the inner demands of the times. Reason enough to limit oneself to German art in the following overview of the new creators of prints. . . .

. . . .

. . . Within printmaking Munch is the first who, if he did not completely abandon this "stylization," nonetheless was inspired with cosmic-rhythmic expression to such an extent that one day it no longer seemed to be ornamental gesture, but the expression of a powerful inner drive. The first step of "Expressionism" . . . was thereby reached! . . .

. . . .

To a far younger generation than Munch and Nolde . . . belong the artists of the Dresden "Brücke," Heckel, Kirchner, Otto Mueller, Pechstein, Schmidt-Rottluff, who in the year 1906 formed an artists' association and who continuously published portfolios of prints. An important date for the history of recent German art and for the decisive role art in black and white specifically has played in it! . . .

In this circle the possibilities of the new "formcutting" were particularly

eagerly exploited. . . . The form-language of the woodcut also influenced their manner of expression in painting. The strikingly massive, uniform manner of working and indistinguishability of material in the early Pechstein, Kirchner, and Schmidt-Rottluff, the flatness and angularity, the always quite summary qualities of their treatment of form, betray thinking appropriate to the woodcut. . . . Beside Nolde it was they, who—even more decisively than Munch—raised the art of black and white in Germany to the direct symbolic and gestural language of inner agitation. . . .

. . . .

The graphic style of the "Brücke" as the first and successful manifestation of a German Expressionism that soon spread to Berlin and the provinces has had incalculable consequences for German art of the last fifteen years. In Dresden itself there is to this day a Brücke tradition; here the versatile Otto Lange and others like Mitschke-Collande, Heckroth, Böckstiegel carry on the tradition with personal variations; resolutely and independently the talented Felix Müller advances it further, . . .

. . . .

. . . Several of Kokoschka's prints, above all the early series on the Passion of Christ, are veritable orgies of that "ugliness" that in Expressionism seems to have acquired an almost canonical status as the expression of "raw" spirituality (as in the Middle Ages). But an exceptional compositional rhythm always brings the fragments and shattered forms back together. . . .

At the other pole stands Barlach. His drawing has none of the big-city nervousness of Kokoschka; it does not disintegrate into countless nuances, but holds together in a large, massive flow of form. . . .

. . . Still the most comprehensive is the range of printmaking activity of Max Beckmann. . . . All along Beckmann too was ultimately an "Expressionist," he always wanted to express the "spiritual"—as mystery, not as brain and nerve—in the material. . . .

. . . .

Let's close our large print portfolio, whose contents also may give us an example of how prints should be collected today. We have assessed today's prints as confession, as unconditional utterance. It is therefore no longer an art for fanciers of minor masters' artistic translations, of technical refinements and variations. It must be collected therefore differently than before. It absolutely demands a new type of collector who unhesitatingly proceeds more on the basis of artistic content, [and is] less [concerned with] rarity and all sorts of connoisseur's values. . . . It must be evaluated just as the artist himself did while creating it, when, for the sake of the full "realization" he would have preferred to supervise all the printing himself! Today one does not collect early proofs, unique impressions, etc.,

for the sake of the extra-artistic sport of collecting, for science, or even—for profit! Whoever does this sins against the spirit, against the true intention of the art that he loves and whose testimony he wants to assemble around himself. In the final analysis, print collecting today should not be undertaken in private cabinets with private capital. Today printmaking is public and popular. Printmaking, above all its most important contemporary exponent, the woodcut, today does not want to be stored motionless in portfolios. The print wants to fly, a broadsheet fluttering downward from spiritual heights to a great people with arms outstretched!—

36. L. de Marsalle [E. L. Kirchner], "On Kirchner's Prints," *Genius*, 1921*

Ernst Ludwig Kirchner, who wrote under the pseudonym L. de Marsalle, was one of the Brücke's most prolific printmakers. His oeuvre includes almost 1000 woodcuts, over 650 etchings and drypoints and more than 450 lithographs. The subjects of Kirchner's prewar prints included the full spectrum of Brücke themes. After a nervous breakdown during the war, he settled in Switzerland and the subject of his prints reflected the new surroundings.

Kirchner experimented with the expressive potential of the printmaking medium from the brittle angularities and bold planar surfaces of the woodcut to the energetic, darting lines of the etching, to the nuanced, painterly qualities of the lithograph. His work in printmaking encouraged the development of what he called his abstract "hieroglyphs," the condensed shapes that for him bore the essential "inner idea" and conveyed an underlying spiritual and emotional life.

This essay, which appeared in a journal—*Genius*—that presented scholarly articles, poetry, and original prints, conveys the artist's involvement with material processes and stresses the importance of personally carrying that process to the final conclusion—printing by hand. Kirchner wanted immediate expression and drew his lithographs directly on the stone. He also made illustrations for books, including the woodcuts for Alfred Döblin's *The Canoness and Death* (*Der Stiftsfräulein und der Tod*) of 1913, Adelbert von Chamisso's *Peter Schlemihl's Miraculous Story* (*Peter Schlemihls wundersame Geschichte*) of

*L. de Marsalle. "Über Kirchners Graphik," *Genius* 3 (1921): 215–63.

1915 and Kurt Wolff's 1924 edition of Georg Heym's *Shadow of Life (Umbra Vitae)*.

The impulse that drives the artist to work in the graphic arts is perhaps in part the striving to fix the singular, flowing form of drawing permanently and conclusively. The technical manipulations, on the other hand, certainly release in the artist powers that do not come into play in the much easier handling of drawing and painting. The mechanical process of printing unites the individual phases of the working process into a whole. The work of giving form can be extended as long as one wants, without danger. There is great excitement in week-, even month-long work, reworking again and again, to achieve the ultimate in expression and realization of form without the plate losing in freshness. The mysterious attraction that surrounded the invention of printing in the Middle Ages is felt again today by everyone who seriously occupies himself with printing and the details of craftsmanship. There is no greater joy than seeing the roller move over the just-completed woodblock for the first time or etching the lithographic slab with nitric acid and gum and watching to see if the effects striven for appear, or examining in the proofs the ripening of a print's formal form. How interesting it is to explore the prints down to the smallest detail, sheet by sheet, without even noticing the hours run by. Nowhere does one come to know an artist better than in his prints.

. . . .

Kirchner's graphic work begins about 1900, approximately. He begins with woodcuts.

The woodcut is the most graphic of the graphic techniques. Its practice demands much technical skill and interest. Kirchner's technical facility made woodcutting easy for him. Thus he readily achieved the necessary simplification for a clear style of representation. In his woodcuts, which are a constant feature in his production, we see the preparation of the form-language of the paintings. . . . Early on Kirchner tried to use the woodcut for illustration. He was the first to have his plates printed simultaneously with the type (in *Der Sturm* 1910), and thereby involuntarily triggered today's flood of woodcut-illustrated books. . . . In addition to these very small things Kirchner also cut posters in wood. Beside the simple black print he created a series of color woodcuts. After many tries he came to work in a new way, with from two to ten plates without using border plates. . . . In printing Kirchner likes to use the elasticity of the wood. . . .

. . . A new style shows itself not only in new proportions and dimensions, but also quite specifically in novel, individual forms. The growth

of individual forms is very clearly recognizable in Kirchner's development. . . . The altering of individual forms goes hand in hand with the alteration of proportions. . . . Thus proportions order themselves according to the feeling engendered by the work, in order to represent this in the most powerful way. . . . Kirchner's deformations are not disturbing because they are correct for the picture; one would not notice them at all if attention were not drawn to them.

. . . The artist recognized that through intensification and simplification he could express himself more powerfully than through shading and cast shadows. Thereby he sought not ornamental effect, but clear graphic form. . . .

. . . .

Through patient experiments and many failures, he found technical processes in lithography that placed this—justly and unjustly, somewhat shabbily treated, on a par with the others. His turpentine etching process brings tonal areas out of the stone that never have been seen before. His lithos are hand printed. He works on his stone until the first drawing has become completely graphic. That is, the drawn lines disappear and are formed anew by the etching. Deep blacks alternate with a silky gray produced by the grain of the stone. The soft tonality has a coloristic effect . . . and lends warmth to the prints. Thus in lithography Kirchner has created a personal technique that is far richer in means than the woodcut. . . .

. . . .

The technique that Kirchner is currently using with special pleasure is etching. It allows him to take the plates with him without difficulty and to make the first underdrawing directly from nature. Thus the etchings contain, especially in the first states, the most immediate hieroglyphs. Rich in lively calligraphy and richly varied in motif, the etchings are like a diary of the painter. . . . The free-spiritedness of this art comes into its own. Further, among even the most recent there are plates that have been worked over again and again, whose original smooth surface has been transformed into an energetic mountain and valley through repeated etchings. . . . Often the etched surfaces are enlivened with strokes of a bare needle.

. . . .

Because Kirchner does his printing himself, he is in a position to utilize fully all of the technical possibilities. Only an artist with a love and gift for craftsmanship should make prints; only when the artist really does the printing himself does the work earn the name original print.

Kirchner creates with a naive pleasure in material and technique and constantly finds new possibilities and paths. A very powerful sensuousness emanates from the prints that fully reveals itself in just those

printmaking techniques that demand the most effort. Just as the "savage" carves a figure out of hard wood with endless patience, the embodiment of his vision, so the artist creates perhaps his purest and strongest works in painstakingly complicated technical work, after the ancient curse, if one may venture to thus understand it: By the sweat of thy brow shalt thou earn thy bread.

37. Paul Westheim, "Kokoschka's Prints," *Das graphische Jahrbuch*, 1919*

Paul Westheim (1886–1963) was one of Germany's leading art critics. As founder and editor of the influential journal, *Das Kunstblatt* (1917–31), his goal was to include "everything of lasting value in the present." Of the journal's genesis during the war Westheim wrote: "A new artistic generation was in existence, . . . a new artistic will aimed at intensification and spiritualization. The works were still being virtually ignored, if not totally rejected. . . . these artists lacked . . . a platform. . . . So the idea for a journal . . . was born. . . . Naturally we were savagely attacked."[42]

Westheim's support for German printmakers went beyond the articles and prints published in *Das Kunstblatt*. In *Die Schaffenden* (The creators),[43] a series of quarterly portfolios of ten original prints, he tried to introduce collectors to established figures and new emerging talents, and to "serve the living creators of these our times," and to "establish a basis for collecting."[44] Each portfolio included bibliographies of artists and descriptive and critical material. His article on Oskar Kokoschka's prints emphasizes the independence and uniqueness of Expressionist printmaking and illuminates one of the main characteristics of Expressionism, its quest for transcendental meaning in individual experience.[45]

Kokoschka's drawings and **lithographs** do not arise as an analogue to the paintings, as a place to work on the same problems with simpler means. . . . Kokoschka's painting always tends toward the absolute; it is the fixing of a world concept; it seeks a balance of cosmic forces. As a

*Paul Westheim, "Kokoschkas Graphik," *Das graphische Jahrbuch*, 1919 (Darmstadt: Joel, 1920).

painter he is the creator who draws things into a new unity, who imposes order on them. . . . Beside the creator, there is in him yet another: the **researcher**, who himself longs to understand the chaos in the cosmos, the antitheses and limitations of existence. This researcher . . . is the printmaker Kokoschka. . . .

. . . Burden and support, pressure and counter-pressure, oppression and victorious upward striving toward the spiritual; these are the tensions that are demonstrated in Kokoschka's prints, as in his plays. A pair of antitheses—as the most primary, generally, man and woman—is singled out, forces striving against one another, which by their nature seem to make war upon one another, and which, nonetheless, are bound together at a deeper level. The polarity between them is at once a repulsion and attraction. . . .

. . . The woman stands in the center as "mana," as it is called in the language of primitive peoples, as "Power" endowed with mysterious, uncanny abilities that can be turned to good or evil, which carry death and life, happiness and sorrow within themselves, against which one must immunize oneself. The **woman** appears as the demonic principle, as it can reveal itself in many beings, in men, animals, also in inanimate things, as the dark power of fate. . . . The endeavor may be, perhaps, to fathom, also to render harmless, this sinister spirit fraught with danger, which has power over body and spirit, and instinct and soul.

. . . .

The "**Fettered Columbus**" originates as the expression of a convulsive experience of the first meeting with Woman. Unimagined, strange things suddenly open his eyes. He himself is Columbus; New Land, who opens itself to him is Woman. . . . Radiant, majestic, the unknown being steps towards the Man, who perplexed in his innermost self, hardly ventures to raise his eyes before it. Bent over a table, Eve extends the apple. Somewhere a candle goes out. A glacial tension seizes the pair. . . . Guilt entangles them. Hallucinations torment. He sees the Woman in the arms of a third. Jealousy gnaws. A world bursts asunder. Desert all around, graves open up, bones of the dead roll out. What was of value, what was true, sinks, disappears. . . . At the end she alone is still there, she, the stronger, the victor.

Spiritual experiences become transposed in a completely uncerebral way in black and white. Just as Kokoschka must create his own language for his poetry, a language fully animated with rhythm, in which each word is placed according to its value, a "speech-language," as I'd like to call it . . . so must he as a graphic artist develop a **drawing-language** suitable to these particular psychic phenomena. He tries to grasp the whole range of relationships with every curve, every lightness and dark-

ness, . . . each phrase is the sign, the expression and eruption of an inner occurrence.

What Kokoschka prepares the way for here, and what was already achieved to such a striking effect in the lithographed heads . . . is a symbolic language of suggestive power. . . .

. . . Once more, . . . he takes up the theme in the Bach-portfolio (fig. 23). . . . Bach's music helped him over the threshold of consciousness. The Woman now appears as the guide . . . who goes before the Man through life, A new spirit, however, a spirit of affirmation, and the indestructible power of belief is evolving. . . . As though before the eye of the falcon that nests on the highest peak, the land extends bright, clear, visible to the last hollow, thus the regions of the spiritual are opened up. . . . It is the creative person's insight into the universe. And in order to document this breakthrough, to proclaim to all the world that all transformations have meaning only in this highest possibility of the human, Kokoschka presents in the concluding print, as the lasting, creative seer: the artist.

38. Rosa Schapire, "Schmidt-Rottluff's Religious Woodcuts," *Die Rote Erde*, 1919*

Rosa Schapire (1874–1954), an art historian who lived in Hamburg, was a collector of Expressionist prints and an early supporter of Expressionism.[46] In 1910 she was listed among the sixty-eight associate members of the Brücke. She became acquainted with Schmidt-Rottluff in 1907 and assembled a nearly complete collection of his prints. Schapire's book, *Karl Schmidt-Rottluff's Graphic Work to 1923*, (*Karl Schmidt-Rottluffs Graphische Werk bis 1923*), remains a basic reference. As a critic and historian she contributed to *Menschen, Neue Blätter für Kunst und Dichtung*, and *Die neue Bücherschau*, and was co-editor of *Die Rote Erde* and *Künding*. Schmidt-Rottluff designed the covers for the last two journals.

The article excerpted here is important for understanding the prevalence of religious imagery in postwar Expressionism, a general phenomenon noted by Gustav Hartlaub in his discussion of the religious and spiritual concerns of Expressionism in *Art and Religion*

*Rosa Schapire, "Karl Schmidt-Rottluffs religiöse Holzschnitte," *Die Rote Erde* 1, no. 6 (November 1919): 186–88.

(*Kunst und Religion*) of 1919 and specifically by Will Grohmann when he described the war-induced, heightened mysticism in Schmidt-Rottluff's work.[47]

Schapire discusses the series of bold, planar woodcuts Schmidt-Rottluff executed in 1918 and 1919, while he was on the censor's staff at the Russian front and after his return home. Schapire's reference to a Third Reich reflects German millenarian thought as yet untainted by Nazism.

. . . The artist's personal relationship with the divine reveals itself the more profoundly in his work the more, in his struggle with the ultimate questions of being, he has grasped the meaning that conceals itself behind all external occurrences, and has drawn a new, mysterious beauty out of the old contents. . . . Today we confront the fact that our young artists, tired of that wave of naturalism that impoverished the world, consciously intensify reality standing as a lover, face to face with the world, seeking the original meaning behind the diverse distractions of appearances. The spirit within the self, understood as something transcendental, came to be opposed to the material. From here it was a short step to being inspired by religious motifs, to finding new aspects in the age-old materials, to risking new solutions.

Schmidt-Rottluff stands first among those who attempted this search. . . . In proud sequence, the woodcuts on the theme of Christ come into being. The three wise men who come with their gifts in order to greet the new light open the suite in 1917. Three figures seen from the front in whose faces live something of that lack of connection to the human, all too human that is characteristic of medieval minatures. . . . The pathos of the crucifixion goes even further. . . . In the Emmaus recognition dawns . . . Large single heads: Christ (fig. 24) seen from the front who, as a new sign of sorrow, wears the date 1918 on his forehead; the head of an apostle with searching, painful glance, resting on a slender neck. . . . the powerful confrontation of Christ and Judas. Judas purses his lips for the kiss, while Christ, with wide-open all-perceiving eyes, calmly takes his fate unto himself. . . .

. . . .

According to a beautiful saying of Buber's, quality in the work of art only ensures admission into the "outer circle"; in the inner, "however, from time immemorial stand the works that embody the meaning of the world." Schmidt-Rottluff's religious paintings qualify for membership in the "inner-ring." The most secret mysteries of the soul reveal themselves in black and white, in lines and planes with the stirring power of the confessions

of the mystics when full of their God, they bear him witness. Words do not have the power to exhaust the spiritual and formal riches of the prints. Each time Christ's figure is different in expression, bearing, structure, even in the centuries-old motif of the halo a new expressive power dwells. Like rays it dissolves the background, swells like a phosphorescing flame, ghostlike around the head of the divine one. . . .

The relationships between the self and the surrounding world reveal themselves in all artistic creations; here we immerse ourselves in a world that, liberated from reality, born of ecstasy, extends to the stars. It is saturated with mysticism, the fertile soil of all great art. Through the power of ecstasy the doors into the Third Reich were opened, the profoundly human seen as a divine thing and given form. It may be the most glorious testament to the freedom of the spirit that the majority of these religious woodcuts, which bear such fervent witness to the deity, originated in Russia during the war. Nothing of the agony the artist went through during the war penetrated into the realm of the spirit. As a creator, a builder of new values, he freed himself from all inhibitions and suffering.

<div align="center">****</div>

39. Paul F. Schmidt, "Max Beckmann's Hell," *Der Cicerone*, 1920*

The art historian Paul Ferdinand Schmidt (1878–1955) wrote one of the earliest articles on Expressionism.[48] As head of the print room at the Kaiser Friedrich Museum in Magdeburg, he bought Brücke prints as early as 1905, and was the only museum curator among the Brücke associate members listed in 1910. The article on Max Beckmann's *Hell* (figs. 25 and 26),[49] a portfolio of lithographs published in 1919 by J. B. Neumann, appeared in Georg Biermann's journal *Der Cicerone* (1909–30), which covered a wide range of current and historical topics in scholarly depth. After the war Beckmann was drawn to Berlin because he wanted to be part of the "grand human orchestra," to confront humanity with his "heart and nerves," and to "expose the ghastly cry of the poor disillusioned people."[50] *Hell* was the result of Beckmann's stay in Berlin in March 1919, a

*Paul F. Schmidt, "Max Beckmanns *Hölle*," *Der Cicerone* 12, no. 23 (1920): 481–87.

period of intense street fighting. The images conjure up the violence he experienced and allude to the January 1919 Spartacist uprisings, during which Rosa Luxemburg and Karl Liebknecht were murdered. Some of the prints specifically refer to their martyrdom (fig. 26). Others describe the situation in general terms; there are, for example, the ideologues, the war-maimed, and the famished. Schmidt's interpretation reflects the Expressionist critics' and artists' assumption that art is a reflection of the times and that the artist is a medium through which impressions of those times are filtered and the era's meaning intensified.

The first impression of these ten prints by Beckmann—very large, very concrete lithographs—is that of a terrible shock. So that is how things look in Germany, that is the way the world of central Europe is mirrored in the clear and unmerciful brain of an artist! Spiritual devastation, dread, hopelessness as the legacy of the period of war and revolution, cripples and the morally defective as heirs of the "Grand Time": That is Germany. The impression of a stay in Berlin in March of last year has this artistic result; and no other name suits it better than "Hell." We live in such a hell, but we do not sense it: we have shifted all the torment and despair of our condition onto the conscience of the artist; as the prophet and soothsayer of the times he carries our burden, he expresses that which the logic and madness of everyday life keeps hidden in our hearts.

What suffering and what salvation! It must have been a terrible pessimism that came over Beckmann in those weeks, and a superhuman struggle was needed to bring it into a form that corresponded to the blackness of those feelings.

And it is with this form that we are dealing here, for it alone is the instrument that transfers the seemingly unbearable from the artist's sensibility to our own. . . . Only because it is totally imbued with graphic form, because an almost overwhelming force of line attacks and captivates us in these prints, does it have such a concrete, such an immediate effect. . . . They became such an unconditional expression of our current sensibility because here that sensibility has created a form adequate to it.

. . . .

For this is the artistic means of Beckmann's lithographs: to connect the utmost reality in the details with an apparitional deviation from reality in the whole. These are the means of dreams, of nightmares: a destruction of all the laws governing life's forms, a balancing of the improbable with very explicit, lightning-sharp observations of nature. Events are distorted

by a seemingly altogether arbitrary perspective and distortion of all proportions, the individual exaggerated to the grotesque and the naturalness of space and surroundings exploded in all directions: thus is created the monstrousness, the shocking immediacy of the events, the impression of an attack on our defenseless nerves. Here the deformation occurs with an unprecedented artistic deliberation and consistency and goes far beyond Meidner's grandiose horrors: because the effect is, in the first and last analysis, achieved in and by the space.

Out of all of the possibilities of so-called Expressionism, Beckmann's supernatural treatment of space is to date the most expressive way of dissociating events from their connection to nature and at the same time materializing them with superhuman clarity. . . . The picture plane advances so violently that it seems to rush forward off the surface onto us, while the things lying further back suddenly recede with an improbable speed: giving an impression of a mighty movement of space, a drunken and dizzy feeling is created, but no real spatial depth because the proportions toward the back are purposely unclear and treated quite confusedly. . . .

In this case the picture is governed not by the laws of the optical qualities of real phenomena, but solely by its spiritual relations, whose laws of formation are rarely shown in such exemplary purity and rarely engender such empathy as in these mature creations by Beckmann.

. . . .

Notes to Part Two: The Expansion of Expressionism

1. See Werenskiold, *The Concept of Expressionism* [as in Part One, n. 1], 49–55.

2. Barbara Drygulski Wright, "Sublime Ambition: Art, Politics and Ethical Idealism in the Cultural Journals of German Expressionism," in *Passion and Rebellion: The Expressionist Heritage*, ed. Stephen Eric Bronner and Douglas Kellner (South Hadley, Mass.: J.F. Bergin, 1983), 87–97.

3. Heinrich Mann, "Geist und Tat," *Pan* 1 (1911): 69–74; for discussion of the impact of Mann's essay on Expressionists, see Allen, *Literary Life*. . . [as in Part One, n. 71], 187–89.

4. See Werenskiold, *The Concept of Expressionism*, 49–52; and for a varying emphasis Charles W. Haxthausen, "A Critical Illusion: 'Expressionism' in the Writings of Wilhelm Hausenstein," in *The Ideological Crisis of Expressionism: The Literary and Artistic German War Colony in Belgium, 1914–1918*, ed. Rainer Rumold and O. K. Werckmeister (Columbia, S.C.: Camden House, 1990), 170–72.

5. Fechter also viewed the German Baroque as carrying forward the Gothic sensibility.

6. See *Marbacher Magazine* 30 (1984; special issue on Theodor Däubler 1876–1934), ed. Friedrich Kemp and Friedrich Pfaffling, 220. For additional references to Däubler's interest in forming an international pacifist group with Gustav Landauer, Martin Buber, and Erich Gutkind in June of 1914, see Eugene Lunn, *Prophet of Community: The Romantic Socialism of Gustav Landauer* (Berkeley and Los Angeles: University of California Press, 1973), 245.

7. Däubler, *Der Neue Standpunkt*, 38, and in the essay included here, see pp. 84–87.

8. Däubler, "Barlach," *Der Neue Standpunkt*, 105.

9. Däubler, "George Grosz," *Das Kunstblatt* 3 (1917): 8–82.

10. [Hartlaub's note.] The recent founding of the quarterly journal *Das Reich* (Munich: Hans Sachs Verlag) is a sign that such a connection has been recognized.

11. Kandinsky, 110–11; English translation in Lindsay and Vergo [as in Part One, n. 50], 194–95. See also Long, *Kandinsky*. . . [as in Part One, n. 52], 134–36.

12. See Selz, *German Expressionist Painting* [as in Part One, n. 19], 238–40; and Dietrich Schubert, "Die Beckmann-Marc-Kontroverse von 1912: 'Sachlichkeit' versus 'Innere Klang,' " *Expressionismus und Kulturkrise*, ed. Bernd Hüppauf (Heidelberg: Carl Winter Universitätsverlag, 1983), 207–44.

13. See Allen, *Literary Life*. . . , 205–9.

14. Victor H. Miesel, "Ludwig Meidner," *Ludwig Meidner, An Expressionist Master* (Ann Arbor: The University of Michigan Museum of Art, 1978). Also see Thomas W. Gaehtgens, "Delaunay in Berlin," *Delaunay und Deutschland*, ed. Peter Klaus Schuster (Cologne: DuMont, 1985), 264–91. For a discussion of Meidner's cataclysmic vision, see Carol S. Eliel, *The Apocalyptic Landscapes of Ludwig Meidner* (Los Angeles County Museum of Art, 1989).

15. Molzahn is an example of an abstract painter whose mysticism embraced both radical painting and politics after the November Revolution. When the Sparticist leaders were killed, Molzahn's memorial in oil bore a trinitarian title, "The Idea—Movement—Struggle"; later the dedication "to Karl Liebknecht" was painted over; see Herbert Schade, *Johannes Molzahn* (Munich: Schnell & Steiner, 1972), 36 and Rose-Carol Washton Long, "Expressionism, Abstraction, and the Search for Utopia in Germany," in *The Spiritual in Art: Abstract Painting, 1890–1985*, ed. Maurice Tuchmann (Los Angeles County Museum of Art, 1986), 209.

16. See Stephanie Barron, *German Expressionist Sculpture* (Los Angeles County Museum of Art, 1983); Andreas Franzke, *Skulpturen und Objekte von Malern des 20 Jahrhunderts* (Cologne: DuMont Buchverlag, 1982); and also Lloyd, . . . *Primitivism*. . . , 67–82.

17. The 1912 Brücke exhibition at Galerie Gurlitt included five wooden sculptures by Heckel and six sculptures by Kirchner.

18. See for example Max Deri, "Die kubisten und der Expressionismus," *Pan*, June 20, 1912, in English translation, document 5. See also Walter Heymann's review, "Berliner Sezession 1911," *Der Sturm* 2 (July 15, 1911): 543.

19. Ernst Barlach, "Letter to Reinhard Piper, Gustrow, 12.28.1911," in *Voices of German Expressionism*, ed. Victor H. Miesel (Englewood Cliffs, N.J.: Prentice-Hall, 1970), 95.

20. Barlach was very interested in Worringer's *Form in Gothic*; see letter to Reinhard Piper, July 21, 1911, Ernst Barlach, *Die Briefe I* (1888–1924), ed. Friedrich Dross (Munich: R. Piper & Co. Verlag, 1968), 374.

21. Radenberg also wrote *Moderne Plastik, Einige Deutsche und Ausländische Bildhauer und Medailleure unserer Zeit* (Düsseldorf and Leipzig: Karl Robert Langewiesche Verlag, 1912).

22. See Barron, *Expressionist Sculpture* . . . , 64, and *Expressionisten, Die Avantgarde in Deutschland, 1905–1920*, 266, for discussion of the titles.

23. See Victor H. Miesel, "Paul Cassirer's *Kriegszeit* and *Bilderman* and some German Expressionist Reactions to World War I," *Michigan Germanic Studies* 2, no. 2 (Fall 1976): 149–68; Paret, *The Berlin Secession*, 236–46; and Allen, *Literary Life*, 195–200.

24. Alfred Gold was an art critic who had editorial responsibility for *Kriegszeit* while Cassirer was at the front.

25. Allen, *Literary Life*, 74, 149, 247–48.

26. Robert Goldwater, *Primitivism in Modern Art*, rev. ed. (New York: Vintage Books, 1967), 35–36. See also Klaus H. Kiefer, "Fonctions de l'art africain dans l'oeuvre de Carl Einstein," in *Images de l'africain de l'antiquité au XXᵉ siècle*, ed. Daniel Droixhe and Klaus H. Kiefer (Frankfurt am Main: Verlag Peter Lang, 1987), 149–56.

27. See Barron, *Expressionist Sculpture*, 100–101.

28. Kirchner first used this pseudonym in 1920 when he wrote an article, "Zeichnungen von E. L. Kirchner," for the art journal *Genius*.

29. Both men died in the mid-twenties; see E. L. Kirchner, "Zur Scherer Gedachtnisausstellung," *Gedachtnisausstellung* (Basel: Kunsthalle, 1928), reprinted in Galerie Thomas Borgmann, Cologne, 1981, unpaginated.

30. Adolf Behne, "Expressionistische Architektur," *Der Sturm* 5, nos. 19–20 (January 1915): 175.

31. From January until July 1920 the first fourteen issues of *Das Frühlicht* appeared as a supplement to the periodical *Stadtbaukunst alter und neuer Zeit*. Subsequently it was published as an independent periodical until its demise in 1922.

32. Rosemarie Haag Bletter, "Expressionism and the New Objectivity," *Art Journal* 43, no. 2 (Summer 1983): 108–20.

33. See discussion of paradox and complementary opposites in Expressionist architecture in Rosemarie Haag Bletter, *Bruno Taut and Paul Scheerbart's Vision—Utopian Aspects of German Expressionist Architecture*, doctoral dissertation, Columbia University, 1973.

34. Rosemarie Haag Bletter, "Paul Scheerbart's Architectural Fantasies," *Journal of the Society of Architectural Historians* 34, no. 2 (May 1975): 83–97.

35. Rosemarie Haag Bletter, "The Interpretation of the Glass Dream—Expressionist Architecture and the History of the Crystal Metaphor," *Journal of the Society of Architectural Historians* 40, no. 1 (March 1981): 20–43.

36. Rosemarie Haag Bletter, "Global Earthworks," *Art Journal* 42, no. 3 (Fall 1982): 222–25.

37. Here Taut alludes to his own book *Die Stadtkrone* (Jena: Eugen Diederichs, 1919).

38. See Sigrid Achenbach, *Erich Mendelsohn, 1887–1953: Ideen, Bauten, Projekte* (Berlin: Staatliche Museen Preussischer Kulturbesitz, 1987); and also Kathleen Andrew James, *Erich Mendelsohn: The Berlin Years, 1918–1933*, doctoral dissertation, University of Pennsylvania, 1990.

39. For comprehensive overviews of German Expressionist printmaking see *German Expressionist Prints and Drawings: The Robert Gore Rifkind Center for German Expressionist Studies*, 2 vols., and Orrel P. Reed, Jr.,

German Expressionist Art, The Robert Gore Rifkind Collection: Prints, Drawings, Illustrated Books, Periodicals, Posters (Los Angeles: Frederick S. Wight Art Gallery, University of California, Los Angeles, 1977).

40. Rudolf Adrian Dietrich, "Geschichte (zur Ausstellung 'Der expressionistische Holzschnitt' bei Goltz in München)," *Die Schöne Rarität* 2 (1918/1919): 16.

41. Wilhelm Valentiner, "Karl Schmidt-Rottluff," *Der Cicerone* 2 (1920): 467.

42. Paul Westheim, as quoted in *The Era of German Expressionism*, ed. Paul Raabe, trans. J.M. Ritchie (Woodstock, N.Y.: Overlook Press, 1965), 202, 204–5.

43. See Beata Jahn and Friedemann Berger, eds., *Die Schaffenden: Eine Auswahl der Jahrgänge I bis III und Katalog des Mappenwerkes* (Leipzig and Weimar: Gustav Kiepenheuer Verlag, 1984).

44. Paul Westheim, "120 Blatt Originalgraphik," *Das Kunstblatt* (October 1922): 440. In 1921 he had published a book on the woodcut, *Das Holzschnittbuch*.

45. See Frank Whitford, *Oskar Kokoschka, a Life* (New York: Atheneum, 1986), esp. 85–126.

46. See Gerhard Wietek, "Dr. Phil. Rosa Schapire," *Jahrbuch der Hamburgischer Kunstsammlungen*, vol. 9, 1964, 115–60.

47. Will Grohmann, *Karl Schmidt-Rottluff* (Stuttgart: W. Kohlhammer, 1956), 90, 92.

48. See document 3 for an English translation of the 1912 article in *Der Sturm*.

49. For a detailed discussion of the portfolio, see Barbara C. Buenger, "Max Beckmann's *Ideologues*: Some Forgotten Faces," *Art Bulletin* 71, no. 3 (September 1989): 453–79.

50. Max Beckmann, "Schöpferische Konfessionen," in Kasimir Edschmid, ed., *Schöpferische Konfessionen*, Tribüne der Kunst und Zeit, no. 8 (Berlin: Erich Reiss Verlag, 1919), 21.

Part Three

War, Revolution, and Expressionism

I. THE WAR EXPERIENCE

by Ida Katherine Rigby

INTRODUCTION

Many Expressionists welcomed the war as the cathartic cataclysm, the cleansing, apocalyptic purge that their paintings and poems had predicted.[1] For others patriotic exultation prompted sacrifice. Franz Marc's letters and Otto Dix's etchings record the war at the front. Max Pechstein carved woodcuts of the wounded and in a portfolio of etchings reported the horrors of the Battle of the Somme. Käthe Kollwitz's prints reported on the home front experience. Madness was the theme of Conrad Felixmüller's soldiers in psychiatric wards. For some, such as Karl Schmidt-Rottluff, the daily proximity of death produced a profound spirituality.

A few artists and intellectuals were early opponents of the war, but for most resistance evolved with experience. They had been surprised and shocked by the carnage wrought by what the French pacifist Henri Barbusse described in his introduction to Dix's war portfolio as "advances of science and technology, hellish inventions, insane discoveries. . . ."[2] The early euphoria was further dampened by the realization that "money was the lubricant of the whole murdering war machine," while "the shareholders in the steel works and oil and poisonous gas companies" sat "safely out of danger" celebrating "dark, devilish triumphs."[3]

Prints became the medium of exchange for antiwar artists and the periodicals where they were published the rallying points for resistance. The artists' disillusionment was reflected in publisher Paul Cassirer's decision to replace his patriotic periodical, *Kriegszeit*, with the more skeptical *Der Bildermann*.[4] Another result of the Expressionists' growing opposition to the war and nationalism was their celebration of a new, universal humanity, so rapturously expressed in Ludwig Meidner's "Hymn of Brother Love," and their romantic identification with the international working-class movement.

40. Franz Marc, letters from the front, 1914–15*

The prewar paintings of Franz Marc, such as the *Fate of Animals* (fig. 27), conveyed the Expressionists' sense of impending apocalypse and the mounting political tensions in Europe. In his early letters, Marc, the romantic idealist, wrote of the war in terms of literary, mythological, and historical metaphor. For him the war was a saga in German history, soldiers Dantesque celebrants, a dying cavalry horse Pegasus, and he himself a member of Caesar's legions. By experiencing the war in mythic terms and as the medium for cultural renewal, he was able to accept the war-wrought suffering as part of a great historical turning point that demanded sacrifice.[5] He also saw it as a positive experience for his own development as an artist in that it induced the state of hypersensitivity and intensified vision described in his letters.

As the war dragged on, however, he came to believe that it has "lasted too long and become meaningless. . . . The sacrifices it exacts are senseless" (July 1, 1915). At four o'clock on the afternoon on March 4, 1916, he fell at Verdun. Marc's wartime letters, as selected by his widow Maria Marc, were published by Paul Cassirer in 1920, along with selected notes and aphorisms.

Letter to Maria Marc, Grubbe (bei Schlettstadt), Sept. 12, 1914
· · · ·

I reflect so much on this war and come to no conclusion; probably because the "events" obstruct my horizon. One can not get beyond the "action" in order to see the spirit of things. But in any case, the war will not make a naturalist out of me,—on the contrary: so strongly do I feel the spirit that hovers behind the battles, behind each bullet, that the realistic, the materialistic, disappears completely. Battles, wounds, movements have such a mystical, unreal effect, as though they meant something quite different from what their names signify; everything just stays coded in an awful silence,—or my ears are deaf, deafened by noise, in order even now to sound out the true language of these things. It is unbelievable that there were times in which war was represented by painting campfires, burning villages, galloping horsemen, falling horses, and patrol-riders

*Franz Marc, *Briefe, Aufzeichnungen und Aphorismen* (Berlin: Paul Cassirer, 1920), 8, 31–33, 39, 46–47.

and the like. These thoughts appear outright strange to me even when I think about Delacroix who, after all, was the most skilled at it. Uccello is still better, Egyptian friezes even better,—but still we must do it after all, completely differently, completely differently! When, I wonder, will I be free to paint again? . . .

Letter to Maria Marc, Mülhausen, Christmas Eve [1914]

. . . Nor do I ever regret having reported to the field. In Munich I would have been unhappy, depressed and dissatisfied all the time, and at home would have gained nothing for my being and thought, certainly not that which the war has given me. . . . The smallest newspaper item, the most ordinary conversations I hear, take on a secret meaning and implication for me; behind everything there is always something more; when you have once gotten the eye and ear for it, it leaves you no rest. The eye too! I am beginning to see more and more behind or better: through things, an other-side once hidden by appearances, and usually artfully hidden, making people seem to be altogether different from what they actually are. In physical terms it is of course an old story; today we know what heat is, resonance and gravity,—at least we have a second interpretation, the scientific. I am convinced that behind this one lies yet another, and many others. But this second meaning has powerfully transformed the human spirit, the greatest typological change that we have ever experienced. Art unhesitatingly proceeds along the same path, in its way, of course; and to find this way, that is the problem, our problem! . . .

Letter to Maria Marc, March 17, 1915

. . . Köhler wrote me today on a Sturm postal card of my *Fate of Animals* (fig. 27). On looking at it I was completely disconcerted and agitated. It is like a premonition of this war, horrible; and gripping, I can hardly imagine that I painted that! In any case in the blurred photograph it was so incomprehensibly convincing that I felt quite uneasy. There is an artistic logic about painting such pictures before the war rather than as a stupid reminiscence after the war. At that time one must paint constructive, forward-looking paintings, not memories, which is mostly the fashion. I too have some such [memories] in my head. I used to marvel at that from time to time; now I know why it must be so. But these old paintings from the Autumn Salon, etc., will have a revival one day.
. . . With me everything adds up to a painful exhaustion in my head;

but I am now beginning to draw quietly in the sketchbook. That relieves and revives me.

Letter to Maria Marc, April 6, 1915

D[earest], last night your dear, good letter of 1.IV arrived. I cannot tell you how completely I share your ideas and especially want to share them in the future. . . . The war is nothing different from the evil times before the war; what one previously committed in one's mind, is now committed in deeds; but why? Because the sham of European propriety is no longer tolerable. Better blood than eternal deception; the war is just as much atonement as voluntary sacrifice to which Europe subjected itself in order to "come clean" with itself. Everything else is completely irrelevant and hateful; but the soldiers who march out and who die are not ugly. There your feelings deceive you, because you do not feel deeply enough. If you cannot bear the sight of war, try, as best you can, to look away from it. But don't call it stupid! . . .

41. Käthe Kollwitz, letter and diary entries, 1914, 1916, 1917, 1920, 1922*

Initially Käthe Schmidt Kollwitz (1867–1945) patriotically supported the war effort, but even before her son Peter was killed in October 1914 she began to question it. Her one contribution to *Kriegszeit, The Fear* (October 28, 1914), was not in keeping with the patriotic spirit of the publication; and in 1916 she contributed a mother and child to *Der Bildermann*, which reflected publisher Cassirer's new antiwar stance. In her February 1917 diary entry, Kollwitz describes one of the antiwar evenings held in Cassirer's gallery, featuring the actresses Gertrud Eysoldt and Tilla Durieux, his wife.

*Käthe Kollwitz, diary entries, September 30, 1914, February 1917, June 25, 1920: reprinted in Käthe Kollwitz, *Tagebuchblätter und Briefe*, ed. Hans Kollwitz (Berlin: Gebruder Mann Verlag, 1949), 56, 69, 86; October 11, 1916: reprinted in Käthe Kollwitz, *The Diary and Letters of Käthe Kollwitz*, Hans Kollwitz, ed., Richard and Clara Winston, trans. (Chicago: Henry Regnery Company, 1955), 73–75. Letter to Romain Rolland, October 23, 1922: reprinted in *Käthe Kollwitz, Das Graphische Werk: Sammlung Helmut Goedeckmeyer* (Lübeck: Overbeck: Gesellschaft, 1967), n.p.

Kollwitz's letters, diary entries, and antiwar portfolio, *Seven Wood-cuts about War*, 1924 (fig. 28), trace the home front experience from patriotic exhilaration in sacrifice to disillusionment, despair, and finally resilience and renewal. She chose the woodcut medium after seeing an exhibition of Ernst Barlach's prints in July 1920. She realized that the powerful condensation of emotion she had been unable to achieve in lithography and etching was available in the woodcut. Although she viewed herself as a realist, and had criticized what she called the studio art of the Expressionists, she sensed that her overwhelming emotions could find form only in this preeminently Expressionist medium.

Diary entry, September 30, 1914

Cold cloudy fall weather. This sober state of mind when one knows: it is war, but one fails to sustain any illusion. What remains is only the horror of the situation to which one has nearly accustomed oneself. At such times it seems so idiotic that young men go off to war. The whole thing is only so empty and mindless. Sometimes the stupid thought: they will not participate in such an insane happening—and immediately like a cold ray: they **must, must!** Everything is equal before death, down with all youth! Then one can despair.

Only one condition makes everything bearable: to make the sacrifice an act of will. But how can this condition be maintained?

Diary entry, October 11, 1916

Everything remains as obscure as ever for me. Why is that? It's not only our youth who go willingly and joyfully into the war; it's the same in all nations. People who would be friends under other conditions now hurl themselves at one another as enemies. Are the young really without judgment? Do they always rush into it as soon as they are called? Without looking closer? Do they rush into war because they want to, because it is in their blood so that they accept without examination whatever reasons for fighting are given to them? Do the young want war? Would they be old before their time if they no longer wanted it?

This frightful insanity—the youth of Europe hurling themselves at one another.

When I think I am convinced of the insanity of the war, I ask myself

again by what law man ought to live. Certainly not in order to attain the greatest possible happiness. It will always be true that life must be subordinated to the service of an ideal. But in this case, where has that principle led us? Peter, Erich, Richard,[6] all have subordinated their lives to the idea of patriotism. The English, Russian, and French young men have done the same. The consequence has been this terrible killing, and the impoverishment of Europe. Then shall we say that the youth in all these countries have been cheated? Has their capacity for sacrifice been exploited in order to bring on the war? Where are the guilty? Are there any? Or is everyone cheated? Has it been a case of mass madness? And when and how will the awakening take place?

. . . .

Is it a breach of faith with you, Peter, if I can now see only madness in the war? Peter, you died believing. Was that also true of Erich, Walter, Meier, Gottfried, Richard Noll? Or had they come to their senses and were they nevertheless forced to leap into the abyss? Was force involved? Or did they want to? Were they forced?

. . . .

Diary entry, February 1917

Yesterday attended an evening of readings by Durieux and Eysold at Cassirer's. Everything else was dull. But Durieux read a story by Leonhard Frank[7] about a waiter who had an only son. He falls "on the field of honor." And then, afterward, a Social Democratic meeting, at which the waiter suddenly finds his voice. The crowd on the street grows; "they want to make peace." The enormous din of the people at the end, and the sounding bells: "Peace! Peace! Peace!" It was unendurable. When she stopped, a man's voice cried out ever louder, "Peace! Peace!"

And to know all this, that the longing for peace is so fervent throughout Europe, everywhere the same, and yet the war cannot stop and goes on day after day, and every hour young people must die.

Diary entry, June 25, 1920

Yesterday was at the Secession with Professor Kern and in the large exhibition in order to choose a print for the Kunstverein. There I saw something that knocked me over: Barlach's woodcuts.

Today I have again looked at my lithographs and again seen that almost all of them are not good. Barlach has found his path, and I have not as yet found mine.

I can no longer etch; I'm through with that forever. And in lithography there are the inadequacies of the transfer paper. Nowadays only with lots of money and pleading can one get lithographic stones brought to the studio, and even on stones I do not do very well. I always hide behind the many obstacles, and when I saw Barlach it suddenly occurred to me that it perhaps is not that at all. Why shouldn't I be able to do more? The basic conditions for artistic works were there, for example, in the war series. First of all strong feeling—these things come from the heart—and secondly they rest on the foundation of my previous works, upon a fairly good foundation of ability.

And yet the prints are not really artistic. Why? Ought I truly, like Barlach, make a completely new attempt and start over with the woodcut? Up until now when I thought about that I always told myself that lithography was the right medium for me for obvious reasons. In the woodcut I do not want to go along with the current fashion of creating patchy effects. For me the issue is only expression, and therefore I said to myself that the simple lines of the lithograph were best suited to it. But the results of my work, except for the print Mothers, never satisfied me.

· · · ·

First I began the war series as etchings. Nothing came of it. Dropped everything. Then I tried it with transfers. With that, too, almost never satisfying results.

Will the woodcut bring them forth? If that doesn't either, then I will have proof that the fault lies only within me. Then I am simply unable to do it any longer. In all the years of anguish these small oases of joys and successes.

Letter to Romain Rolland,[8] Oct. 23, 1922

Most honorable Romain Rolland,

Your letter and greeting was a great joy to me. Throughout the whole war, in the four dark years, your name was—with only a few others— a kind of comfort. Because you represented that which one longed to hear.

· · · ·

All of us—in all belligerent lands—have endured the same thing. Again and again I have sought to represent the war. I could never grasp it. Now, finally, I have finished a series of woodcuts that to some extent say what I wanted to say. There are seven sheets entitled: *The Sacrifice— The Volunteers—The Parents—The Mothers—The Widows—The People.* These sheets should travel the world and together should say to all humanity: so it was—this we all have endured through these unspeakably hard years.

I shake your hand heartily and thank you for your good words.

42. Conrad Felixmüller, "Military Hospital Orderly Felixmüller," *Menschen*, 1918*

Conrad Felixmüller was born Conrad Felix Müller (1897–1977) in Dresden. His family was working class, his father a blacksmith. From 1912 to 1915 he studied at the Dresden Academy of Fine Arts. His early Brücke-derived prints first appeared in 1913, when he executed ten woodcuts to illustrate Arnold Schoenberg's *Songs of Pierrot Lunaire (Lieder des Pierrot Lunaire)*, which the Viennese composer received enthusiastically. In 1914 Felixmüller completed eight woodcuts for Else Lasker-Schüler's poems *Hebrew Ballads (Hebräische Balladen)*, and began to exhibit his work with a show of etchings at the I. B. Neumann Gallery in Berlin. There he met Theodor Däubler, Ludwig Meidner, Franz Pfemfert, Herwarth Walden, and other leading Expressionists. He was with the Sturm circle until 1916, when he joined the more political, antiwar Aktion group.

On 1917 Felixmüller spent a month as an orderly in the military hospital in Arnsdorf. His essay on the experience and a lithograph (fig. 29) in which he scrawled "Sender Felixmüller" on an envelope clutched by a patient, testify to his deep involvement with his charges. In the excerpt here, the intensely imagined, nightmarish, morphine-drugged journey in a Red Cross train evokes a hallucinatory feeling.

The passage captures the excruciating physicality of war and the sense of hovering on the brink of madness that was part of the war experience. It also expresses the widespread disillusionment with capitalism, which was held responsible for the senseless suffering. With human empathy, it vents the same anger George Grosz expressed with bitterness, scorn, and outrage in letters describing his stay at a military hospital, where he sketched at every opportunity in order to preserve the "beastly faces of my comrades, war cripples, arrogant officer, embittered nurses . . . everything that was laughable and grotesque . . . the ugliness and distortions I saw all about me."[9] The essay also reflects the Expressionist faith in a secularized concept of redemption through suffering and universal brotherhood, the foundation of their vision of a future utopia.

*Conrad Felixmüller, "Militär Krankenwärter Felixmüller XI Arnsdorf," *Menschen* 3 (May 15, 1918): 3.

Am now here, military hospital orderly Felixmüller. Emphasize, however, *sick* and Felixmüller. Want first to examine myself and my sick ones. Kindness, sympathy and feeling restore health. Still have heart and soul with which to feel after all. It is night. In twenty beds around me sick soldiers are laid out. Sick in mind, epileptics, madmen, cripples, wounded. All men like me. Flesh, body, bones—strange forms, sometimes weak, sometimes strong. Pains everywhere, above all in the head (three days ago the doctor battered my head with a small hammer, i.e., I have splitting pains). Everything is steeped in blood. Glowing red like molten iron. Lungs, breast, the whole body with capillaries full of these microscopic, fine details. Distended stomach traversed by the blue and red of these thin, swelling capillaries. Green, sulfurous, gleaming intestines, endlessly long, filled with swollen pulp, of flesh like my flesh, permeated with animal blood. Loathing (I feel full) rises up—disgusts me—would like to vomit—cannot. A truck runs over my limbs.

And I make every effort with this body to serve other like bodies, sick, wounded, insane. Laid out in twenty beds. Suddenly all these men are before me enveloped in carbolic clouds, foggy and for a time lost in bloody, festering bandages. Am now everything myself in order to understand and help: am sick, wounded, insane, feverish, and have ice packs in my legs. Have everywhere a red burning rash. It grows fast enough to watch from speck-size to palm size—eventually I am only a single burning rash. And cannot lie, nor sleep. Day dreams. First in combat loaded with rounds of ammunition, almost crushed to death—and soon in a speeding Red Cross express train. Rumbling pause. Lie in ghostly white. Red Cross nurses, white-smocked orderlies and doctors in front of my large-swollen face—consumed, all feeling vanished. [I] howl in a deep, dark infinity. Still hear beautiful cracklings like glass from a knife cutting through skin into flesh, shredding sinews like leather. Sawing leg bones like wood— Off!—blood spurts in a red arc toward the window over cities, villages, fields. Shreds of field bandage fly past, bind up my stump. And howl with the train in the dark red tunnel. Always deeper—watch out—head off—it tears off—plunges down into the abyss until—I feel bed. Terror convulses me. . . .

So beautiful is blood—?! it can flow so beautifully, drip!

If—only—I—could give—all—20 comrades—this—same—joy with my silver needle? bring to them a liberating release from head pain. Extinguish their consciousness just so. If, one after another, I could push my silver steel needle blue, now colored over blood red, into the temple.

Why not then? After all, I have shed no blood so far. After all, I have thrust no bayonet into the intestines—offal stomachs! Knocked no skulls in with rifles!?

So I'll do it at once. If only everyone would sleep peacefully. Should be surprised in the morning. Each lying in his delicate little stream of blood.

It is good that night is over—and comrade orderly summons [us] to wash up.

. . . .

Deranged by an agitated night. The whole night an attack of madness. First one bed—then two close by—then four beds—all beds, and the big orderly—rest.

Two days ago they brought a comrade into the compartment—now they bring him back again still completely high on cocaine. . . . after an unsuccessful effort to escape. He tells me of his discovery of a fire window—window bars broken by a strong thrust, lowered on the bedsheet to escape! I flee along with [him]. Am, however, not crazy!

. . . .

Everyone would immediately become healthy and happy if one said to them: "War is over" said to them: "we delivered you from it through us—because we knew and recognized that thou and thou art our fellow man, hast consumed our guilt for us, art raving and insane." If one were to say to them: "We love you, fellow creatures,—and put an end to it."

. . . .

Warm the walls of ice-cold hearts with love! Burst the obstinate egoism of capitalist liars for these men here in this sink of iniquity that is Europe.

No man is your enemy—in an insane bloody stump thou shouldst still recognize thy fellow man, thou thyself—because thou art the insane one, the raving mad one, the raging one, the *murderer* in the war!

43. Ludwig Meidner, "Hymn of Brotherly Love," from *September-Cry*, 1920*

Before World War I Ludwig Meidner painted visionary, apocalyptic landscapes and cityscapes. In the early months of the war, his pen drawings captured the patriotic hysteria of the war's supporters and the pathos of the prisoners and wounded. He became more involved with the antiwar circles around Franz Pfemfert and Paul Cassirer. In 1916 he was called into the infantry and served into 1918. During

*Ludwig Meidner, "Hymne der Brüderliebe," *Septemberschrei. Hymnen, Gebete/Lästerungen* (Berlin: Paul Cassirer, 1920), 34–37.

this period he wrote the "hymnical prose" pieces published by Cassirer in 1920 as *September-Cry*.

The "Hymn of Brotherly Love" was written in 1917 while Meidner was an interpreter in a German prisoner of war camp, when, as he wrote: "I sit glued fast to the censoring of letters of French prisoners. . . . I stare at these yellowish cards with the gray splatters of tears. On homesickness . . . it moans in every line."[10] He tried to "kindle hatred" within himself, but felt only solidarity. This ode to internationalism reflects the Expressionists' faith in the essential oneness and goodness of humanity, summarized in an anthology of Expressionist testimonials to the universality of the human spirit published in 1920 by Kasimir Edschmid.[11] Calls to internationalism filled the Expressionist journals; the most influential was the critic Kurt Pinthus's "Address to World Citizens."[12]

The rattle of machine guns on sunny, high monoplanes. . . .[13] Men's curses, venal, explode the sunny day. Oh horror that flows out of all mouths. . . .[14] Thou high ark of God, August day in morning glow—and thou pain-torn? earth of the prison camp. Human suffering, inexpressible, of thee must I exult loudly and finally confess my love, deep love.

I am frightened away from barren, scattered court-yards. What turmoil there on a warm human day. Races of Europe and Africa; colored pinions and faces whitened with pain. . . . Oh humanity, thou turnest thy eyes towards me. Thou hast faces like me, with noses, hairs and thin-sorrowful cheeks, human faces calling for help.

Thou Frenchman before me, in bright blue uniform, thy tanned, friendly look, thy casual bearing, arms hanging deep in the pockets of wide trousers, thy mischievous head full of jests, ironies and good jokes, thy heart full of poetic fever and longing for life and withheld fury, thou exuberant Frenchman, thou artist-man and true poet; no, how like you are to me. Art thou not the very closest to me?! come and allow me to call thee my best friend and brother.

Come, ye Englishmen, elegantly built and unaffected as young boys. Thou slandered, much-maligned, how I delight in thee. The books and papers of this time are full of your evil, cunning, self-seeking and treachery. But I need only to see thy free, manly look and friendly and simple bearing. Yes, thou art true, nothing other than true friends. Thou hast in thee the grand simplicity and justice of the sea. Thou art near to me, as only my dear brothers and sisters.

And ye Russians! thou comest yet nearer to me, ye dear Russians!

Shyness, hesitancy speak well of thee, thou fundamentally good, thou beloved of God, thou deep, loving human beings. May I step in thy midst and speak with thee, for yes, thou art clearly shy and do not trust me. Oh, how thou hast all come down in the world, wasted by the terrible winters and pestilential summers. Thy silhouettes, how shattered and unsteady! Ye emaciated and crippled, . . . and scrofulous ones—Oh, that I could help you! Thy faces are indeed grown wild, scarred, and sticky from the daily round of days of imprisonment; trampled down and tread upon by insults and hate. . . . Ye humble, god-fearing Russians, ye beloved, beloved Russians and men!

. . . .

Ye Arabs, colored and pious, what fabulous past one sees in thy gentle and collected gaze. What passionate gestures surround you. Ancient heroic people, great in fervor and moral power. Is it not as though I had always known ye? To me ye have been trusted friends since my fairy tale days of childhood. . . . ye sonorous Moroccans, hot from the carnivore sun of Africa and—ye noble, deeply noble Negroes!

What should I say first to thy glory!? Show me one more beautiful among all the men in these courtyards! . . .

. . . Humanity! White, brown, and black. Broken and upright. Brothers, brothers; all brothers, all equally near to me. How I understand each one of thee. Oh, thou art as miraculous as I myself. Human rock rising up resounding monuments on fleshy legs. Mysterious as I myself and unfathomable. . . . Oh, I know ye are full of folly, spite, and cunning; are cowardly, arrogant, selfish, and full of hate. Let's not speak of that. I am not one whit better. I know, no grain of my soul stands above ye. But I have recognized my love in time. Yes, I have cleared away all foolishness, all evil instincts and now surrender myself completely to my overflowing heart. Now I also turn myself to you. Let us forget hatred and all the wickedness of the recent years that ye inflicted on one another. . . . Ye have listened to the evil ones. Ye ran screaming after the gaudy banners of empty phrases. See the fiery August summer. Open your heart and let it in. Open your hearts' floodgates and inundate the world with warm humanity. . . .

Come out! Come out! Hearts of my brothers, arise, awake and live.

II. CRITICS, ARTISTS AND THE REVOLUTION

by Ida Katherine Rigby

INTRODUCTION

Intoxicated by the vision of Germany rising phoenixlike from the ashes of war (fig. 30), Expressionist artists and writers rallied around the socialist revolution. Periodicals examined the relationship between art and revolution and paid tribute to martyrs of the left such as Karl Liebknecht (fig. 31), Rosa Luxemburg (fig. 26), Kurt Eisner, and Gustav Landauer.[15] Expressionist journals resounded with such exultant exclamations as: "Art and Revolution! They go together. A painter and the son of the muses always stand in flames."[16]

The politicizing of German artists and intellectuals evolved as they began to blame the established powers for the carnage of the war. When on November 9, 1918, Kaiser Wilhelm abdicated and the German Republic was proclaimed, Expressionists saw the opportunity to help design the future. They saw themselves as the spiritual vanguard of the revolution and as its prophets. With the workers they found common ground in shared poverty and the desire for freedom; they believed in a bond between artists who desired creative freedom and workers who sought freedom from economic exploitation. The Expressionists admired the workers for having acted to bring about the conditions that would allow them to participate not only in the reformation of academies, museums, and exhibition policies, but also in shaping the social fabric. Paul Cassirer's radiant vision of postrevolutionary Berlin presents the anticipated results of the collaboration among artists, architects, and politicians: ". . . the city of Berlin appears like a star made out of diamonds, a grand beautiful star . . . Berlin, the working city [*Arbeitsstadt*]."[17]

In their effort to join with or emulate the workers, Expressionist artists formed radical groups, attended workers' meetings, and between the November Revolution and the elections of January 19, 1919, made posters for the provisional government encouraging Germans to exercise their new-found suffrage. The critic Willi Wolfradt summarized the assumptions behind Expressionist activism: ". . . to be the organs of upheaval, the will to redemption, became the justification of art. . . . In the everyday one seeks the miracle, in the filth of the metropolis, paradise. An urgency . . . joins handbill distributors and poets in the brotherhood of expression . . . the art of the present storms unchained into the future utopia."[18] This activism was short-lived. Tappert's letter and the Dada critique of Expressionism and the Open Letter to the Novembergruppe elsewhere in this anthology suggest some of the reasons for the Expressionists' retreat from politics that followed the dizzying events of late 1918 and early 1919.

44. Ludwig Meidner, "To All Artists, Musicians, Poets," *Das Kunstblatt*, 1919*

The painter and poet Ludwig Meidner, like many Expressionists, ecstatically embraced the international workers' movement. He attended the founding meeting of the Novembergruppe and joined the Arbeitsrat für Kunst. With Max Pechstein, he composed the manifesto excerpted here. It was published under Meidner's name, first in *Die Erde*,[19] then in *Der Anbruch* (January 1919), and in a toned-down version in *Das Kunstblatt*. The latter was republished in the Novembergruppe's book, *An alle Künstler!* (To all artists).[20] The last few paragraphs of the earlier version were more rapturous and contained a more explicit call to action: "We . . . must challenge and brand the burgher where we meet him. We must mingle with the poor, . . . enlighten, inveigh, agitate, incite and when the hour comes—all in—with musket against the enemy—Oh, a blood-hot human rampart of hearts and spirits against the foe! . . . We carry off a beautiful prize—; our work will become deeper, the line nobler, the pathos more sublime. . . ."[21]

*Ludwig Meidner, "An alle Künstler, Dichter, Musiker." *Das Kunstblatt* 1 (January 1919): 29–30.

So that we no longer have to be ashamed before the heavens, we must finally get busy and help establish a just order in government and society.

We artists and poets must join in the first ranks.

There can be no more exploiters and exploited!

It can no longer be the case that a huge majority must live in the most miserable, disgraceful, and degrading conditions, while a tiny minority eat like animals at an overflowing table. We must commit ourselves to socialism: to a general and unceasing socialization of the means of production, which gives each man work, leisure, bread, a home, and the intimation of a higher goal. Socialism must be our new creed!

It must rescue both: the poor out of the humiliation of servitude, oppression, brutality, and malice—and the rich it will deliver forever more from merciless egotism, from their greed and harshness.

Let a holy solidarity ally us painters and poets with the poor! Have not many among us also known misery and the shame of hunger and material dependence?! Do we have a much better and more secure position in society than the proletariat?! Are we not like beggars dependent upon the whims of the art-collecting bourgeoisie!

If we are still young and unknown, they throw us alms or leave us silently to die.

If we have a name, then they seek to divert us from the pure goals with money and vain desires. And when we are finally in the grave, then their ostentatiousness covers our undefiled works with mountains of gold coins—painters, poets, composers, be ashamed of your dependence and cowardice and join as a brother with the expelled, outcast, ill-paid menial!

We are not workers, no. Ecstasy, rapture—passion is our daily work. We are free and knowing and must, like guiding banners, wave before our strong brothers.

Painters, poets.[22] who other than we should then fight for the just cause?! In us the world conscience still throbs powerfully. Ever anew the voice of God breathes fire into our rebellious fists.

. . . .

Painters, poets! let us make common cause with our intimidated, defenseless brothers, for the sake of the spirit.

The worker respects the spirit. He strives with powerful zeal for knowledge and learning.

The bourgeois is irreverent. He loves only dalliance and aesthetically embellished stupidities and hates and fears the spirit—because he feels that he could be unmasked by it.

The bourgeois knows only one freedom, his own—namely to be able to exploit others. That is the pale terror that goes about silently, and millions collapse and wither early.

The bourgeois knows no love—only exploitation and fraud. Arise, arise

to battle against the ugly beast of prey, the booty-hungry, thousand-headed emperor of tomorrow, the atheist and Anti-Christ!

Painters, architects, sculptors, you whom the bourgeois pays high wages for your work—out of vanity, snobbery, and boredom—listen: on this money sticks the sweat and blood and life juices of thousands of poor, overexerted people—listen: that is an unclean profit.

Listen further: we must take our conviction seriously, the new wondrous belief. We must join with the workers' party, the decisive, unequivocal party.

Socialism is at stake—that means: justice, freedom, and human love at stake—at stake, God's order in the world!

45. Herbert Kühn, "Expressionism and Socialism," *Neue Blätter für Kunst und Dichtung*, 1919*

During 1919, Herbert Kühn (1895–1980) worked as a political editor and art critic for the *Halberstädter Tageblatt* and was part of the circle around Franz Pfemfert and *Die Aktion*. He had studied philosophy, ethnology, and art history at the University of Berlin and philosophy and the history of religion with the philosopher Rudolf Eucken at Jena, where he completed his dissertation, "The Basis of the Change in Style in Modern Art" in 1918. He became a specialist in prehistoric culture and in 1929 was appointed professor at the University of Cologne.

In this essay, Kühn describes Expressionism as concerned with the life of the spirit and full of faith in human renewal and cultural regeneration through art. He identifies a shared opposition to materialism as the link between Expressionism and socialism. Ironically, it was precisely because of this antimaterialism that the opponents of Expressionism found it and the workers' movement incompatible, since the workers' movement had to be concerned primarily with attaining material goals. The socialist movement and Expressionism shared a common faith in mankind and in internationalism, but the

*Herbert Kühn, "Expressionismus und Sozialismus," *Neue Blätter für Kunst und Dichtung* 2, no. 2 (May 1919): 28–30.

roots of those faiths were very different, as Georg Tappert's letter to Franz Pfemfert [document 47] indicates.

Expressionism is in origin not a problem of form. What is of primary importance is the transformation of the spirit, the change in that primal relationship that is signified in the relation of the self to the world.

. . . .

Machines, created by men to help men, cannons, automobiles, railroads, airships, telegraphs—for the use of man, for his advancement—they arose, raised themselves above the creator—slew him. His will shattered. His consciousness wasted away. Time rebelled.

. . . .

Man perished through materialism. We died from the unspiritual: War.

And we awoke anew to a new existence.

The world war is the final result of an epoch that had forgotten the self, an epoch that had trespassed against the spirit, an epoch that therefore had to destroy itself.

. . . .

We have conquered the soul anew, the spirit. . . .

. . . .

And thus we attain that which the epoch before us had forgotten—humanity.

We bring it forth out of ourselves. We recreate it anew. We build on it, we model and form, in order to raise it to greater heights, in order to conceive it more broadly in order to make the more powerful, luminous, blazing, the One that struggles within us, the One that occupies us, the One that fulfills us: Man.

. . . .

In socialism man awakens to his rights. Man, who formerly looked on— now, enslaved, exploited, oppressed, saw in agony how the world destroyed him. . . .

Matter destroyed us. Matter crushed us. Joyless work, which man invented, the increase of capital, when man created—the machine—raised itself up against man—killed him.

God was killed.

But God does not let himself be killed.

. . . .

1910 the revolution in art began. 1910 Picasso painted, 1910 Kandinsky, 1910 *Die Aktion* appeared.

Art is ahead of its time.

As is philosophy.

Husserl, Bergson, Eucken, Simmel—each name a rediscovery of the spirit, a rediscovery of humanity.

But still the time had not come.

Matter still had to carry out its last blow, the explosion, the destruction—then the way was also politically then completely freed for the belief in humanity—socialism.

· · · ·

Expressionism is—as is socialism—the same outcry against matter, against the unspiritual, against machines, against centralization, for the spirit, for God, for the humanity in man.

It is the same cast of mind, the same attitude toward the world, that has different names according only to different areas in which it appears. There is no Expressionism without socialism.

It is not by chance that the new art opens itself so strongly to politics, it is not by chance that there are periodicals for politics (Social Democracy) and Expressionism.

It is not by chance that the new art rises up just as much against war, against militarism, as the best of the Social Democrats do.

We want humaneness, unity of the spirit, freedom, brotherhood of the essentially human, and we despise border-post insanity, chauvinism, nationalism.

As with Tolstoi, patriotism is for us the most offensive form of meanness, of pettiness, of falsehood. Out of this false breed grows baseness of mind. Inevitably.

· · · ·

We greet you, thou French brothers, comrades, united—thou, Barbusse, and thou Romain Rolland, thou J. P. Jouve, and André Gide, Henri Guilbeaux, and Martinet,[23] Duchamp and all the others.

We greet you Italians, you Czechs, Poles, Russians, Finns, British, and you, you Indians.

The artists are ahead of their times, they prepare the ground, they engrave the hearts, they sow the seeds.

· · · ·

We want a new world. A better world.

We want **Humanity**!

46. Kurt Eisner, "The Socialist Nation and the Artist," *An alle Künstler!*, 1919*

The socialist politician Kurt Eisner (1867–1919) was a visionary philosopher who had studied ethics and philosophy at Marburg before becoming editor of the Social Democratic newspaper *Vorwärts* from 1898 to 1905. He was the only prominent politician directly to address the issue of art and politics and suggest ways to reintegrate artists into society. This address was presented to the provisional Bavarian National Assembly and published posthumously with a few changes in the Novembergruppe's *An alle Künstler!*

On November 8, 1918, the Independent Social Democrats declared Bavaria a republic with Eisner at its helm.[24] For a short time men with close ties to Expressionist circles held official positions. Gustav Landauer, for example, who headed Eisner's Bureau for the Education of the Masses, had been part of the circle around Franz Pfemfert's *Die Aktion*. He tried to no avail to convince the workers to accept avant-garde artists. The Independent Socialists were defeated in the Bavarian general elections and on February 21, 1919, Eisner was assassinated. During the ensuing civil war a coalition cabinet governed from Nürnberg. In Munich, on April 7, Eisner's old friends Landauer, the Expressionist poet and playwright Ernst Toller, and the pacifist editor of Expressionist publications, Erich Mühsam, established in opposition the short-lived Soviet Republic of Bavaria. The Nürnberg regime asked the government in Berlin to intervene to remove the soviet. Landauer was beaten to death; *Das Tribunal* carried a blow-by-blow eyewitness account of the murder. Others, including Toller, were jailed.

It is among German peculiarities that politics is something completely apart, that governing is in reality a juridical activity. I think it was Bismarck who believed that governing was an art, and I think, in my case: governing is as much an art as painting pictures or composing strong quartets. The object of this political art, the material with which this political art is supposed to work, is society, the state, humanity. Therefore I would like to think that

*Kurt Eisner, "Der sozialistische Staat und der Künstler," in [Die Novembergruppe], *An alle Künstler!* (Berlin: [Kunstanstalt Willi Simon], 1919), 25–26.

a true statesman's, a true government's strongest inner affinity should be to no one more than to artists, their professional comrades. . . .

. . . .

And now the question, what can the state do for art and what can it do for artists? If the relationship between the state and art is such as I have just indicated, then the state has above all the responsibility—the government of the state, I mean—to be itself the embodiment of all culture that is united in the present era. A government that in this sense is itself the embodiment of culture thereby advances art in and of itself. . . .

. . . .

. . . Art can only flourish in total freedom. In an artist' assembly I recently stated: **The artist must, as an artist, be an anarchist and as a member of society, as a citizen dependent on the bourgeoisie for the necessities of life, a socialist. The state can give the artist no other advice than that he freely and independently follow his innermost impulses, and that is the best the state can do to encourage art: that it gives the artist complete freedom of his artistic action.** Its concern, and its justified concern, is that the artist be able to live, that he be able to exist as an economic entity.

. . . .

. . . Art demands a total life, great art even demands the renunciation of life. The great artist is possessed, he is a martyr to his art. I have stated that the visual artist should create only in the leisure hours of his inspiration, he should not make a commodity of art under the pressure of economic necessity. He should, for example, not have to eternally repeat himself just to toss goods on the market. . . . I have therefore taken up the question whether **the visual artist should not proceed directly from his own handwork or if he should not base his economic existence on his handwork**—the sculptor, for example, as stonemason—and only in the leisure hours of his inspiration create works of art that he then does not make in haste in 24 weeks in order to live, but on which he often could work on for years. I believe that this thought is not at all utopian, but that it is a return to earlier, healthy artistic conditions. The suggestion is an effort to solve the problem of how the visual artist can live today without living from art. **He should live for art.**

What we can do is to promote art by seeing that the state itself is composed of artists, that it allows freedom; and I do not understand why the **state** should not give **artists in the most diverse fields** their freedom of action **through economic support.** . . .

. . . .

. . . **But the state could assure recognized artists of a livelihood, that it could pay them a salary just as it would pay some examining magistrate, that seems to me to be entirely possible.**

The state can do still more for art. It can, for example, to speak of literature, **eliminate the kitsch from school-books** and promote contemporary artistic production through school texts. That serves not only then the education of the younger generation but is also useful to the artist, the visual artist as well as the designer or the writer. Those are a few things, according to my view, in which the state could beneficially intervene.

. . . .

47. Georg Tappert, letter to Franz Pfemfert, November 23, 1918*

Georg Tappert (1880–1957) was directly involved with Expressionist issues before and after the war. After returning to his native Berlin in 1910 from Worpswede, where he had an art school, he organized another school with the painter and printmaker Moriz Melzer, participated in the founding of the New Secession, contributed to Expressionist journals, including *Der Sturm, Die Aktion, Die Sichel* and *Menschen*, and co-published *Die schöne Rarität*.

Tappert actively participated in the formation of the Novembergruppe and used his many personal contacts to recruit members.[25] He signed the founding statement of the Arbeitsrat für Kunst, and in his response to its questionnaire, published in *YES! Voices of the Arbeitsrat für Kunst*, he chose to address the reform of art education (document 54). Essays by Tappert also appeared in the Novembergruppe's *An alle Künstler!* and in a special Novembergruppe edition of *Menschen*. Tappert's letter to Franz Pfemfert (fig. 32), editor of *Die Aktion*, attests to the front-line political involvement of the politicized Expressionists, as well as to the soul-wrenching dilemma their new-found activism created and the reasons for their disaffection from politics.

For those who had fervently believed in a union with the proletariat, the vehement rejection by the workers (whom they had embraced as comrades in the battle against the stifling bourgeoisie and an authoritarian government), came as a shock. Many like Tappert anguished over the disparity between their vision and reality. Theirs was an aesthetic as well as moral dilemma. Those they supported morally had no use for modernist aesthetics. The Expressionists were unwilling to compromise their new expressive freedom and exchange

*Georg Tappert, letter to Franz Pfemfert, reprinted in Gerhard Wietek, *Georg Tappert, 1880–1957: Ein Wegbereiter der deutschen Moderne* (Munich: Verlag Karl Thiemig, 1980), 48–50.

a bourgeois and imperial artistic dictatorship for a new one. Tappert's letter is an eloquent testimony to the anguish of the engaged artist forced to choose between freedom of expression and the propaganda needs of the left.

Charlottenburg, November 20, 1918

Dear Pfemfert,

Yesterday your presence would have been highly desirable, or at least the presence of an articulate friend. . . . Apart from the fact that Holitscher's voice didn't carry, people were not willing to listen to him, since he avoided all slogans, put the ideas in purely intellectual form, and the crowd was too lazy and stupid to follow him. By contrast, the speaker from the Council of Intellectual Workers was wildly applauded. . . .

. . . There followed further scoffing remarks about Pfemfert and his circle,—about the "pugilist of the Rote Hahn,"[26] whose help was unnecessary and unwanted. . . . the man was captivating with his ardent, sarcastic statements delivered in the language of the proletariat.

Essentially the picture of the assembly was the following: Either one said to the intellectuals, we'll condescend to take you in if you come to us humble and small, or one did a lot of bowing and scraping before the newly empowered proletariat.

I would have wanted you there especially because the collective voice of the assembly would have shown you how correct my expressions of opinions in this area have been up until now. Whether Spartacist or Independent Socialist,[27]—the people want nothing to do with you, with us; nor does [wearing] the proletarian collar help increase hope for trust or understanding. What we strive for is alien to them. They have no desire to understand it, it is a matter of indifference to them, and it will still be so 10 to 15 years from now! The proletarian youth of 1900 would have been a much more suitable object for *Die Aktion* and its efforts. There was an eagerness for literature, for art, for education in it! These young people lined up 2 hours before the theaters opened in order to be received on spiritual and intellectual Olympus. The young proletarian of today does this no more. Class consciousness, political enlightenment hold him back; because he cannot sit in the orchestra stalls, he forgoes it completely. In the last two war years, nevertheless, he and the war profiteers sat there, equally devoid of understanding, merely to demonstrate that he, like every fat bourgeois, could afford it.

He despises intellectual pursuit because, according to his view, it is a privilege of the educated, that for him is synonymous with the "haves." . . .

You will not want to admit that I am right, you will say I am seeing the situation as an artist, as the possessor of spiritual value. I would like to counter that I grew up in the teachings of socialism as the son of a confirmed socialist, knew party life in all of its forms, as well as the proletariat in all its loftiness and profundity. From the moment that I decided to become a painter, I came to be seen as a renegade, a bourgeois. . . .

Your political work with *Die Aktion* will not be appreciated by the comrades, by the manual laborers. You do not speak their language, nor does Jung, nor Bäumer. In the best case you will be tolerated, but not understood. With the Spartacist group it will be the same; today you—we, as fellow travelers—are welcome; in the coming revolution they will break into your shop and, depending on how much power they have, decree what you are allowed to publish. Put the last volume of the *Rote Hahn*, Rottluff—Brust—,[28] in the hands of 10,000 workers; they will not know what to do with it, not today, not in 5 years, because they stand on the ground of naturalism, the ground of actual observation. The proletarian is of the erroneous view that the entire new art is a product of bourgeois society and now demands that he, as the dictator of artists, should prescribe what course the new (now naturally socialistic) art should take. . . . all the more or less bad "Kaiser Wilhelms" will be renounced, and in their places dozens not-much-better statues of Karl Marx will be installed. Menzel will lose as an artist because he illustrated the history of Friedrich the Great. One might suppose that the art of Felix Müller and others who have something of the Reformation broadsheet about them could be or become the means of expression of the time; I doubt it, the masses do not want it, will not want it, will repel every manifestation of an artistic psyche as a foreign body.

My opinion now is, either: you arrange *Die Aktion* to suit the political propaganda of the masses and—woo them, stir them up with slogans that are familiar to everyone, in order to smooth the way for socialist dictatorship for them. Or you turn to the circle of international intellectuals that is already defined today, organize a human community that stands on a socialistic basis, which holds its own against the masses, mass-psychology. It would be the task of this community to absorb much spiritual power, above all to give the youth a structure to build a center in which they can find themselves, to protect them against the danger of being taken in either by party doctrine—or by democracy. We want to imprint our form of expression on that which is to be, but not to be forced to it by any political strongman or the masses.

This eternal citing of "Marx" nauseates one in the long run and recalls damnably the eternal Kant-citations during the war. We need no trade in dogma, but a living feeling and forming, a new humanity. Wouldn't it be a good idea to circulate the pamphlet in the English and French prison

camps, or to put it in people's hands during the evacuation? In spite of the difficult conditions, in spite of Foch's ruthlessness, no revolutionary fever is rising in France yet. We must stay patient, must first make our peace, and then, when the bonds are re-established, work furiously. If we grab hold of the Spartacist, if we act now, we will all die, and there is the danger that the world revolution will fail.

48. Editorial, *Menschen*, 1919*

This editorial response of January 15, 1919 to the murders of Karl Liebknecht and Rosa Luxemburg from the Dresden-based literary journal, *Menschen* (fig. 33), expresses the artists' and intellectuals' identification with left-wing politics and concern that the interim, coalition socialist government might betray the revolution. A poem by Johannes R. Becher, "World Revolution," published in *Die Aktion*, embodied the euphoric spirit of their admiration for these martyrs to the revolution: Liebknecht, "the flame thrower, dionysian partisan . . . , standing upon . . . a lofty and visionary platform"; Luxemburg, "sybil-like angel . . . promise of the east, burning ascetic, pillar of lightning."[29] Liebknecht, son of the founder of the German Social Democratic Party, and Luxemburg, a prominent Polish socialist with a Ph.D. in political science, led the radical Spartacist faction of the German socialist movement against the more moderate socialists. The Spartacists became the German Communist Party in December 1918.

HUMANITY!
Karl Liebknecht and Rosa Luxemburg alone held high the banner of revolution for these four years. Today they were murdered through preventive measures of the "revolutionary" government. The bestial triumphs over the spirit of socialism! The mercenary press rejoices over 480 corpses and 1000 wounded fighters for ideas true to their convictions.

HUMANITY!
The government is guilty of multiple murders! The people-butchers from the military are their hired executioners. Honor and glory to their dead opponents! We bow to the ground before them.
Inform! Discuss! Speak! Shout!

*The Editors, *Menschen* 2, no. 2 (January 15, 1919): 1.

1. Title page of *Ein Protest deutscher Künstler* (1911).

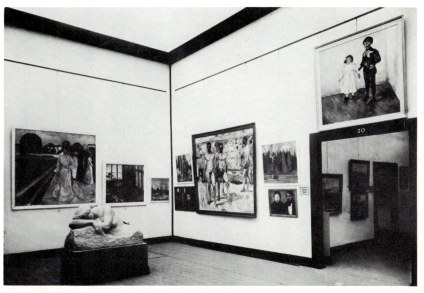

2. Edvard Munch room at the Sonderbund exhibition, Cologne, 1912.

3. Ernst Ludwig Kirchner. Cover of *Künstlergruppe
Brücke* (1906).

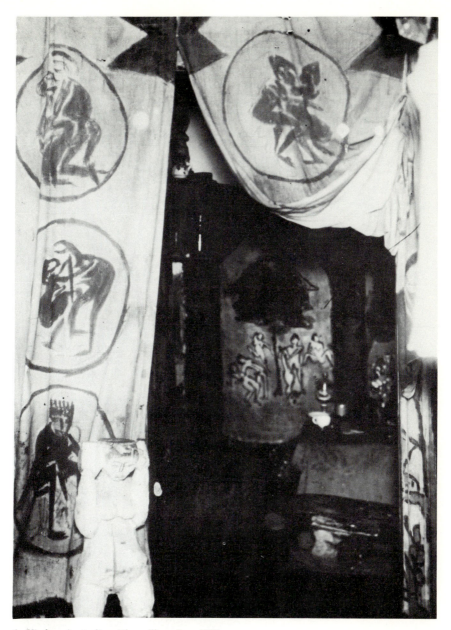

4. Kirchner's studio with wallhanging, 1910.

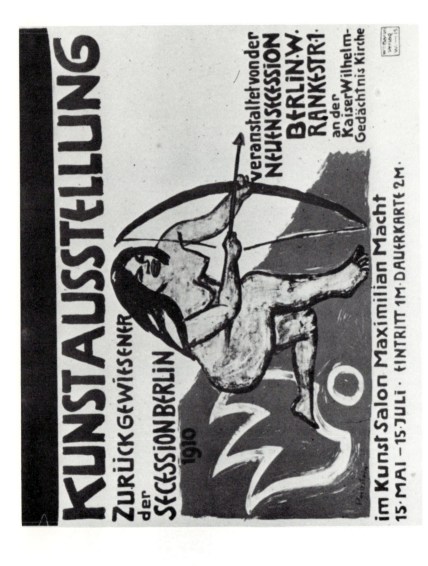

5. Max Pechstein. Poster for New Secession exhibition, color lithograph, 1910.

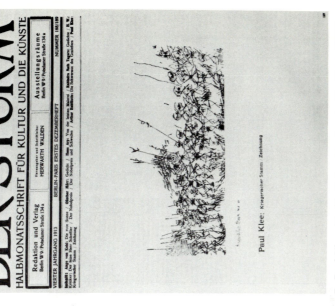

7. Paul Klee. *Warlike Tribe*, drawing, in *Der Sturm* (1913).

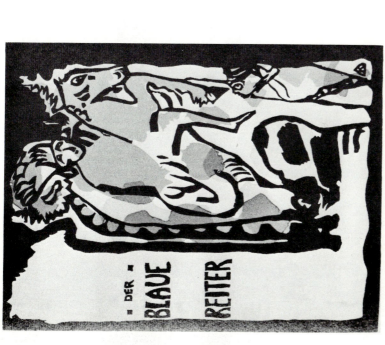

6. Wassily Kandinsky. Cover design for the almanac, *Der Blaue Reiter*, woodcut, 1911.

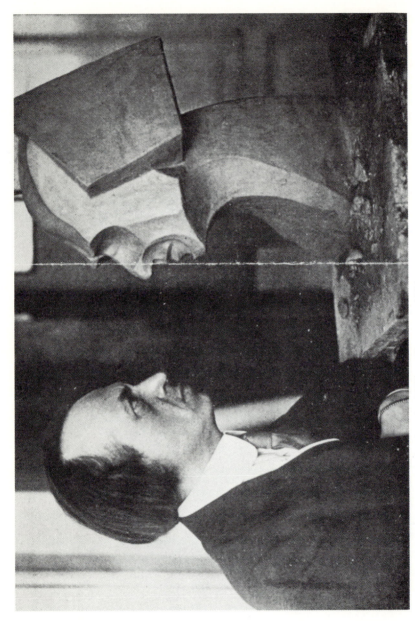

8. Herwarth Walden examining his bust by William Wauer, ca. 1916.

10. Max Pechstein. Cover of Paul Fechter's *Der Expressionismus* (1914).

Die Aktion

WOCHENSCHRIFT FÜR POLITIK, LITERATUR, KUNST

4. JAHRGANG HERAUSGEGEBEN VON FRANZ PFEMFERT 25. APRIL 1914

MALER BAUEN BARRIKADEN

Die besseren Deutschen sind ein zufriedenes Volk. Sie sind zufrieden, zu sein. Bedeutendere Schriftsteller sind hier verfeindet um die Meinungsverschiedenheit, ob man aussprechen soll, was „ist" — oder ob man das nicht soll. Ton auf dem „ist". Niemand fragt nach dem „Was". Aber die besten Deutschen sind nicht mehr zufrieden, sondern phlegmatisch. Sie tun immer so, als kämen sie nach fürchterlichen Revolutionen einzig überlebend wieder auf die Erde getrochen. Sie äußern: „Der Kampf ist ausgekämpft." Oder sie dichten: „Oh Daseyn!"

Für dieses Volk ist fleißige Tätigkeit und Hervorbringung dasselbe. Hier dichten sie, um zu dichten, malen, um zu malen, und jüngere Bildhauer sagen im dramatischen Halbschlaf: „Gebt mir Ton, zu kneten!" Man nennt das Produktion.

Malerei ist nicht du, um gemalt zu werden. Aber ebensowenig, um von Armen genossen zu werden, oder um bei Reichen zu schmücken. Eine wirkliche Ausstellung ist immer eine wirkliche Politik, und Politik heißt höchste Begabung, höchster Wille, unsere Entmaligkeit auf der Welt organisch werden zu lassen. Es kommt nicht darauf an innerhalb der jedesmaligen Vorstellung von Weltgeschichte eine Rolle zu spielen. Es kommt nicht darauf an, zu sein. Es kommt darauf an, vollkommen zu sein und zum ersten Mal zu sein, was immer dasselbe ist. Es kommt darauf an, jede Sekunde unseres Lebens mit der Unmittelbarkeit und Unabgenutztheit des ersten Tages zu haben. Dagegen gilt nichts von dieser Welt der Zeitlichkeit, in der eine Sonne und ein Mond immer viel zu lange Tage brauchen, um auf und unter zu gehen. Was sind die Seligkeiten unserer Telephongespräche vor der Unmittelbarkeit durch die Intensität, vor dem Aufrüttelung des ersten Tags! Dies aus uns Raum werden zu lassen, seinen Raum überhaupt zu

finden, ist die immerwährende ungeheure Revolution durch alle Zeiten. Es ist der Umsturz, überall, unter den Völkern, den Dichtern, Musikern. Den Malern. Der Maler: hat diesen geistigen Raum visionär zu schaffen. Das heißt, nach der Gestaltungskraft des Auges. Visionär ist Picasso, trotzdem er Akademiker ist. Nicht visionär, sondern nur Illustratoren ihrer Unmittelbarkeitsempfindungen waren Beardsley und Gauguin; illustrativ: heute schon ein Kitsch. Visionär ist Delaunay, trotzdem er Plakate malt (und wer privatim über Rubens so gerührt ist, müßte eigentlich in Delaunay dessen zeigenössisches Gegenstück erkennen, mit genau demselben Anlaß zum Farbenexperiment). Visionär ist Kokoschka, dessen überzeitliche Gabe mächtig auf Defreggertum gepfropft ist. (Ein berlinischer Maler darf

Wilhelm Morgner: Zeichnung

9. Cover of *Die Aktion* (April 25, 1914) with drawing by Wilhelm Morgner.

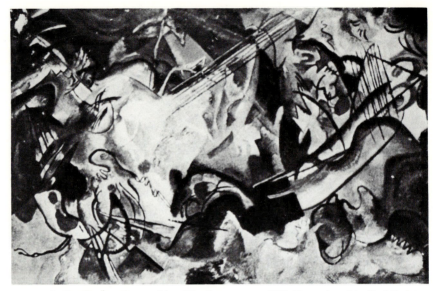

11. Wassily Kandinsky. Composition VI, oil on canvas, 1913. Reproduced in Paul Fechter, *Der Expressionismus* (1914).

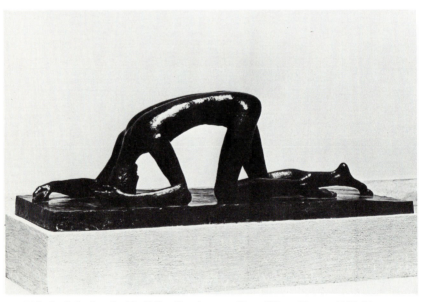

13. Wilhelm Lehmbruck. *The Fallen One*, bronze, 78 × 239 × 83 cm., 1915–16.

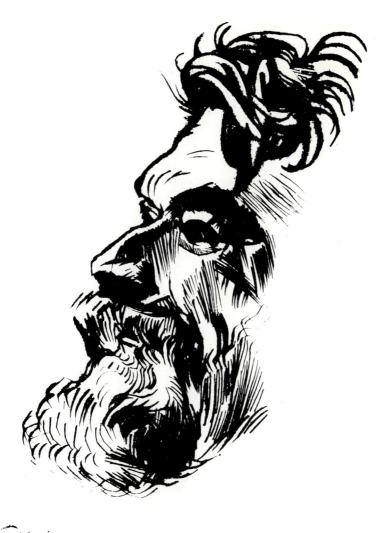

12. Ludwig Meidner. *Portrait of the Poet Theodor Däubler*, drypoint, ca. 1910–11.

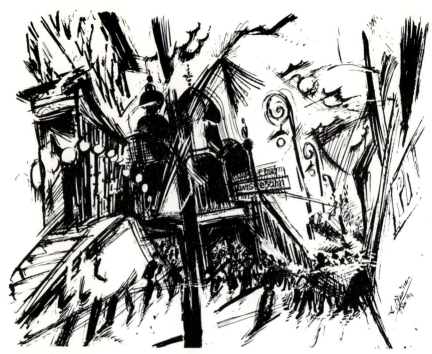

14. Ludwig Meidner. *The Wannsee Train Station*, ink, 46.4 × 59 cm., 1913.

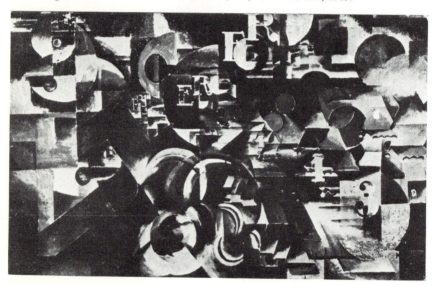

15. Johannes Molzahn. *He Approaches*, oil on canvas, 190 × 110 cm., 1919.

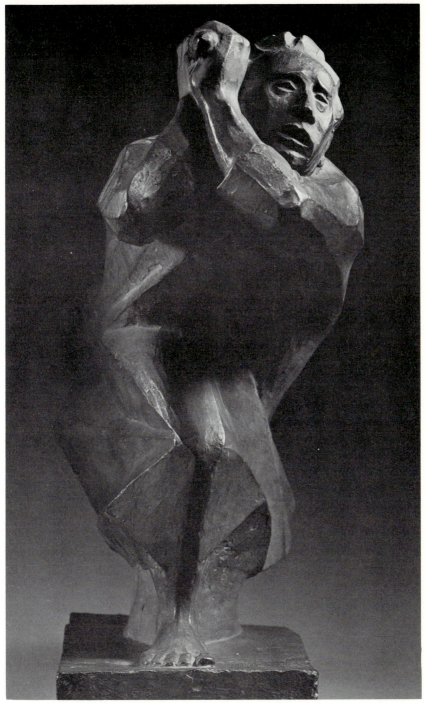

16. Ernst Barlach. *The Avenger* (orig. *Der Berserker III*), plaster, 45.5 × 61 × 23 cm., 1914.

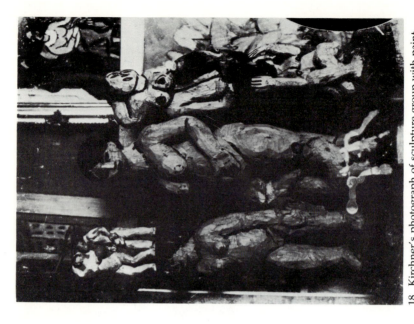

18. Kirchner's photograph of sculpture group with paintings, 1911–12.

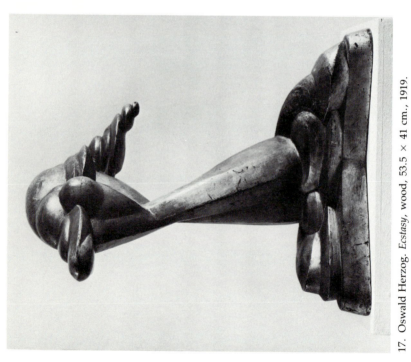

17. Oswald Herzog. *Ecstasy*, wood, 53.5 × 41 cm., 1919.

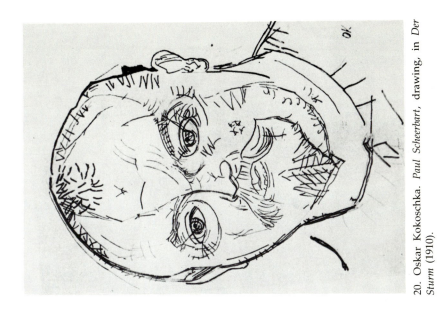

20. Oskar Kokoschka. *Paul Scheerbart*, drawing, in *Der Sturm* (1910).

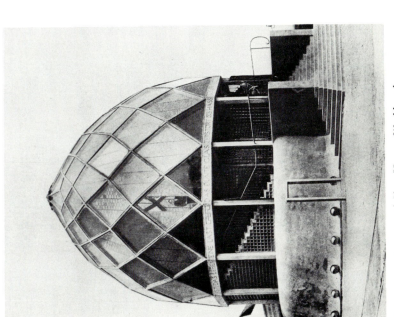

19. Bruno Taut. Exterior of Glass House. Werkbund exhibition, Cologne, 1914.

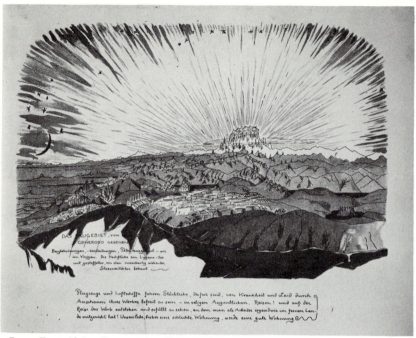

21. Bruno Taut. Alpine Construction. Site seen from Monte Generoso. In *Alpine Architektur* (1919).

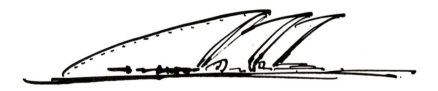

22. Erich Mendelsohn. Imaginary Sketch: Hall (?), ca. 1915.

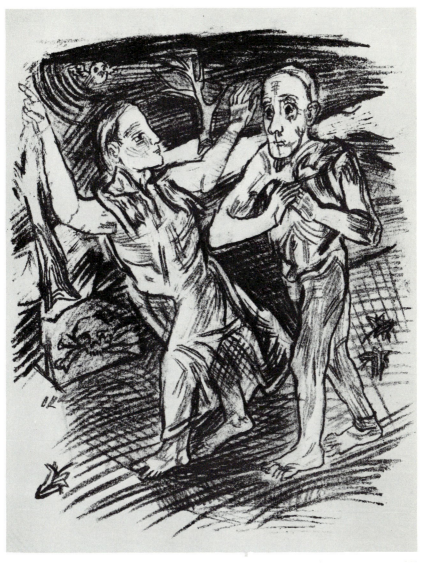

23. Oskar Kokoschka. *The Woman Leads the Man*, lithograph, 1914. From *O Eternity—Thou Thundering Word, Bach Cantata*, 1916.

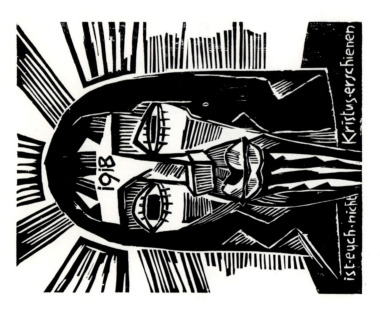

25. Max Beckmann. *The Way Home*, lithograph. From *Hell*, 1919.

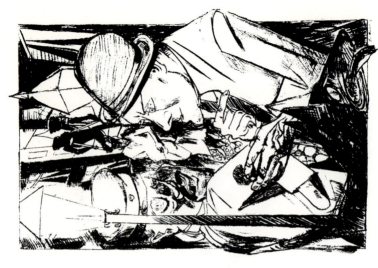

24. Karl Schmidt-Rottluff. *Christ*, woodcut, 1918. From *Schmidt-Rottluff: Nine Woodcuts*, 1919.

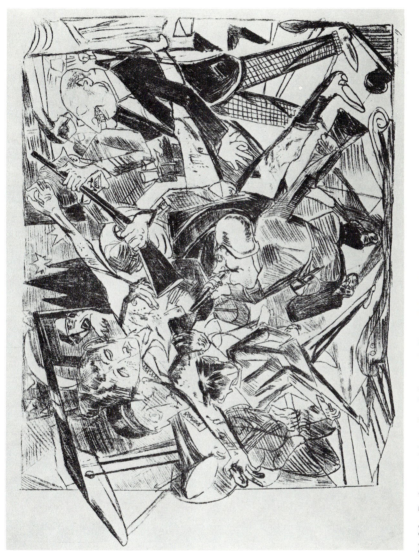

26. Max Beckmann. *Martyrdom*, lithograph. From *Hell*, 1919.

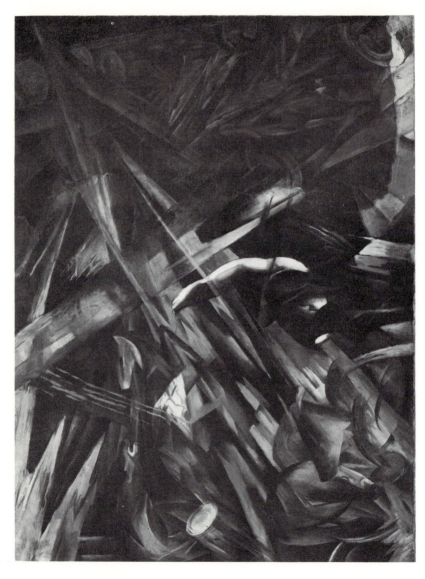

27. Franz Marc. *Fate of Animals*, oil on canvas, 195 × 263.5 cm., 1913.

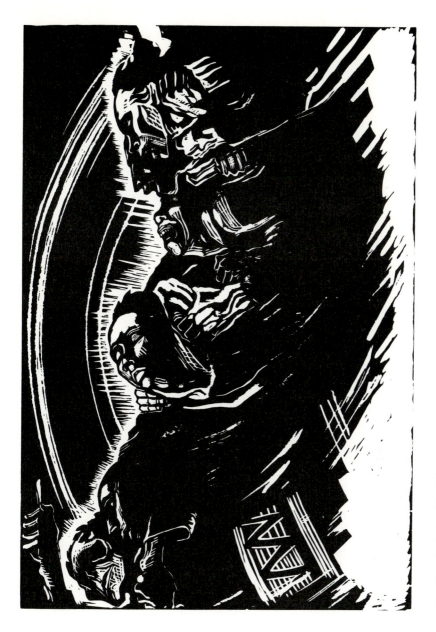

28. Käthe Kollwitz. *The Volunteers*, woodcut, 1922–23. From *Seven Woodcuts on War*, 1924.

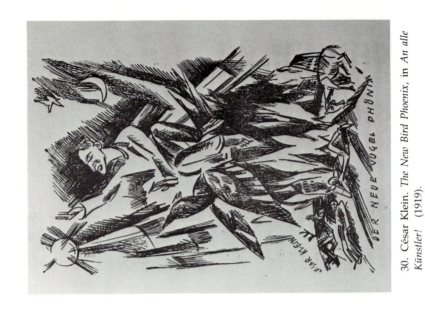

30. César Klein. *The New Bird Phoenix*, in *An alle Künstler!* (1919).

29. Conrad Felixmüller. *Soldier in Psychiatric Ward*, color lithograph, 1918.

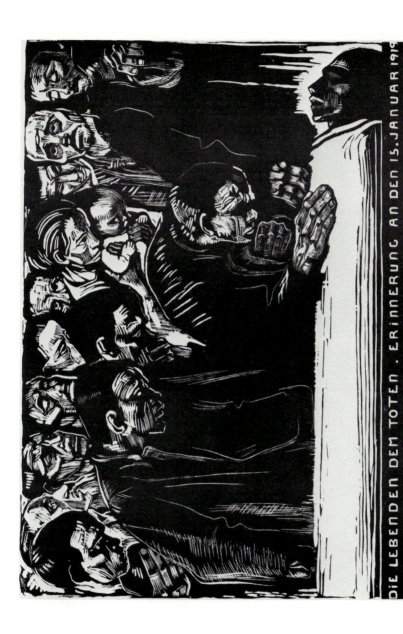

31. Käthe Kollwitz. *Commemorative Print for Karl L. Liebknecht, woodcut,* 1919–20.

33. Conrad Felixmüller. Portrait of Karl Liebknecht for title page of *Menschen* (Jan. 15, 1919).

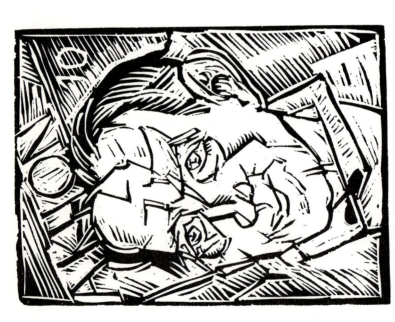

32. Georg Tappert. *Franz Pfemfert*, woodcut, in *Die Aktion* (Feb. 19, 1921).

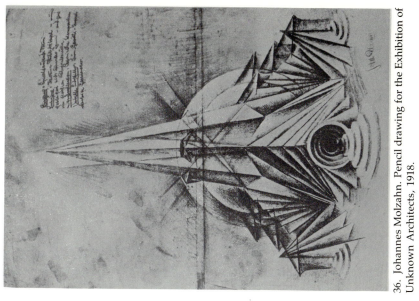

36. Johannes Molzahn. Pencil drawing for the Exhibition of Unknown Architects, 1918.

34. Max Pechstein. *Don't Strangle Our Newborn Freedom*, color lithograph poster, ca. 1919.

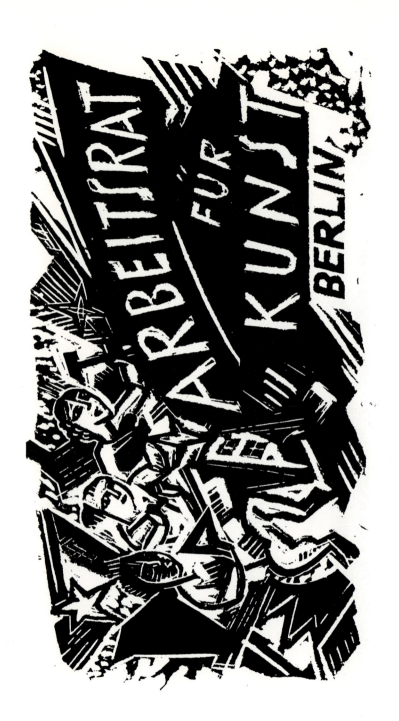

35. Max Pechstein (?). Cover of leaflet for Arbeitsrat für Kunst (March 1919).

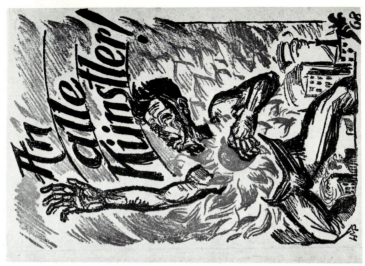

38. Max Pechstein. Cover of *An alle Künstler!* (1919).

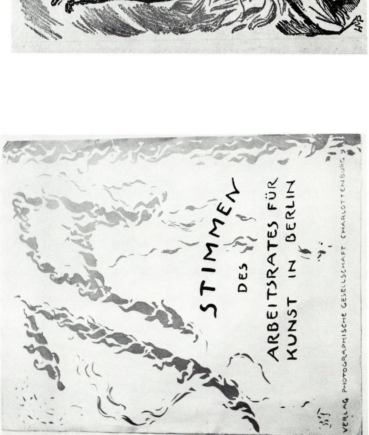

37. Bruno Taut. Cover of *YES! Voices of the Arbeitsrat für Kunst* (1919).

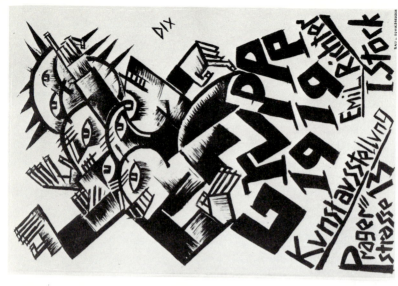

40. Otto Dix. Poster for *Gruppe 1919* exhibition, Dresden, 1919.

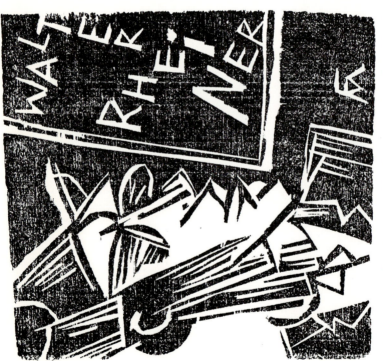

39. Conrad Felixmüller. *Portrait of Walter Rheiner*, woodcut. From *Menschen* (May 15, 1918).

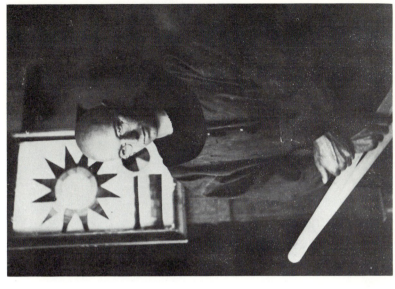

42. Johannes Itten at the Bauhaus in clothing he designed, ca. 1921.

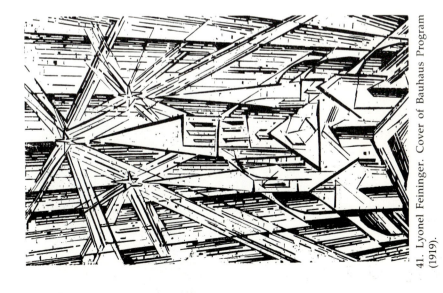

41. Lyonel Feininger. Cover of Bauhaus Program (1919).

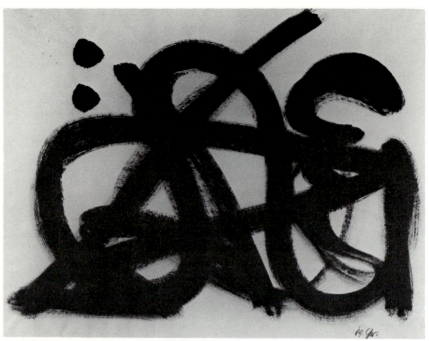

43. Werner Graeff. *Rhythm Study for Itten's Preliminary Course*, tempera on paper, 56 × 75.7 cm., ca. 1920.

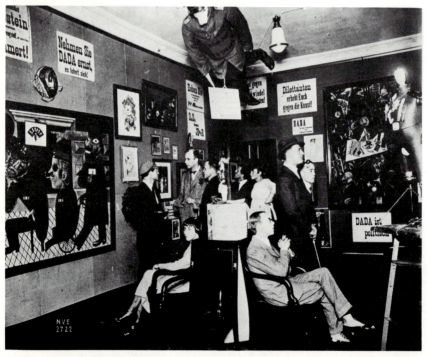

44. Opening of the First International Dada Fair in Dr. Otto Burchard's gallery in Berlin, 1920. Standing, from left to right: Raoul Hausmann, Otto Burchard, Johannes Baader, Wieland and Margarete Herzfelde, George Grosz, John Heartfield. Sitting: Hannah Höch, Otto Schmalhausen.

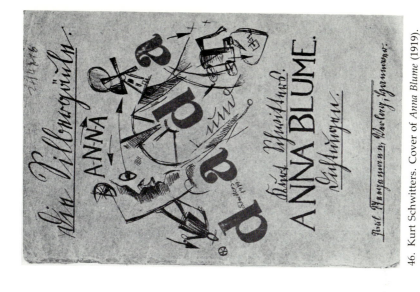

46. Kurt Schwitters. Cover of *Anna Blume* (1919).

45. George Grosz. *Humanity in the Streets*, transfer lithograph, 50.2 × 38.3 cm., 1915–16. From *First George Grosz Portfolio*, 1917.

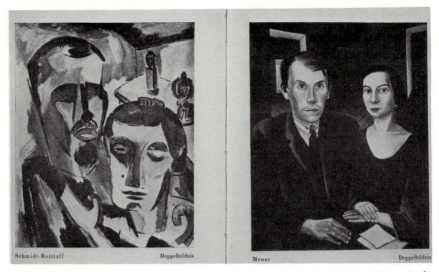

47. Illustration from Franz Roh, *Post-Expressionism* (Leipzig, 1925). Pairing of portraits by Karl Schmidt-Rottluff and Carl Mense.

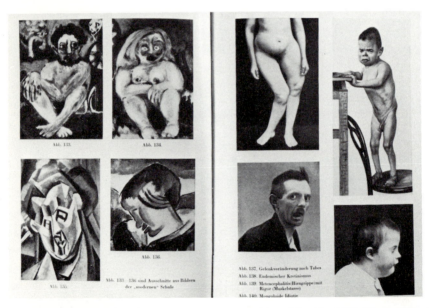

48. Illustration from Paul Schultze-Naumburg, *Art and Race* (Munich, 1928). Works of Karl Schmidt-Rottluff and Amedeo Modigliani paired with photographs of facial deformities.

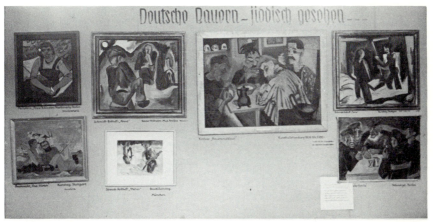

49. Photograph of east wall, Room 3, in the *Degenerate Art* exhibition, Munich, 1937. Heading reads: "German farmers as seen by Jews."

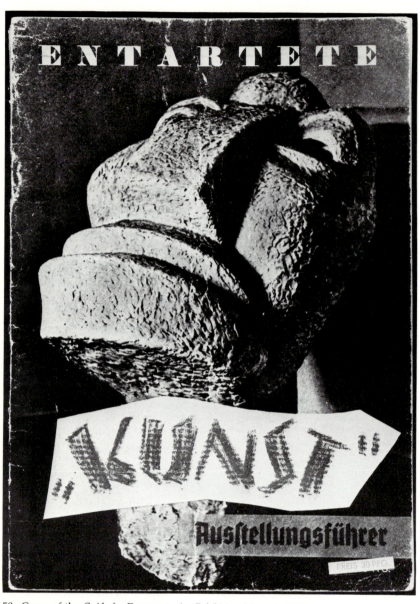

50. Cover of the *Guide for Degenerate Art Exhibition* (Munich, 1937).

49. Käthe Kollwitz, diary entries, 1918, 1919, 1920†

Käthe Schmidt-Kollwitz came from a family with a long history of radical political and religious commitments. Her own reading of a tract by one of the founders of the Social Democratic Party—August Bebel's *Woman under Socialism* (1883)—convinced her that women could be emancipated only under socialism. In January 1920 she was appointed by the new socialist government to be the first woman member of the Prussian Academy. Kollwitz considered herself a moderate socialist even though she commented that the Free Corps'[30] thuggery was driving her further to the left. After Liebknecht's murder, however, she agreed to his family's request for a death-bed portrait; the *Commemorative Print for Karl Liebknecht* (fig. 31), was her first woodcut. It was a memorial to the martyred hero, but also a testament to the aspirations and desperation of the working class, whose lives she had shared since 1891 when she and her physician husband Karl, who shared her socialist beliefs, settled in a proletarian quarter of Berlin. The woodcut was exhibited at the Worker's Art Exhibition in Berlin in 1920; she used the proceeds from sales to support other similar exhibitions.

Kollwitz was one of the few artists who sustained a commitment to the poor. For example, she contributed posters to the international antifamine campaigns of the International Workers' Aid (whose membership included Albert Einstein, George Grosz, Henri Barbusse, Upton Sinclair, and Maxim Gorky). Her art appealed to a broad, liberal art-buying public and therefore could be used to raise money for socialist causes. Opposition to her work came from the left. In 1920 *Die rote Fahne*, the official German Communist newspaper, criticized her recent work for overemphasizing hopelessness and despair rather than encouraging active resistance. Kollwitz's response was that she was representing life itself, not social misery.

†Diary entries of December 8, 1918, January 16, 1919; January 19, 1919; January 25, 1919; October 1920; reprinted in Käthe Kollwitz, *Ich sah die Welt mit liebvollen Blicken. Käthe Kollwitz: Ein Leben in Selbstzeugnissen*, Hans Kollwitz, ed. (Wiesbaden: Fourier Verlag, 1981), 191, 192, 193–194, 198.

Diary entry, December 8, 1918

Sunday begins. Gloomy foggy weather. Horrible oppressive feeling. I even still say to myself, if it came to a choice between the dictatorship of Ebert and the dictatorship of Liebknecht, I certainly would vote for Ebert.[31] Suddenly, however, it occurred to me what the true revolutionaries have, nevertheless, accomplished. Without this constant pressure from the left we would have had no revolution, we would not have thrown off the whole military apparatus. The majority party would not have released us. It always wanted only to evolve. And those who follow their convictions, the independents, the Spartacist people, are now the pioneers again, they press ever forward, no matter what lies ahead. Even if it is idiocy, even if Germany is ruined over it. They will have to be suppressed now in order to get out of the chaos, and there exists a certain justice in that. The winners will no doubt remain the moderates. I myself would wish for it. Only one ought not to forget that those to be suppressed are the true revolutionary ferment without which we really would have had no upheaval. That these are courageous men who immediately set out machine guns, that these are hungry, disenfranchised people, who always got the short end of things. That these are above all people who, had they then already had the power they do now, would have prevented the war. In a word, these are people of revolutionary principles who hold on to them unflinchingly. Of course they are wrong, according to facts. Basing judgment on facts, one must go with the majority socialists. Unless you don't care a rap about the complete collapse of Germany.

Diary entry, January 16, 1919

Vile disgraceful murder of Liebknecht and Luxemburg.

Diary entry, January 19, 1919

Election day. Voted for the first time. Was with Karl. I had looked forward to this day so much and now it is here, I am beset with indecision and mixed feelings anew. Voted majority socialist. Not for Scheidemann,[32] the man, who stood at the top of the list, but for the principle of majority socialism. By inclination I stand more to the left; can, however, not vote independently simply because the candidate is Eichorn.[33]

Diary entry, January 25, 1919

Today Karl Liebknecht was buried, and with him 38 others who had been shot. I was permitted to make a drawing of him and went to the mortuary early. He was laid out in the morgue next to the other coffins. Red flowers laid around the shot-up forehead, the face proud, the mouth somewhat open and painfully distorted. A somewhat wounded expression on the face. The hands folded over one another, a few red flowers on the white shirt. There were many others there whom I did not know. Karl, Hans,[34] Stan had come along. Stan sketched too. I then went home with the sketches and tried to make a better summary drawing.

Lise[35] went into the city in order to follow the procession. The entire center city was closed off. . . .

How mean and false are all these measures. If Berlin—a large part of Berlin—wants to bury its fallen, it is no revolutionary affair. Even between battles there are calm hours for the burial of the dead. It is disgraceful and inflammatory to accompany Liebknecht's funeral procession with military provocation. And it is a sign of the weakness of the regime that it must put up with it.

Diary entry, October 1920

I am ashamed that I still have not sided with a party, and strongly suspect that if I declare no party allegiance, that the real reason for it is cowardice. Of course I am really by no means revolutionary, but evolutionary. However, because people praise me as an artist of the proletariat and of the revolution and press me more and more firmly into the role, I therefore am afraid not to go on playing this role. I was revolutionary. The dream of my childhood and youth was revolution and barricades. Were I now young, I would certainly be a communist. I am even now still pulled somewhat in that direction, but I am in my fifties, I have lived through the war and seen Peter and the thousand other youths die; I am horrified and shocked by all the hate that is in the world. I yearn for socialism, which allows men to live, and think that the earth has now seen enough of murder, lies, destruction, mutilation, in short everything devilish. The communistic state that builds itself thereupon cannot be God's work.

. . . I just should have been left entirely in peace. It cannot also really be expected from an artist, who is in addition to that a woman, that she find her way about in these madly complicated circumstances. As an artist I have the right to draw the feeling content out of everything, let it have

an influence on me, and to direct it outside myself. Thus I also have the right to make a picture of the working class's farewell to Liebknecht, yes, to dedicate it to the workers, without thereby following Liebknecht politically. Or not?! From a man one would surely expect more consistency. A discussion in the *Rote Fahne* also pointed out that my revolutionary period already lies far in the past.

50. Hans Friedeberger, "The Artists' Posters of the Revolutionary Days," *Das Plakat*, 1919*

The provisional, coalition socialist government established after the November Revolution declared January 19, 1919, the date for Germany's first democratic elections, in support of which it commissioned educational posters. The earliest ones bore only written texts, which passers-by simply did not read. The regime then turned to the Expressionist artists of the Novembergruppe for bold, arresting pictorial posters calculated to catch and hold the viewer's attention. A contemporary observer for Germany's poster magazine, *Das Plakat*, described the result: ". . . the paper flood set in. . . . Berlin's streets rioted in color orgies, the houses exchanged their gray faces for an agitated mask."[36] According to Adolf Behne, the socialists sought an alliance with the Expressionists because they hoped that the urban masses would be moved by a style that came out of "the same instinct for freedom" and "spirit of revolution" that had motivated the workers.[37] Hans Friedeberger (1874–1943), a commentator for *Das Plakat*, describes the Expressionist posters and offers an explanation for the posters' failure to influence the masses at whom they were addressed. The posters in fact often alienated the workers, who resented the artists and intellectuals and considered the abstract figures caricature and therefore mockery.

From the very beginning, the art poster of the revolutionary days faced novel problems, whose solution was not simplified by those few experiences accumulated on the occasion of the war bond propaganda. . . .
. . . .

*Hans Friedeberger, "Das Künstlerplakat der Revolutionszeit," *Das Plakat* 10, no. 4 (July 1919): 260–76.

. . . the necessity to use new or at least little-used forms was felt ever more clearly. . . .

. . . from each flat and gluable surface there screamed the choir of admonitions, warnings, and oaths . . . through ever newly arousing, forceful representations. . . .

As one looks over this whole array of election posters, they separate themselves into those that generally preach the necessity and the meaning of the election and of the National Assembly and those that support specific demands or programs, or specific parties. The first come mostly from the official agencies, whose business it is to produce work of that kind. Of them, the poster by César Klein . . . must be discussed elsewhere; since a special section is to be devoted to the effort to create a new artistic poster style, namely the Expressionistic. . . .

When one turns to the posters that served the parties themselves in the election battle, when one looks at them in toto, one thing stands out: namely, that the artistic quality of the posters increases the farther one moves politically from right toward left. To some extent that is not all that astonishing, since the artist, insofar as he is truly a creator and in addition young, has stood on the side of the innovator in all upheavals. And so then this time too, the majority of good posters emanated from the Social Democratic parties. . . .

. . . .

The first thought—and indeed also the nearest at hand—was indeed that a new time also needed new means of expression, and that the art movement which had first—and long before the war—espoused the thoughts judged by the best to be the highest ideas and goals of the revolution, now must also be called upon to make these ideas and goals the firm and self-evident property of everyone. . . . It was hoped that the unindoctrinated, fresh, and impressionable circle of working people would be especially receptive to and willing to absorb an art that had until now found the most stubborn resistance in the educated bourgeoisie's rigid, ingrained, mode of viewing.

The results do not seem to have borne out these anticipations. Along with supportive statements, directed mainly at posters of general content and simple form such as Pechstein's poster "Do Not Strangle the Newborn Freedom" (fig. 34), there sounded voices of dissent right out of the workers' circles, and those in overwhelming numbers. The angular forms that the new art used, its subordination of the whole picture to the overall atmosphere and feeling, and the resulting neglect of the individual forms were perceived as deliberate caricature [and] . . . the manner of delivery was suspected of a lack of respect or esteem. I heard such objections in quantity, for example, those directed expressly against César Klein's poster that wanted to deter the workers from wild strikes. And it seems

to me this is where the error in the reckoning lies. It is doubtlessly correct that the spirit of this art is also the spirit of the revolution and that this spirit should be understood most easily in those circles where the revolution arose. But one forgets one thing thereby: that each style in art is defined and distinguished from others not only through its contents, but—in the visual arts above all—yet far more through its unique visual taste. It is important not only what a period and its people see at any given time, but far more how they see. And this is determined by education and habit. In these efforts, I believe, it has been overlooked that anyone who encounters these new art works unprepared has first, after all, to overcome inhibitions that lie grounded in his optical education. . . .

. . . .

So these endeavors have, to be sure, produced no ripe, sweet fruit; perhaps, however, a hope. It has never been the case that artist and public were born for one another. They must first be educated for one another and also with one another and together. Not much is needed on either side: a little earnestness, a little good will, and a little knowledge. Above all, however, a little respect and love for one another.

III. ARBEITSRAT FÜR KUNST

INTRODUCTION

The Arbeitsrat für Kunst (Working Council for the Arts) was founded in Berlin in November 1918 amidst the general upsurge of revolutionary fervor. Modeled after the Arbeiterräte—the worker's soviets or councils—the program of the Arbeitsrat called for all the arts to work together under architectural direction to shape the artistic values and fabric of the new nation. Although dominated by architects and architectural critics, the Arbeitsrat initially shared with the Berlin Novembergruppe an overlapping membership and such common goals as changing the system of art education in Germany and obtaining greater public participation in design and exhibition decisions. The Arbeitsrat was disbanded in May 1921, but many of its utopian aims became part of the now more well known Bauhaus.[38]

The architect Bruno Taut was the guiding force of the Arbeitsrat from its formation until February 1919. Taut remained an active member even when he gave up the leadership to Walter Gropius, with whom he had worked before the War in the Werkbund to improve design through cooperation between the visual and the applied arts and industry. Both shared a belief in the power of the arts, particularly architecture, to shape human attitudes. When Gropius left Berlin for Weimar, the critic Adolf Behne, who also believed in a missionary goal for architecture, managed the Arbeitsrat.

Many of the members of the Arbeitsrat had been associated with Expressionist groups before the war. Both Taut and Behne had written for *Der Sturm* and had advocated that architects could learn from Kandinsky and other Expressionist painters. César Klein, listed as the vice-director came from the New Secession. Heckel, Pechstein, Schmidt-Rottluff—former members of the Brücke—were on the Executive Committee. Campen-

donck, briefly a member of the Blaue Reiter, was represented in *YES! Voices of the Arbeitsrat für Kunst in Berlin (JA! Stimmen des Arbeitsrates für Kunst in Berlin)*, a 1919 publication of the Arbeitsrat that reflected a clear concern for public participation in the arts.

The Arbeitsrat spread its message through publications, broadsides, and open exhibitions.[39] Though its work was acclaimed, on May 30, 1921, the members voted to dissolve the Arbeitsrat, explaining that they had overestimated "the common will for renovation and . . . artistic cooperation. . . ."[40] It was short-lived, but its idealistic vision underscores the Expressionist messianic fervor of the arts during the first year of the Weimar Republic.

51. [Bruno Taut], Arbeitsrat für Kunst program, 1918 and Bruno Taut, *An Architecture Program*, 1919*

Although the program of the Arbeitsrat bears the signature of over fifty architects and artists,[41] it is generally considered to be the work of Bruno Taut.[42] A comparison with *An Architecture Program* which bears Taut's signature and was written and published at the same time, reveals a number of similarities. Both exude an almost mystical faith in the power of architecture to create a better future. Both contain a clear commitment to breaking down artificial divisions between the arts as well as between the various classes of supporters. The two programs also indicate Taut's concern that the architect, once chosen by a committee of laymen and architects, remain in control of the final design. Taut's guidelines for a world based on communal, anarchistic pacifism included the removal of commercial and bureaucratic government interests from aesthetic decisions, the abolition of privileges, the prohibition of war monuments, the establishment of arts and crafts colonies, and a commitment to experimentation in architecture and the arts.

When the Arbeitsrat was reorganized in February and March 1919 under Walter Gropius, César Klein, and Adolf Behne, the phrases

*" 'Arbeitsrat für Kunst' in Berlin," *Mitteilungen des deutschen Werkbundes*, no. 4 (1918), 14–15, and Bruno Taut, *Ein Architektur-Programm*, 1st ed., December 1918; 2d ed. Berlin: Arbeitsrat für Kunst, 1919; English translation of *Ein Architektur-Programm* from Ulrich Conrads and Hans G. Sperlich, *The Architecture of Fantasy*, translated and edited by C. C. Collins and George R. Collins (New York: Praeger, 1962), 135–36.

in the Arbeitsrat program referring to the artist as the shaper of the consciousness of the people and the reference to radical governments in Munich and Dresden, were removed from the brochure.[43] Nonetheless, the woodcut (fig. 35) by Max Pechstein(?),[44] which dominates the front of the brochure included an architect, a painter, and a women sculptor as the constructors of a new society.

[Bruno Taut], Arbeitsrat für Kunst program

Convinced that the recent political revolution must be used to free art from decades of domination, a circle of like-minded artists and art lovers has congregated in Berlin. This circle is striving to collect all scattered and splintered forces committed to moving beyond the preservation of one-sided occupational interests, in order to cooperate in rebuilding our entire art world. In close touch with the elected governments and with like-minded associations such as the Art Council in Munich, Dresden, etc., the Arbeitsrat für Kunst hopes to be able to succeed in its immediate goals in the near future. The goals are outlined in the following program excerpt.

Above all, this **slogan** guides us:

Art and people must form a unity. Art should no longer be the pleasure of a few but should bring joy and sustenance to the masses. The goal is the union of the arts under the wings of a great architecture. From now on the artist, as shaper of the sensibilities of the people, is alone responsible for the external appearance of the new nation. He must determine the boundaries of form from statuary down to coins and stamps.

On this basis, we **currently** make **six demands**:

1. Recognition of the public nature of all building activity, an end to public and private privileges enjoyed by civil servants. Uniform management of whole city boroughs, streets and housing developments, without encroaching on individual freedom. New assignments: community centers as distribution points of all arts to the people. Permanent experimental grounds for testing and perfecting architectural effects.

2. Dissolution of the Royal Academy of Arts, the Royal Academy of Architecture, and the Royal Prussian State Art Commission in their present form, replacement of these bodies along with a narrowing of their field of activity, with others created out of the community of producing artists itself without state influence. Transformation of privileged art exhibitions into free ones.

3. Freedom for all education in architecture, sculpture, painting, and crafts from government domination. Transformation of arts and crafts education from the ground up. Allocation of government funds for this purpose and for masters' education in teaching workshops.

4. Vitalization of museums as places of education for the people. Establishment of constantly changing exhibitions, made accessible to all the people through lectures and guided tours. Withdrawal of scientific materials into buildings appropriate for them. Segregation of technically organized study collections for craftsmen working in artistic crafts. Fair distribution of government funds for acquisition of old and new works.

5. Elimination of all monuments without artistic value as well as buildings whose artistic value is disproportionate to the value of their materials, which might be made use of in other ways. Prevention of construction of hastily planned war monuments and immediate stoppage of work on the war museums planned in Berlin and elsewhere in the nation.

6. Organization of a government department to ensure promotion of art within the framework of future lawmaking.

The following signed this proclamation: Otto Bartning, Rudolf Bauer, W. C. Behrendt, Joseph Bloch, Theo v. Brockhusen, A. E. Brinckmann, Heinz Braune, Ewald Dülberg, Martin Elässer, August Grisebach, Walter Gropius, Wilhem Hausenstein, Franz Heckendorf, Carl Georg Heise, Fritz Hellwag, Ernst Herzfeld, Willy Jaeckel, Walter Kaesbach, César Klein, Käthe Kollwitz, Leo v. König, Bruno Krauskopf, Mechtilde Lichnowsky, Paul Mebes, Hans Meid, Herbert Mueller, Julius Meier-Graefe, Heinrich Nauen, Wilhelm Niemeyer, Rudolf Oldenbourg, Karl Ernst Osthaus, Friedrich Paulsen, Max Pechstein, Friedrich Perzynski, Hans Poelzig, E. Pottner, Heinrich Richter, Chr. Rohlfs, John Schikowski, E. E. Schlieper, Paul Schmitthenner, Hermann Schmitz, Rich. L. F. Schulz, Erik-Ernst Schwabach, Preuß. Finanzminister Hugo Simon, Milly Steger, Georg Swarzenski, Georg Tappert, Bruno Taut, Max Taut, Heinrich Tessenow, Arnold Topp, Wilhelm R. Valentiner, Hermann Voß, Ludwig Wolde, Wilhelm Worringer—Declarations of support are requested at the Arbeitsrat für Kunst, Berlin NW40, #19.

Bruno Taut, from *An Architectural Program*

Art—**that** is the thing, if it be there! Today such art does not exist. The disrupted tendencies can achieve a unity only under the auspices of a

new art of building, in such a way that each separate discipline will contribute to it. At that point there will be no boundaries between the crafts, sculpture, and painting, all will be one: Architecture.

A building is the direct carrier of spiritual values, shaper of the sensibilities of the general public which slumbers today but will awake tomorrow. Only a total revolution in the realm of the spiritual can create this building; yet this revolution, this building, does not happen by itself. Both have to be sought—today's architects must prepare the way for this edifice. Their efforts toward the future must be made possible and be supported by public funds.

Therefore we propose:

I. Support and Concentration of Intellectual Resources among Architects.

a) The subsidizing of architectural ideas which, beyond the formal, strive for the concentration of all resources of the citizenry into the symbolic construction of a better future, which point out the cosmic character the religious basis of architecture—would-be Utopias. Making available public funds for such projects by means of scholarships to radically inclined architects. Funds for informational publications, for the construction of models, and:

b) Well-situated experimental grounds (in Berlin, for instance, the Tempelhofer Feld), on which architects could work out their ideas in the form of large models. Here, also, new structural effects, such as that of glass as a building material, should be tested, perfected, and shown to the public at large in the form of full-size temporary buildings or sections of such. Layman, woman, and child lead the architect further than would the cautious professional. Expenses to be met by using material melted down from monuments, from dismantled triumphal avenues, and so on, as well as by the aid of industries concerned with the experimental buildings. Workshops with colonies of craftsmen and artists on the experimental grounds.

c) Control over the distribution of funds should rest in the hands of a small council, half of it to be composed of creative architects, the other half of radically thinking laymen. If there is no unanimity, a layman is chosen to make the decision.

II. Community Centers for the People.

a) Launching of vast community centers, not in the city, but in the open country alongside settlements, comprising groups of buildings for theater, music, hotels, and the like and crowned by a general cultural center. . . .

. . . .

III. Housing Developments.

a) Consistent supervision in such a fashion that one architect establishes the underlying and guiding principles, checking all projects and buildings against these, without hampering individual inspiration in the details. This architect should have veto power.

. . . .

IV. Other Buildings.

. . . .

b) There should be no distinction between public and private buildings. So long as there exist free architects there should only be free architects. As long as there are no governmental master potters there is no need for governmental architects. Everybody can build public as well as private structures; commissions should be assigned as suggested in Ic or by competition—not an anonymous competition, but one in which the candidates are invited to participate and are awarded prizes by a council as suggested in Ic; no unpaid projects. . . . No majority decisions by the jury for the prize; if there is no agreement, each judge is individually responsible for his vote. The best would be one judge only. Final selection, perhaps, by plebiscite.

. . . .

d) No titles or honors for architects, such as Doctor, Professor, Building Supervisor, **Geheimer Rat, Wirklicher Rat**, Excellency, etc.

e) In all these matters creativity should be given priority. Once an architect is commissioned he should not be subject to regimentation.

. . . .

g) Only such architectural fraternities as thoroughly observe the principle of mutual cooperation are to be eligible for the council or are to be considered of good standing and to receive public recognition. They will also advise the building inspectors. Only mutual help can make an association productive and efficacious. This is more important than the number of votes, which is meaningless without social union. It excludes inartistic and, therefore, self-interested competition.

. . . .

VI. Architecture and the Other Arts.

. . . .

c) Also, consequently, the introduction of architectural students to the creative "new art." Only that architect is of importance who grasps the whole realm of art and who understands radical tendencies in painting and sculpture. Only he can help bring about a unity to the whole.

The architect's greater importance in public life and his holding of more important offices and the like will result automatically from the carrying through of this Program.

52. Walter Gropius, "Architecture in a Free Republic," 1919; letters, to Dr. Walther Rathenau, February 23, 1919, to Ludwig Meidner, February 26, 1919; speech to the membership meeting of the Arbeitsrat, March 22, 1919*

These texts from 1919 reveal the architect Walter Gropius (1883–1969) as both a visionary and a pragmatist. The essay and the speech to the Arbeitsrat members express Gropius's belief that a spiritual revolution, rather than a political one, will bring about a new humanism, a regenerative surge of collective unity among all levels of people. Although he views the architect in a leadership role, he believes the combined voices of painters, sculptors, and architects could surmount the artificial barriers of class, religion, and politics. In the essay Gropius points to the Gothic as an example of a time when the various arts mutually supported each other for a greater good. Like Taut, Gropius laments the incursions of government, capitalism, and power politics into artistic decision. The significance he attached to the concept of "artistic freedom" led him to urge the members of the Arbeitsrat not to immediately seek broad popular support. Instead in his speech to the members he stresses that a small group should consolidate its strengths and develop its values, and not fear compromising its intentions.

Gropius's letters as the director of the Arbeitsrat point to his great organizational skills, particularly to his ability to attract financial and artistic support for the associations in which he believed. Using contacts from his prewar days as an architect in Berlin, when he worked in the office of Peter Behrens (chief designer for Walther

*Walter Gropius, "Baukunst im freien Volksstaat," *Deutscher Revolutions Almanach*, ed. E. Deahn and E. Friedegg (Hamburg and Berlin: Hoffmann und Campe Verlag, January 1919), 134–36; © 1919 by Hoffmann und Campe Verlag, Hamburg/Berlin. Letter to Dr. Walther Rathenau, letter to Ludwig Meidner, and speech to the membership meeting of the Arbeitsrat für Kunst from original typescript, Bauhaus-Archiv, Berlin.

Rathenau's AEG) and later had his own practice, Gropius was able to rally a number of modern artists and wealthy benefactors to join with him in building the new council. Even after he accepted the directorship of the Bauhaus he remained in constant contact with Behne, who took over the management of the Arbeitsrat after Gropius left.

"Architecture in a Free Republic"

The old decaying regime ruled art with a dictatorial hand. The new regime must serve art in order to be rightly called "free." It will have to provide the open space necessary for the creative spirit to take flight. The thrones have been overturned, but the old ideas are still firmly rooted throughout the country. **We need a new communal spirituality of the entire people.** Government alone cannot provide it. The state is nothing but the sum of individual existences. Let **everyone** help, let **everyone** sweep his own doorstep first. We are deep in the mud of the old sins. **Not even political, only complete spiritual revolution can make us "free."** Capitalism and power politics have dulled the creativity of our generation and the atmosphere of bourgeois philistinism stifles living art. The intellectual bourgeois society of the old regime—indifferent and dull, unimaginative, arrogant, and badly educated—has demonstrated its inability to be representative of German culture. This rigid world has now been shaken, its spirit has collapsed, and it is being molded in new ways. New and spiritually still inaccessible ranks of the people are pushing upward, out of the depths. They are the object of our hopes. Their fresh and untamed instincts are still rooted in nature. The artist of the future will turn to them, to the earthy and cheerful nature of a people not afraid of color, golden brilliance, sweetness, or of innocently admiring beauty.

But how do the people achieve this unity of the spirit which alone engenders the natural rhythm of wholeness? **A great, all-encompassing art assumes the spiritual unity of its time. It needs the most intense relationship with its environment, with living people.** A person must be well formed to start with, only then can the artist provide beautiful clothing. Today's generation has to start from scratch, rejuvenate itself, create a new humanism and a universal form of life for its people. Then there will be art. Then the artist will find the coherent forms of speech in which he can make himself understandable to the people. **Then the people will once again cooperate in the great artistic work of the time.** From their isolation, the "arts" will return to the lap of a comprehensive architecture.

For only with sincere cooperation and collaboration among all artistic disciplines can an era produce the multi-voiced orchestra which alone deserves the name art. Ars una, species mille (thousands of species, but only one art). From ancient times, the architect has been called upon to conduct this orchestra. Architect, that means: leader of art. Only he is able to raise himself up again to be such a leader of art, to be its first servant, its superhuman guardian and organizer of its undivided totality. Yesterday's architect had ceased to be the universal creator and the powerful master of all artistic disciplines. . . .

His high office must once again receive wide recognition in the republic. He himself has to promote it through high human standards that transcend daily events, through an ardent interest in collective work. Just as the problems of painters and sculptors will once again move his spirit with as much passion as those of architecture, so the works of these painters and sculptors must at the same time be filled with the architectural spirit. He will have to surround himself with spiritually like-minded coworkers in close personal contact—just as the masterbuilders of the Gothic cathedrals in their medieval guilds. And in forming the **new, living-and-working cooperatives for all artists**, he will be building a cathedral of freedom for the future, not hindered, but **borne along by the people as a whole**.

Letter to Dr. Walther Rathenau,[45] February 23, 1919

Dear Dr. Rathenau,

I am taking the liberty of sending you the program of the Arbeitsrat für Kunst, herewith enclosed. After the revolution, the Arbeitsrat began to fight for its program. The initial association, joining artists of all groups—architects, sculptors, painters—intends, in accordance with its aims, to actually bring about the unity desired by all strong artists and to surmount the restrictive borders between the individual "arts." The Arbeitsrat has elected me its chairman and charged me with the first and most important task of contacting the most influential and progressively-minded men of the town and of asking them to support our fine and serious project with donations.

So far we have only with difficulty been able to raise enough within our group to print the first fliers. Exciting plans for publications and exhibitions have had to be postponed due to lack of funds. I direct this request for a donation to you, dear Dr. Rathenau, since I can assume that you are in sympathy with the spirit of our association. In return the Arbeitsrat will send you all publications as well as invitations to all exhibitions and other functions.

I ask sincerely for your help.

Yours truly,
Gropius

Letter to Ludwig Meidner, February 26, 1919

Dear Mr. Meidner,

On Saturday afternoon at 4 pm a crucial meeting of the Arbeitsrat für Kunst will be held at the German Society, Wilhelmstr. 67, to which we urgently invite you. After some initial confusion, the A.f.K. has come to the conclusion that it will be able to realize its goals successfully only if the boundaries between individual art groups such as architecture, painting, and sculpture are eliminated and if a *totally radical working committee* is elected. Initially this committee should do its preliminary work quietly until, perhaps in the not too distant future, a second revolution provides the opportune moment to make the demands of the radical artists public.

In Saturday's meeting this working committee will be elected. Naturally, everything else depends on this assembly. We urge you to attend this meeting so that the extreme left wing will be represented in this committee without compromise. We are counting on your help to realize this vision.

Very truly yours
Walter Gropius, Architect

Speech to the membership of the A.f.K., March 22, 1919
. . . .

. . . Gentlemen, I believe we are the first group to actually wipe out the lines separating the diverse kinds of artists, and thus to take the first step in wrenching the various artistic disciplines free of their isolation. It is precisely the longed-for goal of our program: consolidation of the arts under the wings of a great architecture.

I would like to start my chairmanship with a few basic points. . . . First we must slowly struggle to understand clearly what we **want**. The chasm between two fundamentally different intentions has been fatefully intertwined: whether we want to pursue art **politics** on a broad basis, or whether we want to help a radical artistic conviction gain victory by consolidating a small minority. We have been able only gradually to bridge the chasm between the two in favor of the latter view. Now we really have a clear foundation on which we can build, and I believe we can be grateful that our shortage of funds has prevented us so far from stepping

out prominently. Today it is to our advantage that a sense of unresolved mystery surrounds the Arbeitsrat, that the public expects everything or nothing of us.

I look at our association as a conspiracy: we are a small minority. If we want to accomplish something great, we have to honor our program in every respect and not permit any compromises, especially not among ourselves. We will prefer to accomplish practically **nothing** at first because any factionalism is the beginning of the end. We have to believe ourselves capable of enduring until the day comes when we are totally **prepared** to go public—and then with passion. We cannot permit ourselves to be satisfied with a few concessions the other side graciously lets us wrest from them; instead we need the other **spirit**, out of which we will receive fulfillment as a matter of course, once it has been **created**. Let us have the courage to wait until there is better consensus. Maybe it will come sooner than we expect. . . . Anyway, I consider unanimity among ourselves the most important thing and the most valuable to our association, much more important than all the propaganda to the outside. We are all still running next to each other, each one isolated in his work, and the first thing we need is intimate personal contact, so we can talk to each other about our artistic intentions and bring these into a certain practical harmony. We are just beginning to sense the goal we are trying to reach. We do have a fine program with clearly radical goals which, however, are, as the text says, only outlined. . . .

I would further like us to **quietly** consolidate our union among ourselves before we step in front of the public, to painstakingly finish and collect the material: prepare lectures and exhibitions, print flyers and store them, and then, when the time is ripe for it, suddenly jump up with all our material and pronounce: here we are. . . . That way we accomplish more in one day than in years. . . .

53. Adolf Behne: "Unknown Architects," *Sozialistische Monatshefte*, 1919; "General Announcement," from the flyer for the periodical *Bauen*, 1919*

Adolf Behne's name does not appear in the first published announcements of the Arbeitsrat.[46] Nonetheless, under Gropius's reorganiza-

*Adolf Behne, "Unbekannte Architekten," Kunstgewerbe, *Sozialistische Monatshefte* 25, no. 4 (March 1919): 422–23 and Adolf Behne, "Mitteilung an Alle," flier for the periodical *Bauen* (Berlin: Verlag Graphisches Kabinet Neumann, 1919), Bauhaus-Archiv, Berlin.

tion, Behne was made managing director and was so listed in the April 1919 issue of *Der Cicerone*.[47] In a letter dated March 6, 1919, Gropius urged Behne to accept the management of the Arbeitsrat, prophesying: "If the two of us stick together, surely radicalization would succeed with us. . . ."[48]

Behne wrote frequently for *Sozialistische Monatshefte*, a journal disseminating information on the international socialist movement, and after the November Revolution moved from the German Social Democratic Party (SPD) to the Independent Social Democratic Party (USPD). His writings clearly convey his view that the new directions in art and architecture could further the goals of beauty, peace, and brotherhood. For Behne, like the Expressionists before the war, art was transnational: it could break down barriers between nations, as well as classes, and specific fields.[49] The announcement for the periodical *Bauen* reveals Behne's plan for an inexpensive and simply written journal that would be available to all levels of people. In keeping with his equation of internationalism with modernism, Behne blames the unattractive quality of European architecture on the enmity between nations, on the materialism of capitalism, and the repressions of traditional education.

Behne's description of the Exhibition for Unknown Architects, the first exhibition sponsored by the Arbeitsrat in the spring of 1919 gives us some account of the participants as the exhibition pamphlet did not contain a list of exhibitors.[50] Behne's discussion, published in *Sozialistische Monatshefte*, and partly reprinted here, praises the experimental and utopian conception of the plan. Behne justifies the invitation to non-architects, specifically to painters and sculptors, by pointing to the creative possibilities inherent in a situation where imagination, and cultural and political consciousness determine the outcome, not cost. Praising the drawings of Molzahn and Finsterlin, Behne predicts that the exhibition will provide models for future monuments.

"Unknown Architects"

As was announced here previously, an Arbeitsrat für Kunst (Working Council for Art) was formed by Berlin artists and art writers last November. . . . The Arbeitsrat is not a clique, nor does it aim to put through small **reforms**, calculated for the day, by compromising with officials.

Instead the Arbeitsrat wants to do good, not through speeches and debates, but through intensive artistic-intellectual work. The Arbeitsrat does not consider **utopian** ideas to be ridiculous. One may call Bruno Taut's forthcoming architectural program **utopian**; the educational program Otto Bartning is preparing is also **utopian**, as is the idea of architects, sculptors, and painters together making the great models for the future in order to overcome, through practical efforts, the harmful isolation of the arts.

Even part of the Exhibition of Unknown Architects (in Neumann's Print Department), which is the first public event of the Arbeitsrat für Kunst, is **utopian**. It seemed important to the Arbeitsrat to determine whether the number of our good architects really is as embarrassingly small as it appears to be, judging by known works. Therefore, in January it issued an appeal, which is made again here, to all unknown architects to submit their works. The trustees of the Arbeitsrat, Walter Gropius, Max Taut, and Otto Rudolf Salvisberg, have selected the work on exhibit from the materials received. Painters and sculptors were also called upon to furnish architectonic works; because, of course, in order to collaborate in ways we have recognized as necessary, it is very important to know to what extent architectonic forces are already active in other arts.

All this having been said, the painters and sculptors are somewhat disappointing. For the time being, the fact that the works of painters such as Jefim Golyscheff, César Klein, and Erwin Hasz' have considerable graphic appeal does nothing to advance the cause. I find a sense for construction most readily in the works of Johannes Mohlzahn (fig. 36) and Arnold Topp. Of the sculptors, Oswald Herzog sent the color-model of a temple for art, which, with its beautiful crystalline glass roof, gives a valuable inspiration. The sketches by Gerhard Marcks are extremely tasteful, only maybe still a little close to certain Gothic and exotic forms. It is a pity that Hermann Obrist cannot be seen anymore. The cavernous tomb raises high hopes for his architectural capacities.

The projects of the architect Hermann Finsterlin from Berchtesgaden have the most **utopian** effect of all. It is a sign of the alarming gravity of our times that our **specialists** generally want to take so little pleasure in these frequently exquisite sheets. Recognizing the fact that these houses cannot be constructed (although many of the concrete buildings can be), one has reason enough to quibble, instead of being happy that such an original and free spirit has been freed from total oblivion. It would have been almost irresponsible not to exhibit this artist. His delightful lay-outs alone are important as outlines.

· · · ·

"General Announcement," *Bauen*

Dear Reader, we want to build and you should help us.

. . . .

. . . We are artists and writers, outside of bourgeois society, being forced just like you to fight for the complete realization of socialism. Your success in all material matters also liberates us. We would be hurting ourselves if we were to intentionally or unintentionally obstruct your fight. We do hope for your victory, for the victory of true socialism!

We want to cast a new weapon for this victory.

What is socialism?

A way of thinking!

Can a new way of thinking—and we learn each day it is new, that it does not yet prevail—can a new way of thinking be brought about with laws, paragraphs, force, and regulations? No, a socialist scheme of government can be manufactured with paragraphs, but if the collective socialist public spirit is missing, namely the socialistic way of thinking, then the form of law is nothing.

That does not mean that we should not strive for good laws. That is certainly what we want. But it means that we must work with equal passion on the sidelines as of today, to awaken this truly socialistic way of thinking!

How can we accomplish this? Socialism, as well as brotherly love, arises naturally in the course of collective activities and to an even greater extent the socialistic; that is, a truly altruistic way of thinking will develop to the extent that the distance this mutual activity maintains from all practical, petty, and limited aims. An ideal can only be realized through commitment to an idea, in other words, with idealism.

Let us build!

Not as one builds today. Today building is a matter of technology and industry. It violates the pure sound of the word. Nowadays building is slave labor. The construction worker executes the instructions of the architect. . . . We do not mean such a building!

True building is the collective work of art of many people, not only architects, sculptors and painters but also of carpenters, bricklayers, stonemasons, and plumbers. In true building they are engaged as equals—and backing them are the masses of people who watch the building process—they are emotionally engaged in the common project, they are not laborers but co-workers. All are filled with the same idea. Everyone contributes the best from his imagination and forms, embellishing the structure with love, devotion, strength, and the irreproachable quality of his voluntary efforts.

The Gothic buildings of former times came from this kind of broad-based building community. In their infinite richness, in their figurative sculpture and reliefs, stained glass windows, murals and ornaments, Gothic structures reflected not one single designing architect, but **a whole people**, the community to whom a structure belonged.

We want something as grand and beautiful, but something necessarily **new** for the future, because we know that the collective work on such an architecture, that springs magnificently from many hands, creates in the souls of men that which we all yearn for: the truly socialistic spirit. **Only joy and happiness will create the miracle!** Let cheerfulness and loyalty be our motto. Sermons are all well and good, but action, the step to work, is better, and better yet: action is transformation!

. . . .

. . . With cheerfulness and loyalty, we will erect a structure, a symbol of our way of thinking which will put everything around it to shame. Its beauty will bring us closer and closer together.

Beauty . . . what is it?

Beauty is the triumph of the good!

Why is our European environment so ugly?

Because Europe is full of hatred and lacks a sense of what is good.

If we succeed, brothers, after long centuries of want, in erecting a work of beauty worthy of the Gothic, then we will have done with different weapons certainly no less for the victory of socialism than the politicians and theoreticians who fight in our ranks. Then we will have delivered tangible proof that socialism must lead to the good and that socialism is the basis for every truly satisfying creative endeavor.

. . . .

As the focus of our gathering of partisans, we want to publish a series of pamphlets, whose collective title is *BAUEN*.

Soon you will see the first issue in shop windows and on the street. You will recognize it by its strong color and its high spirits. We do not want a serious and ceremonial journal full of culture and aesthetics but pamphlets for all, simple and inexpensively printed so that **everyone** can afford them, but still full of color and joy. We aim above all not to print a line that will not be understood by **everyone**; all jargon will be superfluous. We do not talk about art as others do, as of a far off island requiring a 2. class ticket, for we are willing to prepare the only kind of soil in which true art can grow . . . the people! Everything we advocate serves the idea: to realize the building, to spark the desire so intensively that someday it will be a spontaneous act, even if we do not live to see it. The beckoning call again and again is: Build! Build! Build! Set forth buildings in the world, consider the highest act of man: **building**.

We want to speak to all of you, we are not refined, cultured, or educated: we are filled with the ambition to reach our goal, the building that will impart a luster to the world and that will look out past all boundaries to a free, unified generation of man, undivided in its creativity.

. . . .

54. Questions from *YES! Voices of the Arbeitsrat für Kunst,* and excerpts from the responses of Karl Schmidt-Rottluff and Georg Tappert, 1919*

The introduction to the published results of the Arbeitsrat question-naire proclaims that *YES! Voices of the Arbeitsrat für Kunst* (fig. 37) was "born of the revolutionary movement."[51] According to Behne, the point of circulating a questionnaire about art education, public housing, and artists' relation to the socialist state and to the people, was to "clarify the position of the artists to the movement of their times and to search for a uniform basis, even if only in general, on which unified works by different artists, painters, sculptors, and architects could be built."[52]

Examination of the statements by such respondents as Karl Schmidt-Rottluff, and Georg Tappert in addition to those by Behne, Gropius, Taut, César Klein, Karl Osthaus, and others,[53] uncovers a number of common concerns. The most striking is the antigovern-ment bias, which is clear in Schmidt-Rottluff's response. The repres-sive censorship the custodians of the Wilhelmine Empire had exercised over the arts, their control of the commissions for public buildings and national monuments, and the authoritarian nature of the German educational system had created a strong resistance to government domination of the arts and had nourished the spread of anarchistic and communalist attitudes.

Many of the respondents were dedicated to the concept of artis-tic freedom encouraging creativity. The 1914 Werkbund contro-versy in which Taut and Gropius had sided with Henry Van de Velde in opposition to Hermann Muthesius's call for standardiza-tion of the applied arts, was still very much of an issue. The belief that a return to crafts would dissolve the antagonism between the fine and the applied arts made the question of education and creativity a central concern. As Tappert's answer makes clear, spontaneous release of feelings, exposure to new techniques and methods, and improvement of the public's exposure to art were also predominant concerns.

JA! Stimmen des Arbeitsrates für Kunst (Charlottenburg [Berlin]: Verlag der Photographischen Gesellschaft, 1919), 7–8, 90–91, 96–97.

QUESTIONS THAT NEED CLARIFICATION

I. Curriculum
What measures are considered appropriate to reform thoroughly the education of all those who work in the visual arts?

II. Government support
In what ways should the socialist state support art and artists? (Purchases, art commissions, museums, schools, exhibits, etc.)

III. Public housing
What guarantees should one demand from the government so that housing in the future is planned in accord with far-reaching cultural considerations?

IV. Inducing Artists to turn to the Crafts
How can the broad mass of the art proletariat be persuaded to enter the crafts and avoid destruction by the economic catastrophe which seems imminent?

What must the government do so the education of the next generation is based upon a thorough mastery of craft?

V. The Artist in the Socialist State

VI. Art Exhibitions
What new ways are suited to getting the people interested once more in a **Gesamtkunstwerk**—the unification of architecture, sculpture, and painting?
Government-supported alternate spaces to take the place of salon art exhibitions.

VII. How can artists from the various artistic disciplines form a consensus and unity?

VIII. Handling of color in cities
Ideas for the use of color in the city, bright colors for houses, repainting facades and interiors, and the elimination of easel paintings.

XI. The designing of public buildings by artists
What practical demands must be made upon the government so that public buildings are designed by artists rather than, as is the case now, by engineers and building officials?

X. Harmony with the people

How can the efforts of modern artists reach the people and harmonize with it?

XI. What steps must be taken so that at the right moment material, which has been quietly assembled, can be effectively publicized?

Preparation of newspaper articles, lectures, exhibitions, assurance of sufficient press coverage for the purpose.

XII. How shall the closest contact possible be established with foreign art associations which have similar ideals?

XIII. Position on anonymity for artist and work

Colophon instead of signature.

OPINIONS

Karl Schmidt-Rottluff

I. Training based on craft. A complete mastery of craft for architects. Training in construction techniques which require specific materials. The elimination of all false materials.

The training of painters and sculptors can only be built on a foundational knowledge and mastery of materials. For the rest of it, each artist should search for his own ways. So we actually must also demand that all academies for painters and sculptors be dissolved.

. . . .

V. The artist should also be free in a socialist state, true to his goals, which are always directed toward all of humanity—never toward the government. Rejection of all attempts by the government to integrate art into the entire state. In life and art the artist must be free. As a result it is reasonable to ask that the government should not involve itself with art at all.

. . . .

Ideal Project

Construction of a town in the mountains. The town is supposed to accommodate about 8,000 to 10,000 inhabitants. The external shape of the town presents a great uniform silhouette. On the top of the mountain stands a vast building composed of powerful cubic masses. Painted white, it glows far out into the countryside. The building comprises all the major public buildings of the town. Schools, concert-, and festival-halls, theaters, a hall for worship by the new Christian community. A large courtyard, which again is uniform in itself, also serves as a public meeting

place; it is vividly colored and decorated with large mosaics. . . . The streets, rising in zig-zags, are emphasized by thick walls, which shoot up to the top like white ribbons. The color white is avoided in all other buildings. Blue and red (rough walls), and here and there yellow, serve as colors for individual homes and row houses. Evergreens provide individual sharp accents.

To carry out this plan the government would have to make available a wooded mountain, which would then be cleared wherever construction was feasible. Building lots should be offered free of cost, under the condition that the contractor have it designed by the architect in question. Individual houses and rows of buildings would be planned independently by various architects—they are required only to harmonize with the overall plan of the town.

Georg Tappert

I. Abolish and reorganize previous drawing instruction. Total freedom for children's fantasy in homes and schools up to about the 10th year. No separation of sexes. Teachers, whose job should not involve correcting drawings as far as accuracy, technical cleanliness, and such other things, should encourage children's expressive drawings. The teacher must be concerned with stimulating the child's fantasy and with using it to further shape and expand the child's own imaginative capabilities. Try not to depict a thing by itself, but always in connection with others.

The stimulating and informative word is as important as the drawing abilities of the teacher. Stimulate the child with surroundings of animals, plants, bright paper, and colored glass. Primitive art objects (folk art) should be selected carefully. The pencil is not the appropriate medium, according to my own experience; flowing India ink in the Redis-pen is preferable, also colored chalks and inks, colored paper, development of the sense of touch (theory of space) through modeling with clay, plasticene, plaster. Strong preference for manual skills instruction, lessons about handling materials. Don't coerce students to copy real things correctly (cleanly). The technical skill of drawing "cleanly" has been emphasized too much until now and with students and parents alike it raised the erroneous idea that this skill is sufficient to take up an artistic profession.

These suggestions are valid for the primary school, whether or not the children are to be guided towards a visual profession or not. . . .

IV. NOVEMBERGRUPPE

by Ida Katherine Rigby

INTRODUCTION

The Novembergruppe was founded in Berlin in December 1918 in response to the November Revolution. Like the Arbeitsrat für Kunst, its goals were to bring art to the people, to serve the socialist revolution, and to formulate policies and establish institutions that would respond to the new-found freedom from Wilhelmine controls over the lives of artists. The group's original purposes were public and communal. As the critic Will Grohmann wrote, "The horrible isolation of this solitary, reproached outsider would be at an end, . . . they desired one thing: to reach into the people and carry it aloft, transformed."[54] The artists believed that theirs was a symbiotic relationship with the workers: the workers had effected the external, political revolution; the artists would bring about the internal, spiritual one. For them, "proletarian culture, . . . is still ahead. . . . artistic revolution will succeed completely—. . . the political revolution too!—when the new humanity, whose bearer is the proletariat, supports the new art. To bring the new art and the proletariat together, . . . is indeed the most important task of the Novembergruppe."[55]

Of the radical artists' groups formed in the aftermath of the revolution, the Novembergruppe was the most long-lived and had affiliates throughout Germany. Although its political elan soon dissipated and many of the original members left, the Novembergruppe held exhibitions into 1932. Over forty artists and architects participated in its exhibitions during the first year with the expectation of reaching a broad public. According to Adolf Behne, the Novembergruppe struggled to create "a cultural program," to assist with "all problems of architecture, . . . the transformation of museums, the allocation of exhibition spaces, and the promulgation of arts legislation." For Behne, "the November-socialists" were also "No-

vember-Expressionists."[56] The Novembergruppe lectures, exhibition catalogues, periodicals and book *An alle Künstler!*, published in the fall of 1919, spread their ideas. The group supported experimental film making and music as well.

Press reaction to the Novembergruppe exhibitions was mixed. Progressive art critics were generally positive, although even as sympathetic a critic as Paul Westheim commented that their art was only "a radical art of the middle of the road."[57] The socialist press was hostile, accusing the artists of intellectualism and blasphemy. The popular response to the 1920 exhibition was that it was a "laughter-cabinet" in which "the naive public holds its sides and finds in the works only the occasion for more or less senseless jokes . . . swindle, fraud and bluff," and then "demands its money back."[58] It was this resentful noncomprehension that the Nazis later exploited in their campaign against modernism. But active opposition also came from within the modernist ranks, notably the Dadaists. In 1921 Wieland Herzfelde's *Der Gegner* printed an "Open Letter" to the Novembergruppe accusing it of betraying its political origins.

55. Draft of the manifesto of the Novembergruppe, 1918; circular letter, December 1918; guidelines, 1919*

The three following documents mark the founding of the Novembergruppe. The draft of the Manifesto reflects the liberal republican and socialist politics of the founding members and their commitment as artists to the construction of a new, socialist Germany. They actively recruited support from like-minded groups throughout the country. Declarations of solidarity poured in as the Novembergruppe became a rallying point for radical artists' groups as well as the focal point for activist artists in Berlin. Georg Tappert was very active in the recruitment effort and contacted many personal friends. He also published an invitation to all "Expressionists, Cubists, and Futurists" in the December 1918 issue of *Die schöne Rarität*, which he co-edited.

The circular letter of December 1918 succinctly summarized the goals and international aspirations of the group. Some of the responses to this letter are published in Helga Kliemann's book on the

*Novembergruppe, manifesto, circular letter, and guidelines, reprinted in Will Grohmann, *Zehn Jahre Novembergruppe*, Sonderheft, Kunst der Zeit, Zeitschrift für Kunst und Literatur, 3:1–3 (1928), 11–12, 16.

Novembergruppe.[59] Among the affiliated groups were the Dresden Secession Gruppe 1919, Das junge Rheinland (Düsseldorf), Gruppe Rih (Karlsruhe), Die Kugel (Magdeburg), Hallische Künstlergruppe (Halle), and Kräfte (Hamburg).[60]

The Novembergruppe formulated its guidelines in January 1919. Although the membership of the Novembergruppe and the Arbeitsrat für Kunst overlapped and they shared many common concerns, the minutes of the first meeting of the Novembergruppe (December 3, 1918) record a negative discussion of the Arbeitsrat's suggestion that they merge.

Manifesto (draft)

We stand on the fertile ground of revolution.
Our motto is:
 LIBERTY, EQUALITY, FRATERNITY!
Our union resulted from the identity between human and artistic conviction.

We consider it our noblest duty to dedicate our best energies to the moral reconstruction of a new, free Germany.

We plead for rectitude in everything, and we support this conviction with all of the means at our disposal.

We insist on unlimited freedom of expression and a public statement about it.

We hold it as our special duty to gather all serious artistic talents and to turn them towards the public good.

We are neither party nor class for itself, but people, people who tirelessly perform, in places assigned to them by nature, difficult tasks, which must, like any task that benefits all the people, take into account the general public interest and win the appreciation and recognition of the whole.

We hold achievements in every area and in every form in high esteem and believe that the most difficult problems will be given to the most capable people, who must consider the use and benefit of the whole populace in finding solutions.

Our goal is for each to work—hard and tirelessly—in his place, to build collectively.

Our struggle applies to all destroyers—our love to all reconstructive powers.

We feel young and free and pure.

fight backwardness and reaction with all the powers at our disposal, courageously and without reservation.

In the hope that they will join us, we send our fraternal greeting to all Cubist, Futurist, and Expressionist artists who feel addressed and accountable.

Circular Letter of December 31, 1918

Potsdammerstrasse 113, Villa II

Most Honorable Sir!

The future of art and the gravity of the present hour force us revolutionaries of the spirit (Expressionists, Cubist, Futurists) to unification and close alliance.

We therefore direct an urgent call to all visual artists who have shattered the old forms in art to declare their membership in the "Novembergruppe."

The formulation and the realization of a wide-ranging program that will be carried out by trusted people in various art centers should bring us the closest interaction between art and the people.

Renewed contact with the like-minded in all countries is our duty. The creative instinct united us as brothers years ago. A group exhibition is planned as the first sign that we have come together. It is to be shown in all the large cities in Germany and later in Europe.

The working committee:

M. Pechstein, C. Klein, G. Tappert,
Richter-Berlin, M. Melzer, B. Krauskopf,
R. Bauer, R. Belling, H. Steiner, W. Schmid

Guidelines of the "Novembergruppe" (January 1919)

I. The "Novembergruppe" is the (German) union of radical visual artists.
II. The "Novembergruppe" is not an association for economic protection, nor is it (merely) an exhibition society.
III. Through a broad alliance of the like-minded, the "Novembergruppe" seeks to give creative powers a decisive voice in all artistic questions.
IV. We demand influence and an active role:

1. in all public architectural projects:
city-planning—housing developments—public buildings for administrative, industrial, and social welfare purposes—private

building activity—the care of monuments—the removal of artistically worthless showplaces.

2. in the reorganization of art schools and their curricula:
abolition of bureaucratic patronizing—the election of teachers by artists' associations and students—abolition of stipends—the unification of schools for architecture, sculpture, painting, and decorative arts—establishment of workshops and experimental studios.

3. in the transformation of museums:
abolition of one-sided collecting—elimination of scholarly excesses—transformation into spaces for the people's art, into disinterested purveyors of eternal truths.

4. in the allocation of exhibition spaces:
the elimination of special privileges and capitalistic influences.

5. in arts legislation:
equality of social rights to artists as spiritual creators—protection of artistic property—duty-free status for works of art (free export and import).

V. The "Novembergruppe" will demonstrate its determination and its achievements through regular public announcements and a yearly exhibition in November.

The Central Committee will be responsible for the regular public announcements and exhibitions.

Members are entitled to equal exhibition space and need not submit their work to any jury.

The Central Committee will decide issues relating to special exhibitions in the same way.

56. Max Pechstein, "What We Want," *An alle Künstler!*, 1919*

During the early days of the republic, Max Pechstein was one of the most active of the politicized Expressionists. He made posters for socialist causes, was a co-founder of the Novembergruppe, and joined the Arbeitsrat für Kunst. He exhibited only in the first Novem-

*Max Pechstein, "Was Wir Wollen," *An alle Künstler!* (Berlin: Kunstanstalt Willi Simon, [1919]), 18–22.

bergruppe exhibition, in 1919, however, and then turned to the Berlin Secession. He soon left the turmoil of Berlin for the remote Baltic fishing village of Nidden. In his memoirs he described his involvement with the revolutionary endeavors: "After the collapse of the kaiser's regime, I, with many others, felt a grand freedom, a human existence, was dawning. . . . Resolute, I placed myself at the service of the Social Democratic regime" and "made posters."[61]

In this essay for *An alle Künstler!*, Pechstein, who also designed the cover (fig. 38), addresses one of the Novembergruppe artists' primary concerns, the constraints of traditional art education. He also expresses their common belief that the new socialist republic would make possible the reform of art-related institutions and policies and that educational reform could make the public more open and sympathetic to modern art. His suggestion that artists support themselves through the crafts reflects the group's effort to bring art to the public and to allow artists to profitably apply their marketable skills.

Wincklemann's glorification of classical antiquity is still the cornerstone of the study of art in the state art academies. Life, and all effort to come to terms with it, is forbidden. Craftsmanship is not taught. The most painstaking preparation of neat sheets conceals a lack of ability. Each truly devoted student must acquire the most necessary techniques on his own. . . .

Teaching the art of illusion is the current activity in the academies. Pencil sharpening and the fine grinding of pigments are taught as workmanly skills instead of the casting of artistic ideas into pure matter. The total mass of so-called studies swell up endlessly.

Studies for what? and to what end? I ask!

Master designers of art are being trained. Wake up! Break out of your inertia! Become capable of learning from life and of having an effect on life. Then you will find expression enough and not need to refer back to old emblems of earlier stylistic periods.

Become creative in learning, and you will be the master in teaching!

*

Through the socialistic republic we hope not only for a return to healthy artistic conditions, but also for the formation of a unified art epoch for our time. On the basis of craftsmanship acquired by all visual artists, each according to medium, the light of the unity "people and art" will dawn on us. No longer will it be possible for mainly just sons of wealthy loafers

to view art as an interesting pursuit appropriate to that class. On the contrary, the sons of the people must be offered the possibility of progressing further into art through the crafts. Art is no game, but a duty to the people. It is a public concern.

Likewise those who don't make the grade would then not be useless drones, but still useful, fine craftsmen, whom the state needs as such. We want to get the people in shape in work and in feeling.

. . . .

As to the question of collecting special achievements in art for the people's state (museums for the living), we demand on the basis of our pure hearts, our right of self-determination. We do not want the government to use the old system to saddle us with people from the old order. We do not want to be heard after the fact, but to have a voice beforehand in finding the man who, through his experience, feels the same acute sense of responsibility we do.

Then he will have full responsibility, with no art commissions protecting him. The revolution has brought us the freedom to express and to realize desires held for years. Our sense of duty teaches us that we must also do the work for ourselves. We want it and also do it without personal aims either, the eye pure, aimed at the ideal purpose: "Realization of our contemporary spirit in a Weltanschauung."

For us the realm of creative fantasy replaces the antiquated dogmas of diverse religions: creation brings us nearer to God than could the Catholic religion, which is directed at the gratification of childish, natural fantasy (see patron saints for fire, water, other needs) or the Protestant religion, which is itself devoted to reason.

The call, "Art for the People!" is therefore no empty cry. Our intentions are above reproach, not grounded in personal desire for power. And so we will succeed in instilling in our times the lost spirit of the ideal. We are as rich in inspiration, readiness to sacrifice, belief in our people, as we are poor in possessions.

Let the socialist republic give us trust, we have freedom, and out of the dry earth flowers will bloom in its honor.

57. Peter Leu, Guide to the Novembergruppe Art Exhibition, 1920*

The Novembergruppe's exhibition program was central to its effort to bring art to the people. As Will Grohmann explained, "There

*Peter Leu, *Führer durch die Abteilung der Novembergruppe. Kunstausstellung Berlin 1920* (Berlin: Der Novembergruppe, 1920).

were grand concerns; one wanted to explain oneself to the mass of the people, to mount large exhibitions in which one furnished the architects with a wide space, took part in school and worker exhibitions, in open discussion."[62] Initially the group intended to hold a yearly exhibition in November to commemorate the revolution; this only occurred in 1919, 1920, and 1921, however. The group also held small shows, but its prominent exhibitions were held as sections of larger exhibitions, most often the *Grosse Berliner Kunstausstellung*.[63] Guides were published to the exhibitions of 1920 through 1924.

Although politicized Expressionists dominated the founding membership, the Novembergruppe's exhibitions soon evolved into showcases for modern art in general. Among the international selection of artists included in the Novembergruppe exhibitions were Expressionists, Dadaists, Futurists, and abstract artists of no particular stylistic or ideological direction. In the 1920 exhibition, for which Peter Leu wrote the guide excerpted here, the exhibitors included Rudolf Belling, Otto Dix, Herbert Garbe, Oswald Herzog, Karl Jakob Hirsch, Hannah Höch, Wassily Kandinsky, César Klein, Otto Lange, Moriz Melzer, Enrico Prampolini, Hilla von Rebay, Heinrich Richter, Georg Scholz, Curt Stoermer, Georg Tappert, and Karl Volker.

Leu's essay is filled with characteristic cosmos-embracing, euphoric Expressionist phrases celebrating the human soul and apocalyptic new beginnings. His faith in the ability of art to communicate the deepest spiritual and emotional experiences of its times and to uplift humanity were fundamental to Expressionism.

The Growth of the World

. . . .

Man is the storage battery of world events. In his creative work, his thought, feeling, and behavior, the interrelationships among things express themselves. . . . The living creature becomes the bearer of new things.

Great events of a spiritual and material sort always found resonance in the products of human creatures, . . . Just as the events of the Passion, religion, love, war, found changing expression in life and art, in thought and opinion, so the development that is now beginning is reflected in every kind of human manifestation. . . . New forms are harbingers of

new concepts. Naturally they will be spat upon and laughed at. . . . But the discontented who sense a new world and recognize its signs, gather round and experience the joy of those whose time has come.

This exhibition will take a cross-section through the work of recent years that bears witness to a new kind of artistic expression. One can refuse to trouble oneself at all to understand. . . . And one will be very proud and self-confident and . . . remain old.

To you, however, who are young and want to remain so, I want to address myself. Look; here is youth! Your creation is revolutionary as new art has always been. . . .

. . . .

Learn to understand and grasp your own happiness. **Art is one of the really great creative acts of this beautiful world.** It is an ordering of things, which arises out of the eternal fluctuation of becoming and passing away. Art is the bringing together of the largest amount of truth and beauty possible. It is the concentration of the strongest expression, the elimination of everything inessential.

. . . .

Instead of merely limiting themselves to representing natural appearances from new viewpoints, the artists of the Novembergruppe conceive of color, form, feeling, space and shape from a new spiritual center shaped by the historical development of contemporary world events and the new Weltanschauung. . . .

Abstract or objectless art is a flight from the realities of creation. It is antirestrictions, antipolitical, like plants, blossoms and fruits of a higher, hitherto unknown region, but full of unimaginable beauty and depth.

As the artists of every other epoch expressed their relationship to their environment, the experience of their souls, the longing of their hearts, knowledge and realizations of their intellects with their special means conditioned by the times . . . so the artists of the Novembergruppe want to fill their time—our time!—with new contents, to be in their way the expression of this time, to interpret their relationship to the world and life. They want a new art, not for the sake of the approval of the masses, but in order to give form to the dramas of their souls and the longing of their hearts with new means conditioned by the times. They want to hearken more to the soarings of their souls than to the din of the streets, to seek the beauties and the values of life in their own hearts, to listen more to the stirrings and feelings of the inner self than to the turbulent clamor of warlike and political maneuvers. They want to give form and color to the soaring of the soul, the powers of its being.

Listen to these paintings, where they cry out for joy, where they swoon with devotion, where they sob with pain, where they boil with hate and

where they clash and roar with the pulsation and collision of forms and colors. These paintings soar, sounds ring out, color ecstasies scintillate, like springtide, joy immediately seizes the receptive ones who listen with open souls.

. . . .

58. "Open Letter to the Novembergruppe," 1920–21*

The Novembergruppe's exhibitions soon lost their political overtones and its artists soon turned their energies to consolidating gains in the art world by freely exhibiting their work and by accepting professorships where they had formerly been barred. Their retreat from politics was probably hastened, too, by the workers' repudiation of abstraction and resentment of them. It was not only the Novembergruppe whose political engagement was short-lived. The Arbeitsrat für Kunst disbanded in 1921 and earlier Conrad Felixmüller expressed his disappointment that the Dresden Secession Gruppe 1919 had not embraced politics. Interestingly enough, one of the signatories to this "Open Letter," Otto Dix, had been among those who resisted the politicizing of the Dresden group.

Most of the artists who signed the letter were Dadaists associated with Wieland Herzfelde's Malik Verlag, which published *Der Gegner* (1919–22); Herzfelde, the brother of Dada photomontagist John Heartfield and close friend of George Grosz, founded the Malik Verlag in 1916. He published antiwar and anticapitalist material in periodicals, broadsheets, books, and print portfolios. Among those who signed the "Open Letter," Dix, Max Dungert, Raoul Hausmann, Hannah Höch, Franz Mutzenbecher, Rudolf Schlichter, Georg Scholz, and Willy Zierath had exhibited with the Novembergruppe and continued to do so sporadically into the 1920s. Grosz exhibited with it only in 1929.

In a preface to the letter its authors explained that the Novembergruppe leadership had betrayed the original intentions of the group and that the specific event that prompted the letter was a proposal by the board to found a "Saxon-Weimar Academy whose members would be professors. Suggested were Mssrs. Melzer, Klein, Tappert, Herzog, Brass, Belling. . . . Each should wear a small

*"Offener Brief an die Novembergruppe," *Der Gegner*, 1921, 297–301; from a photomechanical reprint by *Das Arsenal*, Berlin, 1979. © by Das Arsenal, Berlin (West) 1979.

ribbon in his buttonhole."[64] Regular members, according to the opposition, were pawns for electing the new academy, but then became second-class members, introducing the bourgeois concept of "better" artists to divide the group.

. . . .

Ostensibly, the Novembergruppe was founded by artists who wanted to satisfy a revolutionary longing for a genuine community and for a relationship with the working masses outside of the tactics and maneuvering of the snobbish art clubs and dealer speculation. The young artists and those disposed to the proletariat therefore joined the Novembergruppe. . . . But instead of attempting to reject the role of drone and prostitute forced on the artists in capitalist society, the leaders did everything to further their own interests with the help of a rubber stamp membership. They set up statutes in which no trace of freedom and camaraderie can be found; they curried the favor of a regime held on a halter by von Ludendorff, Kapp, and Stinnes,[65] and they went so far in their shamelessness and lack of conscience as to allow themselves to be insulted and managed by this regime and its subordinates. Their hearts and their thoughts are unrevolutionary. . . . It was known to the leaders that among the younger members a certain number believed in the proletarian revolution and . . . that a certain part of the members did not want to be artists according to the bourgeois conception of culture . . . but . . . sought to become the means for conveying the slumbering longings of the masses for a pure and unpolluted life. . . . The corrupt clique of leaders . . . set down their veto against all strivings for any true revolutionary and human goal . . . because they had been tainted by business and fame. . . . because the leaders had their reputations and livings to save, over against the aims of the active force of the group. The ministry had threatened not to allow the section of the Novembergruppe to be opened, if at this time, as in the year before, works were exhibited that did not conform to the authorities' conception of art. . . . President Ebert waltzed through the rooms at the opening and spoke to the pointlessness of the effort. And the servile souls of the artists were satisfied—their vanity had basked in the proximity to "sovereigns," these lackeys of exploiters and promoters of special interests . . . we shall never, never more, have anything in common with them. Our love belongs to the proletariat because only the proletariat will bring about through communism the equality of all men and all work and freedom from slavery. We are not artists for the purpose of living in a comfortable and irresponsible way from the exploiter's passion for luxury. We feel solidarity with the strivings and longings of the proletariat, towards the realization of a

human community in which there are no drones, in which one does not, as now, work out of opposition to society, in order then to live by its favor as parasites. . . . And therefore we say to the leaders: the goal must be to overcome this petty trading in aesthetic formula through a new concreteness that will be born out of an aversion to the exploitative bourgeois society or through preparatory experiments in objectless optics, which, too, in rejecting this aesthetic and society, seeks to overcome individualism in favor of a new human type. There is in the Novembergruppe as it is now constituted no understanding and no place for this position; the leaders term such a desire kitsch and nonsense and emphasize in opposition their aestheticizing standpoint, which is the equivalent of a dictatorship of the aesthetes and businessmen over the energetic forward-looking members. . . . It led, through the toleration of the strivings of the proletarian-minded of the group, to the group's acquiring a revolutionary mask; it has cast off all forward-striving spirits, as far as any still really remain, instead of offering them a hand in comradely fashion. A group, however, which today is not capable of recognizing the strivings and goals of independent spirits and making them its own has no right to exist. . . . We charge the members, who understand that today protest in art is against the bourgeois sleepwalker and against the perpetuation of exploitation and of philistine individuality, to join this opposition[66] and thereby to help bring about the necessary cleansing of intentions. We know that we have to be the manifestation of revolutionary forces, the instrument of the needs of our times and of the masses, and from tomorrow on we disclaim every relationship with the aesthetic profiteers and academics. Ours is the avowal of revolution, of a new society, no lip-service, and so we wish to seriously set about our recognized task: to work together in the building of the new human community, the community of the active!

The Opposition to the Novembergruppe:

Otto Dix. Max Dungert. George Grosz. Raoul Hausmann. Hanna Höch. Ernst Krantz. Mutzenbacher. Thomas Ring. Rudolf Schlichter. Georg Scholz. Willy Zierath.

V. DRESDEN SECESSION GRUPPE 1919

by Peter Chametzky

INTRODUCTION

Soon after the conception of the Novembergruppe and the Arbeitsrat, a diverse group of Dresden artists, under the leadership of the painter Conrad Felixmüller and the journalist Hugo Zehder, formed the Secession Gruppe 1919. With roots in the art of their Dresden predecessors—the Brücke, as well as in French Cubism, Italian Futurism, Chagall's Russian-Jewish mysticism—the Dresden secessionists generally hoped that their art and related activities could further the cause of utopian socialism.

Dresden's art community oriented toward Expressionsim gave strong support to the new group. The journal *Neue Blätter für Kunst und Dichtung*, which Zehder edited at the time, and the journal *Menschen*, which the poet Walter Rheiner edited for 1918 and part of 1919, reproduced works and essays. Their first exhibition was held in April 1919 at the Galerie Emil Richter, where several of them had exhibited together in 1917.[67] The critic Dr. Will Grohmann was also sympathetic to their aims and wrote about them as well as the Novembergruppe. The new head of the City of Dresden Modern Art Collection, Dr. Paul Ferdinand Schmidt, who had been a collector of Brücke graphics since 1905, was the first museum director to acquire the secessionists' works for a public collection.

The Dresden Secession Gruppe 1919 maintained close contact with other radical artists' groups in northern Germany. Among them were the Expressionistiche Arbeitsgemeinschaft Kiel (Expressionist Work Group Kiel) and Kräfte (Forces) in Hamburg.[68] But like many Expressionist associations in the months following the November Revolution, Gruppe 1919 could not achieve consensus as to how art should effectively serve politics.

Within a year, first Zehder and then Felixmüller had resigned. Although new members such as the sculptor Christopher Voll and the painter Otto Griebel joined Otto Dix, Wilhelm Heckrott, and others from the original group in exhibitions through 1922, their activities of 1919 made their reputation.

59. "Regulations," Dresden Secession, January 29, 1919, and statement of purpose, March 1919*

On January 29, 1919, the Dresden Secession Gruppe 1919 issued its regulations, signed by six artists and the journalist Hugo Zehder (1881–1961). The artists were Conrad Felixmüller (1897–1977), the youngest member and chairman of the group; Otto Dix (1891–1969); Wilhelm Heckrott (1890–1964); Constantin von Mitschke-Collande (1884–1956); Otto Schubert (b. 1892); and Lasar Segall (1891–1957). Though Zehder and Felixmüller were the organization's catalysts, they were also the first to resign from it several months later. Von Mitschke-Collande, also disappointed with the political apathy of the other members, resigned in 1920.

Felixmüller and von Mitschke-Collande, who became Communist party members in 1919, and Zehder shared the hope that the Gruppe 1919 would promote radical political activity. Although the text of the regulations omits explicit political statements and demands, its call for "truth, brotherhood, art" is a mild reformulation of the Berlin Novembergruppe motto—itself adopted from the slogan of the French Revolution, "liberty, equality, fraternity."

By the time of the exhibition at the Dresden Galerie Richter in April, the Secession Gruppe 1919 had added new members, among them: Felixmüller's brother-in-law Peter August Böckstiegel (1889–1951); the only woman member, Gela Forster (1892–1957);[69] Otto Lange (1879—1944); and Oskar Kokoschka. Kokoschka, who had arrived in Dresden in 1917 to be treated for war injuries at the Lahmann Sanitorium and from 1919 to 1924

*"Statut," *Sezession Gruppe 1919* (Dresden: Emil Richter Verlag, 1919); reprinted in *Dresdner Sezession 1919—1923* (Munich, Gallerie Del Levante, 1977), n.p.; statement of purpose, *Sezession Gruppe 1919* (Dresden: Emil Richter Verlag, 1919), 6.

taught at the Dresden Academy of Art, was listed in the pamphlet published by the Galerie as a "nonresident" member.

Regulations

1. The Secession "**Group 1919**" consists of a number of artists engaged in terms of their art, in planning utopian projects. These projects necessarily separate them as well as their art from any other artists.

 Basic principles are: truth—brotherhood—art. The energy of the time has produced this group, and the energy of the time to come can destroy it: we will contribute by preparing the way for what is to come, a way we already represent.

2. New members can only be accepted with unanimous approval of all members of the group: the determining factor will always be the courage and the crucial inner conviction in the works of the prospective applicant; membership in other Dresden art organizations is not allowed, in out-of-town organizations only after mutual resolution with ⅔ majority.—A member can be expelled by unanimous resolution of all members.

3. The group will elect a spokesman and a deputy, who together will take care of the group's business. To take care of current affairs of the group and upon special request, the spokesman will call a meeting; ⅔ of the members will represent a quorum.

4. Exhibitions in Dresden will be organized only as a group; exceptions in particular instances can only be granted after the proper resolution. The complete membership of the group will act as a jury.

<div style="text-align: center">

The founders: Felixmüller Otto Dix
Otto Schubert Hugo Zehder
Heckrott Lasar Segall
Constantin von Mitschke-Collande

</div>

Dresden, January 29, 1919

Statement of purpose

The founding of the Secession "Gruppe 1919" is a natural consequence of a long-felt inner need to finally part with old ways and procedures and, with complete respect for personal freedom, to look for and find new expressions for this, our world. We did not just happen to meet; rather

our organization was mandated by an overpowering recognition of the value of such a bond for the future development of art, as we understand it. We took the step having recognized that we are mature enough to take over the leadership of the local young talent, those that follow the path of art towards the goals of the group. We are clear about the fundamental significance of our action. Its effect upon the future will be proven and clearly visible to all.

Dresden March 1919

THE FOUNDERS OF THE GROUP

Felixmüller, Will Heckrott, Lasar Segall, Otto Dix, Otto Schubert, Constantin v. Mitschke-Collande, Hugo Zehder

60. Hugo Zehder, "The Journal 1919 *Neue Blätter für Kunst und Dichtung*," and [Hugo Zehder?] and D. P. Sterenberg, "A Call from Russian Artists," 1919*

These two texts reveal the hand of Hugo Zehder, the editor of *Neue Blätter für Kunst und Dichtung*. Zehder was the only signer of the Secession "regulations" not primarily active as an artist. Trained as an architect, he found himself unable to practice during the war and the building slump that followed. He had turned to journalism, writing radical theater and art criticism for *Menschen* and *Das Junge Deutschland* as well as editing *Neue Blätter für Kunst und Dichtung*.

The first text proclaims the journal *Neue Blätter für Kunst und Dichtung* to be the "living organ" of the Dresden Secession Gruppe 1919. Zehder viewed art as a spiritual weapon that could combine the beauty of past art and the hope for the future. For a short while he believed the art of the Dresden Secession could foster a general spiritual renewal.

The second text expresses the strong feeling of comradeship that existed between radical artists in Germany and the Soviet Union in 1919. It calls for cooperation between the revolutionary artists of both countries. The German commentator was probably Zehder,

*Hugo Zehder, "Die Zeitschrift *1919 Neue Blätter für Kunst und Dichtung*," *Sezession Gruppe 1919* (Dresden: Emil Richter Verlag, 1919) 24; and [Zehder] and D. P. Sterenberg, "Ein Aufruf der russischen Künstler," *Neue Blätter für Kunst und Dichtung* 1 (February 1919):213–14.

and the author of the Soviet statement was David Sterenberg (1881–1948), a Russian painter who had lived in Paris from 1906 to 1917. Sterenberg returned to the Soviet Union in 1917 and held offices within various agencies and schools of Soviet art until 1930. In his text, Zehder draws heavily on apocryphal imagery—World War I is called a "deluge" through which the ark of Expressionism sailed—while Sterenberg is less eschatological, emphasizing the need for international understanding and cooperation through exhibitions, publications, and other collaborative artistic ventures.

Zehder, "The Journal . . ."

The journal *1919 NEUE BLÄTTER FÜR KUNST UND DICHTUNG* promotes living art. Every year new works appear, poetic creations revealing the structure of our soul and the spirit of our times. The art of youth, with a premonition of the gruesome, mechanical death of mankind through a violent act of the future, has desperately opposed the complacency that robbed life of any serious responsibility, that complacency which, in the name of an illusive "progress," shirked the duty to resist the mechanization of human activity. With vigor and self-sacrifice which, in days of lost happiness and brutal egoism, could only evoke contemptuous ridicule or dull hatred, this quite small band attempted to storm the pagan temple of the nonspiritual, urging the hesitant to self-reflection. They could not forestall the catastrophe that threatened. During the years of praise-mongering self-destruction on the part of the enemy, threatened and held in contempt in all countries, they continued to fight—with the weapons of the spirit, erecting symbols and signs, in works of poetry and visual art. The products of this art, born from the need and the longing for a kind of existence that had once again found its final anchor in the divine, are appeals for human dignity, for love, and for humility. Today there are entire nations ready and willing to begin the ascent toward human freedom and brotherly love. The young have decided to erect signs and monuments at stations along the way, to indicate ever higher goals. From the profound reconciliation that follows the battle, there rises a new beauty. Our new art will include that which spirit and soul experience in our present, as well as the seed of all that lies in the future and will unfold in time. Year after year the Neue Blätter für Kunst und Dichtung will follow the path of living art. It will address all those who observe the newly developing world with open eyes and who wish to partake in its

continued improvement. Its art is neither mirror nor deception, but clarifier and explainer. The beauty of this art will stand, as an equal, beside the "beauty" of its sisters, i.e., the art of former times. Except its features, filled with inner life, will be livelier.

The tasks that journal "1919 Neue Blätter für Kunst und Dichtung" has set for itself since its inception now demand that it also serve "Gruppe 1919." It will become the voice of this organization and will in no way restrict its freedom of expression and its independence.

[Zehder] and Sterenberg, "An Appeal . . ."

Let's not forget that the Russians under Kandinsky were the strongest storm troops of Expressionism. Their work, with its striking and intelligibly formulated theories, inasmuch as it was not disturbed, has continued to have a powerful impact. They triumphed before the bloody deluge occurred. But what has happened since? In European countries, no one denies any longer that Expressionism is the truest expression of the spiritual need of its time, and that its originators had the most delicate sense of what lay ahead. That helped Expressionism to victory everywhere. That made it possible to survive the deluge and hold the course. But there, in the East, where salvation came from? What fate awaited the new art there? After the frontline cut the nation off in the summer of 1914, all too little was heard of what the leaders of the most decisive art movement were accomplishing. Since the revolution tore up the front, nothing has improved. Yet, whoever believes in the power of this art, whoever is aware of its metaphysical sources and, not taken in by the fragmentary and arbitrary reports of the daily press, suspects that the momentous events in a Russia not yet desecrated are also of metaphysical origin, will not doubt that there, too, a radical youth has seen its ideals disembark from the rescuing ark on this side of our new time. And now, there is the further message that the men, who are turning from scientific socialism back to utopia in Russia and are attempting to realize this goal by intuitively comprehending the essence, power, and meaning of artistic youth, officially favor them over the older generation. The revolution in art goes hand in hand with the revolution of public life as a whole. The Russian revolutionaries had barely received the news of the German overthrow when they were suddenly overcome by a feeling of spiritual solidarity. They are the harbingers of an international appeal from all the arts that is marching toward us! An appeal from the Russian vanguard, unknown in Germany until now, perhaps suppressed, has been transmitted to us. It reads as follows:

Moscow, November 30, 1918

APPEAL

From the Progressive Russian Visual Artists to German Colleagues!

The new Russian government has called upon all young creative talent to establish a new life, and it has turned over national direction of artistic matters **to the new progressive tendencies**. For only the new creative work, done shortly before the worldwide upheavals, is able to harmonize with the rhythm of the newly developing life.

At last there is the prospect of communal creative work, which will transcend a more narrow, national consciousness and serve international communication.

To start with, the Russians are turning to their closest neighbors, their German colleagues, and asking them to advise and to exchange news within the framework of artistic possibilities. As a practical measure to bring about such relationships, we propose a congress of representatives of German and Russian artists, which will serve as the beginning of a future world conference on art, and which will immediately initiate artistic communication between the two nations about far-ranging projects such as exhibitions, publications, theater productions, and music.

> Chairman of the Board of Artists in Petersburg and Moscow
> (signed) D. P. Sterenberg
> (signed) (Signatures of members of the International Office
> of Painters)

Although political circumstances do not permit us to act on it for the time being, this invitation by the Russian artists fills our artists with gratitude, as does the news that the Russian government is setting an example by entrusting young artists with leadership in general matters of art. In just the first year of the revolution, extraordinary accomplishments already seem to have been made in Russia and many first rate plans are being considered. Academies are giving way to open artists' studios. A board of the People's Council for Enlightenment in Moscow is building a museum in which the new painting, starting at the left with the World of Art, Kusnetzov, Sarian, Jack of Diamonds, will be represented: old painting, however, will be with the arts and crafts, icons, signs, and posters; items from the holdings of the Tretjakoff Galerie will expand this collection, and art from abroad will extend it. Many state art studios, the more liberal heirs of the old art schools in which the routine of Classicism had been taught, have already been opened; their directors are not bound by a program, only artistic excellence is decisive. These studios, accessible to

all, promise to awaken the creative spirit of the people. Craft will become art, since the artist, by abandoning societal biases, will not look down on the craftsman; rigid categories—sculptor and stucco-worker, painter and sign-painter—will disappear, affecting the work. The new order will know only crafts and specialities, both combined into art. The fusion of art with the masses has begun.

So, with a few key words, we have learned what is now transpiring in Russia. It is fundamentally different from the previous art "industry." Those who, in their limited vision, have held on to the antiquated idea that art is a luxury, an idea that must collapse with the wealth of patrons, will now learn otherwise. A new path opens up into an astonishing future. While Germany's art advisors stumble helplessly, Russia's young artists are firmly committed to their new path.

61. Walter Rheiner, statement of purpose for the journal *Menschen*, 1918, and "The New World," *Sezession Gruppe 1919*, 1919*

The poet Walter Rheiner (1895–1925) (fig. 39) was a major mouthpiece for the optimistic utopian yearnings of Dresden's Expressionists. Born Walter Heinrich Schnorrenberg in Cologne in 1895, Rheiner moved to Berlin in 1915, where he met many Expressionists. In 1916 he met Conrad Felixmüller and Felix Stiemer and soon moved to Dresden.[70] His novella *Kokain* was published by Felix Stiemer Verlag in 1918, with illustrations by Felixmüller. He edited the journal *Menschen* published for a brief period by both Stiemer and Heinar Schilling. Rheiner's statement of purpose for this journal declares that *Menschen* represents a new, idealistic generation, that rejects the materialism and nationalism that led to World War I. The idealistic postwar Expressionism, which he and the journal supported, was to be activist in deed as well as in spirit, an echo of Heinrich Mann's 1910 essay, "Geist und Tat" (Spirit and deed).

The essay "The New World" was included in the *Sezession Gruppe 1919* exhibition catalogue. Rheiner describes their art as rising like a phoenix from the old world's ashes, amidst "quivering planes and spaces," and evokes Felixmüller's Cubo-Expressionism, which combined shifting planes often with the themes of apocalypse and

***Menschen* I, 1918, and Walter Rheiner, "Die Neue Welt," in *Sezession Gruppe 1919* (Dresden: Emil Richter Verlag, 1919), 7–8.

resurrection. In 1925 Felixmüller again depicted Rheiner but this time for a memorial;[71] like the protagonist of *Kokain*, Rheiner was a drug addict, and he died in 1925 of a morphine overdose in a Berlin rooming house. In Felixmüller's painting the floating figure of Rheiner recalls the ascension of the martyred Sparticist leaders Karl Liebknecht and Rosa Luxemburg in Felixmüller's 1919 lithograph.[72]

<center>****</center>

Statement of purpose for *Menschen*

The monthly journal *Menschen* is, as a pamphlet, the expression of poets, writers, painters, and musicians whose work seeks a way to change mankind, by calling for unanimity and community. From the establishment of our feeling for life, called today by the name EXPRESSIONISM, to its logical consequence—action, this series will contain primarily contributions formerly blocked by cliquishness and radicalism. Tied to an older generation with which we have much in common and recognize as the basis for our activity, we set our hopes on those who see young people as concerned with an on-going process (rather than with a finished product).

"The New World"

Young painters appear, heralds of a new world. Hunted, tortured, blessed, and sacred prophets of the wonder of wonders: this roaring world, human beings thrown to the heavens, the resonating clouds, screaming sun, fluttering moon, browsing animals, the chaotic commotion that comes storming along and has no end. And they call to you and they sing and they cry—: full of the cosmos that is taking new shape inside of them, new with every day, every hour. . . . Their paintings are the new essence which arises inside of them.—Look at those paintings living there on the walls: drops of water, drops of light, pieces of sun, moondust, seen and formed by a superhuman eye. But created by humans, your peers, who speak to you of things that matter most to you!— Open your eyes! The talk is about you! Something is about to be given, to be done to you. . . . Now stand up, move, recognize your essence and the essence of that which is in you, somewhere, lost, buried perhaps, numbed by the irrelevant, the inessential,—but somehow, somewhere still in you!

Do not search for that which your too-tired eye is accustomed to seeing.

You shall not be amused or bored, you shall not see again what you always have seen. Do not search for portrayal, beautiful reproduction, tender repetition, mere poetry of the eye! These young painters have grasped profoundly that such an understanding, formed and cultivated inside you, deserves to be destroyed. They assist the process, pushing at weak points, toppling what is already off-balance. Your splendid world is breaking up! Don't you notice it yet? It is lying in ruins. It is decayed and is dead—just as everything mechanical is dead and must be dead. But—: live beyond yourselves! Become more than you are! The essential thing is life. A new cosmos—the spirit—originates out of torn forms, liberated colors, quivering surfaces and spaces, out of the resounding mathematics of chaos; the phoenix arises from the ashes, enlivening and moving your emptied skies again with the beat of his wings. Do not look for well-known figures, good, beautiful women, orderly houses, familiar trees and roads, congenial faces. Color, line, surface, space triumphs elementally, rising from the deeper ground of eternal laws in combat, in dark battle. There is no familiar greeting—unless you start at the beginning, at the bottom, looking through the eyes of one who has been blind, and now sees. That's it! Don't just look—: see! And you will feel what the painters know. A magical symphony resonates from crooked or straight lines, dreamily placed surfaces and spaces, frenzied or quiet colors. **Passion!** It transports, it overcomes. The sun-sphere has just generated itself; the moon has crystallized, a house grows, a tree, a path departs, an inspired path, Zeus, origin of being, descends to Leda again, to earth, to conception.—The face forms, flowing landscape, the eye solidifies out of the ether, a tree is really a tree now, nothing else. It sways, it slides from one human being who suddenly appears there, to the other. Adam to Eve. (God is standing somewhere in the distance.) A child grows, a family is formed, engendered within the laws of growth and conception.—The year rises from the course of the earth around the stars. Spring breaks out. May resonates. May Queen donates a thousand wonders, a thousand threads of one great wonder.—Life begins and with it death.

Behold! Close your eyes and look! The world is forming! ("the world begins in man!") The painters stammer at such a beginning. Sculptors give you new curves, create a new body for you, static constellation; they build a new house for you—(ship that lands in the skies)—: frozen prayer, song of your last resting place, whence you came: ecstatic ether!

Open your eyes! Let painters affect you! Let forms affect you! Awake from your sleep! Leave your blindness! Learn vision! Learn spirit!

You are human beings, and we are talking about you!

<div align="right">Walter Rheiner</div>

62. Conrad Felixmüller, "To Art," *Die Schöne Rarität*, 1918*

Conrad Felixmüller was the son of a Dresden factory worker whom Felixmüller remembered turning into a "twisted, bull-necked, empty-headed" relic.[73] In Berlin, he frequented Sturm circles but in 1916 became involved with the more political, antiwar Aktion group. A co-founder of the Dresden Secession Gruppe 1919 and a member of the Novembergruppe, he joined the Communist party in 1919 and was a member until about 1926. When he won the Saxony State Prize in 1920 he used the stipend to return to his proletarian roots and sketch in the coal mining districts of the Ruhr.

Felixmüller began to incorporate Cubist features into his work by 1917, and he considered Dresden's secessionists "Life-Cubists" who desired to activate their lives and their art simultaneously from many social and artistic sources. His own art returned often to portraiture—of individuals (fig. 39), couples, families, groups, and himself. Through these he hoped to connect specific political events, such as the murder of Liebknecht and Luxemburg or conditions in the Ruhr district, to human themes such as marriage and birth. His idealism as evidenced in this early essay tended more towards social than artistic polemics, as his work moved from Expressionist to Cubo-Expressionist and then to a "verist" or semi-naturalist style in a quest to reconcile innovation and communication.

The statement "To Art" appeared in the Kiel Expressionist journal *Die Schöne Rarität* (1917–19), which was edited by Adolf Harms, with assistance from the artist Georg Tappert. Volume 2, no. 3 (1918) was devoted to Felixmüller's woodcuts.[74]

A true work of art always represents human feeling unconditionally; completely free of any references or subjects of an emotional or material nature; form evolves organically, logically and rationally, apart from any intention to be **BEAUTIFUL**. With the spirit as its drive, [art] challenges the indolence of the philistine, the superficiality of the connoisseur, the barren art posturing of exalted intellectals, women—since they come across as dull and non-spiritual.

Artists today still do not know to what extent their "new art" in particu-

*Conrad Felixmüller, "Zur Kunst," *Die Schöne Rarität*, June 1918, 40.

lar is romantic escapism. That it is still not earth itself, that it still represents something unreal that has never been called for by us or future generations. It does not embody our goals nor our ideals. Nevertheless, a very few are aware that it is not expression that counts but rather the form as the expression of the will—the spirit! Let us finally bear witness to our bond with life in the cosmos. Let us demonstrate our principles in the conscious interplay of one with all. The interplay of you and I against the world as form. We, fated to a prescribed orbit within the external world—the law of the form **WORLD-EARTH**, stars, moon, sun. Life in the thousandfold fragmentation and multiplicity of our earth. Infused by the spirit. Let us consciously create art according to the law—not, however, impressions and similar half-measures from some arbitrary standpoint.

Let us begin to break the shackles of tradition. All art from the dawn of history until today is human—unless it was a mistake. Therefore let us start with ourselves. Let us shape our lives. May we be aware that each one of us is the link to the next, and let us show what lies between. For instance, let us paint the day of our birth first, then our first joys— and then our liberation from the agony of over-analyzed emotions. Or: ourselves and our friends—challenging the community. Or, very simply our marriage. We must give form to our will! For once we should listen to our minute feelings, nothing will happen—until they break through our small and separate selves by their own power, they push through to our fellow man and reveal our bonds—until we become aware of the great responsibility toward community (togetherness) resting within and upon us so that we may finally formulate it into a manifestation of a unified **WORLD**.

Man is sick from the chaos of colorful little games. Art with its pure and demanding spirit must pull him out of this black time without sense or spirit,—high up, to the pinnacle of our intrinsic divinity. Manifested in and witnessed by art.

63. Otto Dix, letter to Kurt Günther, ca. February 1919*

Otto Dix became part of the Dresden Secession in 1919 when Conrad Felixmüller saw his war-inspired watercolors at the Emil Richter gallery. In 1919 Felixmüller commissioned Dix to paint a family

*Reprinted in *Kunst in Aufbruch: Dresden 1918–1923* (Dresden: Staatliche Kunstsammlung Dresden, 1980), 41.

portrait for him, and like the works that Dix mentions in this letter to painter Kurt Günther, *Familie Felixmüller*[75] was executed in an Expressionist style that also drew on French Cubism, Berlin Dada, and Italian Futurism. Dix's cover design (fig. 40) for Gruppe 1919's exhibition at the Emil Richter Gallery forcefully synthesizes these sources and is another example of the strong commitment to the concepts of Expressionism revealed in this letter. The letter also points to Dix's ambivalence about women (strikingly represented in much of his work); Dix often divided women into two groups, spiritual-intellectual and "dull and non-spiritual," as Felixmüller stated in his essay, "To Art."[76]

Otto Dix was born in Utermhaus (Gera) in 1891, the son of a factory worker. From 1905 to 1909 he was an apprentice scenery painter; he studied at the school of applied arts in Dresden from 1909 to 1914, and served in the First World War from 1914 to 1918. In 1919 he returned to Dresden and enrolled at the academy, where he studied until 1922. In 1920 he participated in the International Dada-Fair in Berlin, and in the 1920s was considered a leading example of *Neue Sachlichkeit* (New Tangibility) painting.[77]

Hugo Zehder wrote the first article on Dix, published in September 1919. By then he had become uneasy about the growing popularity of Expressionism and connected Dix's art instead to "primitives" such as American Indians.[78]

My Dear Günther,

The sheer press of work has kept me from writing to you at greater length until now. I have started two larger paintings which I will exhibit as soon as they are finished. One is called "Leda" and the other "Woman with a Bowl of Fruit." For 5 years I have been carrying down the ideas around with me and have set down the themes graphically several times.—We, the radicals of Dresden, have formed a secession under the name of **Gruppe 1919**. Next year we will be **Gruppe 1920**, etc. All those in Dresden who have something to offer as Expressionists belong to it. We are getting exhibition space at Richter's and will have our first large exhibition in April. It will be introduced with great fanfare (double issue of the *Neue Blätter für Kunst und Dichtung*, newspaper publicity, etc.). Afterwards the whole exhibition will go to Hannover. Zehder, the editor of the *Neue Blätter* is also participating, a very pleasant and lively guy with extraordinary initiative. The art-association asked me to design the poster

for the February exhibition, Expressionist of course, although somewhat subdued (in my opinion). By tomorrow it will be in every corner of Dresden. The academicians are textbook cases of narrow-mindedness. . . . Regards from Miss Lehnert. She is actually the first female person that interests me, and not just for a few hours. She is very intelligent without being hypercritical. What are you doing there, are you able to work? At the moment it is so terribly cold, we can only afford heat for Saturdays and Sundays, but work is intense nevertheless.

Please write soon.
your Dix

64. Will Grohmann, "Prints of 'Gruppe 1919' Dresden," *Menschen*, 1919*

Each issue of the second volume of the journal *Menschen* was given a special title, and the entire volume was subtitled "Book Series for the New Art." Issue eight was devoted to the graphic art of the Dresden Secession Gruppe 1919, with commentary by Dr. Will Grohmann. At the time Grohmann was teaching at a secondary school in 1919, and went on to become director of the Dresden State Art Gallery from 1926 to 1933, and after World War II wrote numerous studies of Expressionist artists.

Grohmann's text expresses hope that the Secession artists will renew Dresden's art scene. He cautiously suggests that an art work's "ethical force" contributes to its power more than stylistic inventiveness. Significantly absent from this *Menschen* issue is former Secession Chairman Conrad Felixmüller, who by late 1919 was moving away from the Secession, and away from Expressionism. In 1920 his radical politics, and a state fellowship, took him to the industrial areas near the Ruhr river, where he worked in a less Expressionistic, more verist style that he felt could better express the grim reality of working class life; an attitude characterized here by Grohmann as a preference for bread over ecstasy.

For many, Expressionism is merely the style demanded by our time, third-hand experience and therefore aesthetic. Rarely has a word been

*Will Grohmann, "Sonderheft von Graphik der 'Gruppe 1919' Dresden," *Menschen* 2, no. 8 (62/65, 1919): 1–2.

discredited so swiftly. Now the chorus is asking: where is the passion, the vision, the spirituality, where is the secret miracle? Are they not just actors of a prescribed text, just academic, profane, and agitated? They're up to the same tricks, only they use different tools. What do I care about the spirit? I prefer bread. Of course, you'd prefer bread. Let us not think of the makers nor of the word. Look and examine. At the price of diminished justice, others could continue to live. . . . In some [art] lay an ethical force that comes close to denying art [altogether] or at least wanting to make something different out of it, such as a proclamation of love, a new faith in mankind. A fanaticism for truth is burning in some quarters that demands self-examination and explanation. You can test yourselves on such works. Isn't that enough? Only on a few, but where else would it even have happened at all?

Since spring the "Dresdner Sezession, Gruppe 1919" has existed in Dresden. The chorale of the towers and the slightly graying hair of this city are no longer in anybody's way. If signs are not completely deceptive, there is something dawning here, and the Secession will help.—Graphics of P. A. Böckstiegel, Constantin von Mitschke-Collande, Otto Dix, Will Heckrott, Otto Lange, Otto Schubert, and Lasar Segall. As everywhere, there are stronger and weaker ones. Everyone full of faith in his own inevitable calling.

Segall, one of the most original, not here, not in Germany, a European. Like his great Russian relatives some day he will astonish the world. . . .

Mitschke-Collande: . . . Intoxication without escape, without consequence, without burning up. A pillar of fire who still decides what is burning. . . .

Otto Lange has always been more hurried and possessed great skill. Some of the heads might have come from Schmidt-Rottluff, the figures from Heckel. Lately he has come more into his own. . . .

Otto Dix emerged with brutal strength at Easter. . . .

Notes to Part Three: War, Revolution, and Expressionism

1. See Ida Katherine Rigby, *An alle Künstler! War-Revolution-Weimar: German Expressionist Prints, Drawings, Posters and Periodicals from the Robert Gore Rifkind Foundation.* (San Diego, Calif.: San Diego State University Press, 1983).

2. Henri Barbusse, introduction to *Otto Dix*, ed. Gustav Eugen Diehl (Berlin: Das Kunstarchiv Verlag, 1926), 8–9.

3. Emil Nolde, *Welt und Heimat, Die Südseereise 1913–1918*, [written 1936] (Cologne: M. DuMont Schauberg, 1965), 140.

4. See also Victor Miesel, "*Kriegszeit* and *Bildermann* and some German Expressionist Reactions to World War I," *Michigan Germanic Studies* 2, no. 2 (Fall 1976): 146–69.

5. See Franz Marc, "Im Fegefeuer des Krieges," *Kunstgewerbeblatt* (Leipzig) 26 (1915): 128–30.

6. Reference to Kollwitz's son and comrades who were killed in the war.

7. Leonhard Frank was a painter, writer, and poet, who during the war wrote pacifist stories.

8. Romain Rolland was a French critic, novelist, essayist, and poet, well known for his pacifist and internationalist views.

9. George Grosz, *A Little Yes and a Big No: The Autobiography of George Grosz*, trans. Lola Sachs Dorin (New York: The Dial Press, 1946), 161.

10. Ludwig Meidner, *Septemberschrei. Hymnen, Gebete/Lästerungen* (Berlin: Paul Cassirer, 1920), 14.

11. Max Knell, ed., *Manifeste der brüderlichen Geistes*, in the series *Tribüne der Kunst und Zeit*, ed. Kasimir Edschmid (Berlin: Erich Reiss Verlag, 1920).

12. Kurt Pinthus, "Rede an die Weltburger," *Genius* (1919), 167. Pinthus also edited the 1920 anthology of Expressionist poetry, *Menschheitsdammerung*.

13. [Ellipsis in original text.]

14. [Ellipsis in original text.]

15. For discussions of this period see Stephanie Barron, ed., *German Expressionism, 1915–1925: The Second Generation* (Munich, Prestel-Verlag, 1988); Ida Katherine Rigby, *An alle Künstler! War-Revolution-Weimar: . . .*; and Joan Weinstein, *The End of Expressionism; Art and the November Revolution in Germany, 1918–19* (Chicago: University of Chicago Press, 1990).

16. Herbert Eulenberg, "Vorspruch," Galerie Alfred Flechtheim, Düsseldorf, *Expressionisten, 1919* (Potsdam and Berlin: Gust. Kiepenhauer Verlag, 1919), 3.

17. Paul Cassirer, "Utopische Plauderei," *Die weissen Blätter* (January–March 1919), 105.

18. Willi Wolfradt, "Revolution und Kunst," *Die neue Rundschau* 1 (1910): 746, 747.

19. Thomas Grochowiak, *Ludwig Meidner* (Recklinghausen: Verlag Aurel Bongers, 1966), 149.

20. *An alle Künstler!* (Berlin: Kunstanstalt Willi Simon, [1919]); for discussion of the Novembergruppe see Part Three, IV. in this volume; see also documents 46 and 56 for other essays from this anthology. For information on the Social Democrats' commission of this anthology and also of posters, see Rigby, 34 and Weinstein, 50.

21. Ludwig Meidner, "An alle Künstler, Dichter, Musiker," *Der Anbruch* 2, no. 1 (January 1919): 1.

22. [Ellipsis in original text.]

23. Reference to French writers who expressed strong pacifist sentiments during the war.

24. For detailed information on the Bavarian Soviet see Alan Mitchell, *Revolution in Bavaria 1918–1919: The Eisner Regime and the Soviet Republic* (Princeton, N.J.: Princeton University Press, 1965).

25. Kunstamt Wedding, *Die Novembergruppe*, Teil I, *Die Maler* (Berlin: Buchdruckerei Erich Pröh, 1977), 18.

26. *Rote Hahn* (Red Rooster) was a series of literary edtions with original prints that Pfemfert published.

27. U.S. in original; initials for USPD—"Unabhängige sozialdemokratische Partei Deutschlands," often called the Independent Socialist Party.

28. Alfred Brust was a playwright and essayist who joined the Arbeitsrat für Kunst in Berlin (as did Schmidt-Rottluff); he contributed to Expressionist periodicals such as *Die Rote Hahn* as well as to *Menschen* and to the Glaserne Kette.

29. Johannes R. Becher, "Weltrevolution," *Die Aktion* 9, nos. 45/46 (1919): 755–57.

30. Free Corps (Freikorps) were volunteer groups organized to protect the revolution against leftist insurrection but became the center for reactionary counterrevolutionaries.

31. Friedrich Ebert, a leader of the majority socialists, led the provisional government after the November 9, 1918 revolution and became the first president of the Weimar Republic.

32. Philipp Scheidemann, a leader of the majority socialists, proclaimed the Republic from the balcony of the Reichstag building on November 9, 1918, and was prime minister of the Republic from February to June 1919.

33. Emil Eichorn, a left-wing independent socialist who was police

chief in Berlin; his removal from office on January 4, 1919, was the ostensible reason for the Sparticist uprisings against the Ebert-Scheidemann government.

34. Hans Kollwitz was a son of Karl and Käthe.

35. Lise Schmidt Stirm was Käthe Kollwitz's sister.

36. Ernst Carl Bauer, "Das politische Gesicht der Strasse," *Das Plakat* 10, no. 2 (March 1919): 166.

37. Adolf Behne, "Alte und Neue Plakate," in *Das politische Plakat* (Charlottenburg: Verlag Das Plakat, 1919), 13, 22.

38. See Marcel Franciscono, *Walter Gropius and the Creation of the Bauhaus in Weimar: the Ideals and Artistic Theories of its Founding Years* (Urbana, University of Illinois Press, 1971), 134–52; and Rosemarie Haag Bletter, "Bruno Taut and Paul Scheerbart's Vision: Utopian Aspects of German Expressionist Architecture," diss. Columbia University, 1973, 397–451.

39. Most are reprinted in *Arbeitsrat für Kunst Berlin 1918–1921*, Berlin, Akademie der Künste, 1980; for further discussion, see Weinstein, 38–41, 62–77, 96–105.

40. [Adolf Behne], Arbeitsrat für Kunst press release (draft); reprinted in Akademie der Künste, *Arbeitsrat . . .* , 1980, 114.

41. The program also appeared in *Bauwelt*, December 18, 1918, and in *Der Cicerone* 11 (January 1919): 26 (without signatures).

42. See for example, Iain Boyd Whyte, *Bruno Taut and the Architecture of Activism*, 98–102, 270.

43. A letter from César Klein to Adolf Behne, March 18, 1919, indicates that the issue of lay participation was viewed as having much potential for misunderstanding. The letter also indicates a strong distaste for interfering "parliamentairiens" (Behne estate, Staatsbibliothek Preussischer Kulturbesitz, Berlin).

44. Most historians attribute the woodcut on the Arbeitsrat brochure to Max Pechstein, but Pechstein's son, Max K., in a letter to me of September 2, 1984, pointed out that the late Dr. W. Arntz and Dr. Gerhard Wietek believe the print to be the work of Georg Tappert.

45. Walther Rathenau had been director of the Allgemeine Elektrizitäts Gesellschaft (AEG) since 1899, and had become its president in 1915. He was assassinated by a reactionary in 1922 while he was serving as foreign minister for the Weimar Republic.

46. Behne's name does not appear with the Arbeitsrat für Kunst program in either *Bauwelt* (1918) or *Mitteilungen des deutschen Werkbundes* (1918).

47. In the second program announcement of the Arbeitsrat, Behne is listed as Geschaftsführer (managing director). Gropius is listed as Vorsitzender (president), and César Klein listed as Stellv. Vorsitzender (vice-president); see *Der Cicerone* 11 (April 1919): 230.

48. Gropius, letter to Behne, March 6, 1919; Bauhaus-Archiv, Berlin.

49. See Adolf Behne, "Vorschlag einer brüderlichen Zusammenkunft der Künstler aller Länder," *Sozialistische Monatshefte* 25 (March 3, 1919): 155–57 for a clear indication of Behne's internationalist position.

50. Walter Gropius, Bruno Taut, Adolf Behne, statements for the pamphlet for the *Exhibition for Unknown Architects*, Berlin, Arbeitsrat für Kunst, 1919, pamphlet; English translation in *Programs and Manifestoes on 20th Century Architecture*, ed. Ulrich Conrads (Cambridge, Mass.: The MIT Press, 1970), 46–48.

51. [Adolf Behne], "Introduction," *JA! Stimmen des Arbeitsrates für Kunst in Berlin*; reprinted in Akademie der Künste, *Arbeitsrat. . .* , Berlin, 1980, 13.

52. Ibid.

53. Other translations into English of excerpts from *JA! Stimmen des Arbeitsrates für Kunst in Berlin* can be found in *The Architecture of Fantasy*, 138–40.

54. Will Grohmann, *Zehn Jahre Novembergruppe*, Sonderheft, Kunst der Zeit: Zeitschrift für Kunst und Literatur 3, nos. 1–3 (1928): 1.

55. Adolf Behne, "Graphik und Plastik von Mitgliedern der Novembergruppe Berlin," *Menschen* 2:XIV, 81/86 (December 1919): 2.

56. Ibid.

57. Paul Westheim, "Umschau: November-Gruppe," *Das Kunstblatt* 4, no. 7 (1920): 223.

58. Grohmann, *Zehn Jahre Novembergruppe*, 58; see also Weinstein, 28–38, 48–62, 89–96.

59. Helga Kliemann, *Die Novembergruppe* (Berlin: Gebr. Mann Verlag, 1969), 54–55.

60. See Peter W. Guenther, "A Survey of Artists' Groups: Their Rise, Rhetoric, and Demise," . . . *The Second Generation*, 99–115.

61. *Max Pechstein Erinnerungen*, ed. L. Reidemeister (Wiesbaden: Limes Verlag, 1960), 104.

62. Grohmann, *Zehn Jahre Novembergruppe*, 4.

63. For a listing of all of the artists who participated in the Novembergruppe exhibitions from 1919 through 1932, see Kliemann, *Die Novembergruppe*, 50–52.

64. Ibid., 297–98.

65. Erich Ludendorff, member of Supreme Army Command in World War I, and Dr. Wolfgang Kapp, chief organizer of the Vaterlandspartei in 1917, joined with Lieutenant General Walther von Lüttwitz to overthrow the Republic on March 12, 1920, in a right-wing radical impulse known as the Kapp Putsch. Ludendorff participated in the Hitler Putsch in 1923. Hugo Stinnes was a prominent industrialist and financier who greatly profited from the inflation.

66. [Note in original.] Send communications for the time being to the editorial staff of *Das Gegner*.

67. See Fritz Löffler, "Dresden from 1913 and the **Dresdner Sezession Gruppe 1919**," *The Second Generation*, 56–79, and Weinstein, 111–60.

68. For a discussion of some of these groups, see Guenther, "A Survey of Artists' Groups: Their Rise, Rhetoric, and Demise," *The Second Generation*, 98–115.

69. Gela Forster, née Angelica Bruno Schmitz, married the sculptor Alexander Archipenko in 1922 and emigrated to the United States in 1923. Although the work of her Dresden period has been lost, it was the subject of an article by Theodor Däubler; see "Gela Forster," *Neue Blätter für Kunst und Dichtung* 5, no. 2 (June 1919): 51–53; English translation in *German Expressionist Sculpture* [as in Part Two, n. 16], 30–33.

70. According to Felixmüller, he, Rheiner, and Stiemer met in a Dresden bookshop in 1916, when Stiemer showed an issue of *Die Aktion* featuring Felixmüller to Rheiner; see Conrad Felixmüller, "Walter Rheiner," *Conrad Felixmüller, von ihm—über ihn* (Düsseldorf: Edition GS, 1977), 65.

71. Ibid., 69–70. For a reproduction, see *The Second Generation*, frontispiece.

72. This lithograph, "People over the World" was published in *Die Aktion* 9, nos. 26–27 (July 5, 1919) as the title page.

73. Conrad Felixmüller, "Der Prolet (Pönnecke)," in *Die Zwanziger Jahre: Manifeste und Documente deutscher Künstler*, ed. Uwe M. Schneede (Cologne: Dumont Buchverlag, 1979), 48.

74. Paul Raabe, *Die Zeitschriften und Sammlungen des literarischen Expressionismus*, 1910–1921 (Stuttgart: Metzler, 1964), 65.

75. For a reproduction of *Familie Felixmüller* see Wolf-Dieter Dube, *Expressionists and Expressionism* (Geneva: Editions d'Art Albert Skira, 1983), 126, and of *Leda* see *The Second Generation*, 70.

76. See Document 62. For a discussion of Dix's attitudes toward women and those of other Expressionists, see Beth Irwin Lewis, "*Lustmord*: Inside the Windows of the Metropolis," in *Berlin: Culture and Metropolis*, 111–40; and also the sections on Dix in *Art in Germany*, 1909–1936, 170–73.

77. See Brigid S. Barton, *Otto Dix and "Die Neue Sachlichkeit,"* 1918–1925 (Ann Arbor, Mich.: UMI, 1977); and also Alfred H. Barr, Jr., "Otto Dix," *The Arts* 17, no. 4 (January 1931): 235–51.

78. Hugo Zehder, "Otto Dix," *Neue Blätter für Kunst und Dichtung* 2 (September 1919): 119–120.

Part Four

Reactions to Expressionism

I. THE WEIMAR BAUHAUS

INTRODUCTION

In April 1919, Walter Gropius was appointed director of the Weimar Academy of Fine Arts and the former Weimar School of Applied Arts, which he combined and named "the State Bauhaus." Set in the same city as the recently convened National Constituent Assembly, the Bauhaus was much affected by the struggles of the new Republic. Although the school was frequently attacked by right-wing critics for internationalism, mysticism, and communism, its early years were marked by a utopian fervor to reform art education with the hope of changing society. Its faculty, manifestoes, pamphlets, and exhibitions reflected the Expressionist faith in the ability of a union of the arts to reshape human consciousness. As an earlier generation had embraced the Gothic cathedral as its model of artistic cooperation and as its alternate to the classical style, so Gropius's choice of the name Bauhaus—with its reference to Bauhütten, the medieval guilds—indicated the school's association with a communitarian tradition.

From the beginning Gropius was determined that the school become a model for an ideal community. He abandoned the use of titles such as "professor" as hierarchical and reminiscent of Wilhelmine authoritarianism, and introduced a structure of masters, apprentices, and journeymen, which he felt was more egalitarian. Believing attention to the crafts would break down the artificial distinction between artists and artisans and provide a corrective for the weaknesses of past academic schools, Gropius based the Bauhaus educational system on collaborative workshop training. In choosing a faculty, he called upon a number of artists associated with Sturm Expressionism, inviting at first Johannes Itten, Lyonel Feininger, and Gerhard Marcks, and soon after Lothar Schreyer, Georg Muche, Oskar Schlemmer, Paul Klee, and Wassily Kandinsky. Of these eight, seven were painters, reflecting Gropius's view of painting as a stimulus for creativity in the other arts. Despite his vision of architecture

as the pinnacle of the arts, only a few courses in building techniques and architectural drawing were offered.

Although the concept of Bauhaus functionalism developed into mythic proportions at Dessau, where the school moved in 1925, the reaction against mystical cults, romanticism, and isolation began in Weimar. The practical need to generate income for the school and to modify the students' immersion in Mazdaznanism and other mystical cults led Gropius to urge closer contacts with industry. His description of the engineer as "taking over the heritage of the architect"[1] was prophetic of the change in attitude at the Bauhaus even before it shifted from Weimar to Dessau. With the resignation of Itten in 1922 and the appointment of Moholy-Nagy in 1923, the image of the machine soon replaced that of the cathedral. Many of the faculty came to dissociate themselves from Expressionism, but the committment to essentially Expressionist concepts—the belief in art's transcendental and metaphysical nature and in the universalism of basic color and form—remained as one of the legacies of the Bauhaus.[2]

65. Walter Gropius, Bauhaus Program, 1919; speech to Bauhaus students, July 1919; [Anonymous], Bauhaus fund solicitation pamphlet, 1921*

Much of Gropius's approach in the early years of the Bauhaus was a continuation of ideas formulated during his association with the Arbeitsrat. The Bauhaus manifesto, with its Feininger cover alluding to a cathedral (fig. 41), and the July speech to the Bauhaus students, with its metaphoric references to a crystalline sign of a new future emanating from a monument, owe a great debt to Bruno Taut and Paul Scheerbart as well as to Adolf Behne.[3] The egalitarian emphasis on crafts, the commitment to innovation, and the comparison of architecture to religion have a visionary tone that contrasts with Gropius's writings before World War I and compares to the language and phrases of Taut especially. Gropius's experiences during the war had convinced him that a radical break with past structures and systems was necessary. In his response to the Arbeitsrat questionnaire

*Walter Gropius, *Programm des Staatlichen Bauhauses in Weimar* (Weimar: Staatliche Bauhaus, April 1919), English translation from Hans M. Wingler, *The Bauhaus* (Cambridge: MIT Press, 1978), 31–33. Speech to Bauhaus students from hand-corrected typescript, and Bauhaus fund solicitation pamphlet, Bauhaus-Archiv, Berlin.

of 1919, he had indicated his sympathy with socialism and had expressed the belief that it could "destroy the evil demon of commercialism"[4] which had prevented the communal spirit of the people from making art vital. These sympathies were strengthened in the early twenties by the Social Democratic Party's control of the Thuringian legislature and its financial support of the Bauhaus.

Despite this support, Gropius was determined to remain independent of party politics. The attacks by the right led Gropius to insist that Bauhaus students not take part in political demonstrations nor be representatives of a party's platforms. Although Gropius did not advocate rural autonomous colonies as did Taut, initially he urged the students to think of the school as a "secret lodge," removed from the pressures of politicians and patronage so they would have time to develop innovative approaches.

Gropius continued to maintain an architectural practice in Berlin and to accept commissions on which he had some Bauhaus students work, but he devoted most of his time and energy to the school. He was an indefatigable letter writer, drafted petitions for faculty when needed,[5] and raised money for the school from wealthy businessmen in Weimar and elsewhere in Germany. When the Social Democrats lost their majority in the Thuringian parliament in 1924, Gropius sought alternative locations for the school. The city of Dessau, governed by a Social Democratic majority, made the most generous offer and, early in 1925, Gropius with most of the Bauhaus staff moved there.

Gropius, Bauhaus Program, April 1919

The ultimate aim of all visual arts is the complete building! To embellish buildings was once the noblest function of the fine arts; they were the indispensable components of great architecture. Today the arts exist in isolation, from which they can be rescued only through the conscious, cooperative effort of all craftsmen. Architects, painters, and sculptors must recognize anew and learn to grasp the composite character of a building both as an entity and in its separate parts. Only then will their work be imbued with the architectonic spirit which it has lost as "salon art."

The old schools of art were unable to produce this unity; how could they, since art cannot be taught. They must be merged once more with the **workshop**. The mere drawing and painting world of the pattern de-

signer and the applied artist must become a world that builds again. When young people who take a joy in artistic creation once more begin their life's work by learning a trade, then the unproductive "artist" will no longer be condemned to deficient artistry, for their skill will now be preserved for the crafts, in which they will be able to achieve excellence.

Architects, sculptors, painters, we all must return to the crafts! For art is not a "profession." There is no essential difference between the artist and the craftsman. **The artist is an exalted craftsman.** In rare moments of inspiration, transcending the consciousness of his will, the grace of heaven may cause his work to blossom into art. But **proficiency in a craft is essential to every artist.** Therein lies the prime source of creative imagination.

Let us then create a **new guild of craftsmen** without the class distinctions that raise an arrogant barrier between craftsman and artist! Together let us desire, conceive, and create the new structure of the future, which will embrace architecture **and** sculpture **and** painting **in one unity** and which will one day rise towards heaven from the hands of a million workers like the crystal symbol of a new faith.

<div align="right">Walter Gropius</div>

PROGRAM OF THE STAATLICHE BAUHAUS IN WEIMAR

The Staatliche Bauhaus in Weimar resulted from the merger of the **former Grand-Ducal Saxon Academy of Art with the former Grand-Ducal Saxon School of Arts and Crafts** in conjunction with a newly affiliated department of architecture.

Aims of the Bauhaus

The Bauhaus strives to bring together all creative effort into one **whole, to reunify all the disciplines of practical art**—sculpture, painting, handicrafts, and the crafts—as inseparable components of a new architecture. The ultimate, if distant, aim of the Bauhaus is the **unified work of art—the great structure**—in which there is no distinction between monumental and decorative art.

The Bauhaus wants to educate architects, painters, and sculptors of all levels, according to their capabilities, to become **competent craftsmen** or **independent creative artists** and to form a working community of leading and future artist-craftsmen. These men, of kindred spirit, will know how

to design buildings harmoniously in their entirety—structure, finishing, ornamentation, and furnishing.

Principles of the Bauhaus

Art rises above all methods; in itself it cannot be taught, but **the crafts** certainly can be. Architects, painters, and sculptors are craftsmen in the true sense of the word; hence, **a thorough training in the crafts**, acquired in workshops and in experimental and practical sites, is required of all students as **the indispensable basis for all artistic production**. Our own workshops are to be gradually built up, and apprenticeship agreements with outside workshops will be concluded.

The school is the servant of the workshop, and will one day be absorbed in it. Therefore there will be no teachers or pupils in the Bauhaus but **masters, journeymen**, and **apprentices**.

The manner of teaching arises from the character of the workshop:

Organic forms developed from manual skills.

Avoidance of all rigidity; priority of creativity; freedom of individuality, but strict study discipline.

Master and journeyman examinations, according to the Guild Statutes, held before the Council of Masters of the Bauhaus or before outside masters.

Collaboration by the students in the work of the masters.

Securing of commissions, also for students.

Mutual planning of extensive, Utopian structural designs—public buildings and buildings for worship—aimed at the future. Collaboration of all masters and students—architects, painters, sculptors—on these designs with the object of gradually achieving a harmony of all the component elements and parts that make up architecture.

Constant contact with the leaders of the crafts and industries of the country.

Contact with public life with the people, through exhibitions and other activities.

New research into the nature of the exhibitions to solve the problem of displaying visual work and sculpture within the framework of architecture.

Encouragement of friendly relations between masters and students outside of work; therefore plays, lectures, poetry, music, costume parties. Establishment of a festive formality at these gatherings.

. . . .

Gropius, speech to Bauhaus students, July 1919

The masters council really has thought hard and long about the exhibition. On the first day we could not decide on the distribution of prizes; after thorough deliberation we got together once again. . . . I had thought the exhibition should be held only for us in the inner circle. I suggest that for the time being we refrain from any public exhibition and work from a new starting point so that in this turbulent time we could renew ourselves and meet our own standards first. That, we hope, will be a great accomplishment.

. . . .

. . . We find ourselves in a tremendous catastrophe of world history, a transformation of the *whole* of life and the *whole* of inner man. Maybe that is fortunate for the artistic person, if he is strong enough to bear the consequences, because what we need is the courage to face inner experience. Then, suddenly, a new path will open for the artist, too.

Many of us are stuck, still lacking real inner experience. But nobody else can provide us with it, we have to make the experience ourselves. Indifference, inattentiveness, and indolence are the worst enemies of art: they lead to the material historicism in which we are so completely caught. Strength, *intensity, disturbance* of the whole person through *misery, privations, horror, harsh encounters,* or *love* lead to true creative artistic expression. Many of the students have just returned from the war. Ladies, I do not underestimate the human achievement of those who have gone through the war at home, but I do believe that the experience of death is the strongest of all. Those who have experienced it out there *have returned totally changed.* They feel *that the old ways no longer lead anywhere.* I can see that some are uncertain and face serious internal conflict. . . . [Some] are going to ask themselves honestly if they *must* necessarily dedicate themselves to art, if the urge inside them is that powerful, the forces that strong that they can overcome the immense difficulties arising from the world situation alone. *Only one who can honestly give an affirmative answer* to that has the right today, in my opinion, to dedicate himself to art. Our impoverished state today barely has any funds for cultural things and cannot take care of those who merely want to occupy themselves and take a little talent out for a walk. I have to say that emphatically, conscience demands it of me. Because I can foresee that in the near future, need will unfortunately force many of you to leave for paying professions, and only *he* who is able to *starve for art* is going to stay with it. We now have to forget the time before the war, which was totally different. The more quickly we *adapt* to the new, changed world, to its new, if austere beauties, the sooner the individual will be able to find his subjective happiness. We will be more spiritual and profound as a result of the German distress.

As the economic opportunities sink, the spiritual ones have already risen enormously. Before the war we did things backwards and wanted to bring art to the general public the wrong way, through an organization. We made artistic ashtrays and beer mugs and planned to gradually work up to the great edifice. Everything with cool organization. That was a great presumption on which we foundered, and now we are going to try it the other way. No great spiritual organizations but small, secret, secluded leagues, lodges, alliances, conspiracies will emerge to guard and give artistic form to a secret, a nucleus of beliefs, until from out of individual groups a universally great, enduring, *spiritual-religious idea* takes shape, which finally must find its crystalline expression in a great Gesamtkunstwerk. And this great total work of art, this cathedral of the future, will then shine its light into the smallest things of everyday life. Just the reverse of the earlier process. We will not see this happen, but I firmly believe we are the precursors and the first instrument of such a new, great world idea. Until now the artist stood totally alone—I dream about the attempt to make a small community out of the scattered isolation of the individual; if that works, we will have achieved a great deal.

In closing, I come back to the crafts. The next years will show that crafts are becoming a salvation for us artists. . . .

Bauhaus fund solicitation

During the two years of its existence the **State Bauhaus** has built the foundation for the accomplishment of its program, which meanwhile has become the leading arts and crafts education in Germany.

The greatest difficulty the directors of the Bauhaus have had to deal with, since the Institute has finally been recognized by the state, **is that many of the talented apprentices at the Bauhaus are completely without funds**. For the first two or three years, until the workshops can start to show a profit from the work of their apprentices and journeymen, sufficient funds must be collected from donations of those who are spiritually close to the Bauhaus idea and can recognize its viability for the future. In order to protect the talent from the most severe economic hardships and to assure their education, we must succeed in this.

The best support is adequate nourishment. The Bauhaus has established its own kitchen for its members, its own allotment is planted with vegetables and fruits to supply the kitchen cheaply without relying on the market. Funds are lacking for the efficient expansion of the kitchen and garden.

We are asking our friends to assist our cause and to promote it in their circle of acquaintances, too. The cost per person, per day is at present 4

marks per apprentice; hence 1500.00 marks per year. Masters, journeymen, and apprentices have made their graphic works available, from which we will select a return gift for each donor as a sign of our thanks.

We are asking that donations be sent to the secretary, under the title, "Foundation fund of the State Bauhaus at Weimar."

Management and Masters council of the State Bauhaus at Weimar.

66. [Anonymous], "The State Bauhaus in Weimar," supplement to the *Thüringer Tageszeitung*, January 3, 1920*

The report on the Bauhaus in the local paper, the *Thüringer Tageszeitung*, represents the kind of insidious attack to which the new school was subjected in its first year. Picking up the nationalist arguments used by Carl Vinnen and others to attack modernism before the First World War, the author of this critique lamented the international domination at the Bauhaus and the weakening of indigenous Germanic culture. Identifying Expressionism as the main stylistic tendency at the school, this reporter condemned Expressionism by tying it to mysticism and decadence. Other critics used some of the same arguments while adding additional inflammatory allegations, such as accusing the Bauhaus of distributing "Spartacist literature," of allowing Jews to dominate, and of encouraging "Bolshevism."[6]

These attacks give some indication of the climate that led Gropius to prohibit all political activity at the Bauhaus.[7] Although the Social Democratic Party dominated the Thuringian legislature until 1924, the city of Weimar was more conservative. The townspeople viewed Weimar through the lens of the nineteenth century and were put off by the impoverished, frequently unkempt art students. The faculty of the former Weimar Academy of Fine Arts, fearful that their tradition of landscape painting would be abandoned, sought recourse in nationalistic pieties. Many of these arguments resurfaced during the decade[8] and became the cornerstone of the National Socialist attacks on the Bauhaus, Expressionism, and all of modernism.

. . . .

*Anonymous, "Das staatliche Bauhaus in Weimar," *Beilage zur Thüringer Tageszeitung* 2, Sunday, January 3, 1920.

So far we have only talked about the dangers of internationalism as it might influence the art student by **over-emphasizing** foreign art in the curriculum, or by misleading him into the **erroneous** paths of Expressionism. The international direction goes even deeper, into the essential character of the Bauhaus. Herr **Gropius** is not only a sensitive and distinguished artist, he is also full of philosophical, metaphysical, and mystical thoughts. No wonder, since the goal of Expressionism is a deepening of emotional life. The director of the art institute rightly tries to forge an intimate **spiritual community** of all art students with each other and with the masters. The tie that binds this community is not supposed to be just an aesthetic one but also—let's say—a mystic-philosophic one. We do not want to condemn this as freemasonry. The memory of the brotherhoods of the Middle Ages seems a closer analogy. Here we see again the spiritual relationships between the different directions of the Bauhaus program: reconciliation of art and craft just as it was in the Gothic era, submission of artistic form to spiritual experience just as in the times of the Middle Ages, revitalization of mysticism with the aim of finding a dominant idea that would carry the cathedral of the future, just as the Catholic church carries the cathedral of Strasbourg. . . . We do have to point out that no unified, national work of art can grow from such unbounded, syncretistic thought if it is not redirected in time into national paths. Just as there existed a **German Gothic** and a **French Gothic**, a **German mysticism** and a foreign one, so it will be in the future. Today we are further than ever from the biblical promise of one shepherd and one flock. We do not even have a European culture, to say nothing of a world culture. The Brotherhood must be German if it is to bear fruit. Here, too, the direction of the state Bauhaus faces a large and difficult task.

Strange, how in the thought of the state Bauhaus contrasts and harmonies flow next to and into one another. The struggle of the new movement shows today in this **unevenness**; here good German-nationalistic acknowledgment of crafts, there the excesses of a foggy idea of art, here the sincerity of German inner life, there fanciful-cosmopolitan ideas. We could illuminate this state of fermentation, this unevenness with many more details. Let us take for example the program of the Bauhaus: inside a well-thought-out plan of organization, outside an utopian picture. At the architecture exhibition held some months ago on the Karlplatz, on the one hand, houses designed with mathematical and statistical precision were shown, and on the other hand architectural fantasies, which nobody—least of all those who thought them up—believed could be built. Such fantasies were justified by the claim that the new style could not grow up solely out of the crafts, but must also be born from a spirit of mystical creation, free of all earthly weight. But we will stop here.

Let us hope the controversy which has broken out around the Bauhaus will bring clarity for the institution's leadership, reduce the deviations from their course, and quickly resolve tensions. Let us remain strong in the **belief** that the strength of the German spirit will remain victorious even through the demise of the German state and the new danger of internationalism in art. . . .

67. Johannes Itten, "Analyses of Old Masters," *Utopia: Documents of Reality*, 1921*

Of all the painters whom Gropius invited to teach at the Bauhaus, no one has been more closely associated with mysticism and Expressionism than Johannes Itten (1883–1967). Recommended by Gropius's wife[9]—Alma Mahler—whom Itten had met in Vienna where he had started an art school, he arrived in Weimar in October 1920. At the Bauhaus he created a very distinct persona with his shaved head and monk's robe (fig. 42). He was interested in a wide variety of mystically inspired writers, including Jakob Böhme, but Mazdaznan principles of purification and regeneration were central to his life and painting. He insisted on meditation exercise before working and urged his students to feel certain movements before they drew. He encouraged free abstract drawing (fig. 43) and experimentation with unusual materials. The excerpts from his "Analyses of Old Masters" give some indication of his ecstatic and exclamatory style as he strove to communicate the expressive structures of past works of art. Although Itten was greatly influenced by mystical practices, some of his exercises can be traced back to his studies with Adolf Hölzel at the Stuttgart Academy and to reform education theories in his native Switzerland, where he had studied to be an elementary school teacher.[10] Itten's conversion of the Bauhaus cafeteria to vegetarianism and his favoritism toward students who followed Mazdaznan ideology became divisive elements in the school. Gropius convinced him to resign in 1922 and he left Weimar early in 1923. Accounts such as Oskar Schlemmer's [doc. 68], while remarkably thorough, tend to obscure Itten's achievement as an abstract painter and his originality in organizing the preliminary course required of all Bauhaus students.

Itten, from "Analysis. . ."

*Johannes Itten, "Analysen alter Meister," *Utopia: Dokumente der Wirklichkeit*, ed. B. Adler (Weimar: Utopia Verlag, 1921), pp. 2, 4, 9.

To a work of art which means to make the vital, living essence within its form exist personally for me.

means to it,

re-experience

The work of art is born again within me.

• • • • • • • • • • • • • • • • •

We say: To experience a work of art means to recreate it.

Because: from a spiritual standpoint, there is no major difference in a man who experiences a work of art from a man who represents a form he has experienced in an externally-directed work of art. Every man can be trained to draw a circle, but not every man has the power within (himself) to experience the circular line. I can release that power, but I cannot give it to him. Because experience depends on the soul's spiritual agility. And because we will never understand what soul is and what spirit is, we therefore want to say that it is a GIFT OF GOD which has been born into his image and through whose path HE lets his breath flow into the soul of man.

Something represented vitally is always a Vital Experience and Vital Experiences are always represented with vitality.

Something dead will never come to life and something living will never be dead.

The ability to represent things depends on the MATERIAL and PHYSICAL PROPERTIES of a human body, of FINGERS, HANDS, ARMS, FEET, LEGS, of the TORSO, of the INNER ORGANS, such as HEART, LUNGS, STOMACH, of the SENSORY ORGANS and of the BRAIN. In brief, it is dependent on the composition of ALL PHYSICAL MATTER and the ORGANS.

EXPERIENCE IS A PROPERTY OF THE SPIRITUAL SOUL

If it pertains at first to COARSE, MATERIAL PHENOMENA, then it is the PHYSICAL SENSE that produces the experience; or in the second instance, if it pertains to FINE SPIRITUAL PHENOMENA, then the SPIRITUAL SENSE PRODUCES THAT EXPERIENCE ▮

. . .

To perceive form means to be moved

and

to be moved means to form

Even the slightest feeling is a form that radiates movement

ALL

living matter is revealed to man by way of movement. Everything
is moving and nothing is dead; since otherwise it would not exist.

EVERYTHING IN EXISTENCE IS DIFFERENTIATED BY

QuANTI- QuALI-

●●●TY AND TY●●●

ᴛʜᴇ MOVEMENT:
IS DIFFERENTIATED BY

TIME AND SPACE

All FORM is differentiated as MOVEMENT is differentiated.

HOLY SPIRIT

FATHER SON

MAN

POINT

SPHERE CIRCLE

CROSS

MOVEMENT

SPACE TIME

FORM

WITHOUT MOVEMENT NO PERCEPTION
WITHOUT PERCEPTION NO FORM
WITHOUT FORM NO MATTER

MATTER ▬ FORM

FORM═MOVEMENT IN TIME AND SPACE
THEREFORE
MATTER═MOVEMENT IN TIME AND SPACE

. . .

A MAN WHO EXPERIENCES
AND RECREATES THIS FORM
WHICH I HAVE CREATED, WILL
BE MOVED, JUST AS I WAS
MOVED AND I WAS MOVED
JUST AS THE THISTLE MOVES
AND THUS HE IS MOVED JUST
AS THE THISTLE IS MOVED

It is intuitively obvious that the drawn
form of the thistle can ONLY be
correct if the movement of my HAND,
my EYES and my SPIRIT corresponds
to the

happily interpenetrating playfusing

FORM OF THE THISTLE

THAT IS:

MOVEMENT equals **F**ORM
CHARACTER CHARACTER

THIS IS A BASIC PRINCIPLE OF OUR INVESTIGATION.

EACH characteristic of

PHYSICAL
EMOTIONAL
AND SPIRITUAL **MOVEMENT**

CORRESPONDS TO **one** Character of form

Of

Emotion

Sorrow, Pleasure, Love, Hatred,
Repulsion, Attraction

characteristic FORM will, of course, be muddied and altered by the PERSONALITY of the
creator, but it must always remain a SPECIAL characteristic form and the one of sorrow
must not resemble the one of pleasure. It should be easy to understand that the
characteristic form in a BATTLE SCENE must be very different from that of a MADONNA.
Only a few artists actually satisfy this demand, such as FRANCKE, LEONARDO, EL GRECO
and above all GRUNEWALD, FRA ANGELICO, OR MU'CHI the great Chinese. We can add
that the characteristic form will correspond the more perfectly and precisely to feeling the
more precisely and perfectly the PERSONALITY has been ABSORBED into the
characteristic movement, the more perfectly the creator penetrates
into the
oscillations Sorrow, Pleasure, Love, Hatred,
which are form.
Repulsion, Attraction

. . .

68. Oskar Schlemmer, letter to Otto Meyer, December 7, 1921; manifesto from the publicity pamphlet for the first Bauhaus exhibition in Weimar, 1923*

Oskar Schlemmer (1888–1943) was appointed to the Bauhaus in December 1920. Like Itten, Schlemmer had studied at the Stuttgart Academy of Art with Adolf Hölzel and was acquainted with the Sturm circle in Berlin. At the Weimar Bauhaus Schlemmer taught sculpture, life drawing, mural painting, and, after Lothar Schreyer resigned in 1923, directed all theatrical activity. The wall murals and the stage productions, with their innovative dance choreography, brought Schlemmer his greatest acclaim. His detailed diary and lengthy letters have also earned him recognition as a chronicler of Bauhaus activities, from descriptions of daily events to accounts of the tensions and struggles inside and outside the school.

For Schlemmer, the war, materialism, and commercialism had intensified a longing for utopia. Hoping to unite art, mysticism, science, and technology,[11] he envisioned the Bauhaus as having responsibility for the "conscience of the world." In the manifesto in the publicity leaflet for the Bauhaus exhibition of 1923, he compared the school to a "Cathedral of Socialism." Fears of political misinterpretation led the Council of Masters to delete the phrase although a few uncensored copies reached the public.

Letter to Otto Meyer

Weimar, December 7, 1921

Events here induce me to write sooner than I had intended. The Bauhaus is in the midst of a crisis, and no minor one at that. I shall have to fill you in. As I already wrote, Itten introduced the Mazdaznan doctrine. Returned this summer from a convention in Leipzig and was, as he put it, completely convinced that, despite his previous doubts and hesitations,

*Letter to O. Meyer, Dec. 7, 1921: English translation from *The Letters and Diaries of Oskar Schlemmer*, selected and edited by Tut Schlemmer translated by Krishna Winston (Middletown, Conn.: Wesleyan University Press, 1972), 113–15. Copyright © 1972 by Wesleyan University Press. By permission of University Press of New England. Manifesto from publicity pamphlet for the first Bauhaus exhibition in Weimar, 1923: English translation from Hans M. Wingler, *The Bauhaus* (Cambridge: MIT Press, 1978), 65–66.

this doctrine and its impressive adherents constituted the one and only truth.

But the consequences: first the kitchen (the student cafeteria) was converted to Mazdaznan principles. The argument being that only with this sort of cooking could we afford to keep the cafeteria open these days. The meat eaters must give in, and some claim they need the meat. But that is not all: Itten allegedly carries Mazdaznan principles into the classroom, differentiating between the adherents and the non-adherents on the basis of ideology rather than on the basis of achievement. So apparently a special clique has formed and is splitting the Bauhaus into two camps, the teachers also being drawn in. Itten has managed to have his course made the only required one; he further controls the important workshops and has a rather considerable, admirable ambition: to put his stamp on the Bauhaus. To be sure, he has been stomping about on it since its inception (three years ago). Gropius, the only other person who qualified as director (the "Council of Masters" has been in full existence only six months), let Itten have his way, since he himself was too much taken up with organization and administration. Now Gropius has finally taken a stand against Itten's monopoly and asserts that Itten must go back where he belongs, i.e., to his pedagogic tasks. So Itten and Gropius are dueling it out, and we others are supposed to play referee.

Now this is the situation: Gropius is an excellent diplomat, businessman, and practical genius. In the Bauhaus he has a large private office, and he receives commissions for building villas in Berlin. Berlin, business, and lucrative commissions, partially or hardly understood by the students (whom Gropius wants to help get jobs in this way)—these are scarcely the best prerequisites for Bauhaus work. Itten is right to attack this practice and demand that the students be allowed to work undisturbed. But Gropius contends that we should not shut out life and reality, a danger (if it is a danger) implied by Itten's method; for instance, workshop students might come to find meditation and ritual more important than their work. Itten's ideal would be a craftsman who considers contemplation and thought about his work more important than the work itself, and who does not envy his neighbors and their fine workshops. Gropius wants a man firmly rooted in life and work, who matures through contact with reality and through practicing his craft. Itten likes talent which develops in solitude, Gropius likes character formed by the currents of life (and the necessary talent).

The first ideal results in little that is tangible (the saying goes that at the Bauhaus one sees nothing, and one is always asked to be patient), much talk about work and the necessary conditions. The other ideal results in superficiality, even officious bustle with as few tangible products as the quiet one offers. These two alternatives strike me as typical of current

trends in Germany. On the one hand, the influence of oriental culture, the cult of India, also a return to nature in the **Wandervogel** movement and others like it; also communes, vegetarianism, Tolstoyism, reaction against the war; and on the other hand, the American spirit, progress, the marvels of technology and invention, the urban environment. Gropius and Itten are almost typical, and I must admit that once more I am caught in the middle, half pleased, half displeased. I affirm both possibilities, or at least I would like to see cross-fertilization between the two. Or are progress (expansion) and self-fulfillment (introspection) mutually exclusive?

What position does the Masters' Council take? Klee remains the most passive; he says next to nothing. Feininger talks about general feelings. Muche acts as Itten's second and assistant, although remaining much more tolerant than Itten. Marcks, Gropius's intimate, seconds him. Schreyer, the theater reformer, wants to effect a reconciliation. And I—well, I would also like to, but I would further want to see the areas of activity clearly assigned according to talent and capability, and this would mean expressing truths which I do not feel equal to.

Schlemmer, Manifesto, 1923.

The Staatliches Bauhaus in Weimar is the first and so far the only government school in the Reich—if not in the world—which calls upon the creative forces of the fine arts to become influential while they are vital. At the same time it endeavors, through the establishment of workshops founded upon the crafts, to unite and productively stimulate the arts with the aim of combining them in architecture. The concept of building will restore the unity that perished in debased academicism and in finicky handicraft. . . . Such a school, animating and inwardly animated, unintentionally becomes the gauge for the convulsions of the political and intellectual life of the time, and the history of the Bauhaus becomes the history of contemporary art.

The Staatliches Bauhaus, founded after the catastrophe of the war in the chaos of the revolution and in the era of the flowering of an emotion-laden, explosive art, becomes the rallying-point of all those who, with belief in the future and with sky-storming enthusiasm, wish to build the "cathedral of Socialism." The triumphs of industry and technology before the war and the orgies in the name of destruction during it called to life that impassioned romanticism which was a flaming protest against materialism and the mechanization of art and life. The misery of the time was also a spiritual anguish. A cult of the unconscious and of the

unexplainable, a propensity for mysticism and sectarianism, originated in the quest for those highest things which are in danger of being deprived of their meaning in a world full of doubt and disruption. Breaking the limitations of classical aesthetics reinforced boundlessness of feeling, which found nourishment and verification in the discovery of the East and the art of the Negro, peasants, children, and the insane. The origin of artistic creation was as much sought after as its limits were courageously extended. . . . But it is in pictures, and always in pictures, where the decisive values take refuge. As the highest achievement of individual exaggeration, free from bonds and unredeemed, they must all, apart from the unity of the picture itself, remain in debt to the proclaimed synthesis. . . .

. . . .

Germany, country of the middle, and Weimar, the heart of it, is not for the first time the adopted place of intellectual decision. . . . we become the bearers of responsibility and the conscience of the world. An idealism of activity that embraces, penetrates, and unites art, science, and technology and that influences research, study, and work will construct the "art-edifice" of Man, which is but an allegory of the cosmic system. Today we can do no more than ponder the total plan, lay the foundations, and prepare the building stones.

But
We exist! We have the will! We are producing!

II. DADA

INTRODUCTION

Unlike the Bauhaus or the Novembergruppe, Dada was not a school nor a coherent organization with membership lists and guidelines. Instead, Dada, which began in Zurich in 1916 and spread to Berlin and other cities in Germany, was made up of diverse and shifting factions. Rebelling against traditional conceptions of art and culture, Dada artists were united, however, in their opposition to nationalism and militarism, in their initial admiration for psychoanalysis and anarchism, and in their belief in the power of painting, poetry, and drama to revitalize society. Many of these attitudes were an outgrowth of their Expressionist heritage; the beginnings of Zurich Dada, for example, were very closely tied to Kandinsky's abstract Expressionism as Hugo Ball makes clear in his essay.

After the November Revolution, the more political Berlin Dadaists became especially vehement in their opposition to Expressionism. They rejected late Expressionist poets and their emphasis on the transcendental, and, in their desire to find forms that would appeal to the worker and would assist a second revolution in Germany, also rejected abstract and figurative Expressionism. Their attacks on Expressionism intensified in 1919 and 1920 and the essays by Richard Huelsenbeck and Raoul Hausmann, excerpted here, have directed subsequent interpretations of the period in which Dada seemed completely antithetical to Expressionism. Nonetheless, Dada artists even in Berlin shared with their rejected Expressionist fathers an intense concern for the transvaluation of values and a belief in the regenerative power of creative shock to stimulate change. The greater antagonism of the Dada artists to established government and censorship made them more determined to provoke the middle class through sexual parody and spontaneous satire, and through seemingly incoherent incantations of sounds and shapes from mass culture. After 1920, Dada lost its force in Germany, although Kurt Schwitters and Theo Van Doesburg organized a Dada-Constructivist Congress in Weimar in 1922.

69. Hugo Ball, "Kandinsky," lecture, April 7, 1917*

A founding member of Zurich Dada, the German poet Hugo Ball (1886–1927) provides a key link between Expressionism and Dada. Ball, who studied at the University of Munich and prepared a doctoral dissertation on Nietzsche, met Kandinsky in 1912 and planned to work with him and other Blaue Reiter members on a collaborative theater project.[12] His poetry appeared in Expressionist pre-war journals such as *Die Revolution* (which he edited), *Die Aktion*, and *Die Neue Kunst*.

Ball's preoccupation with mysticism, and anarchism[13] led him to neutral Switzerland during the war. With the support of Richard Huelsenbeck, whom he had known in Munich, Hans Arp, who had also contributed to *Die Aktion* and *Revolution*, and Tristan Tzara and Marcel Janco, Ball established the Cabaret Voltaire in Zurich. From February through June 1916, the Cabaret offered simultaneous poetry readings, drum recitals, spontaneous dance, and recitations to an international audience of expatriate artists and intellectuals. In the spring of 1917 Ball organized the Galerie Dada, which hosted exhibitions of Expressionist paintings along with childrens' and primitive art, poetry readings, and lectures on art. In the lecture he delivered on Kandinsky, Ball applauded abstraction in painting, poetry, and drama as inspiring creative regeneration as well as cultural and political revitalization.

<p style="text-align:center">****</p>

I. The Age

Three things have shaken the art of our time to its depths, have given it a new face, and have prepared it for a mighty new upsurge: the disappearance of religion induced by critical philosophy, the dissolution of the atom in science, and the massive expansion of population in present-day Europe.

God is dead. A world disintegrated. I am dynamite. World history splits into two parts. There is an epoch before me and an epoch after me. Religion, science, morality—phenomena that originated in the states of

dread known to primitive peoples. An epoch disintegrates. A thousand-year-old culture disintegrates. There are no columns and supports, no foundations any more—they have all been blown up. . . .

. . . .

The electron theory brought a strange vibrance into all planes, lines, forms. Objects changed shape, weight, relations of juxtaposition and superimposition. As minds were freed from illusion in the philosophical domain, so were bodies in the physical domain. The dimensions expanded, the boundaries fell away. The ultimate sovereign principles facing the randomness of nature remained individual taste, tact, and the logos of the particular individual person. In the midst of darkness, dread meaninglessness timorously raised its head.

And then came a third element, destructive, threatening with its desperate search for a new ordering of the ruined world: the mass culture of the modern megalopolis. Individual life died out, . . . Machines arrived and replaced individuals. . . . Power was measured no longer in terms of single human beings, but in tens of thousands of horsepower. Turbines, boiler houses, iron hammers, electricity, brought into being fields of force and spirits that took whole cities and countries into their terrible grip . . .

II. Style

The artists of these times have turned inward. Their life is a struggle against madness. They are disrupted, fragmented, dissevered, if they fail to find in their work for a moment equilibrium, balance, necessity, harmony. . . . They are forerunners, prophets of a new era. Only they can understand the tonalities of their language. They stand in opposition to society, as did heretics in the Middle Ages. Their works are simultaneously philosophical, political, and prophetic. They are forerunners of an entire epoch, a new total culture. . . . They dissociate themselves from the empirical world, in which they perceive chance, disorder, disharmony. They voluntarily abstain from representing natural objects—which seem to them to be the greatest of all distortions. They seek what is essential and what is spiritual, what has not yet been profaned, the background of the empirical world, in order to weigh, to order, to harmonize this new theme of theirs in clear, unmistakable forms, planes, and emphases. They become creators of new natural entities that have no counterpart in the known world. They create images that are no longer imitations of nature but an augmentation of nature by new, hitherto unknown appearances and mysteries. . . .

The secret of the cubists is their attempt to break up the convention of

the canvas surface; they placed upon that surface one or several imaginary surfaces as the basis for the painting. The whole secret of Kandinsky is his being the first painter to reject—also more radically than the cubists— everything representational as impure, and to go back to the true form, the sound of a thing, its essence, its essential curve. Our age has found its strongest artistic types in Picasso the faun and Kandinsky the monk. . . .

III. The Person

Kandinsky means liberation, solace, redemption, and peace. . . . Kandinsky is one of the very great innovators, purifiers of life. The vitality of his intent is astounding and just as extraordinary as Rembrandt's was for his age, as Wagner's also for his, a generation ago. His vitality embraces equally music, dance, drama, and poetry. His significance rests on the fact that his initiative is equally practical and theoretical. He is the critic of his own work and of his epoch. He is a writer of incomparable verses, creator of a new theatrical style, author of some of the most spiritual books in recent German literature. . . .

Kandinsky is Russian. He has a highly developed idea of freedom, and he applies it to the domain of art. His remarks on anarchy remind one of statements by Bakunin and Kropotkin. Except that Kandinsky applies the concept of freedom, in a very spiritual way, to aesthetics. . . .

IV. The Painter

. . . .

In *Der Blaue Reiter* and *Uber der Geistige in der Kunst* Kandinsky sharply delineated the field of his own formal problems and distinguished it from the fields of expressionism, cubism, and futurism. . . . To the explicit and often blatant "geometric construction," Kandinsky opposes the kind of free construction to be found in Rembrandt, extremely rich in possibilities, most expressive, and "hidden." Cubism is sometimes reviled nowadays in Paris as *Boche* art because of its abrupt and quasi-Prussian centralization and orderliness

. . . .

V. Stage Composition and the Arts

In *Der Blaue Reiter* Kandinsky wrote a critique of the Wagnerian "Gesamtkunstwerk" advocating the monumental art work of the future. In this critique he argued against the externalization of each of the arts that Wagner had involved in the Gesamtkunstwerk. . . . Kandinsky's idea

of a monumental stage composition is based on opposite premises. He envisages a counterpositioning of the individual arts, a symphonic composition in which every art, reduced to its essentials, provides as an elementary form no more than the score for a construction or composition on the stage. Such a composition would allow each individual art its own material mode of operation, and it would create the future monumental work of art from a blend of the refined materials. . . .

. . . .

70. Richard Huelsenbeck, "Dada Manifesto," [1918], *Dada Almanach*, 1920*

The poet and psychoanalyst Richard Huelsenbeck (1892–1974) is largely responsible for our understanding of Dada as a reaction against Expressionism.[14] Huelsenbeck, who had become friendly with Hugo Ball in Munich in 1912,[15] brought many of the ideas of the Zurich Dadaists back to Berlin when he returned there in January of 1917. He introduced some of their anarchistic, primitivizing, and mystical sentiments in an essay with the Expressionist-sounding title of "Der neue Mensch," published in Wieland Herzfelde's periodical *Die Neue Jugend* (New Youth) in May 1917.[16] Nonetheless, in the Dada manifesto, which he said was read on April 12, 1918 at the first, major propaganda-evening for Dada,[17] Huelsenbeck sought to separate Dada from Expressionism by attacking the Expressionists for their lack of involvement in the critical issues of their day and fot retreating into the "pathetic gesture" of abstraction. He included the manifesto in his influential *Dada Almanach* published in 1920 and published another version in his 1920 history of Dada called *En avant Dada*.

In *En avant Dada*, Huelsenbeck elaborated on the evils of Expressionism. He directly attacked the literary figures Theodor Däubler, Kasimir Edschmied, and Kurt Hiller[18] and criticized all Expressionists for abstraction, subjectivity, and isolation from contemporary life. In this version of the manifesto, Huelsenbeck included the political agenda he and Hausmann had developed: they called for the elimination of property, public meals for all creative and intellectual

*Richard Huelsenbeck, "Dadaistisches Manifest," *Dada Almanach*, ed. Richard Huelsenbeck (Berlin: Erich Reiss, 1920), 36–41.

individuals, a "Dadaist sexual center," a simultaneous state prayer, and the creation of 150 circuses to educate people.[19] Despite his political identification with the German radical left, the list makes clear his irreverent attitude toward all systems and philosophies. In 1922 Huelsenbeck left Berlin for Danzig, where, on the basis of his medical degree, he became an assistant in the field of neuro-psychiatry.

dadaistisCHes maniFest[20]

Art, in its production and direction, depends on the time in which it lives, and artists are creatures of their epoch. The highest art will be one in which the thousandfold issues of the day are revealed in its conscious-ness, an art which allows itself to be noticeably shattered by last week's explosions, which is forever trying to collect itself after the shock of recent days. The best and most challenging artists will be those who every hour snatch the tatters of their bodies out of the turbulent whirl of life, who, with bleeding hands and hearts, hold fast to the intelligence of their time.

Has Expressionism fulfilled our expectations of such an art, which should be a measure of our most vital concerns?

No! No! No!

Have the Expressionists fulfilled our expectations of an art that burns the essence of life into our flesh?

No! No! No!

Under the pretext of turning inward, the Expressionists in literature and painting have banded together into a generation which even now is long-ingly expecting its historical validation and is campaigning for honorable bourgeois recognition. On the pretext of cultivating souls, they have, in their opposition to naturalism, found their way back to the abstract, emotional gestures which presuppose a comfortable life free from content or motivation. The stages are full of kings, poets, and all sorts of Faustian types; the theory of a melioristic[21] world-philosophy, whose child-like, psychologically naive manner remains significant for a full critical under-standing of Expressionism, haunts idle heads. A hatred of the press, hatred of advertising, hatred of sensations bespeaks people for whom an armchair is more important than the noise of the street, and who even make being swindled by every small-time profiteer into a virtue. That sentimental resistance to the times, which are neither better nor worse, neither more reactionary nor more revolutionary than any other times,

that feeble opposition, which sidles up to prayers and incense when it does not prefer to make paper cannons out of Attic iambics—these are traits of a youth who never knew how to be young. Expressionism, discovered abroad and—true to style—transformed in Germany into a fat idler with hope of a good pension, has nothing in common with the efforts of active men. The signers of this manifesto have, under the battle cry

<div style="text-align:center">DADA!!!!</div>

assembled together to put forward a new art, from which they expect the realization of new ideals. What then is DADAISM?

The word Dada symbolizes the most primitive relation to the surrounding reality; with Dadaism a new reality comes into its own. Life appears as a simultaneous whirl of noises, colors, and spiritual rhythms, which Dada takes unflinchingly into its art, with all the spectacular screams and fevers of its feisty pragmatic attitude and with all its brutal reality. This is the sharp dividing line separating Dadaism from all artistic directions up until now and particularly from FUTURISM, which not long ago certain weak minds took to be a new version of impressionist realization. By tearing to pieces all the platitudes of ethics, culture, and inwardness, which are merely cloaks for weak muscles, Dadaism has for the first time ceased to take an aesthetic position toward life.

<div style="text-align:center">the BRUITIST poem</div>

represents a streetcar as it is, the essence of the streetcar with the pensioner[22] Schulze yawning and the brakes screeching.

<div style="text-align:center">the SIMULTANEIST poem</div>

teaches a sense of all things in mad, chaotic pursuit of one another; while Herr Schulze is reading, the Balkan Express crosses the bridge at Nish, a pig squeals in Butcher Nuttke's cellar.

<div style="text-align:center">the STATIC poem</div>

makes words into individuals. . . . The word Dada instantly signals the internationalism of the movement, which is bound to no frontiers, religions, or professions. Dada is the international expression of the times, the great rebellion of artistic movements, the artistic reflex of all these offensives, peace congresses, riots in the vegetable market, suppers at the Esplanade, etc., etc. Dada champions the use of the

<div style="text-align:center">**new materials in painting.**</div>

Dada is a CLUB, founded in Berlin, which you can join without commitments. In this club every man is chairman and every man can have his say in artistic matters. Dada is not a pretext for the ambition of a few literary men (as our enemies would have you believe), Dada is a state of mind that can be revealed in any conversation whatever, so that you are compelled to say: this man is a DADAIST—that man is not; the Club Dada consequently has members all over the world, in Honolulu as well as New Orleans and Meseritz. Under certain circumstances, to be a Dadaist may mean to be more

a businessman, more a political partisan than an artist—to be an artist only by accident—to be a Dadaist means to let oneself be moved by things, to oppose all sedimentation; to sit in a chair for a single moment is to risk one's life (Mr. Wengs pulled his revolver out of his pants pocket). One feels torn, one says yes to a life that seeks to progress by saying no. Affirmation—negation: powerful hocus-pocus of existence fires the nerve of the true Dadaist—whether he is reclining, hunting, cycling—half Pantagruel, half St. Francis, laughing and laughing. Down with the aesthetic-ethical attitudes! Down with the bloodless abstraction of expressionism! Down with the world-bettering theories of empty-headed literati. Up with Dadaism in word and image, with all the Dada things that happen in the world! To be against this manifesto is to be a Dadaist!

Tristan Tzara. Franz Jung. George Grosz.
Marcel Janco. Richard Huelsenbeck. Gerhard Preiß.
Raoul Hausmann. Walter Mehring.

O. Lüthy. Fréderic Glauser. Hugo Ball.
Pierre Albert-Birot. Maria d'Arezzo. Gino Cantarelli.
Prampolini. R. van Rees. Madame van Rees.
Hans Arp. G. Thäuber. Andrée Morosini. François
Mombello-Pasquati.

71. Raoul Hausmann, "The German PHILISTINE Is Annoyed," *Der Dada*, December 1919*

The Austrian-born artist Raoul Hausmann (1886–1971), who moved to Germany in 1900, represents the anti-institutional, anti-establishment direction of much of Berlin Dada. Hausmann worked in 1917 and 1918 on the journal *Die Frei Strasse* along with Huelsenbeck and Franz Jung, whose absorption of the psychoanalytic theories of Otto Gross affected Hausmann's outlook.[23] News of the Russian Revolution in 1917 encouraged the three men to maintain that an understanding of psychoanalytic theories, with their emphasis on sexual freedom for men and women, would contribute to the undermining of authoritarian structures and would therefore further the possibility of world revolution. Writing in 1919 for the literary

*Raoul Hausmann, "**Der deutsche SPIESSER ärgert sich**," *Der Dada* 1 (December 1919): 1.

magazine *Die Erde*, Hausmann declared that "Freud and (Adler) were as significant as Marx and Engels."[24]

Although he had once admired the artists of the Sturm Gallery and had explored mystical writings with his friend Johannes Baader,[25] in the essay reprinted here Hausmann attacked Herwarth Walden and other Expressionists for obscuring profit-making enterprises behind a facade of Buddhism and Theosophy. In his own work during this period Hausmann was oriented toward abstraction,[26] with clear ties to the Cubo-Expressionist and Futurist sources he criticized. But, determined to distinguish his output from what he called Expressionist "pure painting," he began by late 1919 to use photographs from popular magazines in his Klebebilder (literally, glued paintings) as his companion Hannah Höch was doing that year. Hausmann and Höch are generally recognized as pioneering experimenters with photomontages.[27] By 1921 Hausmann became more involved with Kurt Schwitters, Theo Van Doesburg, and Ivan Puni and their interest in constructivism.

Why? Just who is the German philistine to be annoyed about Dada? It is the German poet, the German intellectual, bursting with fury because his perfectly larded soul was left to stew in the sunshine of laughter, who rages because he has been hit dead center in his brain which, in his case, is located where he sits. Now he has nothing left to sit on. No, do not attack us, gentlemen, we are our own opponents already and know better than you do how to get to us. Understand that we couldn't care less how you react, we are made of different stuff. Just use your physical powers to beat the drum of your spiritual business, beat firmly about your bellies so that some God may be moved to pity. We threw that old drum in the trash long ago. We pipe, squeak, curse, and laugh out the irony: Dada! Because we are—**Antidadaists!**

There you have it! Give your oppressed bones a rest and mend your tattered traps, you did it all in vain! We feel like celebrating because you cannot line us up against the wall. And so we want you to spill your guts so we can present you with an account of your celebrated values.

After [our] emotional vitality had been thinly diluted into aesthetic abstractions and moral-ethical farces, there arose out of the European sausage-pot the Expressionism of the German patriot, which, laying the enthusiasm on thick, fashioned a profitable little war business out of a decent movement started by Frenchmen, Russians, and Italians. The same

old story about pure poetry, painting, music played in Germany on an exceptionally competent business basis. But this pseudo-theosophical German tea party, which got as far as winning recognition of the East-Prussians, Junkers, shall not concern us here, no more than the business machinations of Mr. Walden, who, typical German philistine, thinks he needs to drape his transactions in a buddhistic-bombastic garb. Respect to his business genius, but his aesthetics and his art-prussianism should go where they came from, the shyster's office. If Walden and his poet-school were revolutionary in the least, they would have to understand this one fact first, that art cannot be aesthetic harmonization of bourgeois ideas of ownership.

Oh my Herr Philistine, you say art is in danger? Don't you know that art is a beautiful female form, without clothes; it counts on being taken to bed, or at least arousing someone. No, my Herr, art is not in danger—because art does not exist any more. It is dead. . . . Give up the sex-romantic, my dear poets—we don't feel like that any more; rather show your nice tattooed bellies, spit out words, splash geometry with colors and call it abstract art—we care as much for that as we care for your tightrope act around Expressionism. **The absolute inability** to say something, to grasp a thing, to play with it—**this is Expressionism**, a spiritual truss for herniated guts, leftovers bad from the start, which caused great ceremonial bellyaches. The bourgeois writer or painter could feel himself properly sanctified, finally he somehow grew beyond himself into an indeterminate, common world-fuddle—oh, Expressionism. You, the world apogee of romantic deception! But the farce only became unbearable at the hands of the activists who wanted to bring the spirit and the art they saw in Expressionism to the people. These imbeciles, who somehow read Tolstoy once and of course never understood him, now drip with an ethic one can only approach with a pitchfork. These dolts, unfit to pursue politics, have invented Activist/Eternist[28] sauce in order to approach the proletarian too. But the proletarian is not so dense, excuse my expression, that he would fail to notice the absolute vacuity surrounding such raving. Art to him is something that comes from the bourgeoisie. And we are Antidadaists enough that if anyone of us wants to set up something beautiful, aesthetical, a safely fenced in little feeling of well-being such as abstract art for example—that we will knock his well-spread sandwich into the muck. To us the world makes no deep sense except that of a most unfathomable nonsense; we don't want to hear about spirit or art. Science is silly—probably the sun still revolves around the earth today. We do not promote any ethic—which always remains ideal (swindle)—but we don't consequently want to tolerate the bourgeois who hangs his money-bags over life's possibilities. . . . We wish to sort out economy and sexuality in a reasonable manner, and we don't give a hoot for culture which

was not tangible. We wish it to come to an end, and thus an end to the philistine poet, the manufacture of the ideals which were nothing but his excrement. We want the world in motion and emotional, unrest instead of rest,—away with all chairs, away with the sentiments and noble gestures! And we are Antidadaist because for us the Dadaist is still too concerned with feelings and aesthetics. We have the right to any amusement, be it in words, forms, colors, noises; but all this is wonderful nonsense, which we consciously make and cherish,—an immense irony just like life itself: we finally recognize perfect mastery of nonsense as the only sense in the world!!

Down with the German philistine!

72. Wieland Herzfelde, "Introduction," *First International Dada Fair*, 1920*

The First International Dada Fair (fig. 44) held in June 1920 was both the largest and the last comprehensive gathering of Berlin Dada.[29] Works by other German artists, among them Hans Arp, J. Baargeld, Otto Dix, and Max Ernst, and the Frenchman Picabia were also included. Most significant was the display of works produced by the unusual juxtapositions of cut-up photographs from commercial magazines and mechanically printed type. These photomontages seem at first chaotic and random, but careful examination reveals their transformation of the political, social, and cultural events of the day. The essay by Wieland Herzfelde (1896–1988) included here, provides a justification for this manipulation of materials, with which his older brother John Heartfield (Helmuth Herzfeld before 1916), George Grosz, Hausmann, and Höch were experimenting at that time.

Herzfelde, who was the son of the socialist poet and dramatist Franz Herzfeld (pseudonym Franz Held), changed his name from Herzfeld in 1916 at the suggestion of the Expressionist poet Else Lasker-Schüler. At that point, Herzfelde, who had poems published in *Die Aktion*, was beginning his career as editor and publisher and purchased the rights to *Die Neue Jugend*. In the next year, he founded the left-oriented publishing house Malik-Verlag, taking its title

*Wieland Herzfelde, "Zur Einführung," *Erste Internationale Dada-Messe* [pamphlet], Berlin, Berliner Galerie, Dr. Otto Burchard, 1920; reprinted in *Die Zwanzieger Jahre*, ed. Uwe M. Schneede (Cologne: Dumont Buchverlag, 1979), 31–34.

from a story by Lasker-Schuler he had serialized in _Neue Jugend_. With the collaboration of his brother and Grosz, he produced under the Malik-Verlag imprint a series of short-lived reviews and pamphlets that included _Jedermann sein eigner Fussball_ (Everyman his own Football) and _Die Pleite_ (Bankruptcy). Along with his brother, Grosz, and the dramatist Erwin Piscator, Herzfelde, who had sympathized with the Spartacists, joined the German Communist party (KPD) in December 1918. He remained committed to Communist ideology throughout his life. He left Germany in 1933 and returned to the Eastern sector in 1949.

. . . .

Painting once had the distinct goal of making it possible for people to see things, landscapes, animals, buildings, etc. which they could not see with their own eyes. Today these tasks have been taken over by photography and film, which perform them incomparably more perfectly than the painters of all times.

But painting did not die off with the loss of this goal; it searched for new ones. Since then all efforts in art can be summarized as follows: they share a tendency to emancipate themselves from reality no matter how different they are.

Dadaism is the reaction to all those attempts to deny the factual, attempts which were the driving force of the Impressionists, Expressionists, Cubists, and also the Futurists (in that they did not want to capitulate to film); but the Dadaist does not try to compete again with the photographer's apparatus, or even to imbue it with soul by preferring (like the Impressionists) the worst lens: the human eye—or (like the Expressionists) by turning the apparatus around and constantly portraying only the world within their own breast.

The Dadaist say: if at an earlier time, love and effort were expended on the painting of a body, a flower, a hat, a shadow, etc., we only have to take the scissors and cut out all these things we need from among the paintings, photographic reproductions; if it concerns something smaller we don't even need a depiction at all, but can take the objects themselves, for example pocket-knives, ashtrays, books, etc., all things which have been quite beautifully painted in the museums of old art, but painted just the same.

Now the famous question: Yes, but the content, the spiritual?

Over the centuries, the uneven distribution of life—and developmental possibilities has produced outrageous conditions in the field of art just as in all other fields. On the one side are a clique of so-called able and

talented people who, partly through decades of training, partly by protection, tenacity, in part too through inherited gifts, have monopolized all judgments about art. On the other side are the mass of people whose modest and naive desires to portray, communicate, and come to terms with themselves and their surroundings have been suppressed by that clique of trendsetters. Today the young person who does not want to give up all claim to education and to the broadening of his native talents has to submit to the thoroughly authoritarian system of artistic education and the artistic public judgment.

In contrast, Dadaists are saying that production of pictures is not important, and that at least one should not assume a position of authority when one does make pictures. In this way, the pleasure the masses may take in the creative activity would not be ruined by the professional arrogance of a haughty guild. For this reason the contents and also the media of dadaistic pictures and products can be extraordinarily varied. By itself any product is dadaistic which is created without influence from and regard for public authority and criteria of judgment. And it remains dadaistic as long as the image works against illusion, out of the need to subversively assist the contemporary world, which obviously is in a state of disintegration and metamorphosis. The past is important and relevant only insofar as its cult must be opposed. . . . Today no man, even one who speaks with the language of art—a genius—could create works whose conditions belong to past centuries and millennia.

The Dadaists consider it an accomplishment to be vanguard opponents of dilettantism, because an artistic dilettante is nothing other than the victim of a prejudiced, arrogant, aristocratic point of view. The only program the Dadaists recognize is the duty to make current events, current in both time and place, the content of their pictures. This is the reason they do not consider the "Thousand-and-one-nights" or "Pictures from Indochina" as sources for their work, but rather the illustrated magazine and the lead stories in the press.

73. George Grosz, "My New Pictures," *Das Kunstblatt*, 1921*

The paintings, prints, and drawings of George Grosz (1893–1959) are best known for their kaleidoscopic urban images (fig. 45) and

*George Grosz, "Zu meinen neuen Bildern," *Das Kunstblatt* 5, no. 1 (1921):11–14.

their satirical caricatures of the militaristic and bourgeois aspects of Weimar society. After studying art at the Dresden academy, Grosz moved back to Berlin in 1912. He met the Herzfeld brothers in 1915 and the following year began a decade-long collaboration with them, which included the publication of his graphic portfolios and the joint editing of various periodicals.[30] Like John Heartfield, Grosz anglicized his name, changing it from Georg Gross as a protest against German nationalism.[31] It was the Expressionist writer Theodor Däubler who first brought Grosz's work to public attention with articles on the artist in *Die Weissen Blätter* and *Das Kunstblatt*.[32] During the war, Grosz's work was published in *Die Aktion* and Herzfelde's *Neue Jugend*.

Grosz joined the German Communist party (KPD) in December 1918. Although his commitment to the KPD did not last, in the late teens and early twenties Grosz was determined to develop a style which would appeal to the masses. As he explains in the essay, included here, the artist is a worker in a collective community. Actively opposing the Expressionists (who had "discovered" him), Grosz refers to their work as "soul tapestries" and offers the artist as engineer in contrast to the Expressionist mystical prophet. In 1919 and 1920 he participated in a number of Dada exhibitions and events. He increasingly moved away from the fragmented, simultaneous works that Däubler had celebrated toward clearer, more precise caricatures of class types. When the National Socialists came to power in 1933, he emigrated to the United States; he returned to Berlin in 1959 and died shortly thereafter.

. . . .

Today art is absolutely a secondary matter. Anyone able to see beyond his studio walls will admit this. In spite of this, art is something which demands a clear-cut decision from artists. You can't be indifferent about your position in this activity, about your attitude toward the problem of the masses, no longer an issue for those who can see straight. **Are you on the side of the exploiters or on the side of the masses, who are giving these exploiters a good tanning?**

You can't avoid this issue with the old trick about the sublimity and holiness and transcendental character of art. These days an artist is bought by the best-paying jobber or patron—this middleman's trade is called, in a bourgeois state, the advancement of culture. But today's painters and poets don't want to know anything at all about the masses. How else can

you explain the fact that virtually nothing is exhibited which in any way reflects the ideals and efforts, the will of the rising masses.

. . . .

What should you do to give content to your paintings?

Go to a proletarian meeting and look and listen how people there, people just like you, discuss some small improvement of their lot.

And understand—**these masses are the ones who are reorganizing the world. Not you!** But you can work with them. You could help if you wanted to! And that way you could learn to give your art a content which was supported by the revolutionary ideals of the workers.

As for my works in this portfolio [omitted here], I want to say the following: I am again trying to give an absolutely realistic picture of the world. I want every man to understand me—without that currently obligatory profundity into which one cannot plunge without a veritable diving outfit stuffed with spiritual, kabbalistic, and metaphysical deceit. In my efforts to develop a clear and simple style I can't help drawing closer to Carra.[33] Nevertheless, I am separated from him by everything that wants to be enjoyed metaphysically and that reflects bourgeois attitudes. My work should be interpreted as training, a systematic, hands-on work-out, without any view to eternity! I am trying in my so-called works of art to construct something with a completely realistic foundation. Man is no longer an individual to be examined in subtle psychological terms, but as a collective, almost mechanical concept. Individual destiny no longer matters. Just as the ancient Greeks, I would like to create absolutely simple sport symbols, understandable to everyone and enjoyable without commentary.

I am suppressing color. Lines are used in an impersonal, photographic way in order to construct volumes. Once more stability, construction, and practical purpose—e.g., sports, engineer, and machine, but devoid of Futurist romantic dynamism.

Once more control over line and form is being established—it's no longer a question of conjuring up on canvas brightly colored Expressionistic soul-tapestries—the concreteness and clarity of an engineer's drawing is a better model than the uncontrollable twaddle of the Kabbalah, metaphysics, and saintly ecstacy.

. . . I see the future development of painting taking place in workshops, in pure craftsmanship, not in any holy temple of the arts. Painting is manual labor, no different from any other; it can be done well or poorly. Today we have a star system, so do the other arts—but that will disappear.

Photography will play an important role; nowadays a photographer can give you a better and cheaper picture of yourself than a painter. Besides, artists today prefer to distort things after their own fashion—and they have a peculiar aversion to resemblance in representation. The anarchism



of Expressionism must stop! Today painters are forced into this situation because they are unenlightened and have no links with working people. But a time will come when artists—instead of being scrubby bohemian anarchists—will be clean, healthy workers in a collectivistic community. Until this goal is realized by the working class, the intellectual will remain cynical, skeptical, and confused. Not until then will art be able to break out of its narrow and shallow confines where it flows anemically through the life of the "upper ten-thousand," not until then will it become a great stream capable of nourishing all of working humanity. Then capital's monopoly of spiritual things will be ended.—

And here also communism will lead to an enrichment and further development of humanity, to a truly classless society.

74. Kurt Schwitters, "**Merz**-Painting," *Der Zweemann*, 1919*

"**Merzmalerei**" (Merz-painting) was first published in *Der Sturm* in July 1919 in conjunction with an exhibition of the works of the Hannover artist and poet Kurt Schwitters (1887–1948). For this version in the Hannover periodical, an additional paragraph was added. Schwitters studied art at the Dresden academy from 1909–1914 and received his first Sturm exhibition, a joint one with several other artists in June 1918. He is said to have met Arp and Hausmann at about the same time and to have shared their irreverent and antitraditional attitude toward German art and culture. His connections with Sturm Expressionism, and, according to Huelsenbeck, his lack of political commitment, kept him apart from Berlin Dada. He was not included in the 1920 Berlin Fair and Huelsenbeck wrote in the *Dada Almanach* that Dada rejected Schwitter's works. The use of the word "Dada" on the cover (fig. 46) of Schwitters's anthology of poems, *An Anna Blume*, published in 1919 by Paul Steegemann (also the Hannover publisher of Huelsenbeck), and the strong, critical reception to the poem—"An Anna Blume"—a parody of conventional love, seems to have intensified the antagonism.[34] Schwitters remained in contact with Arp and Tzara and by 1921 he and Hausmann lectured together as "Anti-Dada and Merz" and

*Kurt Schwitters, "Die Merzmalerei," *Der Zweemann* 1, no. 1 (November 1919): 18.

began to contribute to Van Doesburg's *De Stijl*. In 1922, Schwitters took part in the Dada-Constructivist Congress in Weimar along with Arp, Hans Richter, Van Doesburg, and two former Bauhaus students.

In an essay printed in *Der Ararat* in 1921, Schwitters maintained that he was closer to the essential Dadaism, that of Arp and Tzara, especially when he worked in the universalist tradition of abstraction.[35] He coined the term "merz" in 1919 to describe his use of materials from everyday life. Although undoubtedly stimulated by his contacts with Cubo-Expressionism and with Zurich and Berlin Dada, Schwitters later remembered being aware, after the November Revolution, that everything had to be restructured and that new things would have to be made from the remnants of the old culture.[36] In his *Merzmalerei*, the term he coined in 1919 to describe his use of materials from everyday life, he used discarded objects and paper to create a new order.

The pictures—Merzmalerei—are abstract works of art. Essentially the word "Merz" means the combination of all imaginable materials for artistic purposes and technically the fundamentally equal valuation of the individual materials. Thus Merz-Painting does not use only color and canvas, brushes and palette, but all materials visible to the eye, and all necessary tools. Therefore it is unimportant whether the used materials have previously been shaped for some purpose or not. The wheel of a baby carriage, the wire net, string, and cotton are all factors on a par with paint. The artist creates by choosing, dividing, and de-forming the materials.

Materials can be de-formed by their mere distribution onto the picture surface. The effect is heightened by dividing, bending, covering, or over-painting. In Merz-Painting the crate lid, the playing-card, the newspaper clipping, all become the surface; string, brush stroke, or pencilmark become line; wirenetting, over-painting, or waxed paper become varnish; cotton becomes softness.

Merz-Painting aspires to produce an immediate expression by shortening the path between intuition and the moment the work of art becomes visible.

The words are supposed to provide insight into my art and make it easier for those who are honestly prepared to follow me. Not many will want to. They are going to accept my works the same way they always have when something new appears, with indignation and ridicule.

III. THE CRITICS AND THE "DEMISE" OF EXPRESSIONISM

INTRODUCTION

During 1919 many of the critics who had associated Expressionism with hopes for radical social transformation began to feel that it no longer reflected an attitude toward change but had become merely a style. Visions of a more humane social order that had been raised by the November Revolution were severely weakened as the Social Democratic government under President Ebert sought to contain socialist and anarchist opposition but proved unable to prevent right-wing extremists from annihilating the leaders of the left. The murders of the Spartacist leaders Rosa Luxemburg and Karl Liebknecht, the assassination of the Bavarian Council Republic leader Kurt Eisner, and the fatal beating of the anarchist philosopher Gustav Landauer darkened the new Republic for many intellectuals. The authors included in this section also resented the ease with which the younger generation appropriated an Expressionist style without experiencing or expressing the visionary commitment that had been so much a part of it in the early years. They came to view Expressionism as decorative esoterica and not as art with the potential to inspire change. Painterly organic abstract Expressionism received the most damning critiques of all. The intellectuals also viewed the proliferation of graphic portfolios and journals, in addition to an explosion of expressionistic cinema and drama in established Weimar theaters in the 1920s, as a sign of the growing commercialization of the movement.[37]

By the mid-twenties Gustav Hartlaub and Franz Roh defined the waning of Expressionism and the turning toward specific imagery as a *Neue Sachlichkeit* (New tangibility)[38] and a "Magic Realism." Hartlaub's more influential term for the return to an object-oriented style was coined in

1923 and passed into widespread usage with his 1925 exhibition, *Neue Sachlichkeit: German Painting Since Expressionism.* The term was applied to artists such as Otto Dix and George Grosz, whose work had formerly been characterized by angular forms, compressed space, garish color, and simultaneous multiple viewpoints, when they adopted a style that was more reportorial than revelatory, retaining some traces of Expressionist color and line but using fixed viewpoints on modeled objects set in a seemingly lucid space.

75. Wilhelm Hausenstein, "Art of this Moment," *Der Neue Merkur*, 1919*

Although he had been an early supporter of Expressionism, during 1919 the art historian Wilhelm Hausenstein (1882–1957) began to feel that Expressionism had become bankrupt. In the essay published in *Der Neue Merkur*, where he was an editor from 1919 to 1922, Hausenstein claimed that Expressionism had grown mediocre and mannered. He bitterly criticized Expressionism for becoming a stylish commodity and thus betraying its earlier revolutionary potential.

In 1913, however, Hausenstein had been a strong proponent of Kandinsky, describing him as the "representative of the newest idealism."[39] But in this essay, he did not make a positive reference to Kandinsky or Marc. Instead he praised artists such as Kubin, Klee, Kirchner, and Meidner, who, although associated with Expressionism, followed a more figurative rather than abstract direction.[40] By 1919, abstraction had become identified with Expressionism and had become a negative concept for him. He described it as an "esoteric formalism" too related to decoration, incomprehensible, with no collective impact.[41]

Hausenstein, who had some art history training as well as training in economics and political history, had joined the Social Democratic party in 1907.[42] But after the November Revolution he became disillusioned with politics. The events of 1918–19 led him to believe that art could not always identify with a revolutionary cause as art had its own laws, "the poetic and the imaginative," which could

*Wilhelm Hausenstein, "Die Kunst in diesem Augenblick," *Der Neue Merkur* 3, *Sonderheft* no 2—"Werden" (1919–1920), 117, 119–22, 123, 125–26.

not in every situation be balanced with the social needs of the times.[43] In his reminiscence of Kurt Eisner, one of the murdered leaders of the Bavarian Räterepublik, Hausenstein questioned whether it was ever possible for men of culture to participate in the mediocre world of politics.[44] After World War II, however, Hausenstein began to take an active part in politics, serving from 1950 to 1953 as the Federal Republic of Germany's General Consul to France, and from 1953 to 1955 as the German ambassador to Paris.

. . . .

. . . . In the enthusiasm of a new moment, we took Expressionism, and above all ourselves as a turning point, as a "twilight of false gods." We almost placed it at the origin of art. . . .

. . . .

. . . What is Expressionism? Who is an Expressionist?

The claim that no one is an Expressionist is equally valid as the one that all are or perhaps some: for it is uncertain what exactly Expressionism is. There is something like a distinguishing flourish, perhaps even a pattern for Expressionism. It could be defined as: form derived from deformation. This, however, is a negative statement. In a positive sense one could say: form derived from imagination. Obvious, all too obvious, the commonness (or banality)—of the tendency in that direction. The significance of the trend is also clear. And also obvious, all too obvious, is the chronic vagueness; which, by now, after a decade, has become a horrifying vagueness. Many have found this deeply disturbing for quite a while. How does this happen?

An attempt to find a solution. . . . In Expressionism the demand for the absolute has brought forth only that which is relative.

We, who at one time expected everything from it [Expressionism], are not spared the admission that we are sinking back into bankruptcy after tremendous efforts. Ten or fifteen years ago, earlier for some areas, we were correct in noting the bankruptcy of Impressionism. After a passionately extended effort we have no choice but to confirm the collapse of Expressionism. We have moved from one ending into another.

The end of Impressionism occurred when it made too few demands on itself. Expressionism tested the saying: qui trop embrasse mal étreint [his reach exceeds his grasp]. It embraced the universe. It wanted to embrace God and the heavens. It wanted more than it could handle. But this could have been simply a tragedy; and we, since we are human, would have

suffered no shame in succumbing to it. The misery began when the catastrophe, after having claimed the blood of the best, settled comfortably into a mannerism of too many arriving too late. As far as the arts and crafts are concerned, Expressionism has long since been exhausted. Its lack of feeling for more precise craftsmanly tasks—evident not only among the great mass of mediocre Expressionism—resulted in the corruption of mime, set design, and especially dance. In these areas, we must tolerate numerous dilettantes who want to be expressive at all costs while expressing nothing. Today Expressionism has its crystal palace. It has its salon. No cigarette advertisement, no bar can get along without Expressionism. It is revolting. Those who did it should have their heads bashed in. They are exploiting the catastrophe—our catastrophe. Expressionism is the conceptualization of the catastrophe. It is the apotheosis of catastrophe; it is its attempt to be positive, even optimistic. Yet secretly it has become the catastrophe of catastrophes. We, after having consciously experienced Expressionism, after having loved and fought for it, live today with the nagging feeling of having come face to face with nothing.

. . . [Expressionism] hardly knows how much it knows of God and of things. It is a convulsion which is as close to everything as to nothing. Hence the variety in the experiment; the incomprehensibility of the concept, the immense expanse between Picasso and Nolde, Kandinsky and Rousseau, Klee and Meidner, Seewald and Kokoschka. The common denominator is vanishing. . . .

Nevertheless: isn't this a good thing? Isn't it certain that the beauty of the heroes of the so-called Impressionists lies on a higher level than Impressionism as such? Indeed it is so. But the wonderful individuation of these heroes was so successful because it did grow out of the common soil of the genius of this epoch. This is the place to emphasize, for once, the value of collectivity. It is this that was missing in the epoch of Expressionism, in spite of all its socialistic protestations. If for any reason the word "Expressionism" were forgotten, then every suggestion that could lead us to overestimate the collective aspect of the movement would disappear instantly.

Certainly this is understandable. An epoch that sets its art up against the cosmos has more roads than those leading Christians to Rome. . . .

There are two ways out of the Expressionist chaos: the salvation of the object and the salvation of the individual . . . only at this moment does a third solution seem possible: communication, collectivity, style.

Expressionism has two poles: the metaphysical and the formal.

Expressionist art could be derived solely from a history of form. It is not so difficult to trace how Expressionism's methods evolve from those of Impressionism through all sorts of intensification, condensation, con-

solidation, and sublimation—in extreme cases through dialectical contrasts. Sublimation and the surmounting of Impressionist methods signify in the final analysis an inbreeding of formal characteristics. This is how esoteric formalism arose in Expressionism. Along with the purely formal development, in which dwelled a kind of characteristic gesture, an incomprehensible yet illuminating distance from events, there went a transformation of motif. . . . There was talk of the subjugation of the object. There was talk of art without objects; of getting rid of objects, of self-determination of pure process. So many terms and so many errors. The lack of concreteness was merely relative as compared to Courbet's "Hammock" or to Leibl. . . . In Expressionism a new notion of the object arose—just as in former times, form arose against ornament, landscape against form, and still life against narrative. The only problem was that the Expressionist approach to objects did not succeed in identifying itself. What was it? That was the question.

. . . .

It was hardly possible, of course, that such eccentricity of orientations would coincide into a truly collective movement. There is no Expressionism. There is Alexandria. There is the Hellenism of the 20th century. . . . Apart, as well in the midst of this turmoil, individuals have developed who, without the agitation and multiplicity called Expressionism, would not have become what they are (for better or for worse)—who however did not bow to Expressionism. Coming from a (sometimes bitter) freedom, today on the road to perfection: [they are] above all, Kokoschka, Beckmann, Meidner, Nolde, Heckel, Kirchner, Beeh, Unold, Seewald, Grossman, Klee, Caspar, Albiker, Lehmbruck, Fiori, Scharff—and the nocturnally phosphorizing Kubin who already has almost the patriarchal stature of an ancestor. . . .

. . . .

Expressionism's withdrawal from the object was finally no accident. Things disappeared from painting as they disappeared from the world, and to subjugate the object meant to turn necessity into virtue. As long as there are objects, art has no reason to ignore them or to subjugate them. . . . During the war we lived on surrogates and we still do. By this time art, even painting, music, and lyrics recorded examples and symbols of the breakdown of our actual world, before the most extreme collapse had taken place. In such matters, cause and effect mix up time and space. Effects seem to take place before the causes. But these were merely the refined nerves of art that feel the event before it occurs. Art. Kassandra.

. . . .

76. Wilhelm Worringer, from *Current Questions on Art,* 1921*

By 1919 Worringer's *Abstraction and Empathy* was in its ninth edition and the following year *Form Problems in the Gothic* reached a twelfth edition. Nonetheless, Worringer had become convinced that Expressionism would not be the catalyst for the new spiritual epoch he envisioned, and he expressed his dismay in several lectures.[45] He gave the speech from which these excerpts are taken at the Goethe Society in Munich in October 1920 and, feeling that the press had misunderstood his thoughts—"everything that depended on nuance and sound of voice was compressed to slogans"[46]—he decided to have it published.

For Worringer by this time, Expressionism had lost its relation with the underlying issues of man and his community and, as a result, had become full of "empty gestures." He warns that previous comparisons of Expressionism to Gothic, Baroque, or primitive art are no longer relevant since Expressionism has ceased originating from metaphysical needs, the source of all great art. Relating the vacuousness he finds in the new art to the pessimism in Oswald Spengler's *Decline of the West,* the first volume of which appeared in 1918, Worringer primarily blames the galleries for the degeneration of Expressionism into "wall decoration" and "artistic fashion calligraphy." Abandoning his championship of Expressionist art, Worringer praises modern philosophy, history, cultural criticism, and science for revealing more universal concerns. He indicates that these developments, rather than the paintings so mistakenly labeled, might more truly be called Expressionism.[47]

Motto: Of my analogies do not complain,
 Without them I could not myself explain.
 —Goethe
Current questions on art? The plural is superfluous. There is only one question for visual arts today and all of us prophets know about it even if we don't want to admit it to any and all outsiders. . . . It is called: crisis of Expressionism. Followed in discreet brackets by: the end of Expressionism. . . . In the final analysis, it is not Expressionism that is being ques-

*Wilhelm Worringer, *Künstlerische Zeitfragen* (Munich: Hugo Bruchmann, 1921), 7–8, 9–10, 15, 19–20, 27, 28–29, 31–32.

tioned—that would be an unimportant studio matter—but it is the voice of our whole spiritual existence today that is in question. Many today are bankrupt Expressionists who do not know anything about art. But let's pretend it is just a matter of art. Maybe it hurts less if one is allowed to speak in analogies.

The crisis and the end of Expressionism. How did it happen and how did it happen so fast? . . .

. . . .

We face the present crisis exactly because Expressionism legitimized itself through its vitality rather than through its logic. . . . Its vitality, not its logic, is played out. And only for this reason is the case hopeless. Expressionism today extends its air-roots greedily in all directions: the space surrounding it has become empty and dried out, and no longer offers nutritive power. Yes, this growing vacuum surrounding Expressionism has not been a secret to the knowledgeable for a long time now. We have heard for a long time that the cries of Expressionism sounded more and more shrill, because they broke less and less through the resistance of real air. The gesticulation of Expressionism became more and more a ghostly play with empty gestures, the hollow sense of futility appeared steadily more threatening, and amid the forced certainty, numb fear became more and more perceptible, resistance against a half-conscious emptiness. With the times so disposed, only such a sinister phrase as the "decline of the West" needed to be mentioned and the catastrophe of changed viewpoints was upon us: one saw Expressionism from behind—saw its back—and suddenly it looked like a last-ditch effort of art despairing about itself.

. . . We all know how much Expressionism was searching for its forebears. We know further how the lines of the great Expressionism of the past ran together and crossed each other when they passed through the small, delicate lens of our modern expressionist feeling—this passing agitation in us—and that we, receiving, recognizing—but not producing it, began to understand what elemental art is. Gothic, Baroque, primitive and Asiatic art: all suddenly revealed themselves as—it may be said,—as they never had to any generation before. . . . And the closer they came to us as the observers, the more completely they eluded us as creators.

. . . .

And just what has remained alive in the whole world of art? The painting of pictures. Art as wall decoration. The last intimate phase of an art that has played out its last extensive possibility. Art, once the central organ for metaphysical energy, is now content to be a beautiful, interesting spot on the wall for people who now and again are also aesthetically inclined. . . .

. . . .

Today we are facing the fact of Expressionism becoming calligraphic and superficial. . . . What many of us perceived as the anticipated, liberating breakthrough from our exhausted intellectuality to a new elementariness and naivete reveals itself now, in hindsight, as merely a new impetus to greater refinement of craftsmanship. From the whole effort, only a new decorative, very attractive, and stimulating swirl remains in the calligraphy of fashion. Not much more. The nucleus has almost disappeared in this process of calligraphic externalization. . . . Now there is no tragedy as we play with the empty shells of Expressionism and shape them, with the blessing of a now-trusting public, into a new decorative chic.

This judgment applies to the mass movement of Expressionism, it is directed at facts, not persons. Do I even have to say that there are creative Expressionists even today, people sentenced to Expressionism who are the great suffering lonely ones? To whom Expressionism is fate and not manner? No, this does not need to be said. What does have to be said is this and not more, that Expressionism, however fatefully deep it may sit with a few, has become a new superficial attraction overall.

. . . .

. . . Today one senses an expanding spiritual impulse at work, which embodies the phenomenon of Expressionism in a more genuine and timely manner than does Expressionist painting. The same conquering spirit that produced, when directed at inappropriate objects, only little fictions in a vacuum is truly valid and productive in the realm of theoretical perception. It is finally no less exciting than the semi-serious excitement generated by our unsatisfactory efforts at art.

. . . .

It is difficult to capture in words and terms this atmosphere of a new spirituality equal to art in its creative capacity. It cannot be explained to somebody who does not sense it. For now we can only sense that our thinking is about to enter a new condition of totality and to acquire a new fluidity which will render the assumed polarity between creating art and thinking more invalid with every passing day. . . . Until now we could visualize essence only through the medium of art: now we can take part in it directly through the medium of thinking, and this seems to me to be the creative achievement of our time.

Does this sublimation of all our creative sensuality into a mere sensual thinking really mean the decline of the West? . . . It seems to me that the tremendous hypercritical consciousness of our time is seen in the synthetic and most of all in the synoptic nature of Spengler's concepts. It is from this synoptic nature that they gain the power to effect their most recent and most genuine changes.

. . . .

I don't just mean for my thoughts to sound iconoclastic. They are directed more against the art business than against art itself. I would like to grant art some time to breathe, a break, so it can reconsider the limits of its vital possibilities. . . .

. . . The law of the conservation of energy is valid for artistic energy too. It lives on in sublimated form in the style of our thinking. Let us not insist on finding it in the style of our paintings. Let us not resist its having found a new form and new mode of life in the pictures of our minds.

77. Iwan Goll, "Expressionism Is Dying," *Zenit*, 1921*

"Expressionism Is Dying" is less a repudiation of Expressionism itself than a bitter cry of disappointment over the political situation in the German Republic. Iwan Goll (born Herbert Lang[48] 1891–1950), an Alsatian poet, dramatist, and critic, had described Expressionism in 1914 as part of "the air of our times . . . less an art style than a form of experience."[49] He had begun publishing poems in *Die Aktion* in 1913 and as a pacifist spent the war years in Switzerland. After the war he was involved with the Dresden Secession, writing for *Menschen* and *Neue Blätter für Kunst und Dichtung*, where he was an editor. The essay included here was meant as a farewell to Expressionism. Emphasizing the antimilitarist and communitarian aspiration of many Expressionists, Goll raises the specter of anti-Semitism and mourns the destruction of humanitarianism by the deadly struggles of the right and left in Germany.

The essay is nonetheless written in Goll's Expressionist style: short, intense bursts of language recall his Expressionist poetry, such as *Der Panama Kanal* (published in 1914 under the pseudonym Iwan Lassang) and *Der Neue Orpheus: Eine Dithyrambe* (1918). The essay is also filled with references to Expressionist literature. Some of these are explicit, such as that to the activist Ludwig Rubiner, while others must be deciphered like bits of a collage: the phrases "Man screams. We are. One Another." are from three different poems.[50] Some references are clearly antagonistic: the title of Leonhard Frank's novel "Man Is Good,"[51] the credo of optimistic pre-revolution Expressionists, is dismissed as "just a phrase."

*Iwan Goll, "Der Expressionismus stirbt," *Zenit* (Zagreb), 1, no. 8 (October 1921): 8–9.

The essay appeared in the original German in the journal *Zenit* (Zenith), the publication of a group of radical Serbo-Croatian writers. Goll's empathy with those whose national identity was changed by events beyond their control (evident in the essay in his final reference to the new countries emerging beyond the Balkans) reflects his own story, as summarized by Kurt Pinthus: "Iwan Goll has no home: by fate a Jew, by accident born in France, marked as a German by a stamp on a piece of paper."[52] By the time the essay was published, Goll had moved to Paris, where he lived for twenty years. In 1939 he fled Europe for America.

What has been whispered, smiled about, and suspected everywhere is now confirmed: once again an art is dying of a time that betrayed it. Whether the art or the time is at fault is not important. Critically it could be proven, though, that Expressionism is choking on the carcass of the same revolution whose motherly Pythia[53] it wanted to be.

This can be explained by the fact that Expressionism altogether (1910–1920) was not the name of an art form, but of a *state of mind*. It was more the subject of a "Weltanschauung" than the object of an artistic requirement.

Ludwig Rubiner: "The Poet gets into Politics" (*Die Aktion*, 1912). Also: "Our call to the future, to all lands and beyond is: L'Homme pour l'homme, instead of the former L'art pour l'art"[54] (*Zeit-Echo*, May 1917).

Kasimir Edschmid: ". . . No program of style. A question of soul. A matter of humanity" (*Neue Rundschau*, March 1918).

Hasenclever: "Let the theater be expression, not play!" "Theater for art, politics, philosophy" (*Schaubuhne*, May 1916).

Thus:

Demand. Manifesto. Appeal. Accusation. Oath. Ecstasy. Struggle. Man screams. We are. One another. Passion.

Who was not there? Everyone was there. I was there: "New Orpheus." Not a single Expressionist was a reactionary. Not a single Expressionist was not antiwar. There was not one who did not believe in brotherhood and community. Among the painters as well. Proof: Attitude.

And: Expressionism was a beautiful, great, and noble affair. Solidarity of the mind. Deployment of the genuine.

Through no fault of the Expressionists, however, the result is unfortunately just a logo for the German Republic, 1920. Intermission. Please exit to the right. The Expressionist opens his mouth . . . and just closes it

again. The weapon, namely the tuba, falls out of the hands of Meidner's European prophets. The very same one who waved his arms so earnestly in the air is now doing it for different reasons. The pistol cracks louder.

Yes, my dear brother Expressionist: the danger today is to take life too *seriously*. Fighting has become grotesque. The spirit is a hoax in this age of profiteering. The "intellectual," his consciousness raised toward bolshevism, has to make himself small, very small, before the masses, perhaps even draw a mask of stupidity across his Jewish forehead, so that his teeth won't get knocked out by stones. The ecstatic mouth becomes bitter, very bitter.

The "good man" disappears into the wings with a desperate bow. Life, the *machine*, nature are still right: beyond good and evil. The beautiful strength, to which Alexander Blok,[55] as the first of the Moderns, dedicated the "Skythen." Primitive man, with the dark blood of centuries and unsettling eyes, steps out from the equatorial jungle and from the polar tundra: with secrets of the sun and the moon. He dances over the meridians of the globe.

The fraternal call, oh Expressionist, what sentimentality! What passion in your kind of human nature.

Naked life is better, rather truer than you. Proof: your "Weltanschauung" has not triumphed anywhere. You have not saved the life of one in sixty million. "Man is good": just a phrase. "But perhaps in a thousand years."

A new power seems to be coming over us: one of brain-machinery. The crane of time takes us by the neck and moves us. You tear hair: My God, what rhythm sounds on earth. Why reach for heaven. *Heaven is also earth*, as the aviator knows. The earth has long since been heaven for the Negroes and the primitives. Perhaps he is right. Every American says "Yes." Away with sentimentality, you Germans, which means the same as, you Expressionists. You can bet: Ludendorff[56] is ultimately an Expressionist too?

In France, where I live, one did *not get sentimental* during the entire war apart from three weaklings who don't count. From beyond the Urals, beyond the Balkans, and beyond the oceans, new lands beckon with their will to life and strength. Young countries. Young people. Their first word addressed to us is electric.

78. G. F. Hartlaub, preface to catalogue of Neue Sachlichkeit exhibition, Mannheim, 1925*

In 1923 Gustav Hartlaub, who had written extensively on Expressionist painting and graphics, was promoted to director of the Mannheim Kunsthalle. He immediately began organizing the exhibition, *Neue Sachlichkeit: German Painting since Expressionism,*[57] which opened in the middle of 1925 with 124 paintings by 32 artists, including Max Beckmann, Otto Dix, George Grosz, Karl Hubbuch, Carlo Mense, Rudolf Schlichter, Georg Scholz, and Georg Schrimpf. The exhibition traveled to other German cities, among them Dresden and Dessau, and served to publicize "Neue Sachlichkeit" as the label of a new movement.

Hartlaub had been searching for alternatives to Expressionism. In a review of the 1920 Darmstadt exhibition *German Expressionism*, he pointed to the crisis emerging from the dissipation of "revolutionary pathos" and urged artists "to shorten the distance from physical nature and reality" and to avoid "intoxicated ecstasies . . . cosmic swirls . . . and incomprehensible abstractions."[58] In May 1923 Hartlaub circulated a letter to museum directors and art dealers in which he outlined his intention for the Neue Sachlichkeit exhibition and asked for help in contacting artists "who in the last ten years have been neither impressionistically relaxed nor expressionistically abstract . . . those artists who have remained unswervingly faithful to the positive palpable reality, or who have become faithful to it once more."[59] In 1929, he wrote that the term "Neue Sachlichkeit" had become widely misappropriated but he stated it could refer to those artists who had applied "a socialistic flavor" to the new realism that had emerged from "the general contemporary feeling in Germany of resignation and cynicism after a period of exuberant hopes (which had found an outlet in Expressionism)."[60]

At the threshold of this exhibition of the newest German painting, we wish to avert a dangerous misunderstanding. Artistic tendencies which first became identifiable after Expressionism are in evidence here and seem—in some respects—to be a reaction against it. Yet **no** position is

*G.F. Hartlaub, "Zum Geleit," *Neue Sachlichkeit: Deutsche Malerei seit dem Expressionismus* (Mannheim: Städtische Kunsthalle, 1925).

being taken against Expressionism or the generation of artists that adhered to it. It is doubtful whether Expressionism is dead—note the continued development of its best representatives just recently. If Expressionism should really be "surpassed" as a "movement," a world view, and an artistic signature, we are not diminishing its accomplishments, its worth, or the character of those who gave it form. Any "movement" bound up as it is with one generation, ages with that generation, stepping into the background at some point, perhaps later to be rejuvenated under different conditions. But then what is a "movement," actually, other than the intersection of specific artistic purposes with the broader consciousness of a whole generation, in all its hopes and fears?! What is it other than exactly that fresh, new, tension-filled springboard which a generation of artists takes as its point of departure?! . . .

. . . One may concede that some painters represented in the exhibition grasp the concrete current reality in a way that departs markedly from the objectless, almost transcendental expressive discoveries of certain "Expressionists." But if one considers the uninhibited **intensity** with which some express their inner history, others their exterior constitution, or if one attends to the **constructive** trend which is as strong in today's realist art as it was among yesterday's Cubists and Futurists, one finds much **common ground**, which could have been used as a common denominator of the "isms." Today, buffeted as we are by the most profound upsets and wild fluctuations in our lives and values, we see the differences more clearly: the move toward topical, restrained findings in some, the emphasis on concreteness, the technical precision in all. Soon one would know that the germ of the new art lay embedded in the old and that even in "verism" much of the visionary fantasy of the old lives on.

The exhibition does **not** attempt to provide a **cross-section** of all the "Post-Expressionists" creative impulses.[61] It does not take up the work of the abstract "constructivist" movement: these experiments—in which the new impulse to be tangible manifests itself in a completely different way— are reserved for a special exhibition. We are rather concerned with a shared expressive means, a characteristic mark of **concreteness**, in itself purely external. This mark appears in two different groups among the artists represented. The first—one would almost want to speak of a "left wing"—is tearing actual things out from the world of real events, evoking experience in its actual tempo, its specific heat; the other is searching for the **timelessly** valid object in order to realize, in art, the eternally valid laws of existence. One has been called "verist"; the other might almost be called classicist. Both designations are only half correct, describe the thing only imprecisely, and could easily lead again to a new dominance of art **concepts** over the tangible richness of physical phenomena. We don't want to insist on slogans. We are only showing **that art still exists,**

that it is striving after the new, the unspoken, struggling for the right to be new and unspoken. Let art **live**—in spite of a cultural situation apparently as hostile to art's very existence as few ages have been. In the midst of catastrophe, let the artists—disappointed, sobered, resigned often to the point of cynicism, almost giving up after a time of unbounded, nearly apocalyptic hope—consider what is closest, most certain, and most durable to them: the truth and their craft.

79. Franz Roh, from *Post-Expressionism, Magic Realism: Problems of Recent European Painting*, 1925*

The Neue Sachlichkeit exhibition and the book *Post-Expressionism: Magic Realism* by the art historian and critic Franz Roh (1870–1960) defined the shift to more naturalistic, more object oriented painting in Germany in the 1920s. But Roh emphasizes the reactive aspect of this move by labeling the tendency "post-Expressionism," and calls attention to fantastic or magic realist tendencies to make it clear that this was not simply a revival of nineteenth-century naturalism. In this way Roh also points out an affinity with Italian "metaphysical painting," especially di Chirico, in Munich painters such as Carl Mense and Georg Schrimpf.

Roh's training with Heinrich Wölfflin, with whom he wrote his dissertation on seventeenth-century Dutch painting, is evident in the arrangement of the illustrations (fig. 47) and in the chart, both of which present binary oppositions between Expressionism and Post-Expressionism.[62] Roh's oppositions, such as ecstatic/sober, warm/cool, rough/smooth, are clearly indebted to Wölfflin's schema differentiating Renaissance and Baroque—linear/painterly, closed form/open form, etc. In place of Hartlaub's division of the Neue Sachlichkeit artists into a "left" and "right" wing, Roh detects instead some seven sub-divisions among them[63]—all of which he places between the "abyss on the left and on the right."

Two years after the book was published, Roh began to produce experimental photographs and collages,[64] which he continued to make until 1933 when he was briefly imprisoned by the Nazis. After the Second World War, Roh was reinstated at the University of

*Franz Roh, *Nach-Expressionismus, Magischer Realismus: Probleme der neuesten europäischen Malerei* (Leipzig: Klinkhardt and Biermann, 1925), 3, 13–15, 27–28, 35, 119–20.

Munich. In line with the general tendency among art historians in the 1950s in the Federal Republic, Roh began to promote abstraction as "the greatest discovery of our century" over and against his earlier interest in realism.[65]

Introduction

. . . .

We wish to establish only for the time being that, next to a series of existing modes of painting, a new style has appeared in all European countries. What we basically mean, however, is that a decisive change is at hand, one that will eventually, when seen from a distance, prove to be as fundamental as the transition from Impressionism to Expressionism. In this respect we set a turning-point at 1920 as well as at 1890, the obligatory date for the beginning of Expressionism (van Gogh and Gauguin). We are convinced that the future will shortly belong to the new possibilities, however limited their horizons may seem now to an outsider. . . . But if the lines of development of the newest painting, now roughly parallel, should at some point divide, it would not undermine our account in the slightest. It is intended primarily to describe the new type in European painting from 1920 to 1925.

. . . .

Relationships to Objects in General

Not every art can be evaluated conclusively on the basis of its relationship to objects. A musical work is always an original since its forms do not really yearn for a bond with nature. Architecture does not require this affinity either. Painting, however, which has almost always belonged to some form of nature, had shed its representative and imitative significance as far as possible in the course of Expressionism, which is how specific objects fell under the suspicion of being non-spiritual. Futurism gave only a diffused and disrupted picture of the world of objects. Post-Expressionism, on the other hand, is making an attempt to reestablish reality in connection with its visibility. The elemental joy of recognition once again is coming into play. Painting will again be the mirror of a perceptible exterior. This is the sense in which a new realism has been talked about, which is not thought of as a driving force—which was attributed to the last realisms of European art. Those who are still rooted in this view are not at all satisfied with this new "cold, lifeless" realism.

We would like to demonstrate with an example what we mean by object relatedness. If I see a few apples on a table, then I have had, even from a strictly aesthetic standpoint, a highly complex experience. Not merely the breath of rich color satisfies me, in which Impressionism so delighted, and not merely the transformed scheme of colorful and deformed spheres, which fascinated Expressionism, attracts me. I am compelled by a much more sweeping, comprehensive juxtaposition of colors, spatial forms, tactile impressions, and memories of odors and chewing. A truly inexhaustible complexity, that we combine in the concept of the actual. From this comprehensive vision of Post-Expressionism the ideas of Im- and Expressionism appear as brazen simplifications, which cheat us, on the one hand, through a one-sided surface shimmer and on the other through stereometric and colored abstractions, out of the rapture of the phenomenon as a whole. As a relationship is again established with objects, all the connections and feelings we don't get with pure harmonies of color and form are set in motion. Only since art became abstract could what was experienced as vague, empty, unsatisfying be newly transfused with the feeling for objects, become a fundamental experience again. Only after this revitalization could the relationship to objects again become the special pleasure of painting. . . .

. . . .

A comparison could be made not only to the reflective man but also to the new type of active man, in order to clarify their respective positions with regard to an existing world of objects. The period of the late nineteenth century—which includes Impressionism—had equipped many people to appreciate, to perceive, yes even to savor the existing world in new ways. The Expressionist generation had rightly opposed this with the man of ethical norms, the man constructively planning a future, the utopian who disdains mere connoisseurship of life already lived. It was a far nobler and more daring type, who truly moves the world and one who—if indirectly—has always provided the decisive impulse for new developments. The most recent art corresponds to a third type. He does not abandon any of the constructive goal directedness, but he does know how to combine it with an intensified down-to-earth quality, a savoring of what exists, as well as with objects to be intensified. This is neither the "empirical political" and Machiavellian, nor the unpolitical, exclusively moral philosopher, but the ethical homo politicus with equal emphasis on both concepts. The new situation, if it persists, will be in between, not from weakness but from strength. It will be the narrow path bordered by abysses typical of the left and the right.

SCHEME

Expressionism	*Post-Expressionism*
Ecstatic Objects	Sober Objects
Many religious themes (motifs)	Very few religious themes (motifs)
Suppression of the object	Clarification of the object
Rhythmical	Representational
Exciting	Absorbing
Extravagant	More severe, puritan
Dynamic	Static
Loud	Quiet
Summarizing	Developing
Foreground (Close-up)	Fore-and background (Close-up and long view)
Advancing	Also receding
Large-Scaled	Large-scaled and variegated
Monumental	Miniature
Warm	Cool, even cold
Thick pigment	Thin pigment
Textured	Smooth
Like unfinished stone	Like polished metal
Exposing process (Faktur)	Concealing process
Expressive deformation of objects	Harmonizing purification of things
Rich in diagonals, tilting, often pointy	Usually at right angles, parallel to the frame
Contesting the limits of the frame	Respecting the frame
Primitive	Cultivated

IV. EXPRESSIONISM AND THE THIRD REICH

by Ida Katherine Rigby

INTRODUCTION

The Nazi campaign against modern art consolidated the ideological antimodernism of both right and left. The right-wing opposition out of which Nazi policy directly evolved[66] received a powerful political formulation in 1929 when Alfred Rosenberg founded the antimodernist agitational group, the Kampfbund für deutsche Kultur (Fighting League for German Culture).[67] After the Nazis assumed power on January 30, 1933, there was an intense struggle between Rosenberg and Dr. Josef Goebbels, the Reich minister for public enlightenment and propaganda, over who would control German cultural life.

This rivalry continued even after the Reich Culture Chamber was established in September 1933 under Goebbels' Propaganda Ministry.[68] Although Adolf Hitler played the contenders off against one another, a definitive antimodernist policy was in place while the "debate" continued. Antimodernism was a useful propaganda tool. According to an observer, Jacques Barzun, the policy had strong support: "The condemnation of modern art . . . was clearly a popular policy. The lower-class mind was jubilant, vindicated at last in its hitherto insecure aesthetic instincts. The crazy, morbid . . . charlatans who had monopolized the attention of art critics . . . were now getting their due."[69]

Nonetheless, a few of the party leadership, including close associates of Goebbels', considered Expressionism uniquely German and campaigned to enshrine it as the official style of the Reich. In July 1933 the National Socialist Students' League of the University of Berlin organized two polemical exhibitions: "German Art" (including Ernst Barlach, Emil Nolde, Karl Schmidt-Rottluff, and a young Expressionist painter who was

one of Goebbels' chief aides, Hans Weidemann) and "Thirty German Artists." Reich Interior Minister Wilhelm Frick ordered the latter closed.[70]

By this time the Nazis were dismissing teachers and inaugurating the "degenerate art" exhibitions, which culminated in the massive pillage of German collections for the Munich Degenerate Art Exhibition of July 1937. Many of the confiscated works were destroyed; some were sold at auction. Although a number of "modernist" artists remained in Germany and worked quietly and some galleries had back rooms where their work could be seen, many major figures emigrated.

80. Käthe Kollwitz, excerpts from diaries and letters, 1933*

Käthe Kollwitz was among the earliest targets of Nazi antimodernism. In February 1933 Kollwitz and Heinrich Mann[71] were forced to resign their professorships at the Prussian Academy because they had signed a leftist call to unite against Nazism; Kollwitz was, however, allowed to keep her studio in the Academy and teach master students until October 1933. A month later the home of her son Hans was searched and her work seized. On July 13, 1936, Gestapo officers threatened her with internment because of statements published in *Izvestia*. She repudiated the published statements, but refused to reveal who else had been present at the interview. From then on she and her husband carried flasks of poison. Although her work was not exhibited in the Munich Degenerate Art Exhibition, it was confiscated from public collections and Kollwitz was vilified in the press for her agitational, "bolshevik," and racially inferior subjects. In 1937 she was one of only three non-Jews to attend Max Liebermann's funeral, and in 1938 she was among the few who had the courage to attend Ernst Barlach's.

1933
The Third Reich dawns.

*Kollwitz, letters and diary entries: January 30, 1933; February 15, 1933; April 1, 1933; May 10, 1933 in Käthe Kollwitz, *Ich Sah die Welt mit Liebvollen Blicken. Käthe Kollwitz: Ein Leben in Selbstzeugnissen* (Wiesbaden: Fourier Verlag, 1981), 205ff; February 1933: reprinted in *The Diary and Letters of Käthe Kollwitz*, Hans Kollwitz, ed. (Chicago: Henry Regnery Co., 1955), 170.

January 30, 1933
Hitler becomes Reich Chancellor. Then everything in rapid succession.

February 15, 1933
Heinrich Mann and I must leave the Academy. Arrests and house searches. At the end of March two weeks to Marienbad. There with the Wertheimers. Mid-April we shall return with the firm intention of remaining. The most complete dictatorship.

February 1933

Dear Jeep,
Has the Academy affair reached your ears yet? That Heinrich Mann and I, because we signed the manifesto calling for unity of the parties of the left, must leave the Academy. It was all terribly unpleasant for the Academy directors. For fourteen years (the same fourteen that Hitler has branded the "evil years") I have worked together peacefully with these people. Now the Academy directors have had to ask me to resign. Otherwise the Nazis had threatened to break up the Academy. Naturally I complied. So did Heinrich Mann. Municipal Architect Wagner also resigned, in sympathy with us—But they are allowing me to keep my position until October 1, along with my full salary and the rooms I use.

April 1, 1933
Boycott of Jews.

May 10, 1933
Books are burned.

81. Paul Schultze-Naumburg, from *Art and Race*, 1928*

Paul Schultze-Naumburg (1869–1949) was an architect, painter, lecturer, and writer. His influential book *Art and Race* tied through

*Paul Schultze-Naumburg, *Kunst und Rasse* (Munich: J. F. Lehmanns Verlag, 1928), 20, 87, 91–93, 142.

word and image (fig. 48) the creation and appreciation of art to hereditary racial characteristics, thus laying the pseudoscientific basis for Nazi aesthetics.[72] In his writings he explained the decline of art and architecture using the theories of Oswald Spengler and the racist anthropologist Hans F. K. Günther. He equated borrowing from other cultures with miscegenation and argued that the survival of the Aryan race was at stake in the political battles of the day in art and architecture.

Before turning to architecture, Schultze-Naumburg had studied sculpture and painting and had taken part in the founding of the Berlin and Munich Secessions. He contributed an essay to Carl Vinnen's *A Protest of German Artists*, and after the war his views became increasingly chauvinistic and reactionary. He became one of the most popular lecturers for the Kampfbund für deutsche Kultur, and the Nazi newspaper, *Völkische Beobachter*, enthusiastically followed his writings and speeches. Although his ideas formed the basis for Nazi art-politics, he was never given a government appointment, probably due to his close association with Alfred Rosenberg, the Nazi propogandist and editor of *Völkische Beobachter*.

. . . .

The question that we must raise first is whether the works of an artist always exactly and faithfully reproduce his own physical and spiritual uniqueness or whether it is bound up with a vastly complicated process that we only understand through analogies with the laws of biological inheritance.

. . . .

. . . The culture of a people at a particular time can be read in none of its expressions so clearly as in its works of visual art. Here the forms of the environment, of the dress, tools, occupations, and all other phenomena, above all the corporeality of the bearers, become manifest in an order that is easy to survey and we recognize . . . the ideals of the times and its symbols in the clearest forms.

. . . .

. . . It is striking that in German art today the representation of the Nordic man is encountered only as a very rare exception, and predominantly even then only in inferior versions. Foreign exotic features dominate in the representation of human beings. Within this type, however, again a strong tendency is to be observed, namely not to represent the noble traits

of the type, but unmistakably those of primitive man, resembling, down to its grimacing face, the animal-like cave dweller. In addition we see everywhere a preference for and emphasis on manifestations of degeneracy. . . . Even the events chosen to be represented . . . point more or less to a physical and mental nadir. . . . It is a true hell of subhumanity that unfolds here before us, and one breathes a sigh of relief when one steps out of this atmosphere into the pure air of other cultures, especially of the antique and the early Renaissance, in which a noble race struggles in its art to express its longings in its art. . . .

. . . .

One must certainly search about at length if one wants to come across such conditions in real life. They are not to be met among healthy men and in places towards which healthy men are drawn. Surely one must descend into the deepest depths of human misery and of human scum: in the insane asylums, the psychiatric clinics, homes for cripples, the wards for leprosy, or in slatterns' corners, in which the most depraved hide themselves. . . . But even though impressions of such ghastliness came from those places that photography is scarcely able to reproduce them, they still do not come close to this kind of art.

. . . .

But what does it say for the life of the Volk that a certain level expresses itself artistically in such a way and a far larger element accepts it and admires it like any other fashion?

. . . Is the Nordic man truly retreating as a part of the German populace, as it would appear from art? And secondly, yet almost more importantly: is the strata of degenerates with all its attributes: ugly, malformed body, the signs of illness, of vice and mental inferiority, moving so prominently into the foreground of our people's life that it determines the expression of the whole? . . . Three possibilities exist:

Either that which appears as art . . . is in fact an essential expression of the reality of the whole people. Then, to be sure, our cultural world would appear ripe for decline, or for exclusion from the cultural circle of white peoples. Or it is the life-expression of a circle that, for reasons that cannot be explored here, makes itself bigger than it is, by allowing only a small segment of the whole to speak. Or finally the body of the Volk is going a different direction physically and spiritually, and is healthier; only the art of today is biased toward phenomena of decay and degeneration. . . .

. . . .

What today surrounds us as art assumes not only an anxious, ugly environment, one much more terrible than truly exists, but also shows us all too vividly the yearnings of the Subhuman, which, in his greasy world with contorted faces and twisted bodies, appears to be in good health. If

one leaves him the task of building the future world, then its appearance will be the same as that of his pictures.

82. A. Rosenberg, "Revolution in the Visual Arts," *Völkische Beobachter,* 1933*

Alfred Rosenberg (1893–1946) fancied himself the Nazi party philosopher, and his writings were frequently cited in the Nazi press. Rosenberg was born in Reval (Estonia) and studied architecture in Riga and Moscow. The Russian Revolution made him a dedicated antibolshevik. He moved to Munich in 1918, went to work for the *Völkische Beobachter* in 1920, and became editor in chief in 1923. In *The Myth of the Twentieth Century* (1920), he explained his theory of "will-determined aesthetics" and declared, "Today a new faith is stirring: the myth of the blood . . . the belief . . . that Nordic blood represents that mystery which has replaced and overcome the old sacraments."[73] He founded the Kampfbund für deutsche Kultur in 1929 to fight for this new faith.

In 1934 Rosenberg was placed in charge of "The Overseeing of the Entire Spiritual and Ideological Training and Education of the National Socialist Party," a position without power. He did, however, direct publication of the official, glossy art magazine *Die Kunst im Dritten* [later *Deutschen*] *Reich*, which promoted the *völkisch* realistic and academic, neoclassical revivalist aesthetics favored by Rosenberg.

When in July 1933 the National Socialist Students' League of the University of Berlin held an exhibition polemically entitled "German Art," one of the organizers published an article attacking Kampfbund historicism and defending Expressionism.[74] Rosenberg retaliated with two articles in the *Völkische Beobachter*, one of which is excerpted here. On July 15 he followed up with a Kampfbund rally condemning Expressionism.

This essay is characteristic of Rosenberg's urgent, mystical millennarianism and the Nazis' insistence that art is intimately related to the spiritual life of the people. Rosenberg's condemnation of an "engineer's art" expresses Nazism's regressive antimodernism that exploited Germans' yearning for a return to a rural Golden Age. The

*Alfred Rosenberg, "Revolution in der bildenden Kunst," *Völkische Beobachter*, July 7, 1933, 1.

racist underpinnings of Nazism inform his opposition to taking inspiration from non-German, particularly tribal, arts. His call for the "healthy" racial instincts of SA men to judge what is German art reflects the populist appeal of Nazism.

The political revolution of National Socialism is, above all, the most important base for the movement. It is legitimate, however, only because it represents the external side of a mental-spiritual transformation of German man. The great seizure of power thus does not exist in itself, but is aimed at a specific goal, driven by a specific will. For that reason more and more aspects of life will be taken up into the surging waves of the movement, millions of souls freshly inspired and spurred to take action [Gestaltung]. For a long time there also has been a bitter conflict of opinion in the visual arts, and it is quite conceivable that politically like-minded National Socialists still think very differently about questions of art, yes, that in the judging of certain artists, opinions are often quite volatile.

. . . a lively discussion has broken out around men such as **Nolde** and **Barlach**. One group of National Socialist artists wants to know that these two will be excluded from our mental image of a future art; another, which calls itself **revolutionary**, chooses them as leaders.

Let us try to form a judgment free of all subjectivity, in a manner conforming with National Socialist thought as a whole. Thus we will have to establish that . . . a distinct ideal of beauty governs artists of the Nordic stamp. This powerful, true-to-nature ideal appears before us nowhere more beautifully than in Hellas, but it governs Titian as well as Palma Vecchio, Giorgione, and Botticelli, who actually painted forms similar to Greek forms. This ideal is as evident in Holbein as in the portrayals of Gudrun or Goethe's Dorothea. It governs the face of Pericles just as it does the Bamberg knight's.

Regardless of whether an individual completely conforms to this ideal or not, so long as the **yearning** for it is still alive, the nation is near and tied to its *völkish* racial spirit. It is this instinct that here joins with ideal type [Gestalt] and form in order to prepare the path to the future, perhaps in the realm of painting and sculpture. In relation to this exhibition, then, one asks oneself what the situation must be in relation to Nolde and Barlach, one thus becomes able to say, so at least I believe, for my part, that both artists doubtless exhibit a marked talent; a seascape by Nolde, for example, in the Kronprinzen Palace is vigorously and powerfully painted. Next to it, however, hang some efforts at portraiture: Negroid, irreverent, unrefined, and devoid of any pure inner power of form. Barlach for his part controls his material with virtuosity and no one will

dispute the monumentality of his woodcarving. But what he made of human beings, that is foreign, completely foreign: massiveness enslaved by the earth and joy in the pressure of the material's own weight. These are his "Mecklenburg peasants"; oh no, these [Mecklenburgers] stride over the earth in a completely different way from this humanity of Barlach's! And finally: Look at Barlach's Magdeburg "War Memorial," which he made for the church there; small, half-idiotic, down-trodden mixes of undefinable stock with Soviet helmets are supposed to stand for German National Guardsmen! I think: here, **every** healthy S.A. man would give the same judgment as knowledgeable artists. . . .

83. Robert Scholz, from *Vital Questions about the Visual Arts*, 1937*

Robert Scholz (1902–) studied art at the Hochschule der bildenden Künste in Berlin. In 1933 he became art editor for the *Völkische Beobachter* and chief editor for *Die völkische Kunst*. In 1937 he was named editor of the official art magazine, *Die Kunst im Dritten* [later *Deutschen*] *Reich*. In the early 1940s he was special staff officer for the visual arts in the agency that inventoried the art stolen from occupied territories.

Scholz's writings were rooted in the Nazi blood and soil mythos and Paul Schultze-Naumburg's racist aesthetics. His preoccupation with cultural decadence and faith in art as a potential weapon in the struggle for cultural regeneration typified Nazi art writing. The difference between Scholz and most Nazi art writers was that he had a good knowledge of art history. According to Scholz, the party's mission was to return art, which he believed had become the province of an intellectual elite, to its once central position in the life of the German people. In his book, *Vital Questions about the Visual Arts*, Expressionism figured prominently as a major contributor to German cultural decadence, not only because it had drawn on alien sources, but also because its emphasis on self-expression had supposedly elevated the individual above the communal.

. . . .

*Robert Scholz, *Lebensfrage der bildenden Kunst*, Munich: Zentralverlag der NSDAP, 1937, 5, 24, 25–28, 29, 30–31, 44–45, 54.

Thanks to the efforts to achieve cultural-political enlightenment, the manifestations of decline in the visual arts, earlier seen by only a small circle of a few philosophers, are now today becoming recognizable to a wider circle. This crisis of decline, which represents as much a spiritual as a biological deterioration of the power of art, has separated art and the people, and in the last decades driven art so far from the great life-flow of the time that it seemed merely to vegetate on the periphery of contemporary life. . . .

. . . .

. . . Expressionism rested on this admiration for Negro art and the art of early epochs outside of Europe. It is indeed to be seen as the expression of the highest decadence that twentieth-century man consciously reverts to admiring Negro art and in so doing can believe he is setting art on a completely new basis. . . .

. . . .

. . . These painters stepped into the public view with pictures in which the object and optical-spatial accuracy were handled with a contempt just as unaccustomed and astonishing as the exotic taste that marked it distinctly in color and form. These painters had thrown overboard not only all of the values in . . . previous painting, but also the whole emotional value and content of European art in favor of a barbaric tropical romanticism. . . . The psychological core of this painting is . . . the flight of individualism before the collective tendencies of civilization. . . .

. . . Expressionism had actually succeeded in drawing to itself the hopes of many of those dissatisfied with reality. . . . Thus Expressionism came to be the bearer of all destructive artistic tendencies, a fertile soil on which a self-doubting individualism could sow its wild oats. And it lived to the end of its life, fully, as though it had wanted to take revenge on the whole of European culture. . . . It is easy to demonstrate that all forms of spiritual illness precipitated in Expressionism. All of this becomes most blatantly clear, however, in the scion of Expressionism, in what is called Dada.

. . . .

"The poisoning and destruction of a body of a people [Völkeskörper] through the manifestations of our art-bolshevism are almost still more devastating than the effects of political and economic communism."

Adolf Hitler

. . . .

. . . Liberal Marxism recognized its spiritual forerunners in the artistic modernism of the prewar years, in Futurism, Cubism, Expressionism, and Dada, and adopted these artistic movements as its state art program. . . . The representatives of the modern art movements greeted the Marxist revolt jubilantly as their liberator. . . .

. . . .

. . . At the same time an even more repulsive politically inclined art turned up . . . an art depicting misery and poverty became all the rage. Poverty, illness, misery in painting were not, however, transfigured by the love of the compassionate viewer and the capacity of the artist's eye to recognize more profound meaning, which was the case when someone like Rembrandt had represented poverty and suffering; rather misery became misery for the first time through detachment from its meaning as part of an ennobled destiny, through its presentation as provocation. The bias of this misery painting was toward the politics of Marxism; it was illustrated class hatred. . . .

. . . .

In this regard it is also necessary to establish historically what a large part nationally and racially foreign elements had in the invention and rise of modern art-isms in Germany. Half of the first group of Expressionists mentioned earlier, the so-called Brücke, were racially alien elements, such as, for example, the Russians Kandinsky and Archipenko. There were also, at almost every point, demonstrably full- and half-Jews who led the literary and the art dealers' propaganda for modernism in art. . . . That a part of the leading Expressionists were Germans does not disprove the contention that modernism was based on a racially foreign ideology. . . .

. . . .

. . . Rosenberg discovered the goal of this effort to palm off Expressionist art on the new state as the revolutionary art suitable to it when he stated: "If it succeeds—that is to say—in banishing the German, heroic ideal of beauty from our world of mental images and in replacing it with the 'Expressionistic' sub-humanity, then it will have dealt just as irreparable a blow to racial science as to the spiritual striving that at long last dominates our time. It will again have succeeded in poisoning the awakening German instinct."

84. Emil Nolde, letter to the president of the Prussian Academy of Arts, 1937*

In this letter to the president of the Prussian Academy of Arts, Emil Nolde (1867–1956) offers the rationale used by National Socialists sympathetic with Expressionism to justify its continuance under the Third Reich. It draws on the earlier attempt to explain Expressionism as the direct spiritual descendant of the German Gothic and therefore

*Emil Nolde, letter to the President of the Prussian Academy of Arts, Berlin, July 12, 1937 (archives, Akademie der Künste, Berlin).

representative of the continuity of German culture. His viewpoint is also rooted in the chauvinistic affirmation of the "Nordic" elements in German art represented by Carl Vinnen's *A Protest of German Artists*.

Nolde was an early Nazi party member. Nazi ideology appealed to his nationalism, anti-Semitism, and quest for a spiritual mission. Despite his commitment to Nazi politics, Nolde had persisted in expressing his admiration for tribal arts, as opposed to the "saccharine," "overbred, pale, and decadent" arts that surrounded him in Europe;[75] and he had also criticized Greek art after the archaic period. Both views were in stark opposition to the prevailing ideology that posited a "Nordic-Greek" basis for the regeneration of German art. Interspersed in his unorthodox writings, however, were convictions more congenial to the Nazis, for example, "Glory be to our strong, healthy German art."[76]

Nolde was condemned by the Kampfbund für deutsche Kultur and in Paul Schultze-Naumburg's *Art and Race* for drawing inspiration from tribal arts and for producing brutal anatomical distortions that resulted in representations of degenerate human types. On July 2, 1938, Nolde wrote a letter to Josef Goebbels requesting the return of parts of his confiscated *Life of Christ* (1912).[77] Although the parts were eventually returned,[78] Adolf Ziegler, president of the Reich Chamber for Visual Arts, expelled him from the chamber in August 1941 because, as Ziegler wrote, 1,052 works of art from him alone had to be confiscated from German museums and he had continued to paint in a manner incompatible with National Socialist thought.

Sebull bei Neukirchen; (Schleswig) 12.7.37

Dear Mr. President:

Your notification of the imminent change within the Academy is completely understandable to me. Even though I've become a member, I have stood far from all [its] enterprises and have participated in no exhibition of artistic work. This lay rooted in my seclusion, to which I was condemned since the lost struggles against the unclean art dealing at the time, against foreignization of German art, and against the power of men like Liebermann and Cassirer. With much courage and idealism I had, about 1910—as almost the only German visual artist to do so—taken up this struggle against a thousandfold superior force and was overcome, barred from the Berlin Secession, outlawed, and for decades thereafter pursued to the edge of destruction by the press and all its means of power. It is perhaps not my place to mention these things—an artist's life is struggle and work—I do it only because my high-placed ideals were and are essentially like those being fought for

through National Socialism. My wish is to request you to consider these events, and whether then it nevertheless remains your desire to dismiss me from membership in the Academy.

By the terms of the Versailles Treaty I am an alien German transferred to Denmark, and I lived apart from the decisive struggles for German awakening. When the German National Socialist Party in North Schleswig was founded I became a member. My way of thinking and entire love is for Germany, the German people and its ideals.

Heil Hitler!
Emil Nolde

85. Fritz Kaiser, *Guide to the Degenerate Art Exhibition, 1937*[*]

The *Degenerate Art* exhibition was opened in Munich on July 19, 1937, to coincide with the opening of the Haus der deutschen Kunst, where officially sanctioned, "healthy" Nordic art was displayed.[79] On the average, twenty-thousand people a day visited the exhibition,[80] which contained about 650 paintings, sculptures, prints, drawings, books, and photographs (fig. 49). It remained in Munich through November 30, 1937, then traveled to twelve cities in Germany and Austria from February 1938 through April 1941. The guidebook (fig. 50) by a Fritz Kaiser[81] of Munich, presented the rationale for the format of the exhibition and reiterated the cliches of Nazi art politics.

This exhibition, the largest in a series of "abominations exhibitions" or "chambers of horrors" begun by the Nazis immediately after they assumed power, was calculated to arouse public opinion against modernism. On June 30, 1937, the Reich Art Chamber president Adolf Ziegler called for the confiscation from all public collections of works of art reflecting the degeneration of German art since 1910. Wolfgang Willrich, an academic painter who specialized in overly idealized Aryan types and wrote books and articles on the relationship between race and art, was on the committee. Willrich maintained that art was the best medium for spreading notions of racial purity and "the eternal racial life of the German people."[82] Other members were Dr. Klaus Graf Baudessin, an SS leader and Nazi-appointed director of the Folkwang Museum in Essen, who

[*]Fritz Kaiser, *Führer durch die Austellung Entartete Kunst*, Berlin (Verlag für Kultur-und Wirtschaftswerbung, 1937), pp. 2, 4, 6, 8, 11, 14, 16, 18, 20, 22.

had stated that the most "perfect form, the most beautiful creation
. . . in the course of the last epoch . . . was the steel helmet
worn by the attacking gray columns";[83] Hans Schweitzer, Reich
commissioner for artistic design; art theoretician Robert Scholz;
and Walter Hansen, a journalist and drawing teacher.[84] They were
responsible for the confiscation of more than 16,000 works of art.[85]

When Hitler opened the *Degenerate Art* exhibition on July 19,
1937, he proclaimed: "From now on we will lead a relentless war of
purification against the last elements of our cultural decay."[86] His
original intention was that the confiscated works be stored and
exhibited as monuments to a period of German decadence.[87] The
works were displayed haphazardly, without frames, leaning up
against walls, and poorly lit. The purchase prices, paid in inflation
period marks by named museum directors, were prominently posted.
On the walls, too, were statements by critics who had supported
modernism, including Karl Scheffler, Julius Meier-Graefe, Carl
Georg Heise, Paul Fechter, and Wilhelm Hausenstein. Among the
112 artists represented were Ernst Barlach, Max Beckmann, Hein-
rich Campendonk, Otto Dix, Lyonel Feininger, Conrad Felixmüller,
Otto Freundlich, Ludwig Gies, George Grosz, Erich Heckel, Was-
sily Kandinsky, Ernst L. Kirchner, Paul Klee, Oskar Kokoschka,
Wilhelm Lehmbruck, Franz Marc, Paula Modersohn-Becker, Otto
Mueller, Emil Nolde, Max Pechstein, Christian Rohlfs, Oskar
Schlemmer, and Karl Schmidt-Rottluff.

What Does the "Degenerate Art" Exhibition Want?

It wants, at the beginning of a new era for the German people, to give
a general insight, by means of original documents, into the dreadful final
chapter of the cultural degeneration of the last decades before the great
turning point.

It wants, in appealing to the people's healthy judgment, to bring an
end to the idle talk and sloganeering of those literary and fraternal cliques
that, sometimes, even today, still would like to deny that we had a degen-
eration of art.

It wants, to make clear that this degeneration of art was something
more than just the passing delirium of a few foolishnesses, follies, and
all-too bold experiments that would have played themselves out even
without the National Socialist revolution.

It wants to show that we are concerned here not with a "necessary

process of fermentation," either, but with a systematic assault on the essence and the continuing existence of art generally.

It wants to show the common roots of **political** anarchy and **cultural** anarchy, to unmask the degeneration of art as **art bolshevism** in the full sense of the word.

It wants to expose the ideological, political, racial, and moral purposes and aims pursued by the driving forces of decay.

It wants also to show to what extent these manifestations of degeneration spread from the conscious driving forces to more or less ingenuous, blind adherents, who despite formal talent . . . were **weak** enough in **conscience, character**, or **instinct** to take part in the general Jewish and Bolshevik racket.

It wants also, however, to thereby show precisely how dangerous a development directed by a few Jewish and politically unequivocal Bolshevik spokesmen was, when it also could enlist such people in the **cultural-political** Bolshevik plans for anarchy, people who perhaps would have stayed far away from **party-political** belief in Bolshevism.

It wants thereby to show, for once conclusively, that today none of the men who then participated in some way in this degeneration of art may come and speak only of "harmless youthful stupidities."

. . . .

On the Organization of the Exhibition

Because the profusion of manifestations of degeneration . . . nearly overwhelms each visitor, a clear overall organization was provided . . . works that belong together on the basis of intention and form are clearly combined in groups. . . .

Group 1.

Here one can gain a general overview of the **barbaric representation** from the standpoint of craftsmanship. In this group one sees the progressive **destruction of feeling for form and color**, the conscious **scorn for all craftsmanly foundations** of the visual arts, the **garish color** along with the **conscious distortion** of drawing, the absolute **stupidity of choice of materials**, . . .

Group 2.

In these rooms are gathered such paintings as deal with **religious contents**. In the Jewish press these horror-pieces were once called "manifestations of German religiosity." . . . a person of normal perception . . . no

matter to which religious confession he belongs, feels them to be a shameless **mockery of every religious concept**. . . .

Group 3.

The prints shown in this section are sure evidence for the **political background of the degeneration of art**. Here the **demands of political anarchy** are preached with the means of **artistic anarchy**. Each individual painting . . . calls for **class struggle** in the Bolshevik sense. . . .

Group 4.

This section, too, has a pronounced **political intention**. Here "art" steps into the service of Marxist propaganda for draft evasion. . . . The viewer is supposed to see the soldier as the murderer or the pointless victim of battle, in the sense of Bolshevik class warfare. . . . Above all, however, people's deeply rooted respect for every soldierly virtue, courage, bravery, and readiness to act is to be driven out. Thus in the drawings of this section we see, beside caricatures of war cripples painted with all refinement deliberately to arouse disgust, . . . the German soldiers represented as idiots, vulgar erotic libertines, and drunks. . . .

Group 5.

This section of the exhibition gives an insight into the **moral** side of the degeneration of art. For the "artists" represented in it, the whole world is apparently one large **bordello**, and humanity consists for them of nothing but **prostitutes** and **pimps**. . . . Almost all of these obscenities also show a clear Marxist-class-warfare tendency. Again and again one encounters prints on which libertines of the "propertied classes" and their prostitutes are placed in contrast to the starved figures of the proletariat, dragging themselves along exhausted, in the background. In other drawings the prostitute is idealized and placed in contrast to the woman of bourgeois society who, in the view of the creators of this "art," is morally much more vile than the prostitute. In short: **the moral program of Bolshevism cries out from all of the walls in this section.**

Group 6.

Here . . . it becomes apparent that degenerate art also variously placed itself in the service of that part of Marxist and Bolshevik ideology whose aim reads: The systematic **killing of the last vestiges of any racial con-**

sciousness. . . . we now meet here the **Negro** and **South Sea Islander** as the apparent **racial ideal** of "modern art. . . ."

Group 7.

. . . besides the Negro as the racial ideal of art that was "modern" at the time, a very singular spiritual ideal was also in their minds, namely the idiot, the cretin, and the paralytic. Even when these "artists" portrayed themselves or one another, markedly cretinish faces and forms appear. . . . Here are portraits compared with which the first historically known efforts of human representation in the stone age caves are ripe masterworks. **But also as the purchase prices proved, such horror-pieces still demanded and received the highest prices a few years ago.**

Group 8.

In a small room only Jews are represented for a change. . . . The great "gains" that the Jewish spokesmen, dealers, and promoters of degenerate art doubtless obtained adequately justify this **"special honor."**. . .

Goup 9.

To this section one can only give the heading **"Consummate Madness."** It takes in the largest space of the exhibition and contains a cross-section through the abortions of all the **"Isms"** that the Flechtheims, the Wollheims, and Cohen-types have contrived, promoted, and sold over the years. . . . But when one considers that all these "artworks" too were taken not from the filthy corners of abandoned studios but out of the art collections and museums of the great German cities . . . **then one can no longer laugh: then one can only fight one's rage over the fact that such a fraud could ever have been perpetuated on so decent a people as the Germans.**

V. THE LEFT AND THE DEBATE OVER EXPRESSIONISM IN THE THIRTIES

INTRODUCTION

The late thirties saw a renewed debate among theoreticians of the Marxist left about the success and failure of Expressionism as an artistic movement. The September 1937 issue of the Moscow based German emigrée periodical *Das Wort* began a year-long investigation into the implications of "the foundation and essence of Expressionism"[88] with the publication of two essays, one by Klaus Mann and the other by Bernhard Ziegler. Although many of the arguments could be traced to the late teens and early twenties, the charge that Expressionism could not be a revolutionary art form and that, as the product of imperialist capitalism, it bore the responsibility for fascism, stems from a 1934 essay by the Marxist theoretician Georg Lukács. Accordingly, this section begins with excerpts from Lukács's essay. Of the sixteen articles in the series in *Das Wort*,[89] this section includes the essay by Mann and two other essays, one by Herwarth Walden—then living in Moscow—and one by the Marxist theoretician Ernst Bloch.

The controversy over Expressionism has been interpreted as the left's debate on the nature of modernism as it attempted to form a "popular front" against fascism.[90] Expressionism—understood as Germany's modern movement—came under attack from those convinced by Soviet ideology that a revolutionary art should be linked to realism and classicism. Less devastating than the National Socialist crusade against modernism, the debate on the left had long-term implications. Historians who later related painting with naturalistic objects to the philosophic condition of objectivity and/or related painting with abstracted images

or no objects to the philosophic condition of subjectivity and relativity (hence the semantic confusion of the term "nonobjective") helped to perpetuate Lukács's critique that Expressionism was subjective and emotionally irrational. By the 1950s critics no longer focused on the communal and utopian interests nor on the political and reforming implications of Expressionism.[91] Instead they primarily interpreted Expressionism as a powerful conduit of individual emotions and subjective feelings. This emphasis created many misunderstandings about Expressionism as well as modernism.

86. Georg Lukács, "Expressionism: Its Significance and Decline," *Internationale Literatur*, 1934*

Two and a half years before the debate on Expressionism appeared in *Das Wort*, the Marxist literary theoretician Georg Lukács (1885–1971) published the argument that Expressionism had facilitated the Nazis' rise to power. It had done so, he claimed, by encouraging bourgeois intellectuals critical of capitalism to retreat into an abstract, formalistic critique of "middle-classness," without concretely depicting and opposing the sources of capitalist oppression in the economic base and in imperialism. By the time "Expressionism: Its Significance and Decline" was written, Lukács had become influenced by the Stalinist hostility to modernist art. His polemic was also prompted in part by the positive statements concerning Expressionism made by Goebbels, prior to the Nazis' decision that it was "degenerate" art, and by the propaganda statements on behalf of the Nazis made by the Expressionist poet Gottfried Benn in 1933–34.[92] But Lukács's targets were primarily the theorists of Expressionism, rather than the artists and he focused mainly on literature, not the visual arts.

Lukács had never been enamored of Expressionism nor of modernism in general. Born in Budapest, the son of a wealthy Jewish banker, Lukács developed into this century's leading Marxist theoretician of realism. Converted to Marxism after the Russian Revolu-

*Georg Lukács, " 'Grösse und Verfall' des Expressionismus," *Internationale Literatur* 1 (Moscow, 1934), 153–73; English translation by David Temback in *Georg Lukács: Essays on Realism*, Rodney Livingstone, ed. (Cambridge: MIT Press, 1980), 87, 91, 96, 101, 104–7, 109–113.

tion, he joined the Hungarian Communist Party in December 1918, twelve days after it was founded. His theories derived in part from his years spent in Germany under the influence of Georg Simmel and Wilhelm Dilthey and from his close contact with Ernst Bloch,[93] who would later be his adversary in the 1930s debate on Expressionism, modernism, and realism. Running through his early studies and consistent with his later work is a deeply felt seriousness about art's social role.

. . . .

As an opposition from a confused anarchistic and bohemian standpoint, expressionism was naturally more or less vigorously directed against the political right. And many expressionists and other writers who stood close to them took up a more or less explicit left-wing position in politics (Heinrich Mann is an exceptional case). But however honest the subjective intention behind this may well have been in many cases, the abstract distortion of basic questions, and especially the abstract "anti-middle-classness," was a tendency that, precisely because it separated the critique of middle-classness from both the economic understanding of the capitalist system and from adhesion to the liberation struggle of the proletariat, could easily collapse into its opposite extreme: into a critique of "middle-classness" from the right, the same demagogic critique of capitalism to which fascism later owed at least part of its mass basis. . . .

For expressionism is undoubtedly only one of the many tendencies in bourgeois ideology that grow later into fascism, and its role in the ideological preparation for fascism is no greater—if also no less—than that of many other simultaneous tendencies. Fascism, as the general ideology of the most reactionary bourgeoisie in the post-war era, inherits all the tendencies of the imperialist epoch in as much as these express decadent and parasitic features; and this also includes all those that are sham-revolutionary or sham-oppositional. . . .

. . . .

The World War and its ending form the high point of expressionism. In this period it attained an importance that went beyond the literary field in the narrow sense—the first literary movement to do so in Germany since the beginnings of naturalism. This seems at first sight to contradict what we have maintained about the ideology of expressionism, but only at first sight. For we did indeed grant that expressionism was a literary opposition movement, even if, as a result of the circumstances that we explained, it stood ideologically on the same terrain as its adversary (imperialism). We shall now see that this common ground was never really

abandoned, even at the time of the most violent, and subjectively most sincere, opposition. The passionate struggle of the expressionists against the war was objectively only a mock battle, even when their literary works suffered prosecution in wartime Germany. It was a struggle against war in general, and not against the imperialist war. . . .

. . . .

. . . however, the method of abstraction . . . , which diverts from the real battlefield of the class struggle, was also a spontaneous manifestation of the expressionists own class position; their continued use of this method in their world outlook and creative method was thus not just a political manoeuvre, treachery, or a betrayal. The objective affinity of method, which at some points amounted to actual identity, was due to the fact that both tendencies, USPD and expressionism, while remaining on the class foundation of the bourgeoisie, sought to avoid a confrontation with the underlying causes by their attacks on symptoms. Within this affinity, however, there was the distinction that the expressionists who, naively, and out of genuine conviction, retained the backward, petty-bourgeois values, imagined—both in their world outlook and in their creative method—that at the level of form they had reached the topmost peaks of abstraction, the purest essence of the phenomena, and necessarily fell into the same exaggerated and empty, even if subjectively honest, pathos, that characterizes this era of war and revolution.

. . . .

. . . The bitter struggles of the first ten years of revolution, and the initial defeats of the revolution in Germany, were to shatter ever more clearly the sham distinctions between revolutionary phrase and whimpering capitulation. And so expressionism came to an end as the dominant literary tendency in Germany—at the same moment in time, and this by no accident, as the dissolution of the USPD.

. . . .

What was new in the creative method of expressionism lay in the way that on the one hand it accelerated this process of abstraction, while on the other hand it transformed its formal orientation. The impressionists and symbolists, as open and honest subjectivists, subjectivized their creative method more and more, i.e., they mentally abstracted the material to be depicted from its real foundations. Yet they still preserved the general structure of immediate reality. . . . The expressionist precisely abstracted away from these typical characteristics, in as much as he proceeded, like the impressionists and symbolists, from the subjective reflex in experience, and emphasized precisely what in this appears—from the subject's standpoint—as essential, in as much as he ignored the "little," "petty," "inessential" aspects (i.e., precisely the concrete social determinations) and uprooted his "essence" from its causal connection in time

and space. This "essence" is then presented by the expressionist as the poetic reality, as the act of creation that simultaneously reveals the "essence" of reality as attainable by us.

. . . .

. . . But while the naturalists, with the almost photographic fidelity of their superficial presentation, kept at least certain (uncomprehended) features of the mode of appearance of this conflict, the expressionist abstraction from reality only serves up as the "essence" a childish nonsense. Of course, this nonsense is not accidental: it shows close affinity in content with the romantic and reactionary "youth movements.". . .

. . . .

Here we can see the internal contradictions of expressionism as contradictions of creative method. Firstly, its extreme subjectivism is revealed—a subjectivism that borders on solipsism. . . . the second point—that expressionism should raise [is] the question of totality. Its internal contradiction, from the standpoint of class basis and world outlook, shows itself in the expressionist creative method in the contradiction that, while on the one had it has to lay claim to a total portrayal (simply on account of the social and political position it adopted during the war and after), on the other hand this creative method does not permit the portrayal of a living and dynamic world. The totality, therefore, can only be brought in via an external surrogate, and is purely formal and empty in the works of expressionism." Simultaneism, for example, is such an empty and formal external means designed to substitute, for the missing internal all-round context, an external juxtaposition of words grouped by association. But this means a gaping contradiction between content and form. And the sham solution that expressionism invents shows the same antagonism in its most intense form. The nothingness of the content—and this is the third point—is disguised in a self-trumpeting emotionalism in the use of language. . . .

. . . The fact that the fascists, with a certain justification, see expressionism as a heritage that they can use, only seals its tomb the more firmly. Goebbels accepts expressionism, and also the validity of the "new objectivism" (which is again instructive), but he rejects naturalism, which "gets distorted into environmental description and Marxist ideology," i.e., he maintains artistic continuity only with the art of post-war imperialism. . . .

. . . .

. . . As a literary form of expression of developed imperialism, expressionism stands on an irrational and mythological foundation: its creative method leads in the direction of the emotive yet empty declamatory manifesto, the proclamation of a sham activism. It has therefore a whole series of essential features that fascist literary theory could accept without having

to force them into its mould. Naturally the conscious tendencies of expressionism are different from this, indeed sometimes even the direct opposite. And for this reason it can only be incorporated in the fascist "synthesis" as a subordinate element. But its abstracting away from reality, and its lack of content, facilitate such an incorporation and *"Gleichschaltung"* to an extraordinary degree.

. . . .

. . . In actual fact the theory and practice of national socialism is a unity of decadence and regression. The expressionists certainly wanted anything but a regression. But since they could not free their world outlook from the basis of imperial parasitism, since they shared uncritically and without resistance in the ideological decay of the imperialist bourgeoisie, even being sometimes its pioneers, their creative method needed no distortion to be pressed into the service of fascist demagogy, of the unity of decadence and regression. Expressionism forms a legitimate part of the general "November legacy" of national socialism. For despite its rhetorical gestures, it was unable to rise above the horizon of the 1918 Weimar republic. Just as fascism is the necessary result of the November betrayal of the German working class and the revolution by the SPODE and USPD, it can also take up this November legacy in the literary field.

87. Klaus Mann, "Gottfried Benn: History of an Aberration," *Das Wort*, 1937*

Klaus Mann (1905–1949), the eldest son of Thomas Mann, is often remembered today as the author of *Mephisto*.[94] Although his birth date precluded him from being either an Expressionist or an anti-Expressionist during the movement's vital years, he was committed to the idea that Expressionism had produced valuable works, was well-intentioned, and was not responsible for the failure of the Weimar Republic and the rise of fascism. In his 1937 essay, Mann discusses Benn's capitulation to fascism as an act of madness, emphasizing that he was the only major Expressionist author to do so. Mann was a great admirer of Benn's poetry and an ardent anti-Nazi; accordingly, he was very distressed by Benn's radio addresses and essays of 1933–34 in support of the new regime. He had written to Benn in May 1933 and, partly in answer to Lukács's critique, pro-

*Klaus Mann, "Gottfried Benn. Die Geschichte einer Verirrung," *Das Wort* 2, no. 9 (September 1937): 35–49.

duced an essay on literary Expressionism, not published until after his death.[95]

In his 1937 essay, Mann cites other Expressionists, such as Stefan George and Oswald Spengler, who were involved with a mythic primevalism, but, unlike Benn, had rejected National Socialism. Mann explains that Benn had abandoned the humanistic side of Expressionism in his pursuit of form and blamed Benn's own personal regression for allowing him "to be seduced, intoxicated, tempted onto the wrong path." Nonetheless, he did not feel that Benn's early poetry reflected fascistic thoughts.[96]

Unlike the other authors in this section, and those who wrote about Expressionism for *Das Wort*, Mann was not a Marxist. He did, however, in the political atmosphere of the Nazi period, tend toward the activism of his uncle Heinrich Mann.

We have to start with the question: why are we concerned with the "case of Gottfried Benn?" . . .

. . . His "case" is interesting only because he is the one distinguished German author—the only one!—who followed National Socialism seriously and with some intellectual consistency. All the others, who today belong to an institution that calls itself—as I have been told—"National Literary Board," have just "gone along" a little—sometimes maybe even a little grudgingly—: out of opportunism, fear and weakness, or lower-class reactionary instincts. On the other hand it is considered a fact that Gottfried Benn, at least for a time, really was taken in by the clumsy and blatantly false propaganda of Fascism. Today he may be disappointed, bitterly isolated, disillusioned—: but does it matter? . . .

. . . .

. . . One must consider that minds bearing as great an intellectual affinity for Fascism as Benn's—for example Oswald Spengler or Stefan George— immediately and decisively opposed the new regime—simply because they were **disgusted** by the physical and "spiritual" physiognomy of these new trappings of leadership, risen to power through intrigue; because they could not, with a clear aesthetic conscience, acknowledge Goebbels and Rosenberg as their spiritual mentors—or even only as their spiritual pupils. . . .

. . . .

. . . Everyone in Germany who has taken the problem of form seriously— and especially Nietzsche, to whom Benn refers a hundred times in a totally senseless and confused manner—has set it in the context of South-

Mediterranean-antiquity—in short, in **Europe**. And it is precisely the Mediterranean and the antique—exactly this tradition of European form—from which the Nazis want to distance and detach Germany. Why would Nietzsche have detested these Nazis?—and there is no question for me that he would have detested and deeply despised them. Exactly **because** they set the "Germanic Mythos" and its formlessness (that mythos against which Nietzsche's instincts recoiled most violently) against: "Europe" (and in this context that means: against the Mediterranean and France) and demand the unconditional supremacy of the Germanic over the European. Why else **did** Stefan George abhor Hitlerism?—and I **know** **he** did. Exactly because in his concept of beauty, the Mediterranean element, the antique, and the French element were much too essential and central for him to tolerate the Rosenberg "Return to Walhalla," the whole foul wizardry of Bayreuth and Braunau. . . .

. . . .

. . . the whole absurdity, the almost clinical aberration of form-ethos as portrayed by Benn and as it portrays itself to him can be demonstrated in connection with Heinrich Mann. Because the particular case of Heinrich Mann shows with exemplary clarity how the will to civilization—meaning therefore, the will to social progress—comes from the will to form, and how those two will-tendencies complement each other and in an important way enhance each other.

To begin as an "aesthete" and to end a socialist: I never was able to see a paradox in such a developmental curve. The pathos of beauty can lead in a straight line to a social-moral pathos—or, to remain with the example of Heinrich Mann: there is a straight line from his early Italian novels and the countesses of Assy up to the fiery protest—and accusatory writings against the Hitler regime. . . . With his false pathos of form, Benn narrows and undermines the idea and the essence of human morality altogether—something that hardly is surprising since he would really like to suspend the entire idea of morals in his atavistic longings and intoxication. . . .

. . . .

Another one of his macabre games is the attempt to justify Expressionism before the propaganda ministry—as if anything cultural could be justified there—. Ideologically anything can be claimed about Expressionism—which is practically characterized by its ideological confusion. But one thing is certain for the Nazi: that this entire—in part very valuable—literature of the German postwar epoch is above Hitler's horizon and therefore "Culture-Bolshevism." Meanwhile Benn swears by his Goebbels, "by that great natural instinct for the racially perfect that floats above the whole movement," by the extraordinary "measure of interest that the leadership of the new Germany brings to questions of art," even forgiving

Expressionism that several of its adherents meanwhile have become socialists. Vain effort! While Benn begs in the highest places for consideration of those talents—who today are either in exile or . . . talents no longer—the great Expressionist painters are cast out of German museums into the cellars. . . .

. . . .

Benn's example remains the crassest example of the degradation, the dishonor, the self-destruction of an intellectual who betrays the ideas of progress and humanism to the pseudo-ideology of "form" and "discipline." Such self-betrayal brings a terrible punishment. One is transported not just to Hannover,[97] but to hell.

The intellectual who bears witness against the spirit decays while still alive. I cannot without horror reread the lines of the earlier Benn:

Oh soul, decay is all around,

you are barely still alive, and still it is too much.

88. Herwarth Walden, "Vulgar Expressionism," *Das Wort*, 1938*

Herwarth Walden's contribution to the Expressionist debate in *Das Wort* has been termed "brilliant, but unfortunately long-neglected."[98] In 1932, after his conversion to communism in the 1920s, the former editor of *Der Sturm* emigrated to the Soviet Union and worked on the journals *Internationale Literatur* and *Das Wort* and taught at the Moscow Foreign Language Institue. He died in captivity in 1942, the victim of a purge.[99]

In an acerbic, polemical style, Walden condemned the idea that Expressionism led to fascism. For Walden, only in the twenties did Expressionism become tainted by capitalism and then "vulgar," as so many artists, publishers, and novelists took its name and abandoned its content. Walden argues that Expressionism was originally revolutionary, created not for one class, and drew from international sources with mass roots in tribal, peasant, and children's art. Walden also emphasizes that Expressionism related to its time and shaped it as well. Walden's appeal for cooperation between the "Popular Front" against fascism and avant-garde artists follows the position put forth shortly before in the Prague exile journal *Die Neue Welt-*

*Herwarth Walden, "Vulgär-Expressionismus," *Das Wort*, 3, no. 2 (February 1938): 89–100.

bühne, in a collaborative piece by Bloch and the composer Hanns Eisler.[100]

. . . .

Expressionism was the International that was fought against and had to be fought against. Everything dead felt revived by the world war:
"But now a spirit of rebirth wafts through our land."
That was the world war. But even this spirit produced only a dead fruit. The world war ended, and Expressionism survived. Now everything pounced on it. The same thing happened to it that has to happen with every victory in a capitalist country: it became a business trend. A big business trend. Vulgar Marxism and vulgar Expressionism flooded all of Germany. Against enemies one could defend oneself, against friends it was hopeless. All living painters, poets, writers, journalists, publishers, art dealers, upper-middle-class, lower-middle-class, conservatives, democrats, catholics, social democrats: they all were Expressionists, because they simply *named* themselves thus. Every old and new style felt fit for it.

But by and by its adherents became frightened. The word "Cultural-Bolshevism" was coined for Expressionism. . . .

Now the Third Reich has started the fight *against* allegedly fascist Expressionism on the largest scale. Paintings were taken from the museums and an exhibition of "decadent art" was shown in Munich. According to newspaper articles, they were mainly expressionistic paintings. How can the sensational attendance at this exhibition and the sales abroad be seen as a "highly pleasing antifascist demonstration," if Expressionism is fascist? . . .

. . . .

Consciously or unconsciously, unfortunately too often unconsciously, the artists of the avant-garde are trying to shape the means of expression, to shape their times. Truly great artists always have been revolutionaries and still are. . . .

Why did the new art cause such a sensation before the world war? Because it *stirred* the senses. Not because it created new forms, but because it expressed the new form of life. It went from the individual to the typical. It tried to express the common will, often with insufficient means. It tried to show the expression of the times. It was not satisfied with the impression the period gave. It had to destroy in order to create. . . . Should one not destroy graven images, when one must destroy their carriers? . . .

Now, it is said that the masses and particularly the proletariat reject the new art. That is a lower-middle-class idea. . . . For the masses art was

synonymous with the luxury of the rich. At best, a matter for museums. A visit to the museum required leisure, in most cases even money, and above all time. Poetry was luxury for the masses. At best, unintelligible. The poets always concerned themselves with antiquity or the Middle Ages. Or they used expressions which assumed a scientific or technical education, and could only be understood symbolically. The means of this education were inaccessible to the masses, who, in the capitalist countries, were, and even are, systematically prevented from gaining access to them. Only one thing was left to them: folk art. Only these anonymous artists expressed what moved them, and spoke in a way they could understand, because they could not speak any other way. This folk art was not published, most of it was not even written down. It was conveyed orally, in performance, conveyed in a memorable form. Thus the metric, unrhythmic verses emerged.

. . . .

But to take this as proof, or to deduce from this that the masses cannot or do not understand art is, simply said, nonsense. If art exists at all, it cannot be the privilege of one class or even for one caste or even for one individual person. Because everything that is dance, music and poetry can be traced historically back in its origin, that is, its originality, to the so-called people, the masses. . . .

In the search for new forms and rhythms, one discovered Negroes who in this one single area, had so far not been exploited, namely in their original artistic productivity. Jazz-music, suitably formulated, began its triumphant march around the world. Again rhythm triumphed over meter. Painters turned to the so-called "wild beasts" not from decadence; they searched for new means of creation in the continuous productivity of the unspoiled masses. Others watched the visual and aural responses of children whose senses still absorb things in a direct and unspoiled way. . . .

. . . .

The word "Expressionism" is a fighting word. If it is not understood or misunderstood, it means nothing, a characteristic it shares with all words. It means: to revolutionize art. To find the artistic means of expression which signify the common will of progressive humanity. To find *the* means of expression which bring the social reality of life to sensually perceptible form. With the political freedom of spiritual, unsymbolic, direct expression, with the use of the latest technical knowledge and understanding of the present. With the creation of artistic forms which make the content of the times truly visible and audible, to make the expression of the period visible and audible not only in the work of art, but in life itself. . . .

. . . .

It is not a matter of defending the *word* "Expressionism"! What is at stake is the word's *content*, its content as it has been set forth here. I have not

read anything into this term, I have only read out what does not belong to it. That is I must protest, in the strongest terms, against the branding of the avant-garde of the time before the war, during the war, and the present, as low-brow or even fascist by those who live from its vulgarization or withdraw to some past moment. Political realities in fascist and semi-fascist countries, the emigration of the Expressionist artists especially, and the persecution of their creations prove the correctness of this assertion. Practical experience cannot be disputed.

The great political goal of the Peoples' Front requires support of the artistic avant-garde; it is an active part of the Peoples' Front. The more the artists educate themselves politically and socially, that is, the more they recognize the times they live in, the more they take part in the building of the Soviet Union, the more each one will recognize what matters: the style of the times.

89. Ernst Bloch, "Discussing Expressionism," *Das Wort*, 1938*

In this essay the Marxist philosopher Ernst Bloch (1885–1977) focuses his attention on the article by Georg Lukács with which this section opened as the actual beginning of the debate over Expressionism. This was a logical move for Bloch, as he and Lukács had been close friends and theoretical collaborators prior to World War I and had gone their separate ways in part because of their different opinions on the value of modern art, especially Expressionism.[101] Bloch also challenges an essay in *Das Wort* by the Marxist critic Bernhard Ziegler, who condemned Expressionism in language even more simplified and formulaic than Lukács.[102]

Bloch castigates Lukács specifically for ignoring Expressionist visual art and for concentrating his attention on theorists of Expressionism, many of whom Bloch also thought had missed the utopian thrust of the movement. But for Bloch, Expressionism challenged traditional values of art and society and drew from the folk art of many peoples, unlike the Neo-Classicism to which Lukács and Ziegler were so attached. Bloch pointed to the complexities of Expressionism, its spatial and temporal fissures, as

*Ernst Bloch, "Diskussionen über Expressionismus," *Das Wort* 3, no. 6 (June 1938): 103–12; English translation from F. Jamison, ed., *Aesthetics and Politics*, Ernst Bloch et al., trans. Rodney Livingstone (London: NLB [now Verso], 1977), 17, 18–19, 20–27. © Verso 1977.

reflecting the struggle of moving from one age to the next. While remaining a committed Marxist throughout his long life, Bloch continued to support artistic experimentation as an anticipatory exercise that could help condition mankind for the future.

. . . .

. . . We refer to Lukács's essay *The Greatness and the Decline of Expressionism*,[103] published four years ago in *Internationale Literatur*. It is that essay which furnishes the conceptual framework for the latest funeral oration on Expressionism. . . . he insisted that the *conscious* tendencies of Expressionism were not Fascist, and that in the final analysis, Expressionism "could only become a minor component of the Fascist 'synthesis.' " But in his summing-up he also observed that "the Fascists were not without justification in discerning in Expressionism a heritage they could use." Goebbels had found the "seeds of some sound ideas" here, for "as the literary mode corresponding to fully-developed imperialism(!), Expressionism is grounded in an irrationalist mythology. . . ."

. . . .

What material does Lukács then use to expound his view of the Expressionists? He takes prefaces or postscripts to anthologies, "introductions" by Pinthus, newspaper articles by Leonhard, Rubiner, Hiller, and other items of the same sort. So he does not get to the core of the matter, the imaginative works which make a concrete impression in time and space, a reality which the observer may re-experience for himself. His material is second-hand from the outset; it is literature on Expressionism, which he then proceeds to use as a basis for literary, theoretical, and critical judgements. . . .

. . . .

. . . But there is surely no need to labour the point that in the emotional outbursts of the art of the period, with their semi-archaic, semi-utopian hypostases, which remain today as enigmatic as they were then, there is to be found far more than the "USPD ideology" to which Lukács would like to reduce Expressionism. No doubt these emotional outbursts were even more dubious than enigmatic when they had no object outside themselves. But to describe them as the expression of "the forlorn perplexity of the petty-bourgeois" is scarcely adequate. Their substance was different; it was composed mostly of archaic images, but partly too of revolutionary fantasies which were critical and often quite specific. Anyone who had ears to hear could hardly have missed the revolutionary element their cries contained, even if it was undisciplined and uncon-

trolled, and "dissipated" a considerable amount of the "classical heritage.". . .

Given such an attitude, what recent artistic experiments can possibly avoid being censured? They must all be summarily condemned as aspects of the decay of capitalism—not just in part, which might not be unreasonable, but wholesale, one hundred percent. The result is that there can be no such thing as an avant-garde within late capitalist society; anticipatory movements in the superstructure are disqualified from possessing any truth. That is the logic of an approach which paints everything in black and white—one hardly likely to do justice to reality, indeed even to answer the needs of propaganda. Almost all forms of opposition to the ruling class which are not communist from the outset are lumped together with the ruling class itself. This holds good even when, as Lukács illogically concedes in the case of Expressionism, the opposition was subjectively well-intentioned and its adherents felt, painted, and wrote as adversaries of the Fascism that was to come. In the age of the Popular Front, to cling to such a black-and-white approach seems less appropriate than ever; it is mechanical, not dialectical. . . . On the same grounds, Lukács even doubts whether Cézanne is of any substance as a painter, and talks of the great Impressionists *in toto* (not just of the Expressionists) as he speaks of the decline of the West. In his essay nothing is left of them but a "vacuity of content . . . which manifests itself artistically in the accumulation of insubstantial, merely subjectively significant surface details."

By contrast, the Neo-classicists emerge as true giants. Theirs alone is the heritage. . . . In the face of such a simplification we need to remind ourselves that the age of Neo-classicism witnessed the rise not only of the German bourgeoisie but also of the Holy Alliance; that the Neo-classical columns and the "austere" manorial style take account of this reaction; that Winckelmann's Antiquity itself is by no means without feudal passivity. . . . But in general, the Classical is seen as healthy, the Romantic as sick, and Expressionism as sickest of all, and this is not simply by contrast with the undiluted objective realism which characterized Classicism.

. . . But what if Lukács's reality—a coherent, infinitely mediated totality—is not so objective after all? What if his conception of reality has failed to liberate itself completely from Classical systems? What if authentic reality is also discontinuity? Since Lukács operates with a closed, objectivistic conception of reality, when he comes to examine Expressionism he resolutely rejects any attempt on the part of artists to shatter any image of the world, even that of capitalism. Any art which strives to exploit the *real* fissures in surface inter-relations and to discover the new in their crevices, appears in his eyes merely as a wilful act of destruction. He thereby equates experiment in demolition with a condition of decadence.

. . . Lukács himself acknowledges that Expressionism "was ideologically a not insignificant component of the anti-war movement." Secondly, so far as "collusion" in an active sense goes, the actual furtherance of cultural decline, one must ask: are there not dialectical links between growth and decay? Are confusion, immaturity, and incomprehensibility always and in every sense to be categorized as bourgeois decadence? Might they not equally—in contrast with this simplistic and surely unrevolutionary view—be part of the transition from the old world to the new? Or at least be part of the struggle leading to that transition? This is an issue which can only be resolved by concrete examination of the works themselves; . . .

The importance of Expressionism is to be found . . . ; it undermined the schematic routines and academicism to which the "values of art" had been reduced. Instead of eternal "formal analyses" of the work of art, it directed attention to human beings and their substance, in their quest for the most authentic expression possible. . . . As a phenomenon, Expressionism was unprecedented, but it did not by any means think of itself as lacking in tradition. Quite the reverse. As the *Blue Rider* proves, it ransacked the past for like-minded witnesses, thought it could discern correspondences in Grünewald, in primitive art, and even in Baroque. If anything, it unearthed too many parallels rather than too few. It found literary predecessors in the *Storm and Stress* movement of the 1770s, it discovered revered models in the visionary works of the youthful and the aged Goethe. . . .

. . . .

For all that, the passions of an earlier period still stir controversy. So perhaps Expressionism is not outmoded after all; might it still have some life left in it? . . . Ziegler asks, to test his own hostility to the movement, the questions "Antiquity: 'Noble simplicity and serene grandeur'—do we still see it in that light?" "Formalism: enemy number one of any literature that aspires to great heights—do we agree with this?" "Closeness to the people, popular character: the fundamental criteria of any truly great art— do we accept this without reservation?" . . . Hitler has already unreservedly answered the first and third questions in the affirmative, but that does not put him on our side.

Let us leave aside "noble simplicity and serene grandeur," which involves a purely historical, contemplative question, and a contemplative attitude toward history. Let us confine ourselves to the questions of "formalism" and "closeness to the people," however ambiguously they may have been formulated in the present context. There is surely no denying that formalism was the least of the defects of Expressionist art (which must not be confused with Cubism). On the contrary, it suffered far more from a neglect of form, from a plethora of expressions crudely, wildly or

chaotically ejaculated; its stigma was amorphousness. It more than made up for this, however, by its closeness to the people, its use of folklore. That disproves the opinion of it held by Ziegler, who conceives of Winckelmann's view of Antiquity and the academicism derived from it as a sort of artistic equivalent of Natural Law. It is enough, of course, that fake art [*kitsch*] is itself popular, in the bad sense. . . .

. . . At a far lower level, Heartfield's satirical photography was so close to the people that many who were intellectuals thereafter refused to have anything to do with montage. If Expressionism can still provoke debate today, or is at any rate not beyond discussing, then it follows that there must have been more to it than the "ideology of the USPD," which has now lost any sub-structure it ever had. The problem of Expressionism will continue to be worth pondering until they have been superseded by better solutions than those put forward by its exponents. But abstract methods of thought which seek to skim over recent decades of our cultural history, ignoring everything which is not purely proletarian, are hardly likely to provide these solutions. The heritage of Expressionism has not yet ceased to exist, because we have not yet even started to consider it.

Notes to Part Four: Reactions to Expressionism

1. Gropius, "The Viability of the Bauhaus Idea," from a February 3, 1922, circular to the Bauhaus masters; English translation in Hans M. Wingler, *Bauhaus* (Cambridge: MIT Press, 1969), 51–52. See also "Idee und Aufbau des Staatlichen Bauhaus Weimar," 1st pub. 1923; English translation as "The Theory and Organization of the Bauhaus," in *Architecture and Design 1890–1939*, ed. T. Benton, 119–27. In both of these essays, Gropius discusses coming to terms with the machine and industry.

2. For a concise overview of developments during the Bauhaus's existence, see Frank Whitford, *Bauhaus*, (New York: Thames and Hudson, 1984).

3. See Franciscono, *Walter Gropius*, 91–95, 118–26.

4. Gropius, response from *JA! Stimmen des Arbeitsrates für Kunst in Berlin*, 1919, 30–33; partial English translation in *Voices of German Expressionism*, ed. Victor Miesel, 173.

5. Gropius was not above writing to the Cultural Minister of the new Weimar Republic for assistance when, for example, his attempt to hire Paul Klee and Oscar Schlemmer was opposed by accusations of their being wild Expressionists; see Gropius letter to Edwin Redslob, December 13, 1920, Bauhaus-Archiv, Berlin.

6. See, for example, Emil Herfurth, *Weimar and the Staatliche Bauhaus*, pamphlet, Weimar, 1920; *The Dispute over the Staatliche Bauhaus*, brochure, Weimar, 1920; and Ministry of Culture in Weimar, *Results of the Investigation Concerning the Staatliche Bauhaus in Weimar*, [supplement to *The Dispute*], in Wingler, *The Bauhaus*, 37, 38–39, 39–42.

7. Ministry of Culture in Weimar, *Results of the Investigation . . .* , 1920, in Wingler, *The Bauhaus*, 42. The attacks may have also been another factor in the Bauhaus's eventual disengagement from identification with Expressionism.

8. For a collection of excerpts from press clippings about the Bauhaus during its Weimar tenure, see *Pressestimmen für das Staatliche Bauhaus Weimar*, ed. Peter Hahn (Munich: Kraus Reprint, 1980).

9. Johannes Itten, "Aus meinem Leben" (1948), in *Johannes Itten: Werke und Schriften*, ed. Willy Rotzler (Zurich: Orell Fussli, 1972), 399, n. 65–66.

10. Franciscono, *Walter Gropius . . .* , 173–237 and Karin von Maur, "Es wuchs ein Kristall: Johannes Itten in Stuttgart 1913–1916," in *Johannes Itten: Künstler und Lehrer*, Bern Kunstmuseum, 1984, 55–65.

11. Arnold H. Lehman and Brenda Richardson, eds., *Oskar Schlemmer*, The Baltimore Museum of Art, 1986.

12. *Hugo Ball (1886–1986) Leben und Werk*, (Pirmasens: Wasgau Palle, 1986), 12–17.

13. Ibid., 18–22, and Richard Sheppard, "Dada and Mysticism: Influences and Affinities," in *Dada Spectrum: The Dialectics of Revolt*, ed. Stephen

Foster and Rudolf Kuenzli (Madison, Wisc.: Coda Press, 1979), 92–113; see also Hugo Ball, *Flight Out of Time: A Dada Diary*, 1st pub. 1927, Eng. ed. John Elderfield (New York: Viking, 1974), 10–25.

14. See Karin Füllner, "*The Meister-Dada*: The Image of Dada through the Eyes of Richard Huelsenbeck," *New Studies in Dada: Essays and Documents*, ed. Richard Sheppard (Driffield, England: Hutton Press, 1981), 16–34, and *Richard Huelsenbeck. Texte und Aktionen eines Dadisten* (Heidelberg: Carl Winter, Universitatsverlag, 1983).

15. Huelsenbeck had gone to Munich to study art history with Heinrich Wölfflin and literature with Artur Kutscher. In 1914 he went to Berlin to study medicine.

16. Richard Huelsenbeck, "Der neue Mensch," *Die Neue Jugend* 1 (May 23, 1917); excerpt in English in Richard Huelsenbeck, *Memoirs of a Dada Drummer*, ed. Hans J. Kleinschmidt (New York: The Viking Press, 1974), xxx–xxxii.

17. See "Die dadaistische Bewegung, Eine Selbstbiographie von Richard Huelsenbeck," *Die Neue Rundschau* 31, no. 8 (1920), 978, and Part Four, n. 20. For discussion of the evening and date see Füllner, "*The Meister-Dada*," 18, 32 n. 14, and Timothy O. Benson, *Raoul Hausmann and Berlin Dada* (Ann Arbor, Mich.: UMI Research Press, 1985), 83–84. How much or whether the manifesto was revised for the Almanach is not yet known.

18. In *En avant Dada*, Huelsenbeck referred to Hiller as a melioristic theoretician, that is, someone who blindly believes the world is getting better and better, and he described meliorism as the underpinning of Expressionism; see Richard Huelsenbeck, ed., *En Avant Dada: Eine Geschichte des Dadaismus* (Hanover: Steegman, 1920); English translation in *The Dada Painters and Poets: An Anthology*, ed. Robert Motherwell (Boston: G.K. Hall, 1981, reprint of 1951 edition), 40. For a description of Hiller's political goals, see Istvan Deak, *Weimar Germany's Left-Wing Intellectuals, A Political History of the "Weltbühne" and Its Circle* (Berkeley: University of California Press, 1968), 77–80; and also Allen, *Literary Life . . .* [as in Part One, n. 71], 75–92.

19. Huelsenback, *En Avant Dada*, in *Dada Painters and Poets*, 41–42; for background see J. C. Middleton, "Bolshevism in Art: Dada and Politics," *Texas Studies in Literature and Language* 4, no. 3 (August 1962): 408–30; and Richard Sheppard, "Dada and Politics," *Dada: Studies of a Movement*, ed. R. Sheppard (Chalfont St. Giles, England: Alpha Academic, 1979–80), 39–74.

20. [At bottom of p. 36 in original text]: "First Dada Manifesto in the German language, drawn up by Richard Huelsenbeck, delivered at the large Berlin Dada evening in April 1918."

21. The idea that the world is getting better and better; see note 18.

22. Small investor.

23. Arthur Mitzman, "Anarchism, Expressionism, and Psychoanalysis," in *Passion and Rebellion, the Expressionist Heritage*, ed. Stephen Eric Bronner and Douglas Kellner (South Hadley, Mass.: J. F. Bergin, 1983), 55–81.

24. Raoul Hausmann, "Schnitt durch die Zeit," *Die Erde*, October 1, 1919, 542–43.

25. See Stephen C. Foster, "Johannes Baader: The Complete Dada," *Dada/Dimsensions*, ed. S. C. Foster (Ann Arbor, Mich.: UMI Research Press, 1985), 249–71.

26. See Benson, *Raoul Hausmann and Berlin Dada*, 13–43, 50–56, 60–62.

27. For a discussion of rival claims about the first "photo-montage," see Benson, 110–44; also Dawn Ades, *Photomontage* (London: Thames and Hudson, 1986), 19–36; and Maud Lavin, "Strategies of Pleasure and Deconstruction in the Weimar Era Photomontages of Hannah Höch," *The Divided Heritage*, Irit Rogoff, ed. (Cambridge: Cambridge University Press, 1990), 93–115.

28. The Activists were associated with the circle of Kurt Hiller and were strongly critiqued by the Dadaists for their cultural presumptions; see note 18.

29. For discussion and photographs of the exhibition, see Helen Adkins, "Erste Internationale Dada-Messe, Berlin 1920," *Stationen der Moderne* . . . , 156–183; and also Adkins, "Erste Internationale Dada-Messe, Berlin 1920," *Stationen der Moderne, Kataloge* . . . (commentary volume) [as in Part One, n. 78], 77–94.

30. For a list of the Grosz graphic series published by Malik Verlag, see Beth Irwin Lewis, *George Grosz, Art and Politics in the Weimar Republic* (Madison: University of Wisconsin Press, 1971), 272–76, 274–86.

31. For discussion of Grosz's fascination with the United States, see *Envisioning America: Prints, Drawings, and Photographs by George Grosz and His Contemporaries, 1915–1933* (Cambridge: Busch-Reisinger Museum, Harvard University, 1990).

32. Theodor Däubler, "Georg Grosz," *Die Weissen Blätter* 3, no. 11 (October–December 1916): 167–70; and "George Grosz," *Das Kunstblatt* 1, no. 3 (March 1917): 80, 82.

33. Futurist painter.

34. John Elderfield, *Kurt Schwitters* (New York: The Museum of Modern Art, 1985), 12, 30–48. Ball's name along with Arp and Tzara, in addition to a reference to *Anna Blume*, appears on the cover of *En Avant Dada: Die Geschichte des Dadaismus*, the collection of essays on Dada that Huelsenbeck edited and Steegemann published in Hannover in 1920. For discussion of some of Schwitters' political connections, see Annegreth

Nill, "Weimar Politics and the Theme of Love in Kurt Schwitters' *Das Bäumerbild*," *Dada/Surrealism*, no. 13 (1984): 17–36.

35. Kurt Schwitters, "Merz," *Der Ararat* 2 (January 1921); reprinted in *Kurt Schwitters: Das Literarische Werk*, ed. Friedhelm Lach, vol. 5 (Cologne: Du Mont Buchverlag, 1981), 78.

36. Kurt Schwitters, autobiographical statement, 1930, reprinted in Lach ed., *Kurt Schwitters*, 5:335–36.

37. See Allen, *Literary Style*, 45–51.

38. English translations of the term vary. "New Objectivity" is most frequently used, although "New Sobriety" is also seen. But "New Tangibility" or "New Impartiality" would be closer to the dual implications of the word *Sachlichkeit*, which has a figurative meaning of "matter of factness" and "impartiality" and a literal meaning denoting a return to the depiction of objects from an optical viewpoint.

39. "Für Kandinsky," *Der Sturm* 3, no. 150/151 (March 1913): 273.

40. Even in a slightly earlier volume *Uber Expressionismus in der Malerei* from Kasimir Edschmid's Tribüne der Kunst und Zeit series (Berlin: Erich Reiss, 1919), Hausenstein indicated a preference for nineteenth-century realists such as Wilhelm Leibl and Gustave Courbet. He also stated in this book that he did not see any Expressionists achieving the greatness of "Grünewald, Michelangelo, Rembrandt, Delacroix"; see 36 and 71.

41. For a discussion of Hausenstein's theories and their relationship to other critics of the period, see Charles W. Haxthausen, "A Critical Illusion: 'Expressionism' in the Writings of Wilhelm Hausenstein," in *The Ideological Crisis* . . . [as in Part Two, n. 4], 169–91.

42. For a presentation of Hausenstein's attitude toward art and politics before the war, see Joan Weinstein, "Wilhelm Hausenstein, the Leftist promotion of Expressionism, and the First World War," *The Ideological Crisis* . . . , 194–99, 211–15.

43. Hausenstein, "Kunst und Revolution," *Der Neue Merkur* 3, Sonderheft no. 1—"Der Vorläufer" (1919), esp. 77–82.

44. Hausenstein, "Erinnerung am Eisner," *Der Neue Merkur* 3, no. 1 (1919–1920): 56–68.

45. A similar lecture to the one included here was delivered at the Cologne Kunstverein in March 1919, and was also published; see Wilhelm Worringer, "Kritische Gedanken zur Neuen Kunst," *Genius* 1 (1919): 221–36.

46. Worringer, "Vorbemerkung," in *Künstlerische Zeitfragen*, n.p. [preface unpaginated].

47. For discussion of Worringer's attitude toward critical, historical, and scientific investigations, see Perkins, *Contemporary Theory of Expressionism* [as in Part One, n. 13], 59–63.

48. Goll published under various pseudonyms, including Iwan Lassang, Tristan Torsi, and Tristan Thor.

49. Tristan Torsi, untitled introduction to *Films* (Verse) (Berlin-Charlottenburg: Verlag der Expressionistischen Hefte, 1914), n.p.

50. Albert Ehrenstein, *Der Mensch schreit* (Man Screams) (Leipzig: Kurt Wolff, 1916); Franz Werfel, *Wir sind* (We Are) (Leipzig: Kurt Wolff, 1913); Franz Werfel, *Einander* (One Another) (Leipzig: Kurt Wolff, 1915).

51. Leonhard Frank, *Der Mensch ist gut* (Zurich: Leipzig: Rascher & Co., 1917).

52. Kurt Pinthus, ed. *Menschheitsdämmerung* (Berlin: Ernst Rowohlt Verlag, 1919), 300.

53. Pythia, the priestess of Apollo who delivered the answers of the oracle at Delphi, is used here to refer to one who reveals the hidden knowledge of the divine purpose and prophesies the future.

54. Man for man's sake, instead of art for art's sake.

55. Russian Symbolist poet who at first welcomed the Revolution.

56. See Part Three, n. 61.

57. For discussion of this exhibition, see Caroline Hille, "Neue Sachlichkeit. Deutsche Malerei seit dem Expressionismus, Mannheim 1925," *Stationen der Moderne, Kataloge* . . . (commentary volume), 131–150; and Helen Adkins, "Neue Sachlichkeit. Deutsche Malerei seit dem Expressionismus, Mannheim, 1925," *Stationen der Moderne* . . . , 216–235. Between 1923 and 1933 (when Hartlaub was removed from his post by the Nazis), he organized a wide range of exhibitions, including one on Primitivism in 1923, European abstract painting in 1927, and Pre-Columbian art in 1930.

58. G.F. Hartlaub, (review of) "Deutscher Expressionismus, zur Darmstädter Ausstellung," *Frankfurter Zeitung*, July 15, 1920, 1–2.

59. Circular letter, May 18, 1923, reprinted in Fritz Schmalenbach, "The Term *Neue Sachlichkeit*," *Art Bulletin* 22, no. 3 (September 1940): 161.

60. Hartlaub, letter of July 8, 1929, to Alfred H. Barr, Jr.; reprinted in Barr, "Otto Dix," *The Arts* 17, no. 4 (January 1931): 237.

61. The word *Kunstwollen*, rendered here as "creative impulses," would have recalled the Hegelian idea of an impersonal "will to art" among contemporary readers.

62. Juliane Roh, *Franz Roh, Retrospective Fotografie* (Düsseldorf: Edition Marzona, 1981), 6.

63. Jost Hermand, "Unity within Diversity? The History of the Concept 'Neue Sachlichkeit,' " *Culture and Society in the Weimar Republic*, ed. Keith Bullivant (Manchester University Press, 1977), 167 ff.

64. See, for example, Franz Roh and Jan Tschichold, eds., *Foto-Auge: 76 Fotos der Zeit* (Stuttgart: Akademischer Verlag F. Wedekind, 1929).

65. Franz Roh, "Ruckblick auf den magischen Realismus," *Das Kunstwerk* 6, no. 1 (1952): 8; see also discussion in Hermand, 170.

66. See Bettina Feistel-Rohmeder, *Im Terror des Kunstbolshewismus: Urkundensammlung des "Deutschen Kunstberichtes" aus den Jahren 1917–1933* (Karlsruhe: Verlag E. F. Muller, 1938). Feistel-Rohmeder, a painter, founded the right wing Deutsche Kunstgesellschaft in 1920.

67. For a detailed discussion of the relationship between art and politics during this period see Barbara Miller Lane, *Architecture and Politics in Germany 1918–1945* (Cambridge: Harvard University Press, 1968).

68. See Hildegard Brenner, *Die Kunstpolitik des Nationalsozialismus* (Reinbek bei Hamburg: Rohwolt Taschenbuch Verlag GmbH, 1963), 235–49, for a list of the functions and functionaries of the Reichskulturkammer.

69. Jacques Barzun, "On Nazi Art," *Magazine of Art* (October 1945): 211. Barzun (1907–), a French-born intellectual, came to the United States in 1920 and has been a critic, biographer, historian, and translator.

70. Der Norden, a group led by Otto Andreas Schreiber and Hans Weidemann, exhibited at Ferdinand Moeller's gallery in Berlin, which hosted the proscribed "Thirty German Artists" exhibition, and in October 1933 founded *Kunst der Nation*, which had 3,500 subscribers when it was banned in 1935.

71. Heinrich Mann, brother of Thomas Mann, was also an author, novelist, and dramatist.

72. His 1934 *Kunst aus Blut und Boden* attempted to establish a tie between art and the blood and soil mythos; his 1937 *Nordische Schönheit, ihr Wunschbild im Leben und in der Kunst* attempted to isolate the ideal Aryan type.

73. Quoted in Joachim C. Fest, *The Face of the Third Reich: Portraits of the Nazi Leadership*, trans. Michael Bullock (New York: Pantheon Books, 1970), 167, 168.

74. Otto Andreas Schreiber, "Jugend kampft für deutsche Kunst," *Deutsche Allgemeine Zeitung*, 193

75. From Nolde's book on tribal arts, begun in 1912: *Jahre der Kämpfe* (1934); translated and excerpted in Herschel B. Chipp, *Theories of Modern Art: A Source Book by Artists and Critics* (Berkeley and Los Angeles: University of California Press, 1968), 150–51.

76. Ibid., 151.

77. Emil Nolde, letter to Dr. Josef Goebbels, July 2, 1938; translated in Miesel, *Voices* . . . [as in Part Two, n. 19], 209.

78. Martin Urban, "Nolde's Forbidden Paintings," *Nolde: Forbidden Pictures (Watercolours) 1939–1945* (London: Marlborough Fine Arts, 1970), 5; as cited by Carmen Stonge, "The Anatomy of a Defamation: Nolde's *The Life of Christ*" (New York: Frick Symposium paper, 1991).

79. For a thorough documentation of this exhibition see Stephanie Barron, et al., *"Degenerate Art": The Fate of the Avant-Garde in Nazi Germany* (Los Angeles: Los Angeles County Museum of Art), 1990.

80. Frankfuter Kunstverein und Arbeitsgruppe des Kunstgeschichtlichen Instituts der Universität Frankfurt im Auftrag der Stadt Frankfurt. *Kunst im 3. Reich: Dokumente der Unterwerfung*, (Frankfurt am Main: Kunstverein Frankfurt, 1975), 27.

81. The name Fritz Kaiser is not among the identifiable Nazi writers on art.

82. Wolfgang Willrich's most famous book is *Säuberung des Kunsttempels. Eine Kunstpolitische Kampfschrift zur Gesundung deutscher Kunst im Geiste nordischer Art* (Munich/Berlin: J.F. Lehmanns Verlag, 1937), see especially 144.

83. Franz Roh, *"Entartete" Kunst: Kunstbarbarei im Dritten Reich* (Hannover: Fackelträger-Verlag [1962]), p. 51.

84. Mario-Andreas von Lüttichau, *"Entartete Kunst*, Munich 1937: A Reconstruction," in Barron, *"Degenerate Art"* . . . , 45.

85. Ibid., 48. According to the official inventories, the number of confiscated works ends with the number 16,558. A partial toll as listed in Roh, 52, follows: Mannheim Kunsthalle, 584; Düsseldorf, Städtische Kunstsammlung, 900; Frankfurt Stadelgalerie, 496; Breslau Schlesischen Museum, 560; Stuttgart Galerie, 283; Dresden, the Staatsgalereie, 150, Städtmuseum, 381, and Kupferstichkabinett, 365; and the Hamburg Kunsthalle, 983.

86. Brenner, *Die Kunstpolitik des Nationalsozialismus*, 203.

87. Ibid., 255, n. 2.

88. See editor's note, *Das Wort* 2, no. 9 (September 1937): 35.

89. These articles have been reprinted in *Die Expressionismusdebatte*, ed. Hans-Jurgen Schmitt (Frankfurt: Suhrkamp, 1973).

90. See Stephen Eric Bronner, "Expressionism and Marxism: Towards an Aesthetic of Emancipation," *Passion and Rebellion* . . . [as in Part Two, n. 2], 411–53; and Franz Schonauer, "Expressionismus und Faschismus: Eine Diskussion aus dem Jahre 1938," two parts, *Literatur und Kritik* 7 (1966): 44–54 and 8 (1966): 45–55.

91. See Long, "Scholarship: Past, Present, and Future Directions," *German Expressionist Prints and Drawings* . . . [as in Part One, n. 8], esp. 183–95.

92. See, for example, Gottfried Benn, "Expressionismus," 1934, trans. as "The Conversion of an Expressionist," in Miesel, *Voices* . . . , 192–203.

93. See Mary Gluck, *Georg Lukács and His Generation, 1900–1918* (Cambridge, Mass.: Harvard University Press, 1985), esp. 21–23, 58–61, 108–10, 160–63; and Harry Liebersohn, *Fate and Utopia in German Sociology 1870–1923* (Cambridge, Mass.: The MIT Press, 1988), 126–96.

94. Amsterdam: Querido, 1936.

95. "Klaus Mann, 1919—Der literarische Expressionismus," in Klaus Mann, *Prüfungen, Schriften zur Literatur*, ed. Martin-Dellin (Munich: Nymphenburger, 1968, 192–209).

96. See Franz Schonauer, "Expressionismus und Faschismus, Eine Diskussion aus dem Jahre 1938," first part, *Literatur und Kritik*, no. 7 (October 1966): 44–54.

97. Benn was a military doctor practicing in Hannover at the time.

98. David Bathrick, "Moderne Kunst und Klassenkampf, Die Expressionismusdebatte in der Exilzeitschrift *Das Wort*," *Exil und Innere Emigration*, ed. Reinhold Grimm and Jost Hermand (Frankfurt am Main: Athenaum, 1972), 106.

99. Paul Raabe, *Die Autoren und Bücher* [as in Part One, n. 82], 501.

100. Ernst Bloch and Hanns Eisler, "Avantgarde-Kunst und Volksfront," *Die Neue Weltbühne*, 33/50 (December 9, 1937), 1568–73; English trans. "Avant-Garde Art and the Popular Front," *Critical Texts* 4, no. 3 (1987): 6–9. In the *Das Wort* essay, Walden quotes from an earlier article by Bloch, "Der Expressionismus," *Die Neue Weltbühne* 33, no. 45 (November 4, 1937): 1415–21. See also Peter Chametzky's "Translator's Introduction," *Critical Texts* 4, no. 13:1–6.

101. Bloch and Lukács met around 1910, when they were members of Georg Simmel's private seminar in Berlin. In 1911 they both moved to Heidelberg, where they entered the circle of the sociologist Max Weber. Bloch became aware of Expressionism, particularly the works of the Blaue Reiter artists Kandinsky and Marc, around 1914, and he frequently referred to them in his essays of the 1930s. For Bloch's reminiscences of his early relationship to Lukács, see Michael Lowy, "Interview with Ernst Bloch" [Tübingen, March 24, 1974], *New German Critique* 9 (Fall 1976): 37–38. On the early origins of the Lukács-Bloch debate see also Wayne Hudson, *The Marxist Philosophy of Ernst Bloch* (New York: St. Martin's Press, 1982), 176–78.

102. Bernhard Ziegler [Alfred Kurella], "Nun ist dies Erbe zuende . . . ," *Das Wort*, 2, no. 9 (1937): 42–49.

103. A variant translation of " 'Grösse und Verfall' des Expressionismus."

INDEX

337